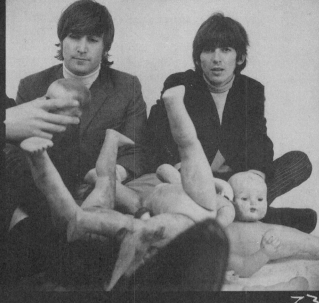

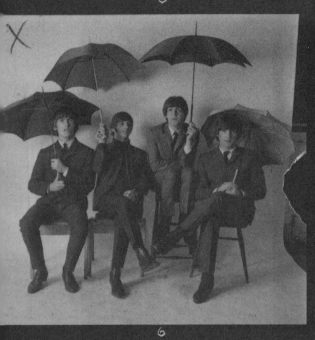

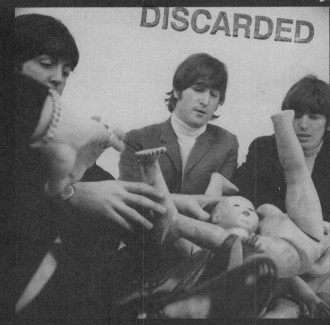

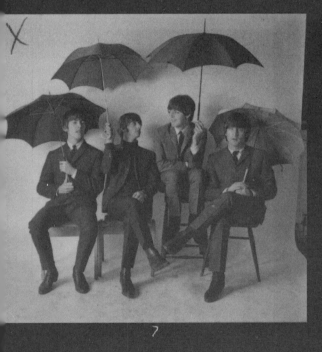

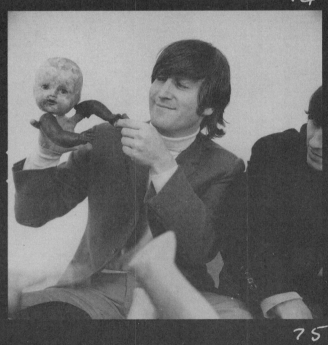

DISCARDED

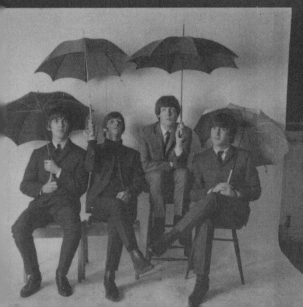

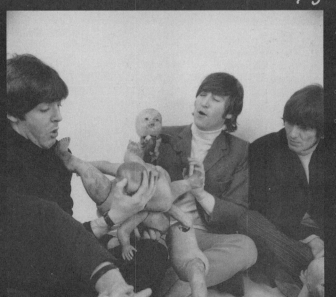

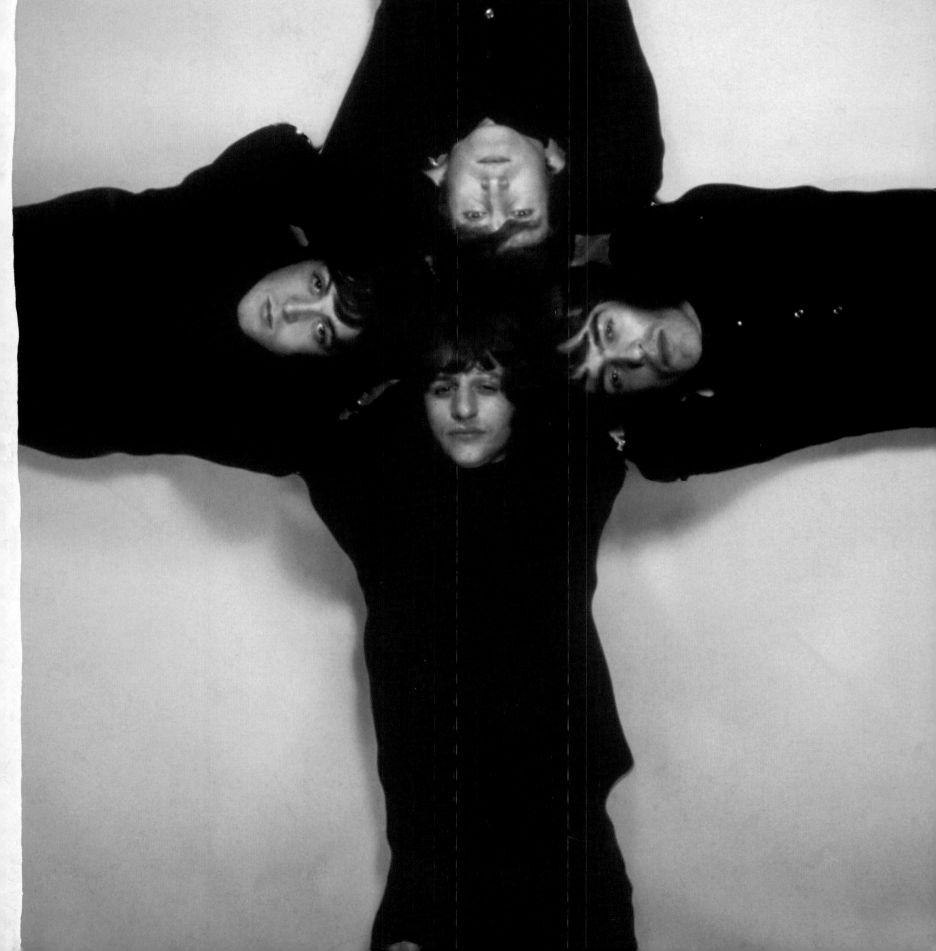

WITH THE BEATLES

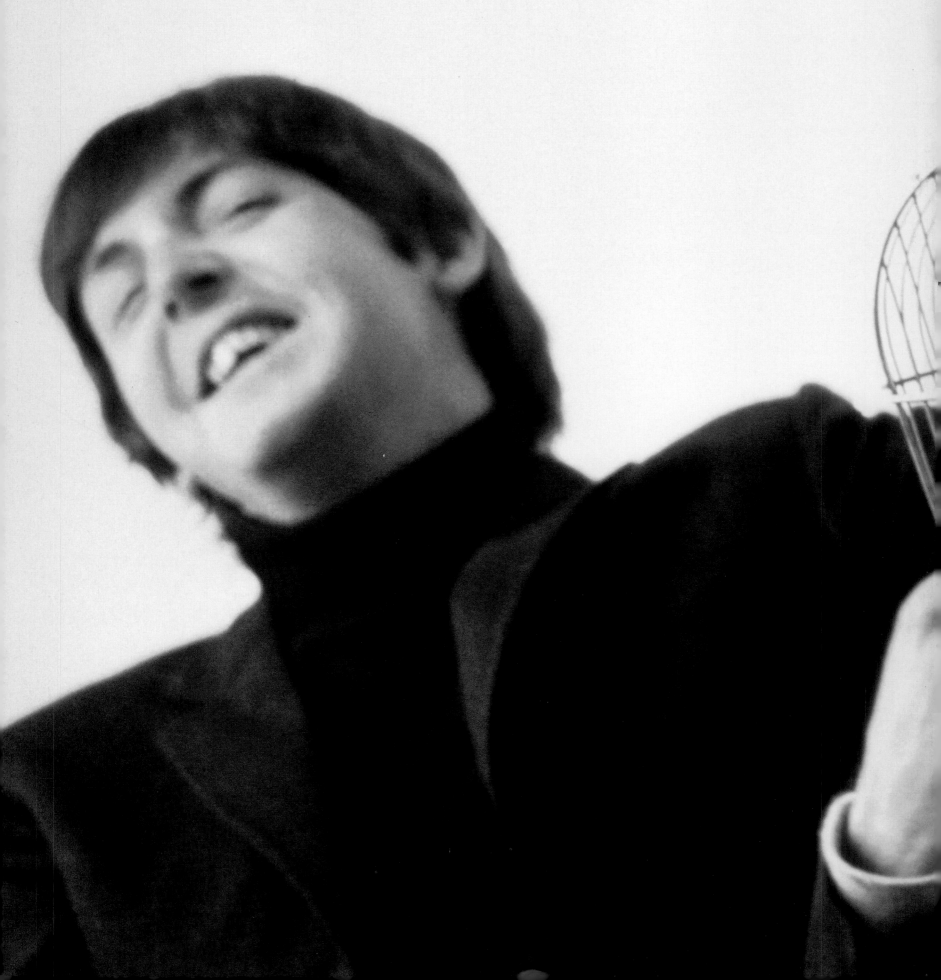

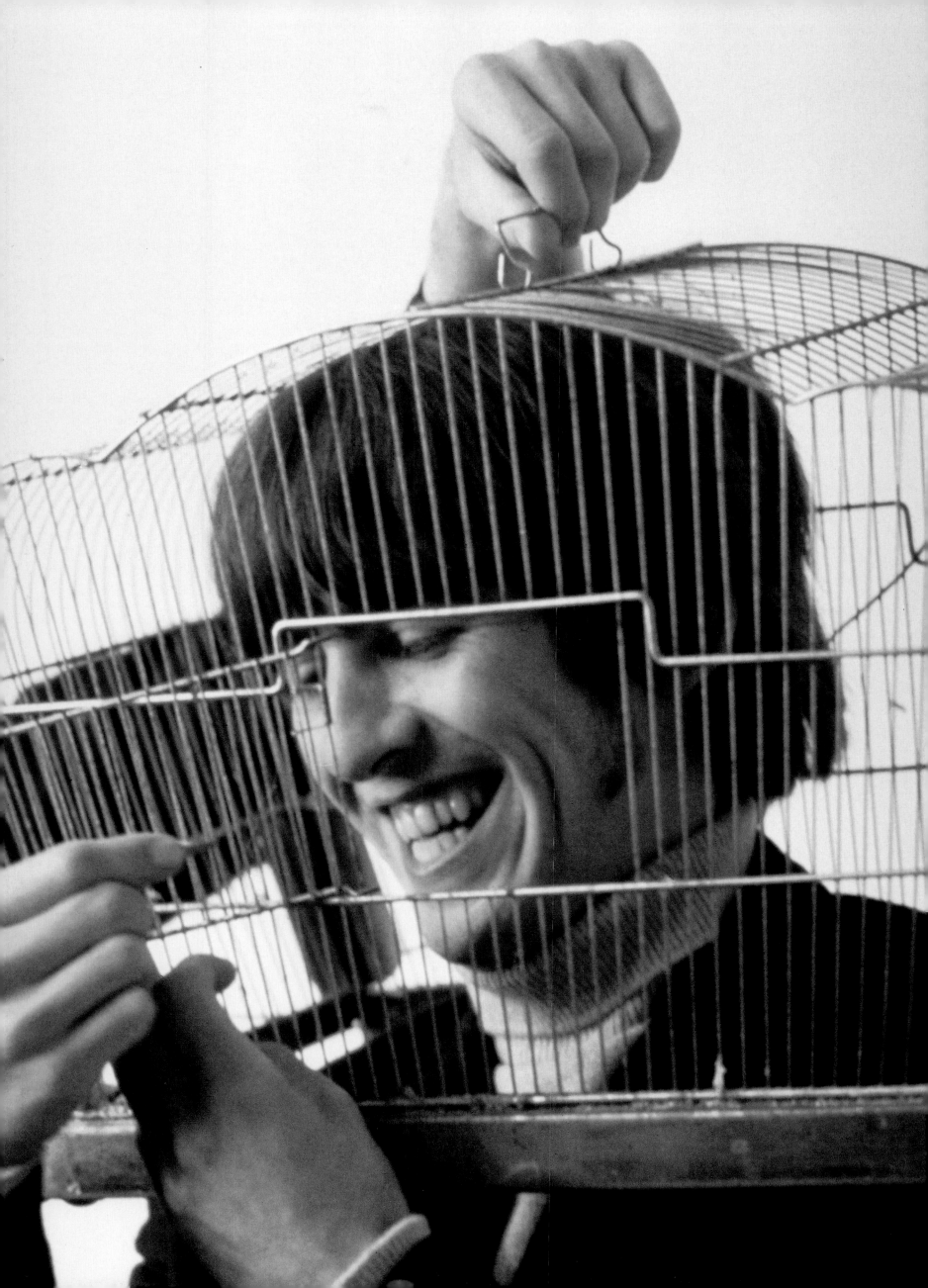

Page 1: A 1965 portrait
Pages 2-3: From the famous "butcher cover" shoot
Pages 4-5: John in Japan in 1966

LIFE BOOKS

Managing Editor Robert Sullivan
Director of Photography Barbara Baker Burrows
Creative Director Anke Stohlmann
Deputy Picture Editor Christina Lieberman
Writer-Reporters Amy Lennard Goehner (Chief), Michelle DuPré
Copy Editors Parlan McGaw (Chief), Barbara Gogan
Photo Associate Sarah Cates
Consulting Picture Editors Mimi Murphy (Rome), Tala Skari (Paris)

Special Picture Consultant Russell Burrows

Editorial Director Stephen Koepp

EDITORIAL OPERATIONS

Richard K. Prue (Director), Brian Fellows (Manager), Richard Shaffer
(Production), Keith Aurelio, Charlotte Coco, Kevin Hart, Mert Kerimoglu,
Rosalie Khan, Patricia Koh, Marco Lau, Brian Mai, Po Fung Ng, Rudi Papiri,
Robert Pizaro, Barry Pribula, Clara Renauro, Katy Saunders, Hia Tan,
Vaune Trachtman

TIME HOME ENTERTAINMENT

President Richard Fraiman
Vice President, Business Development & Strategy Steven Sandonato
Executive Director, Marketing Services Carol Pittard
Executive Director, Retail & Special Sales Tom Mifsud
Executive Publishing Director Joy Butts
Director, Bookazine Development & Marketing Laura Adam
Finance Director Glenn Buonocore
Associate Publishing Director Megan Pearlman
Editorial Operations Director Michael Q. Bullerdick
Assistant General Counsel Helen Wan
Assistant Director, Special Sales Ilene Schreider
Book Production Manager Suzanne Janso
Design & Prepress Manager Anne-Michelle Gallero
Brand Manager Roshni Patel
Associate Prepress Manager Alex Voznesenskiy

Special thanks: Christine Austin, Katherine Barnet, Jeremy Biloon, Stephanie
Braga, Jim Childs, Susan Chodakiewicz, Rose Cirrincione, Lauren Hall
Clark, Jacqueline Fitzgerald, Christine Font, Jenna Goldberg, Hillary
Hirsch, Amy Mangus, Robert Marasco, Kimberly Marshall, Amy Migliaccio,
Nina Mistry, Dave Rozzelle, Adriana Tierno, Vanessa Wu

WITH THE
BEATLES

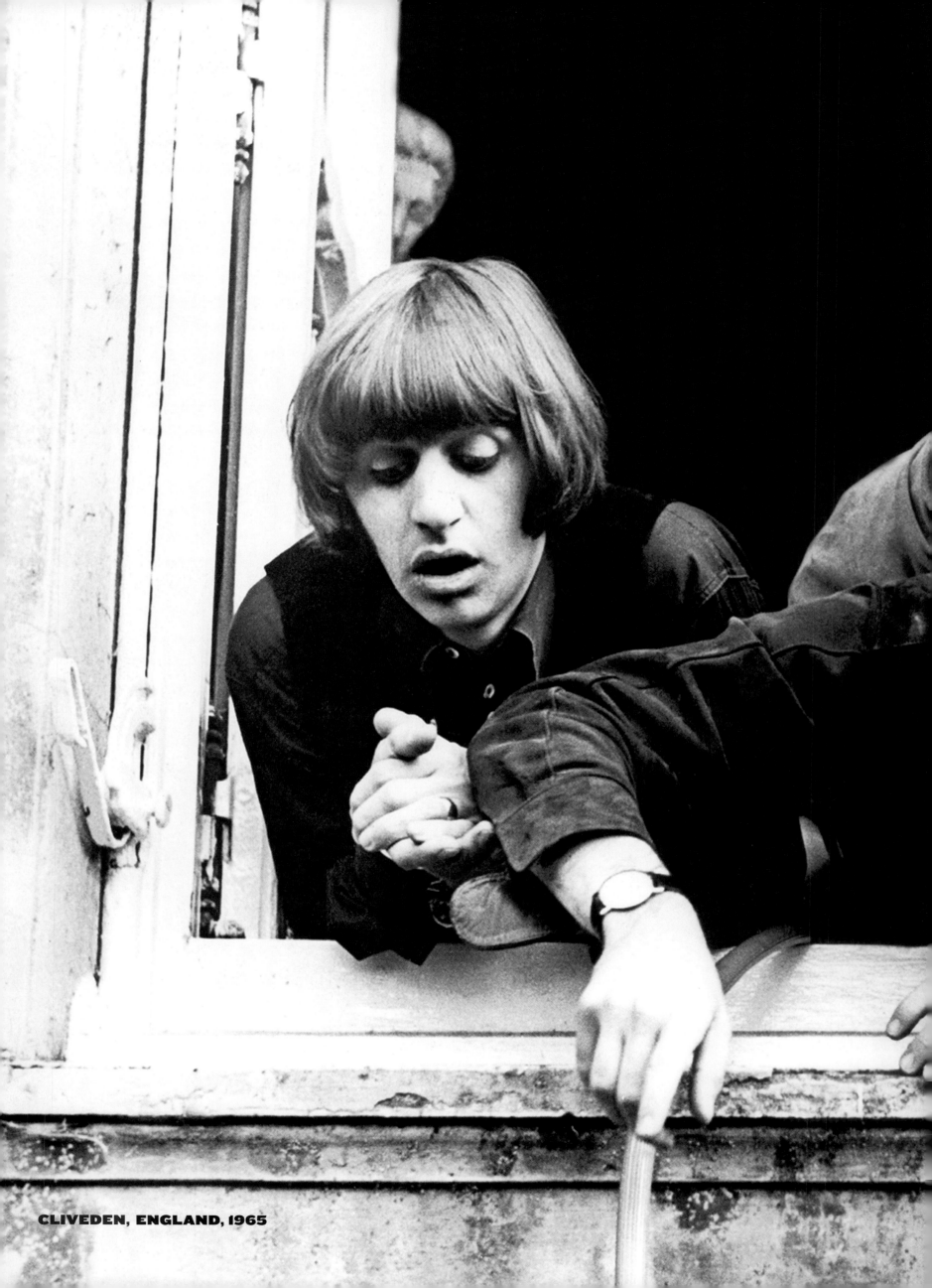

CLIVEDEN, ENGLAND, 1965

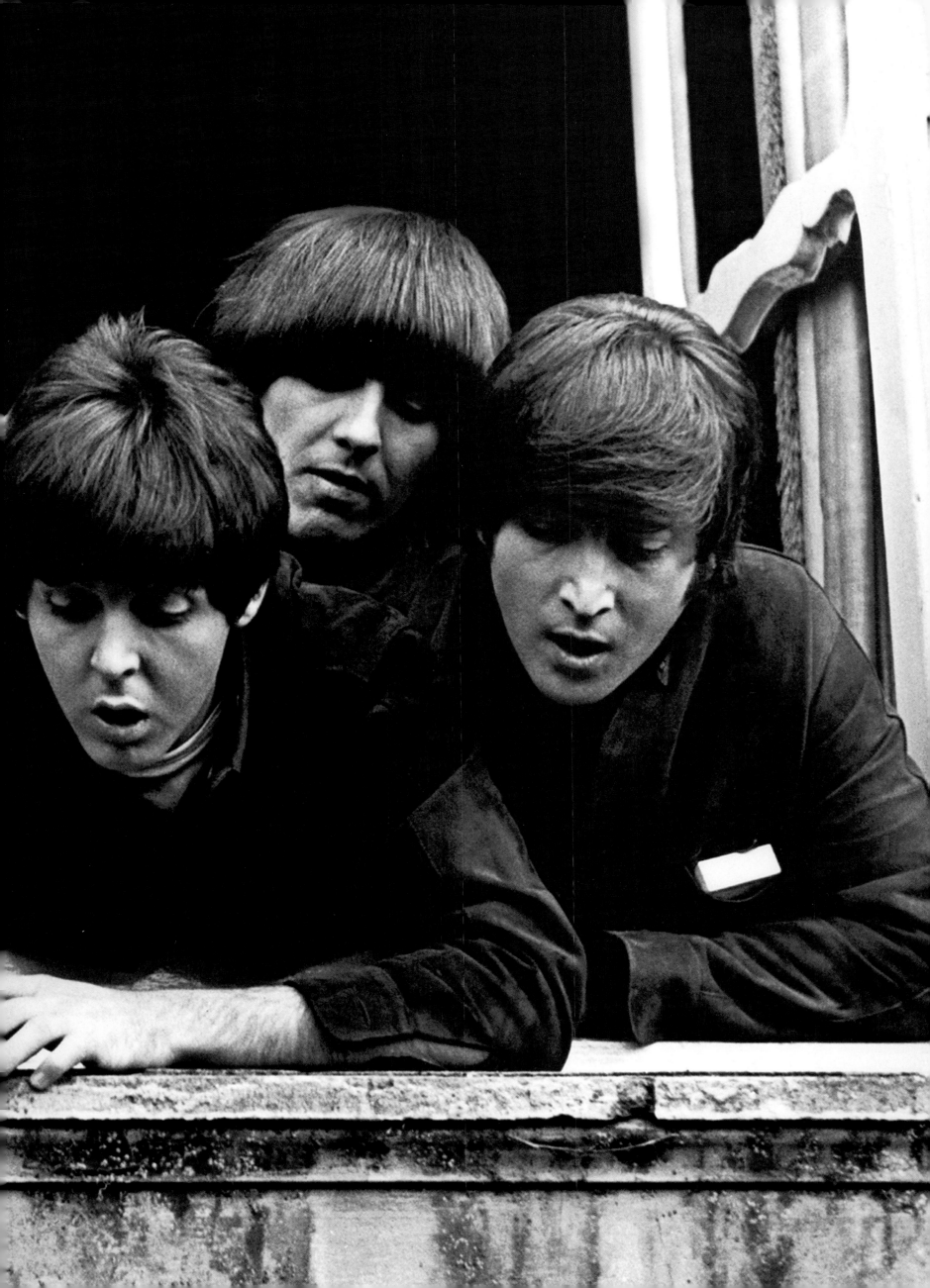

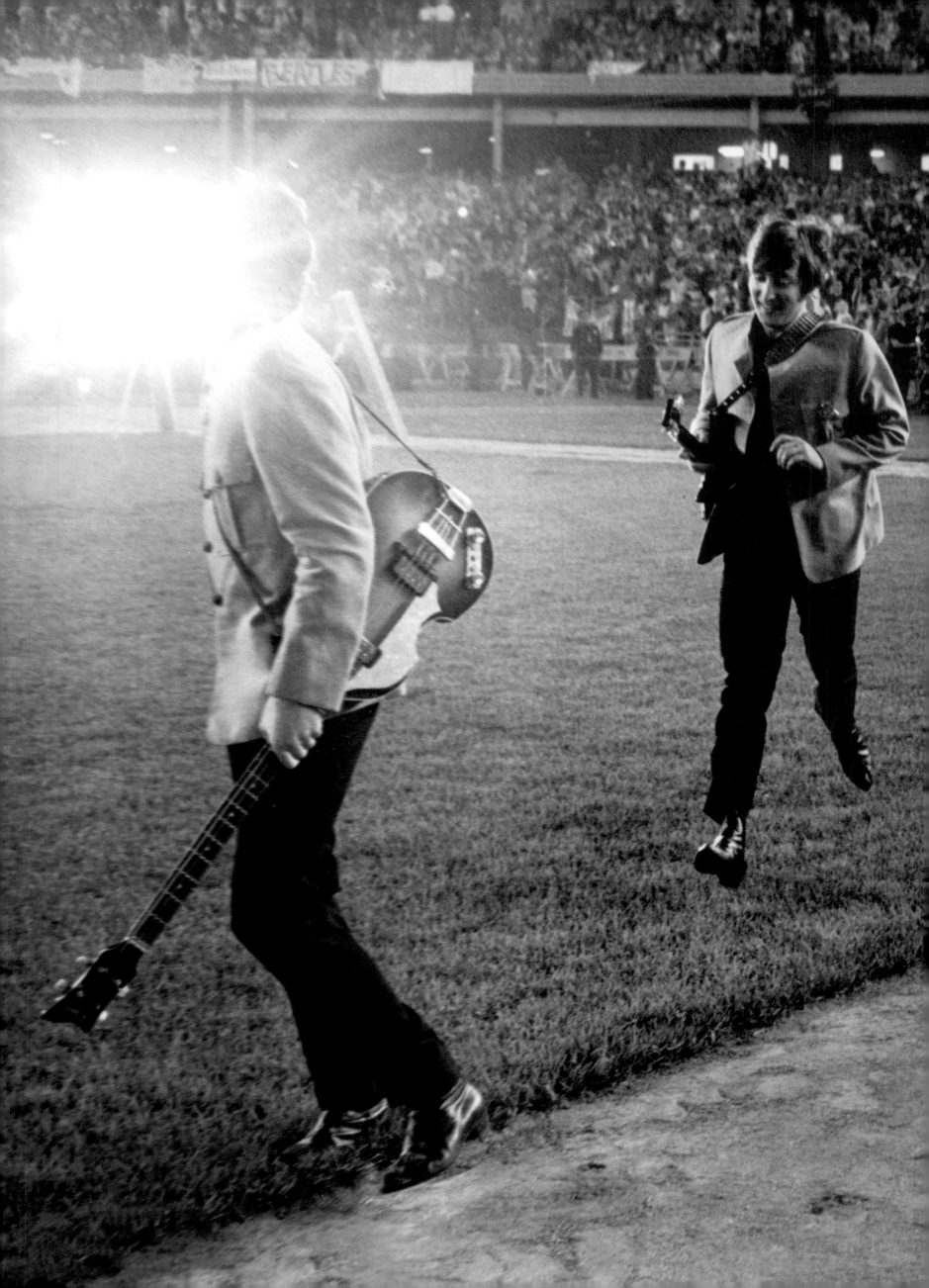

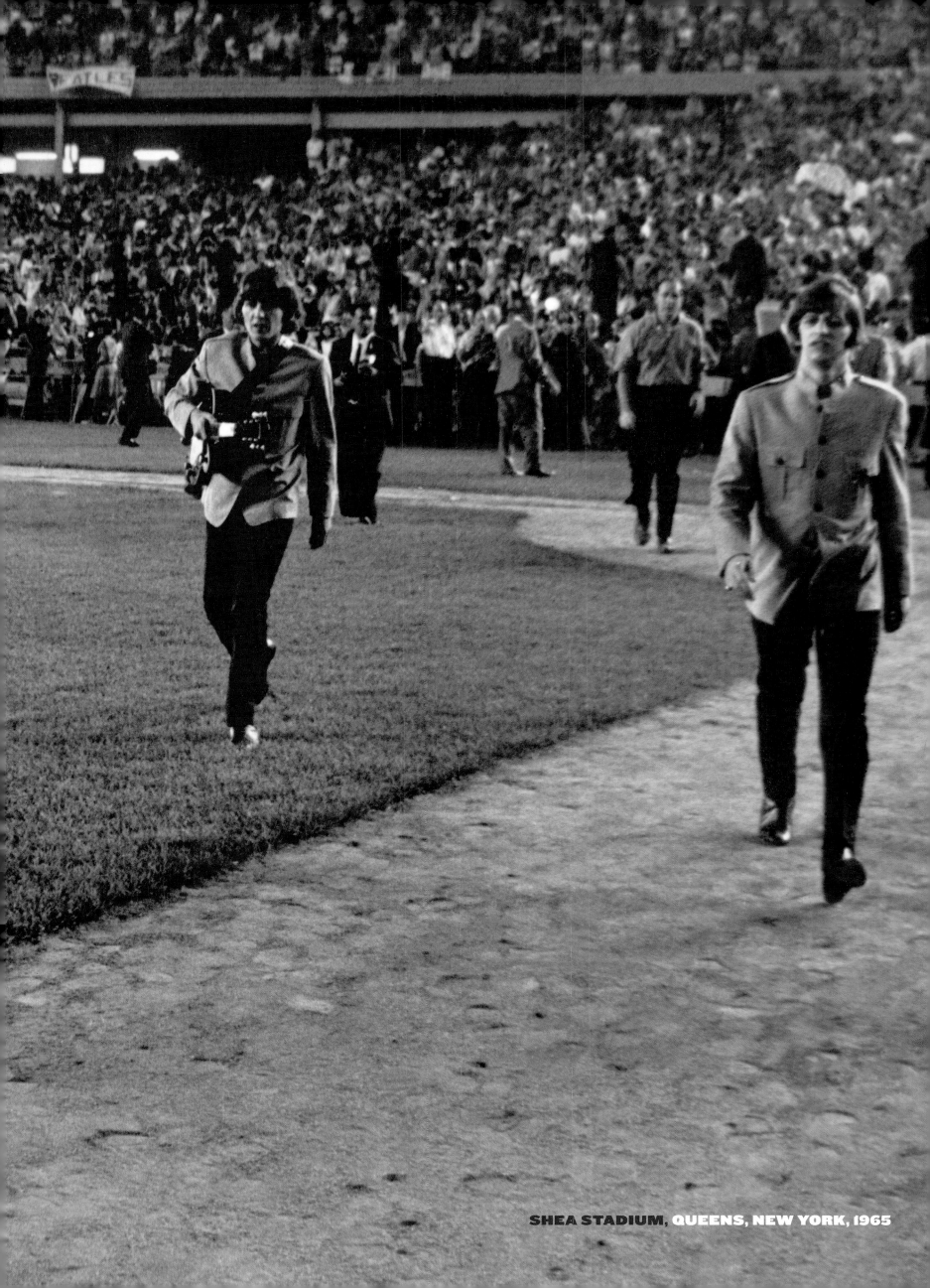

SHEA STADIUM, QUEENS, NEW YORK, 1965

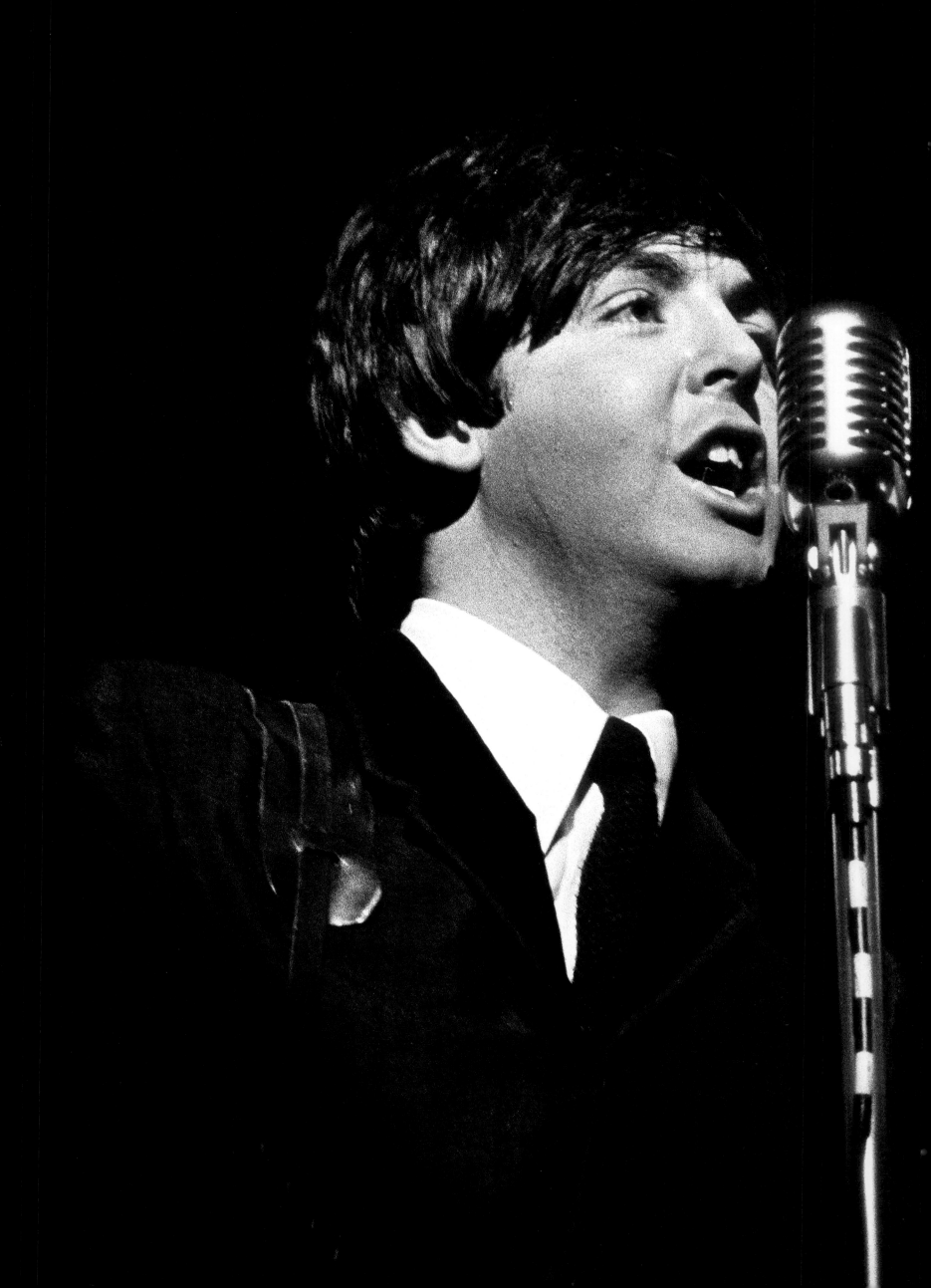

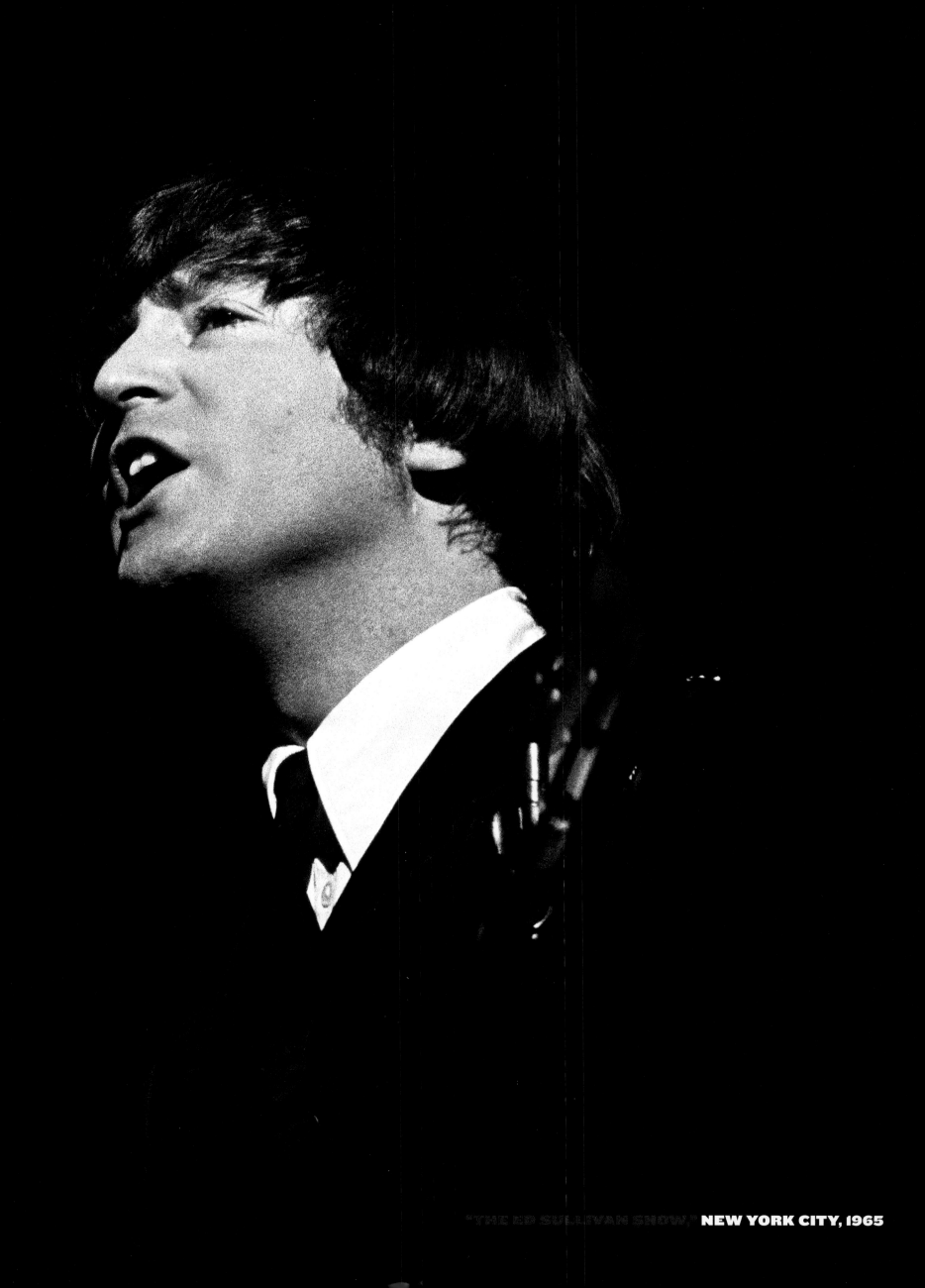

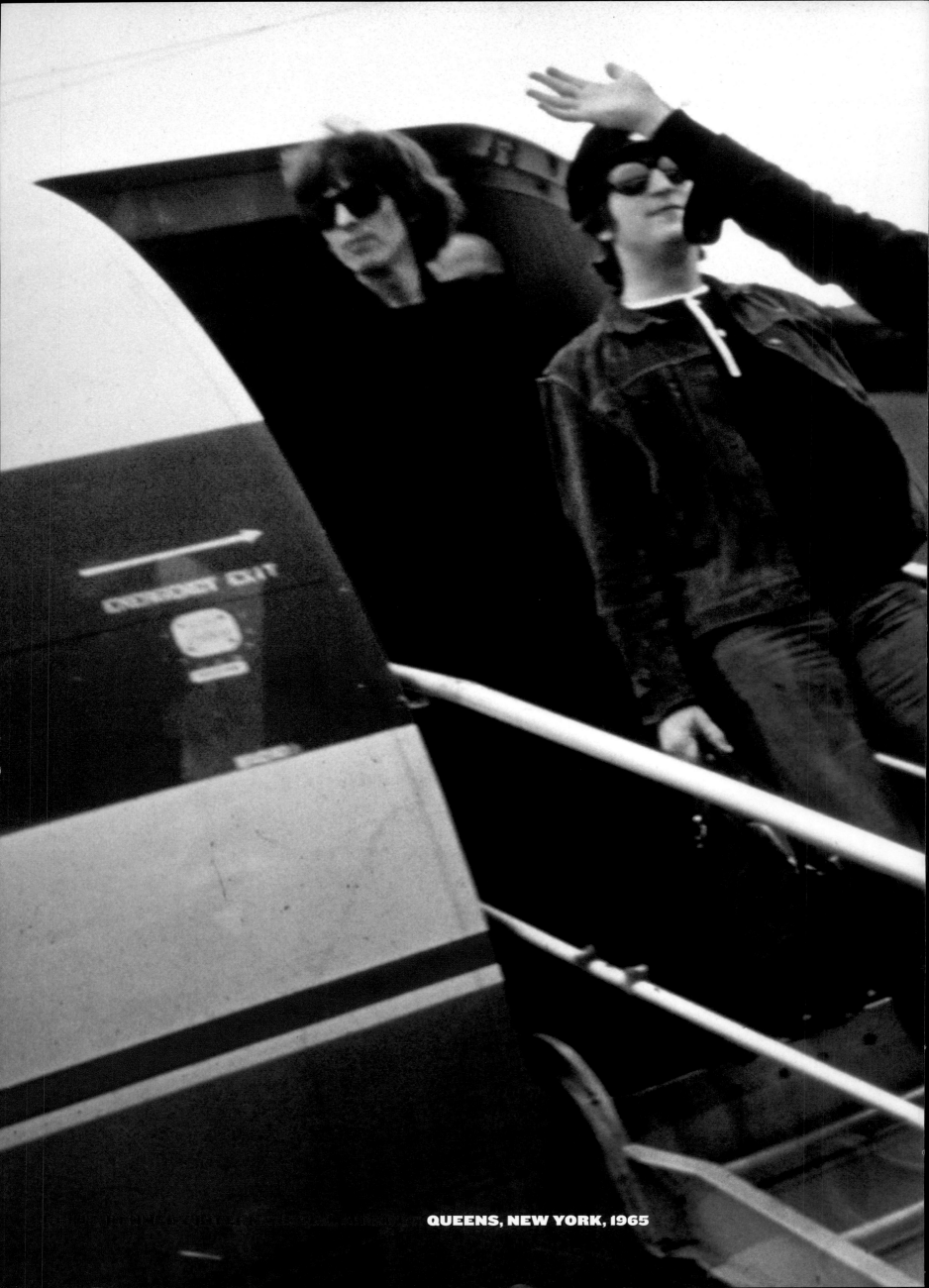

QUEENS, NEW YORK, 1965

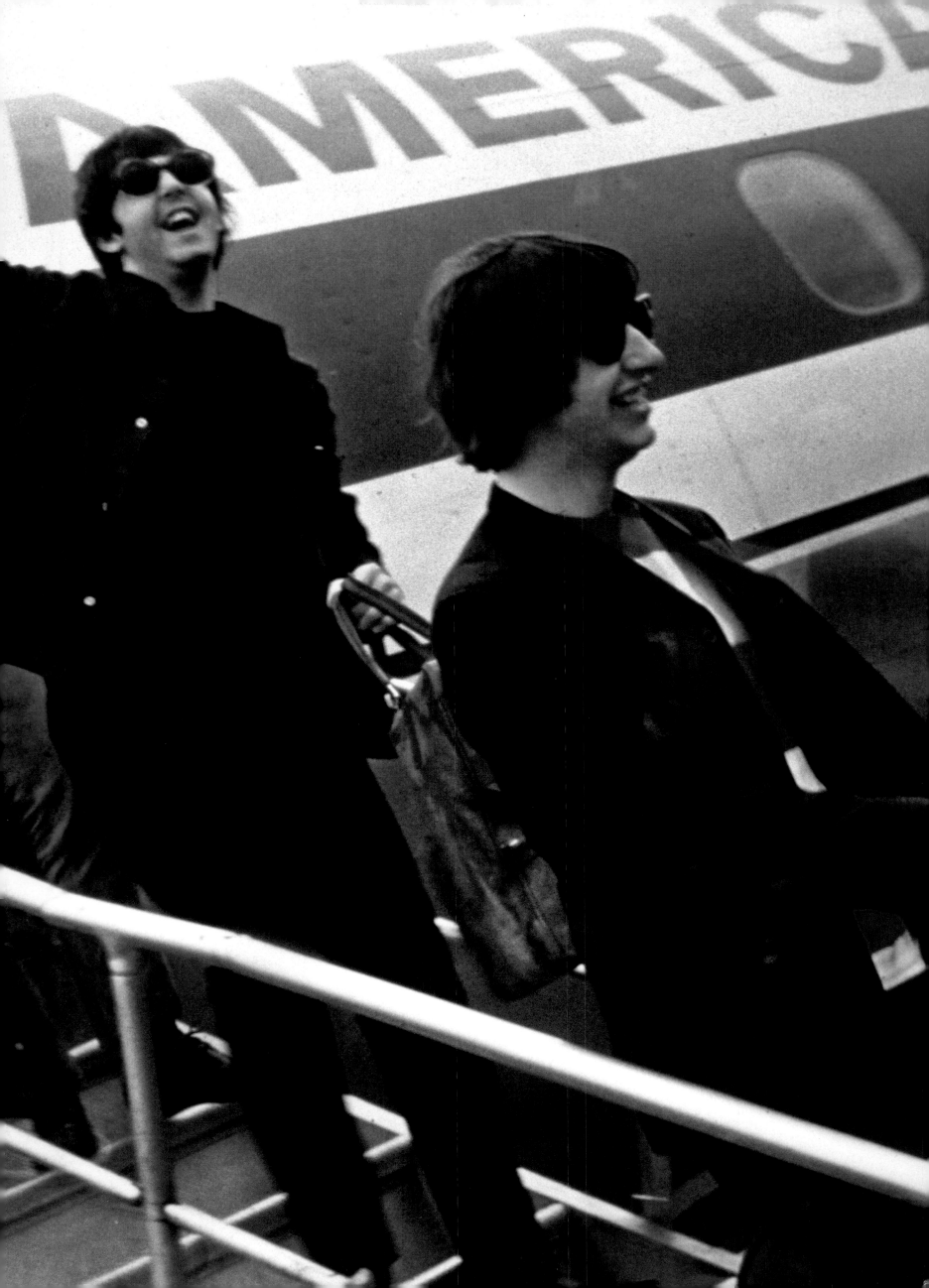

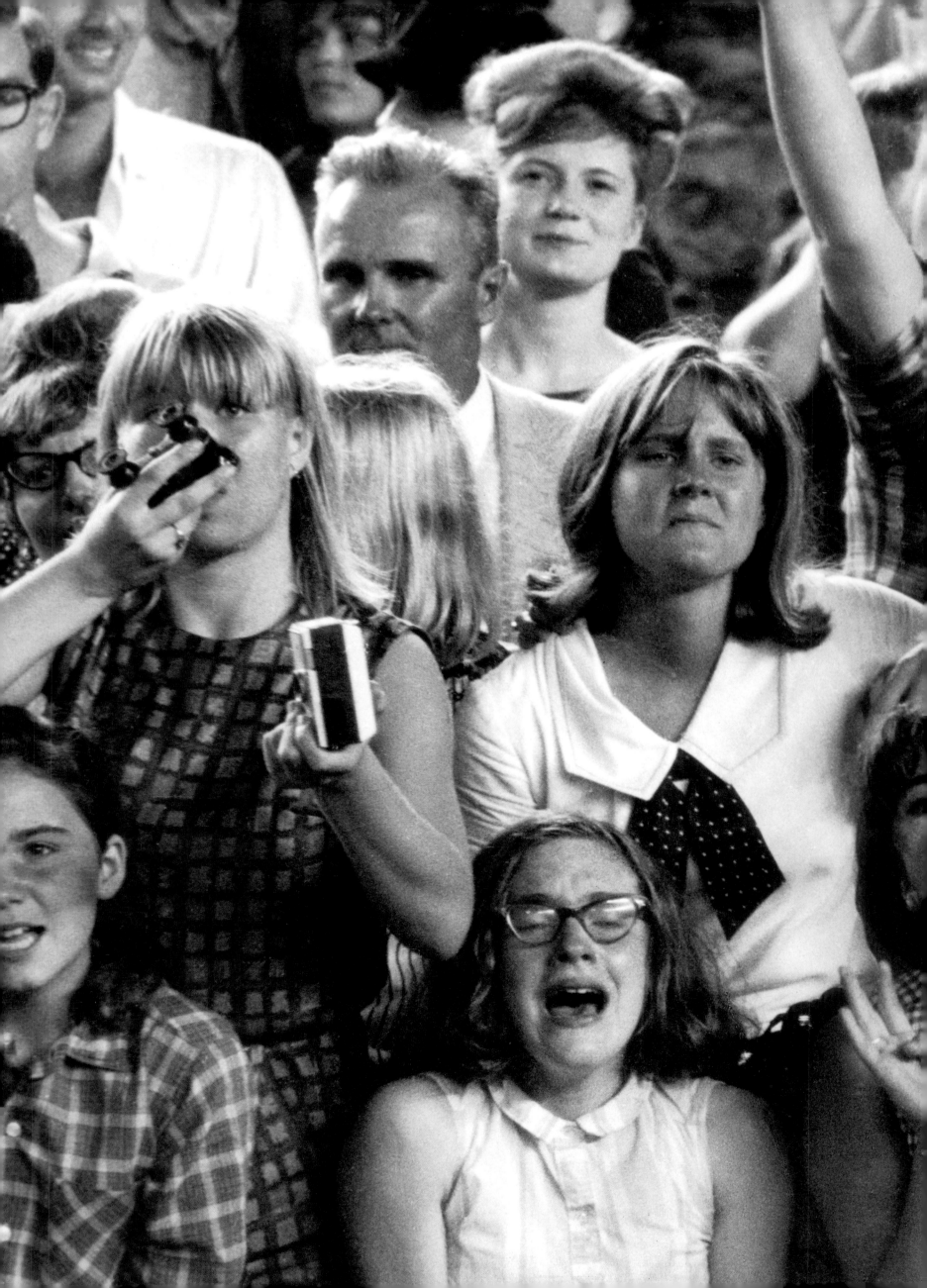

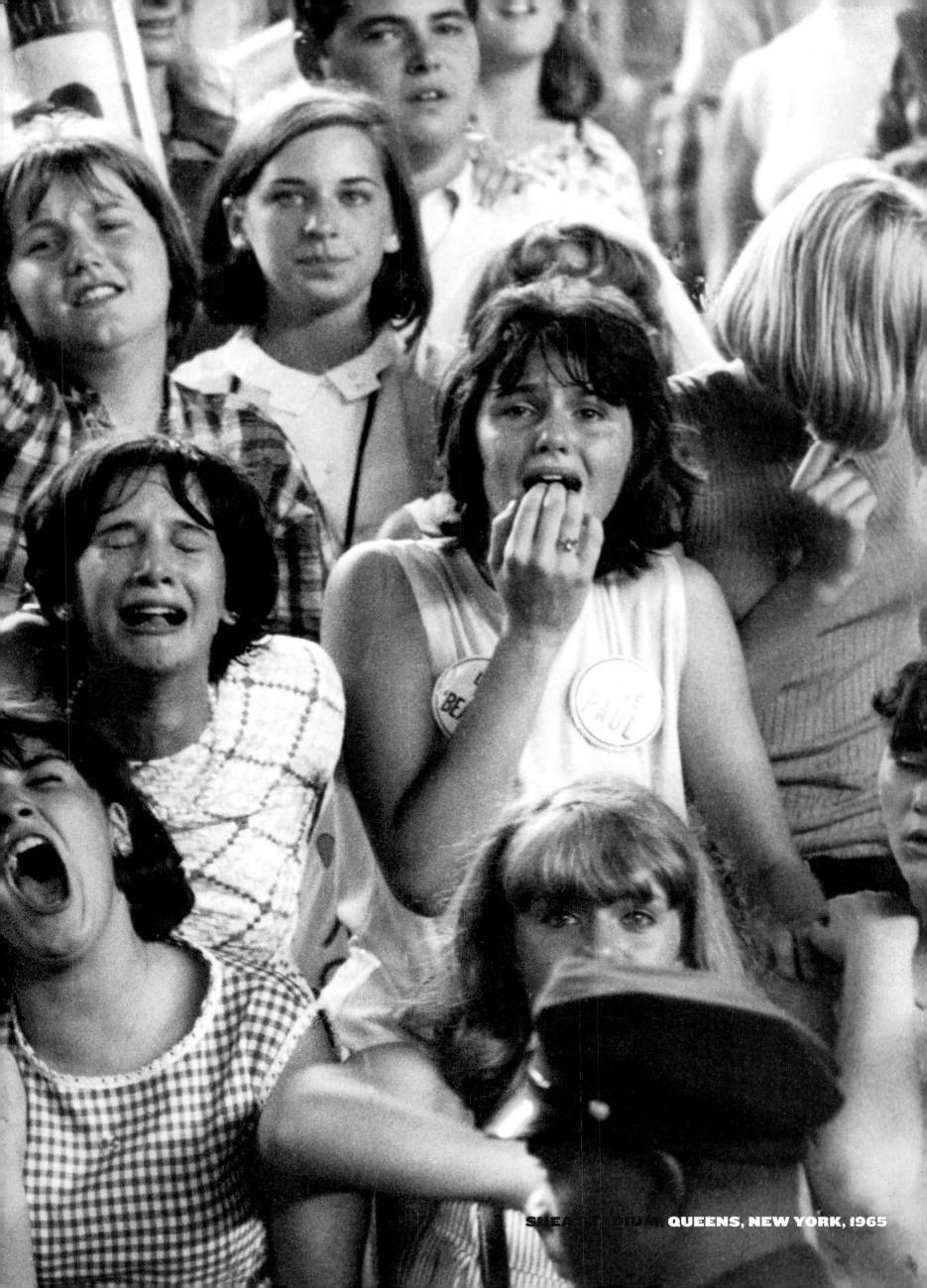

SHEA STADIUM QUEENS, NEW YORK, 1965

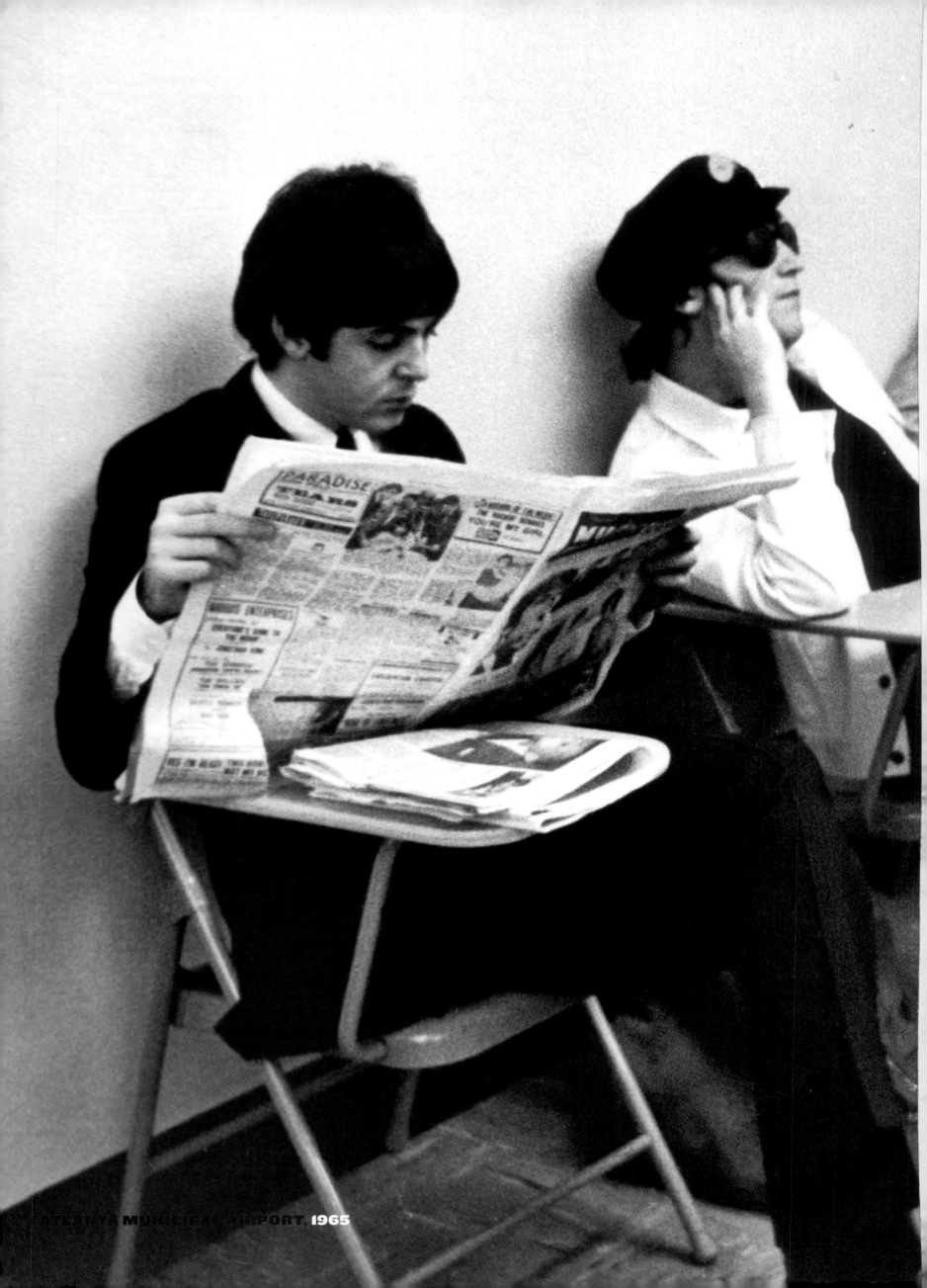

ATLANTA MUNICIPAL AIRPORT, 1965

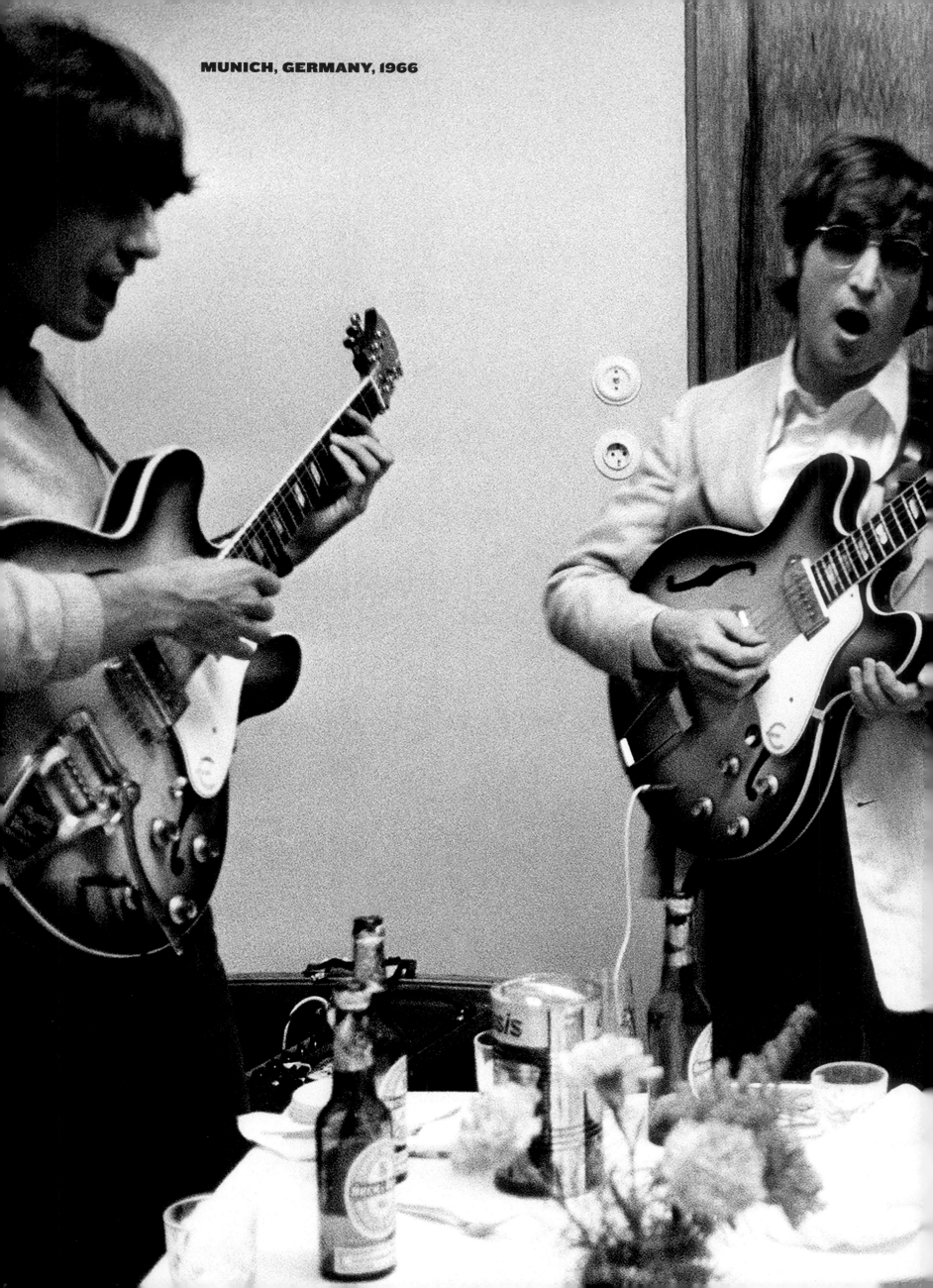

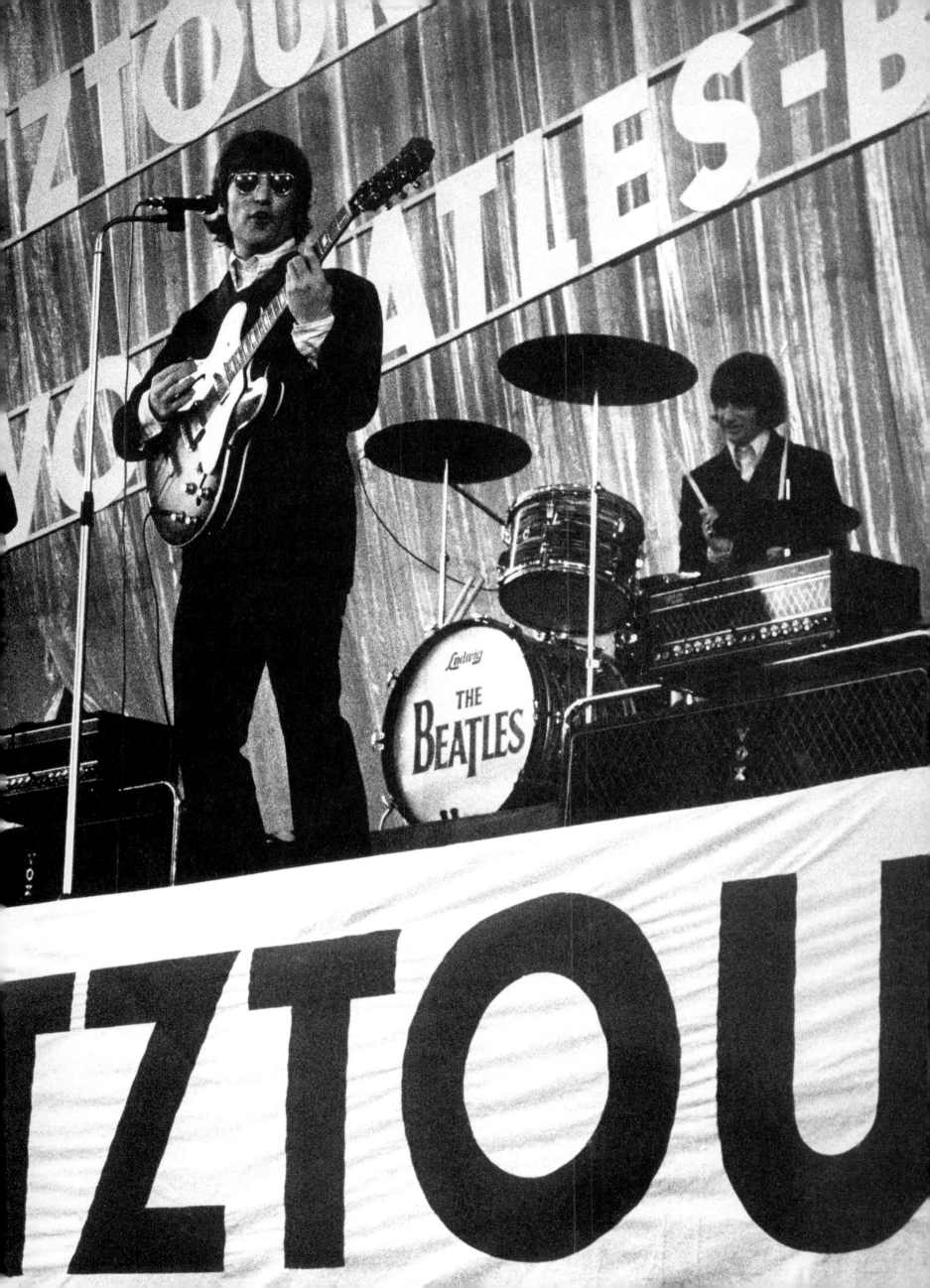

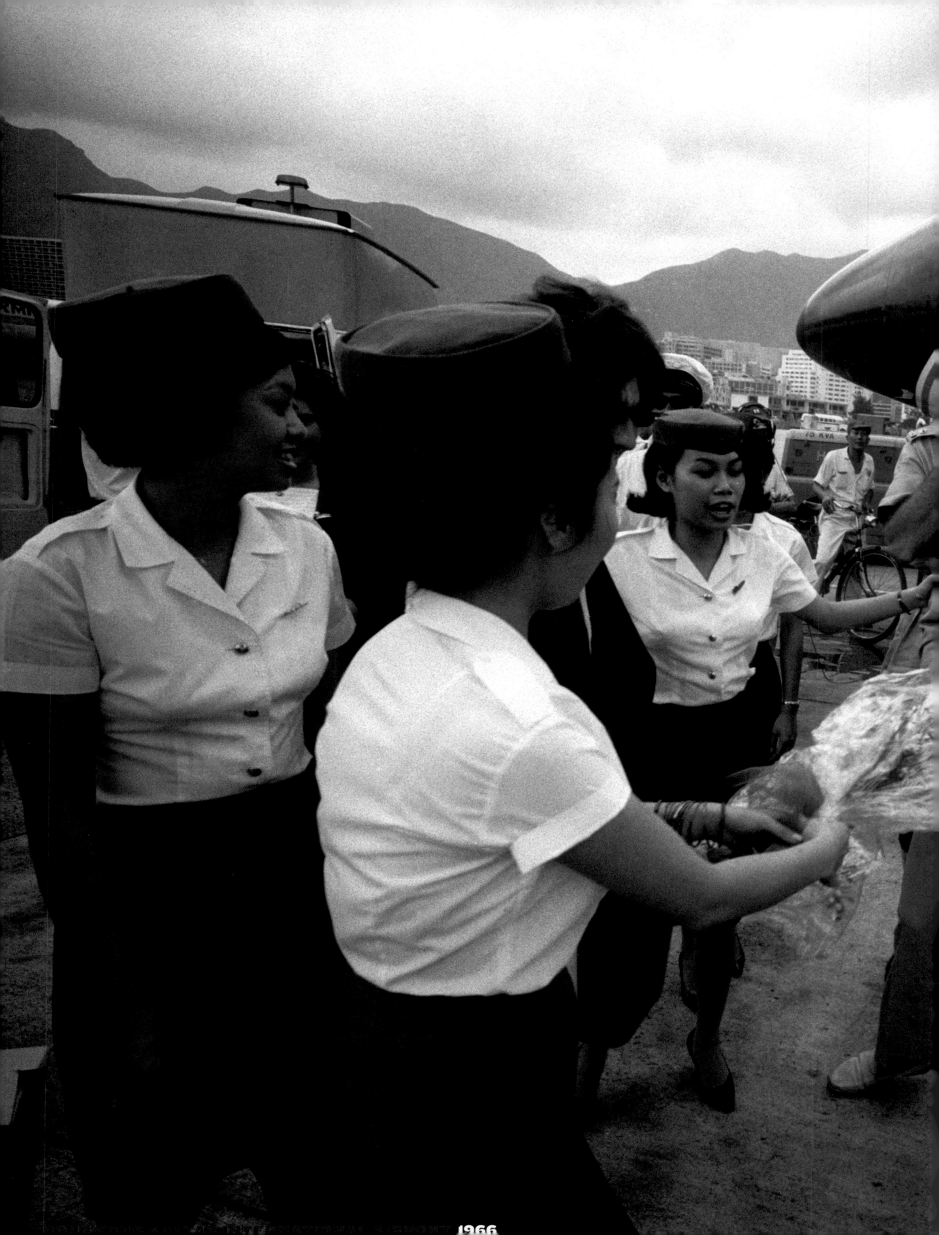

1966

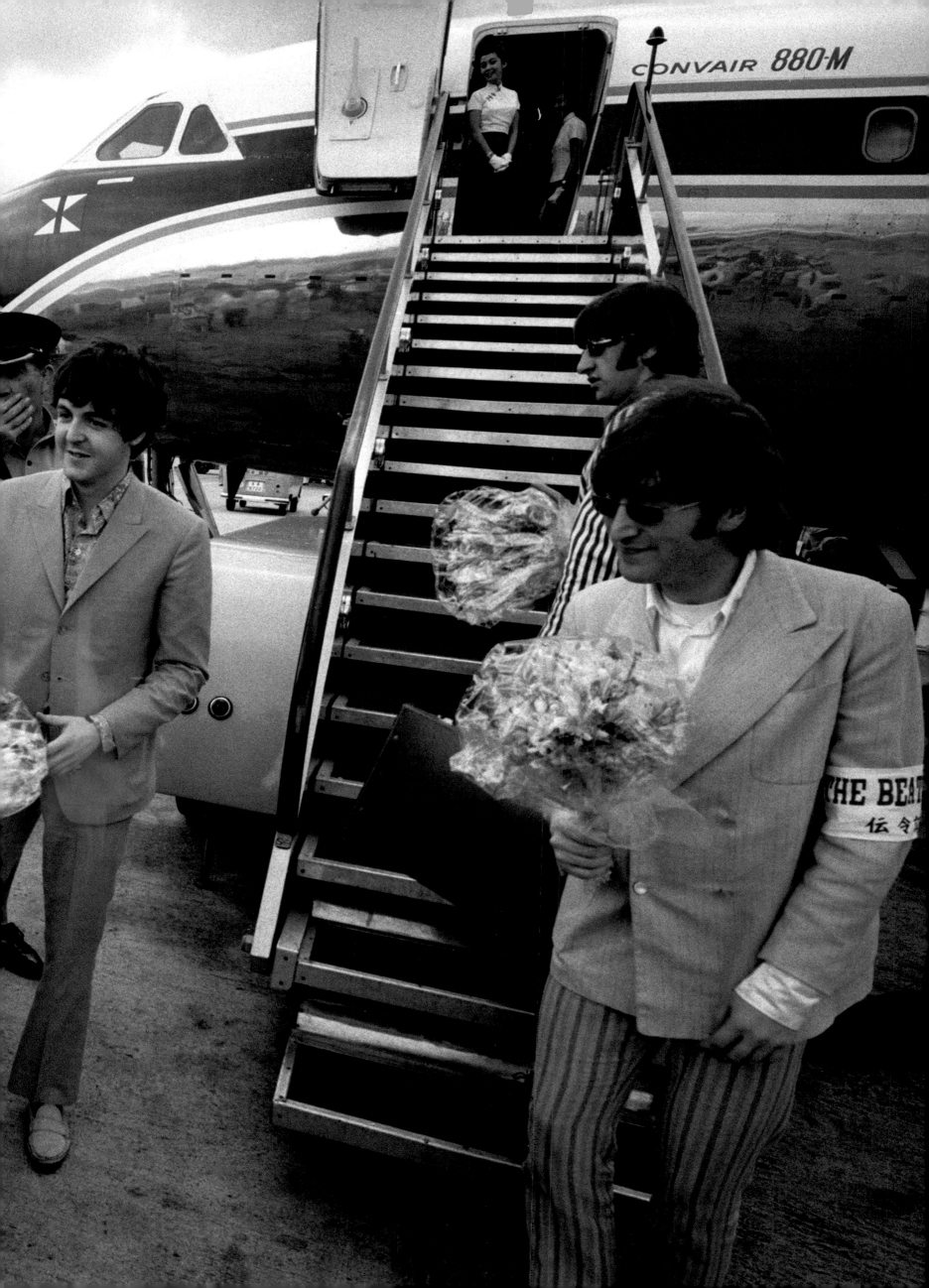

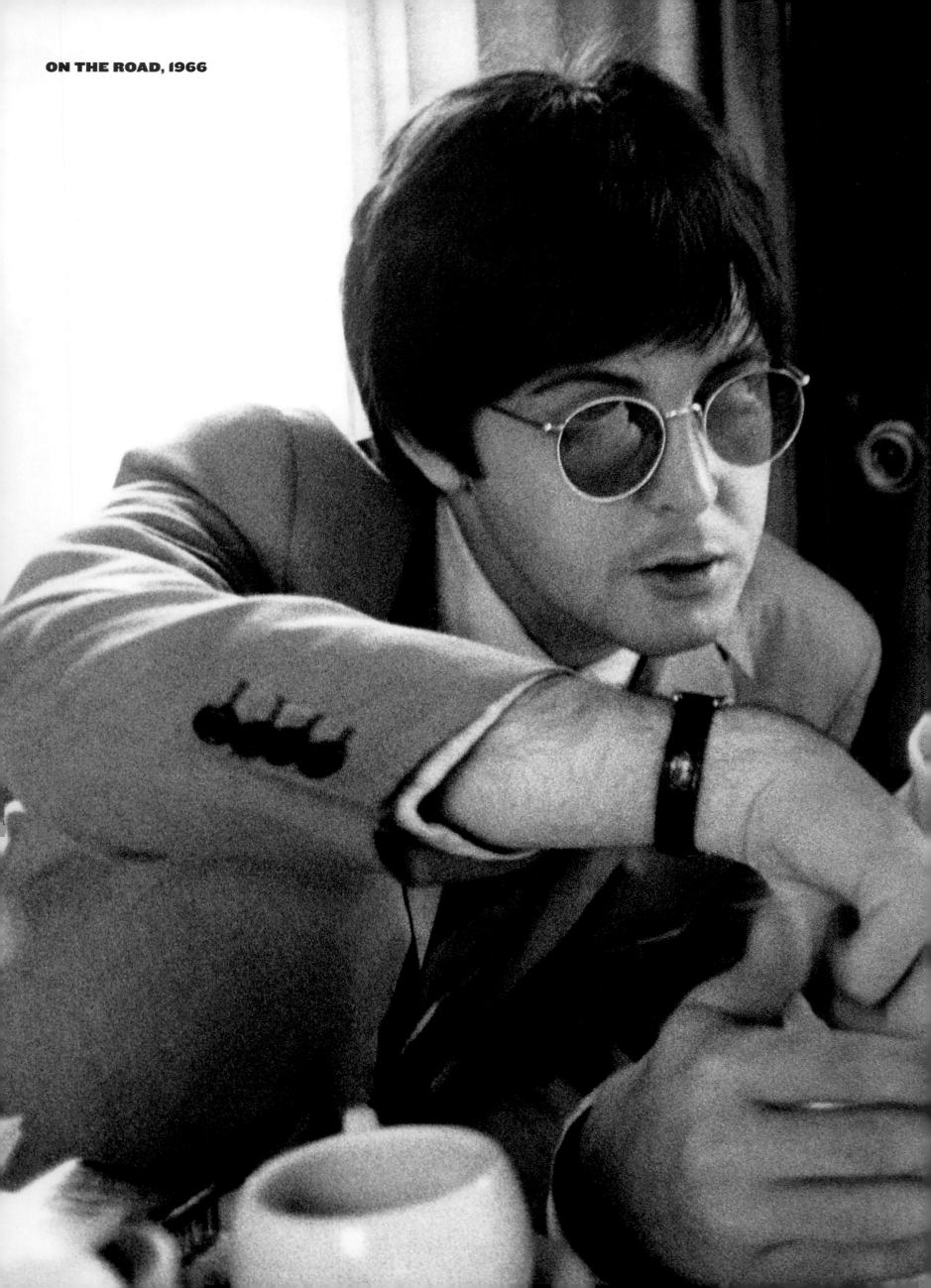

ON THE ROAD, 1966

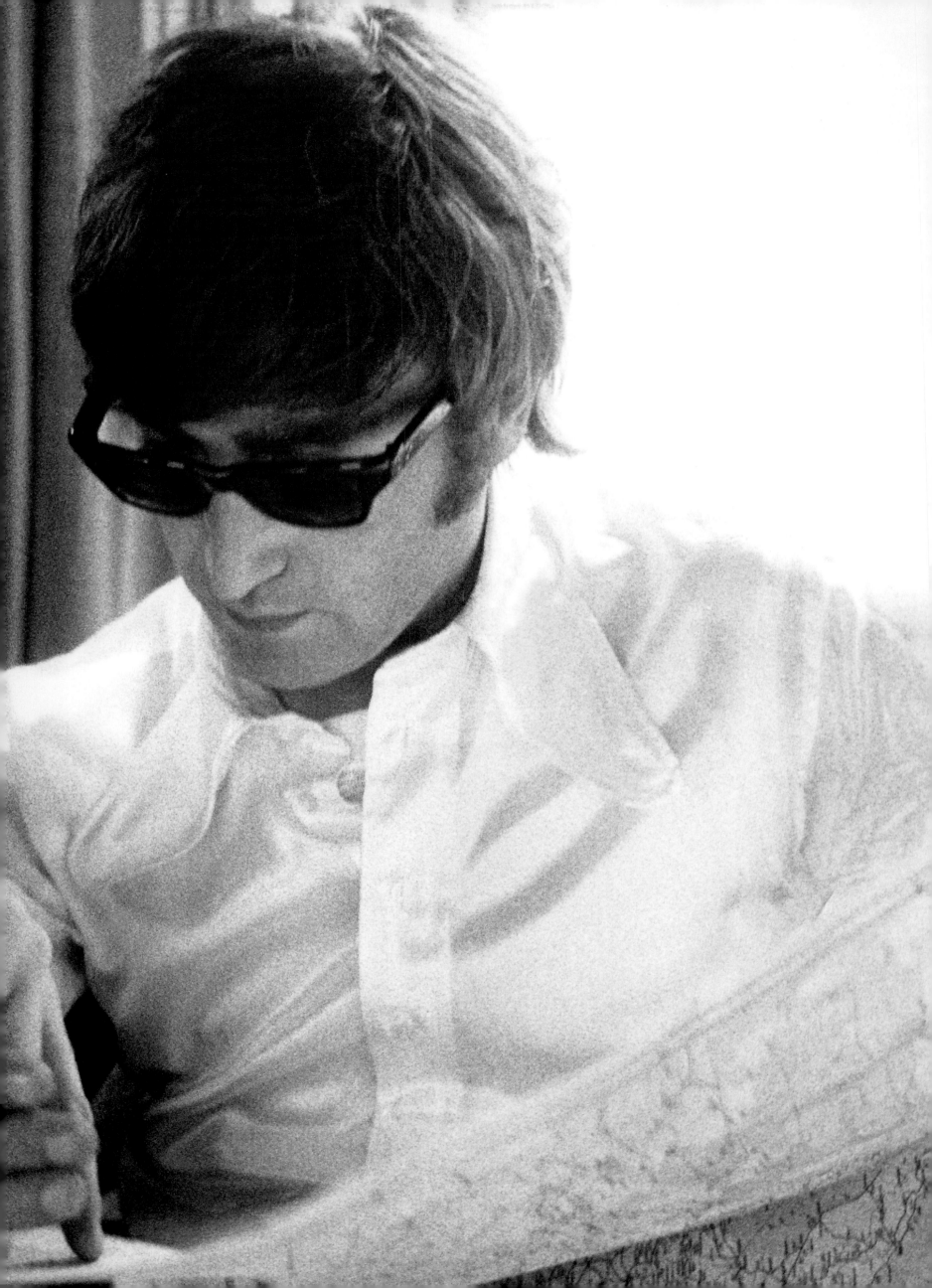

BOB WHITAKER'S STUDIO, SUSSEX, ENGLAND, CIRCA 1992

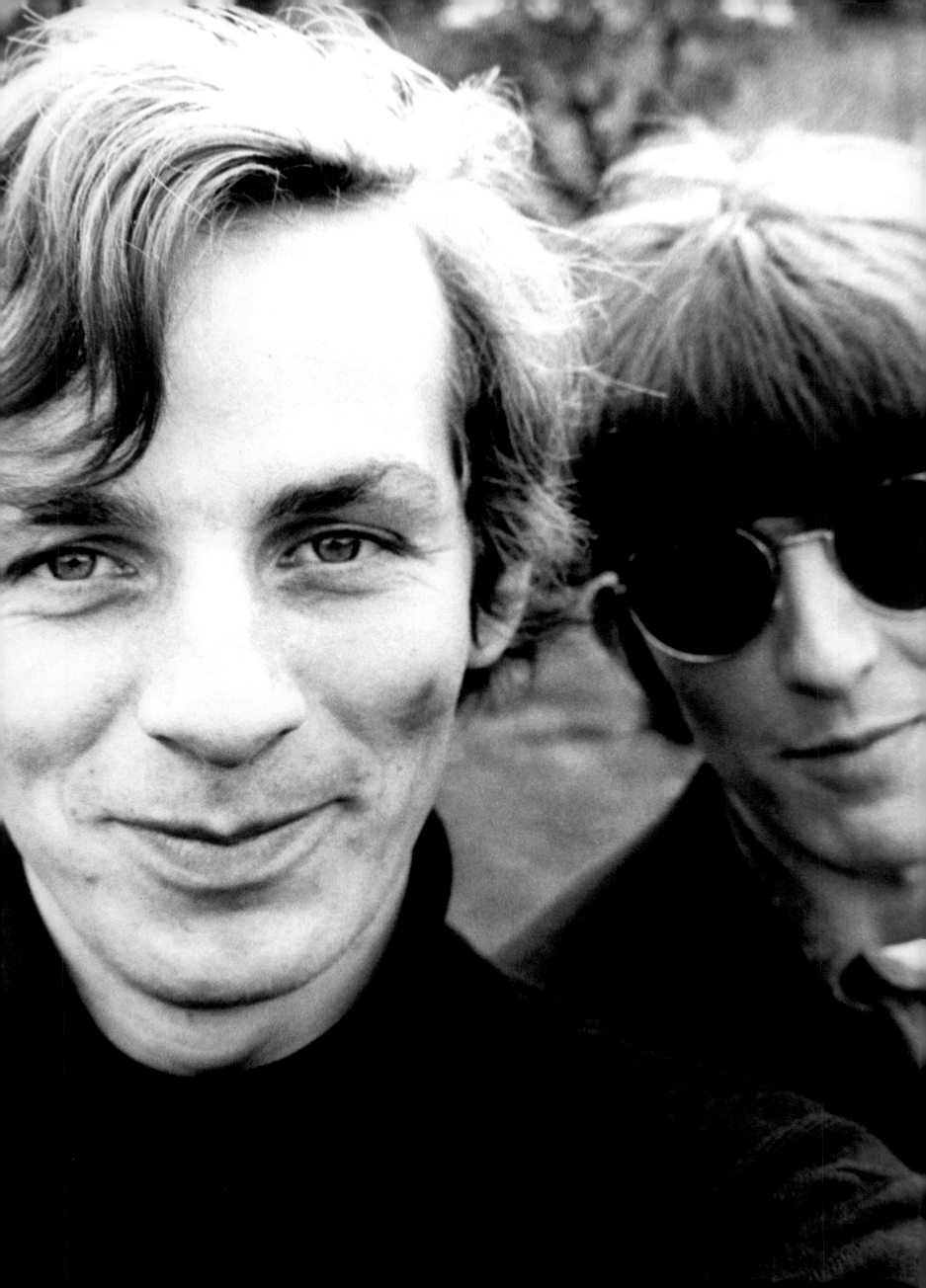

WITH THE BEATLES

Robert Whitaker in the Swinging '60s

FROM 1964 TO 1966, Bob Whitaker (opposite, left) is in the employ of Brian Epstein, and is here, there and everywhere with the Beatles. In this instance, he and George take a break from shooting a promotional film for "Paperback Writer": a Neanderthal version of a music video.

This book is about the Beatles, certainly, but it is equally about Bob Whitaker. He was the man behind the camera for all of the photographs in these pages. He was the person who was, in addition to John, Paul, George and Ringo, *there.* They were there, and so was Bob. *There.*

Let's first address this eternal question about a Fifth Beatle. Brian Epstein was, according to Paul McCartney (who is a pretty good source, we can perhaps all agree), the bona fide Fifth Beatle. George Martin, their producer, has also been seen as the Fifth Beatle. Pete Best, the drummer who was given the boot, and Stu Sutcliffe, the guitarist who died tragically young in Hamburg, Germany, have each been called the Fifth Beatle. And in a personal conceit, Murray the K, a New York City disc jockey, claimed to be the Fifth Beatle.

But when the images on the following pages were made back in 1964, '65 and '66—the heyday of Beatlemania—Robert Whitaker was as close as there was to a Fifth Beatle. He was the lads' fellow traveler and often their coconspirator. When they wanted to be cute at the outset of it all, Whitaker rendered them cute. When they wanted to be cool or cutting edge, he rendered them cool and cutting edge. As they grew tired of the constraints of pop stardom, so did Bob. Together, the boys and their "official" photographer stretched things, and made them more interesting. As you will see in these hundreds of images on the pages that follow, Robert Whitaker understood the Beatles and what made them not only different but exciting and charismatic. And the Beatles understood Robert Whitaker and what made him the right photographer for their life and times.

Who was he?

He was an Englishman, though he is often depicted as an Australian. He was born on November 13, 1939, in Harpenden, in the county of Hertfordshire. Before he relocated to Australia, he already felt himself "one part Aussie lad," as both his father and paternal grandfather hailed from Down Under. In Whitaker family lore, the grandfather was the man principally responsible for building the Princes Bridge in Melbourne. Maybe so.

Bob took up the camera in England and enjoyed it as any kid might: as a toy, a splendid toy. By the earliest '60s, he was in Australia and becoming more serious about his craft. He studied at the University of Melbourne and fell in with fellow artsy types. He was talented; that was obvious. He was also, to use that word again, cool, very cool. Hip. And handsome. All of this would constitute an advantage as

the '60s started to swing. Whitaker was ready-made for the decade to come.

After attending college, Whitaker set himself up with a freelance photo studio on Flinders Lane, in Melbourne, and made pictures of many of his contemporary young Aussies, including the feminist writer Germaine Greer and the cross-dressing comic Barry Humphries (a.k.a. Dame Edna Everage). These were his friends, but theirs was, at the time, a smaller stage. If any of them supposed worldwide fame, they might have been accused by their confreres of "tall-poppy syndrome": a high flower sticking its head above its fellows, only to find it chopped off in the end. This was an Australian pastime: not letting a fellow rise above his station. Whitaker, a good guy, would never be a tall poppy. But he was about to be plucked from Australia into the maelstrom of global pop celebrity by Brian Epstein. It would happen quietly, but quickly.

While Whitaker and his friends were being all avant and coffee-house and laid-back and louche in Melbourne, things were going absolutely nuts in the Northern Hemisphere. At the center of the madness: the Beatles. They had been around for a little while, coalescing as a band during extended gigs in Hamburg and in their native hard-bitten English city of Liverpool. As they morphed and ultimately settled into their final foursome of John, Paul, George and Ringo, they built an avid—rabid—fandom. They thoroughly conquered their native land, then France, then the United States, where they appeared on *The Ed Sullivan Show* in February of 1964, just after "I Want to Hold Your Hand" went to No. 1 on the U.S. *Billboard* chart. Australia certainly felt the aftershocks and was eager for the Beatles.

The band scheduled an international tour for June of 1964, a series of concerts that would secure the Beatles' worldwide dominion. It would come off triumphantly, despite the fact that Ringo, ill, could not perform in Denmark, Asia or at the start of the Australian leg and was replaced by drummer Jimmy Nicol for several shows. No matter; the Beatles soared.

Whitaker was ready for them when they arrived in Melbourne that June. He was a young man with a camera,

CLAD IN A Japanese *happi* coat in 1966, Whitaker apparently can't convince himself to say cheese for this self-portrait. Security is extremely tight in Japan during this tour, but Bob is lucky: He, unlike the Beatles, is free to leave his hotel room.

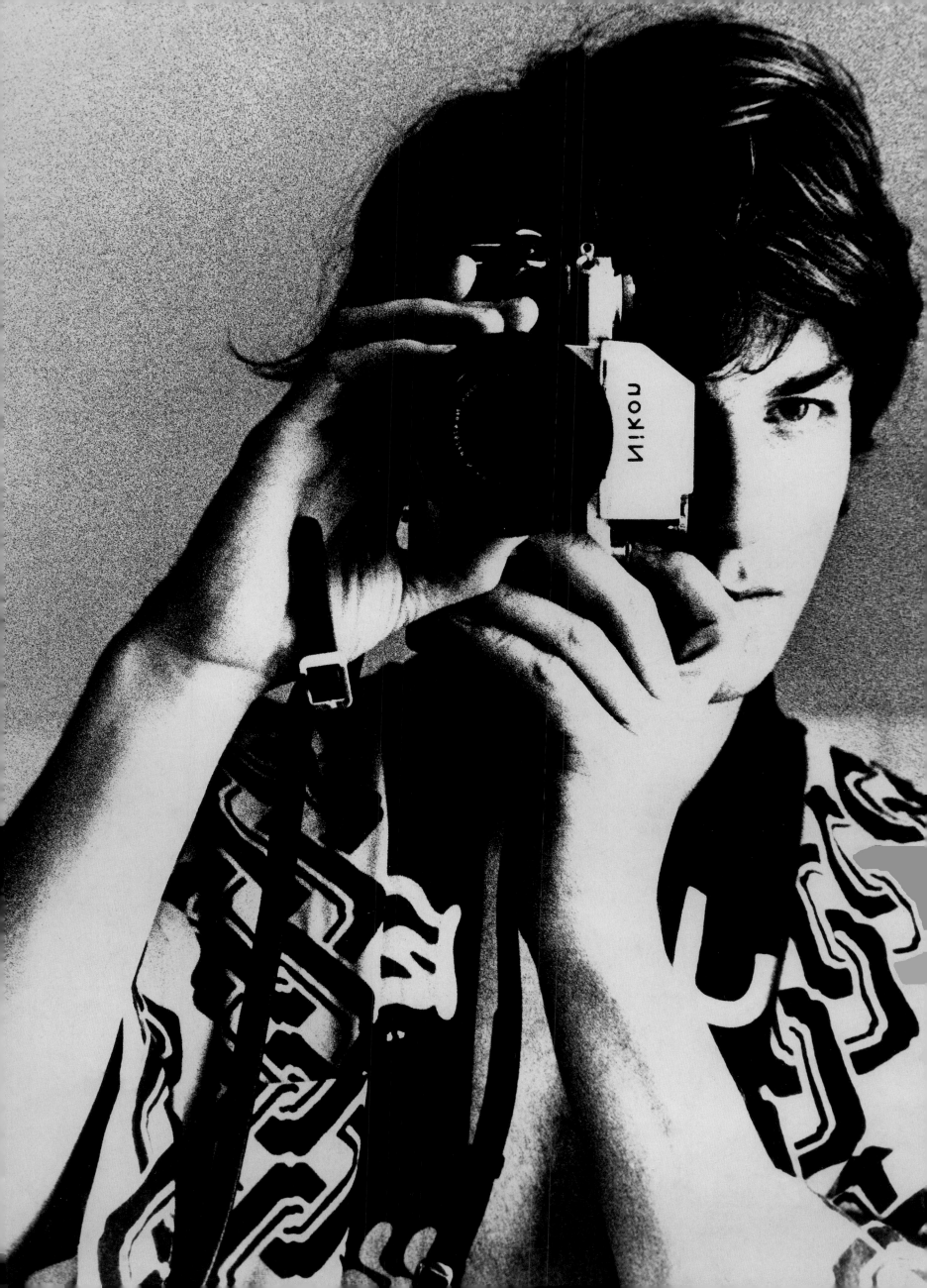

and when the Beatles hit town all cameras were poised to click. And click and click and click again.

Whitaker, for his part on the front end of the band's onslaught, happened to accompany a journalist to an interview with Beatles manager Brian Epstein for an article to appear in the *Australian Jewish News* in Melbourne. "I photographed Epstein, saw he was a bit of a peacock and a cavalier, and put peacock feathers around his head in photographic relief," Whitaker later remembered. He told LIFE: "In doing portraits, I usually put some objects in the photograph as a point of reference as to who or what the subject is. With him, I put the peacock feathers around his head. He loved the idea, then went to see an exhibition I had up at the time. It was an exhibition of collages I had at the Museum of Modern Art [in Melbourne] and immediately he offered me the position of staff photographer at NEMS, photographing all his artists. He asked me if I wanted to return to London and work for him."

NEMS, for North End Music Stores, was Epstein's Liverpool-based management company, which was handling the Beatles and a few other pop acts at the time. "I initially turned it down," Whitaker remembered to LIFE. "Then Brian said, 'Well, come see the Beatles at Royal Festival Hall.' I got shoved into the orchestra pit, so I was right between the Beatles playing their music and these girls just screaming and fainting away. I couldn't hear a damn thing, but I could see these girls and I thought, 'I suppose I'm missing out on something here.'" Yes, perhaps.

Whitaker's picture of Epstein with the peacock feathers as adornment (please see page 42) was published with the *Australian Jewish News* article, and was followed in Australia by Whitaker's first shots of the Beatles themselves: pictures of Paul McCartney and George Harrison holding up boomerangs that had been presented to them by Australian fans. In these early months of his relationship with the band, kitschy was cool. And, yes: Rather than miss out on something, including screaming, fainting girls, Whitaker shook hands on a deal with Epstein, and accepted a plane ticket to London.

Bob Whitaker arrived back in the land of his birth in August of 1964 and quickly went to work, photographing Epstein clients Billy J. Kramer & the Dakotas, Cilla Black, Gerry and the Pacemakers and, of course, the Beatles. His photography and album sleeves represented the visual face of the so-called Merseybeat sound. Although Epstein and many of his acts were indeed from Liverpool, hard by the River Mersey, the scene quickly moved to London, and Whitaker was a perfect fit. "There were about 100 people who ran the '60s," he said later, not mentioning that he may have been one of them. While he shot the album covers and portraits, he was also engaged in

23 WEST SMITHFIELD IN LONDON is the former address of Farringdon Studio, where Whitaker made portraits of the Beatles all three years he worked with them. From this session came the photographs used on the cover of the U.S. album *Beatles '65.*

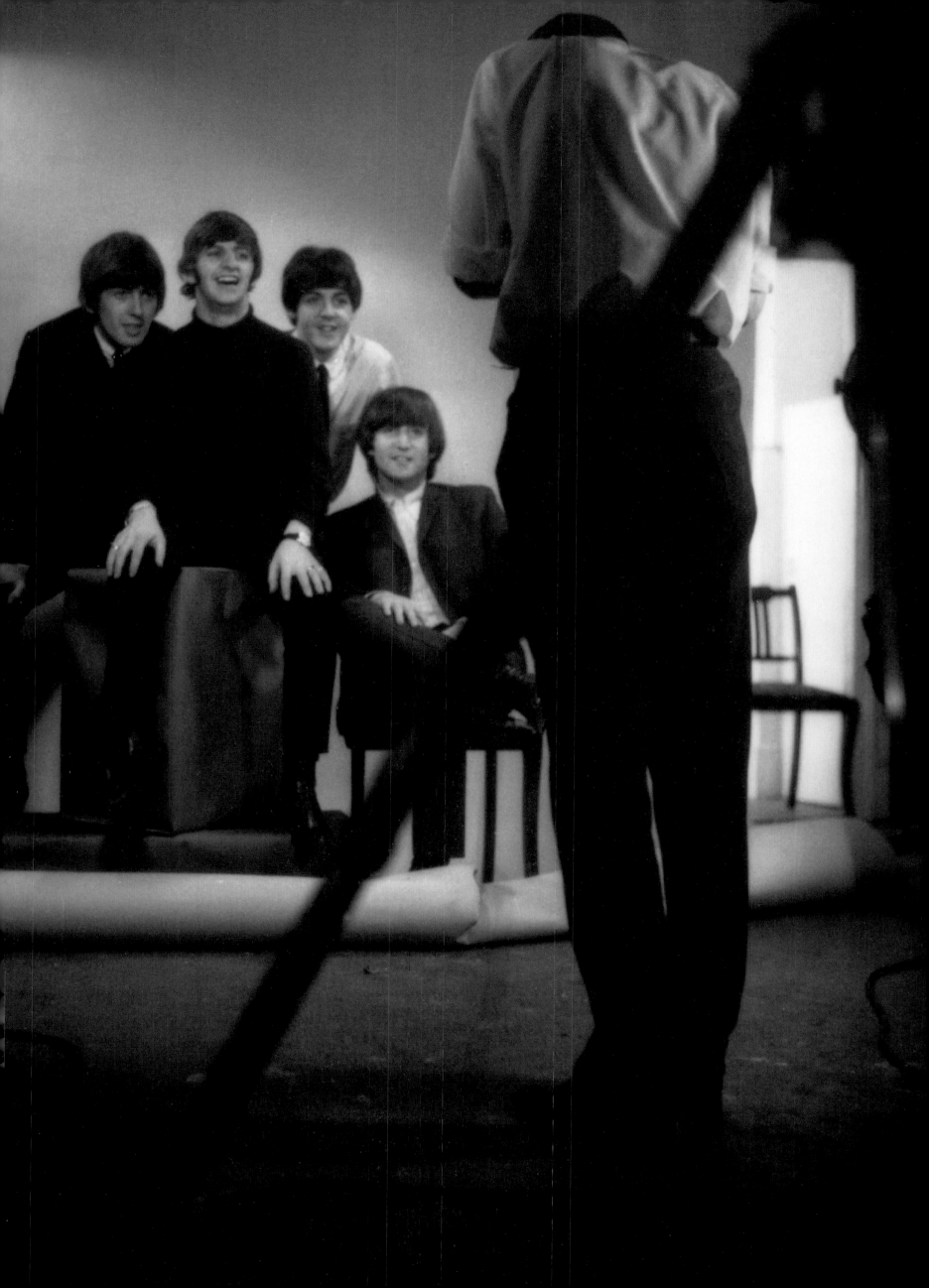

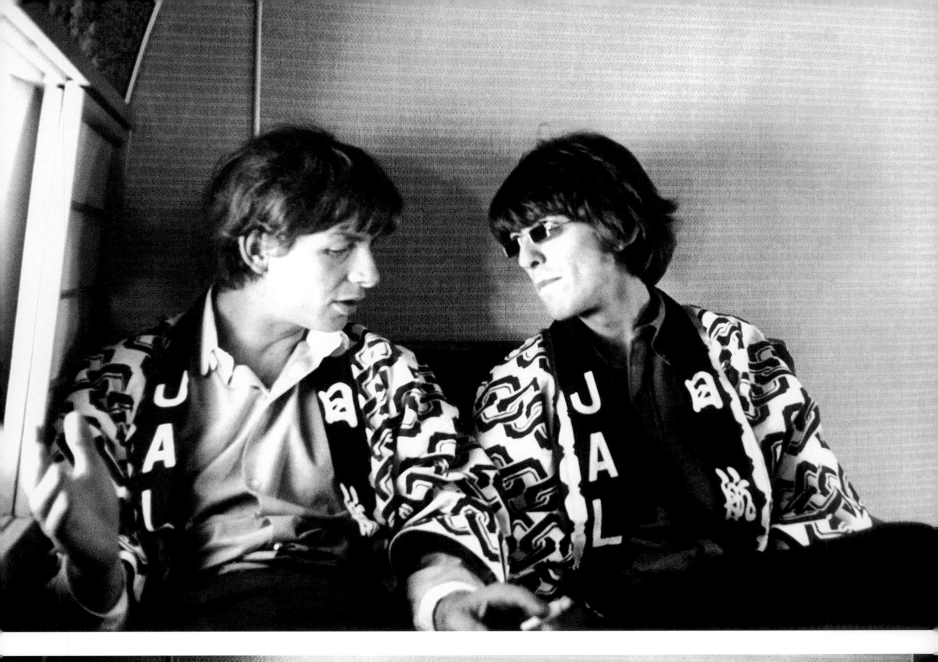
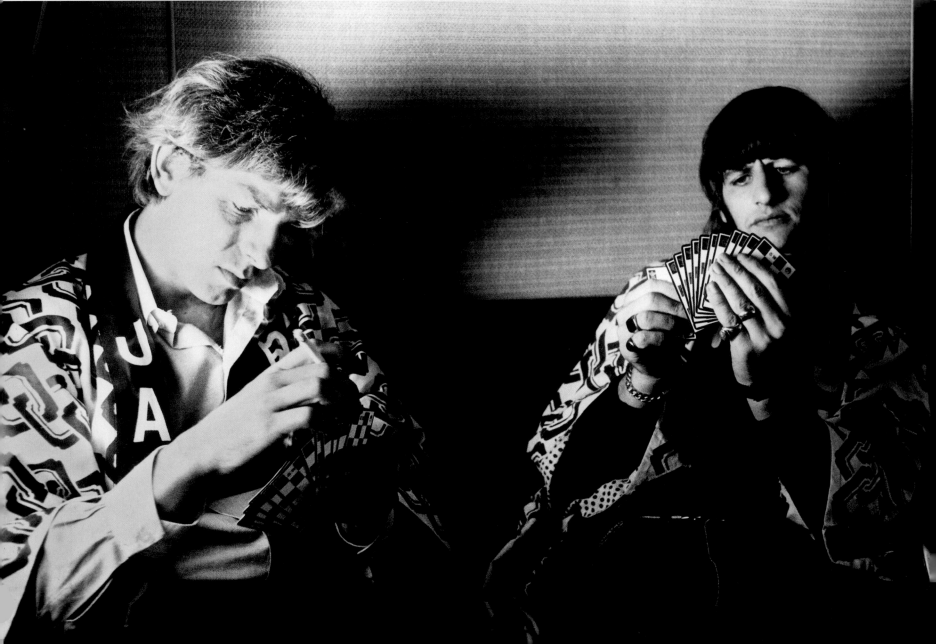

A KEEPSAKE, even, perhaps, a historical artifact: At right is Bob Whitaker's airline ticket for his 1964 trip from Melbourne to London, which would begin his formal relationship with the Fab Four. Opposite: Bob, George and Ringo while away the time en route to Japan in '66.

capturing what he called "the creativity and excess of London in the '60s"—an amazing place in an amazing time.

Knowing what we now know about the Beatles, it is an obvious conclusion that, in the frantic years, they would not countenance hangers-on who were less than congenial or (in the ragtag way of the '60s) at least marginally professional. They not only countenanced Bob Whitaker, they welcomed him on a daily basis. Most of the Beatles enjoyed his company, although it was made eminently clear that there was, in fact, no Fifth Beatle. Bob was always present, though usually at arm's length. Whitaker told LIFE in 1996: "I found it actually quite difficult to become part of the group. I didn't talk music. Paul seemed to sneer when I'd point a camera his way. Ringo was always a great wit, and could cope fantastically, but we weren't very close." John Lennon, though, became a good friend.

"Once I started with them, I realized right away that shooting the Beatles wasn't the sort of work I was used to doing, which was fashion photography, working with photomontage, other odd things," Bob told LIFE. "I think that's why John liked how some of it turned out—it was different."

Life with the Beatles, as Whitaker slyly implied in our conversation back in the day, was fast and furious and a whole lot of fun. One of his assignments in Epstein's employ was photographing the group during its frenetic second

American tour in 1965, which included the tumultuous Shea Stadium concert in the borough of Queens in New York City. Whitaker spent that year and the next traveling with the band, shooting them at work, at rest, at play—performing, recording, napping, posing. Album covers were churned out (and sometimes, as with the famous "butcher" cover—please see page 195—turned into chum) and hundreds of publicity photos were made. Whitaker captured candid moments as well. All of it amounted to what is, all these years later, a singular and indispensable portfolio: the great visual document of the Beatles when they were a band, riding high, ruling the world.

In late 1966, the Beatles decided they had had enough—they were done. They would continue to make music (*Sgt. Pepper's Lonely Hearts Club Band,* *The Beatles* [a.k.a. the White Album] and *Abbey Road* were yet to come), but they would no longer perform in public. It had simply gotten too crazy, too scary. None of them enjoyed it, and George hated it. And so: They were done with the road.

No one knew it at the time, but this marked the beginning of the end for the Beatles. Everything was happening so fast in the 1960s, there was no predicting in 1966 that the Beatles as a live performing band would be history within months rather than years. Bob Whitaker was still there to record the

WHITAKER OBSERVES
as Ringo puts on finishing
touches before stepping onto Shea
Stadium's infield in 1965. "Ringo
obviously enjoyed his clothes
enormously," the photographer later
observed fondly. "He never failed
to amaze me with his suits."
Bob Whitaker grew closer to John
than to the others, but was very
attuned to Ringo's role in the band,
and how much it meant to him.

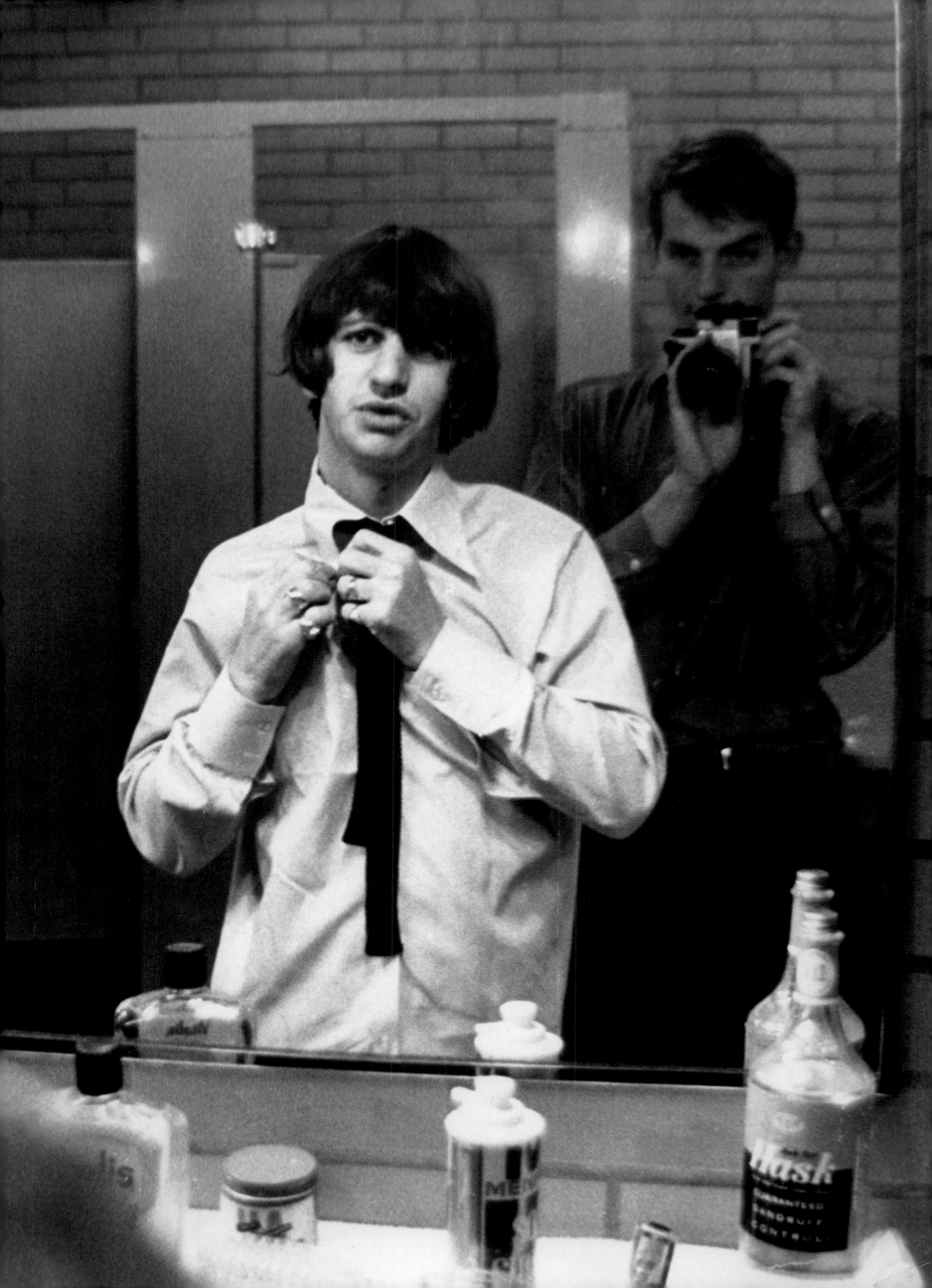

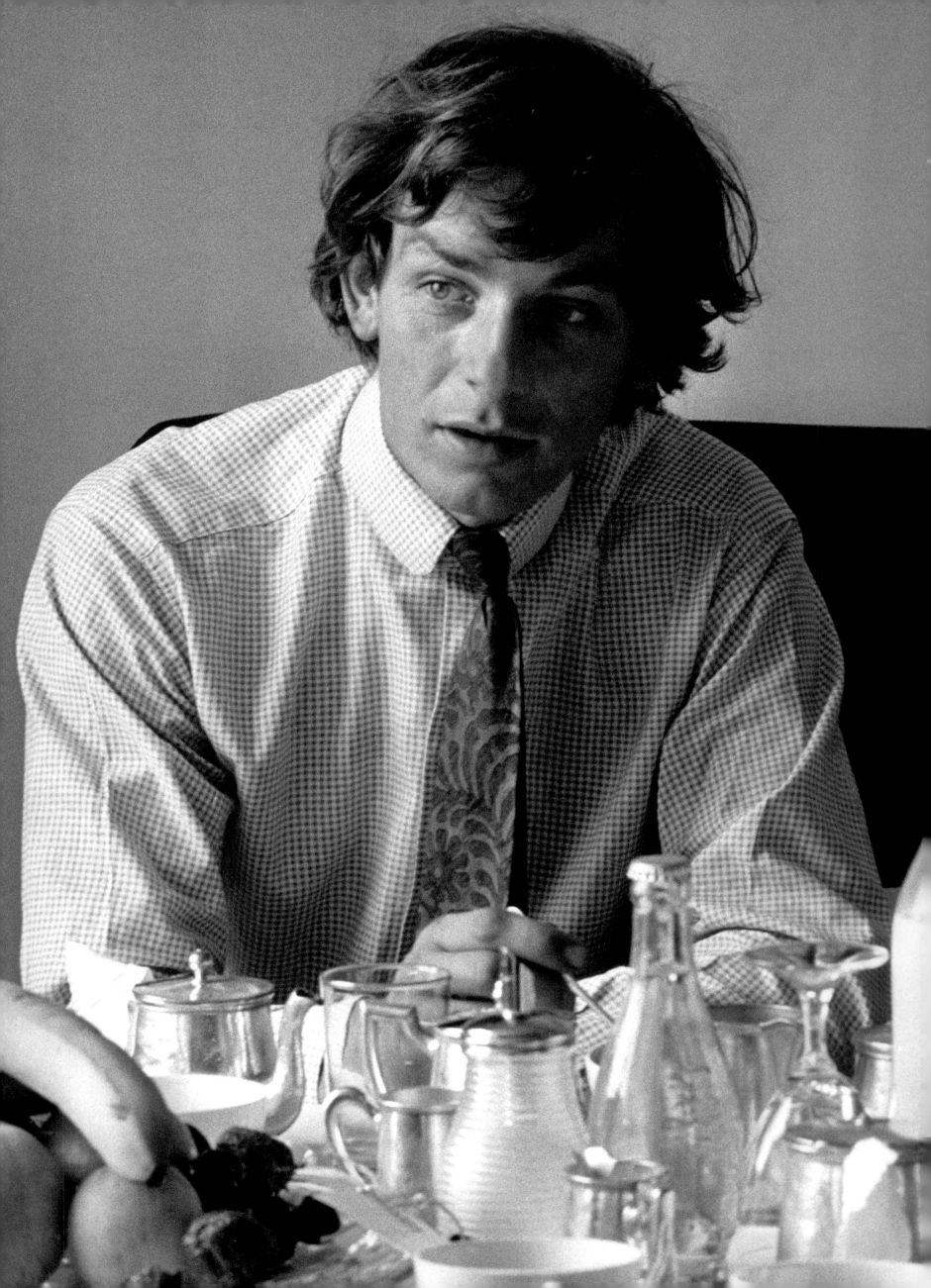

ultimate chapter. Then, suddenly, he was needed no more. The following year, Brian Epstein was dead, and all of the other NEMS acts had faded. The Beatles were going their various ways, and the group would formally dissolve soon enough. It was time to get on with life.

Whitaker did so. He found himself, in the aftermath of his Beatles tenure, living well and successfully in the Pheasantry on Chelsea's King's Road, in London. Among his Aussie cohorts in this art colony were Greer and also the artist and designer Martin Sharp. Whitaker, as he mentioned earlier in these notes, had always enjoyed working with montage—his photographs were plentiful on the Klaus Voormann–designed *Revolver* album cover, for example—and now he and Sharp dipped into (in fact, helped invent) psychedelia. "Cream were going to do a tour of the north of England and Scotland," Whitaker later remembered of his second-most-famous association with a rock band. "I just jumped in a car. Various things presented themselves to us on our journey around Scotland, none of which I could have recreated in a studio. I was very lucky that Martin had discovered Day-Glo paint. I had all the pictures, which I knew were for some form of publicity. I made a whole series of color prints and Martin just started cutting them up—much to my annoyance, because they weren't cheap to do. He then laid them out on a 12-inch square as a piece of finished artwork and then painted all over it." This became the famous album cover of Cream's *Disraeli Gears*.

In 1969, Whitaker photographed Mick Jagger (who nicknamed him "Super Click") when Jagger was starring in the movie *Performance*, and then again during the filming, in Australia, of *Ned Kelly*. But with all these rock stars—Lennon, McCartney, Clapton, Jagger—he felt he was being pigeonholed, and so Whitaker branched out as a photojournalist. He covered crises, including the war in Vietnam and the flooding of Florence, Italy, for *Time* magazine and also for LIFE. In short: He quite willfully moved on.

He contributed photographs to the early editions of the influential countercultural magazine *Oz*, which had begun its life in Australia in the early '60s but had relocated to England toward the end of the decade. It is still remembered fondly today. Whitaker's adventures in dangerous places ended abruptly in 1972 while he was working in Syria when

WHITAKER IN MUNICH: He later said, "We set off for Germany in June 1966, none of us aware that these would be the last European concerts the Beatles would ever play." It seemed like he had joined them only yesterday. But now, known to no one, it was all coming to a close.

his wife, Sue, was nearly killed by a rocket blast. They then bought a farm in England and moved into a lifestyle that was immediately more enticing, growing crops and raising cattle.

Bob Whitaker, having openly declared that he was not a person destined to spend his life in the rock world and having now forsaken the war zone, eventually sauntered back whence he had come, to the art colony. He approached one of his eternal heroes, the Spanish surrealist Salvador Dalí, and asked, "Can I make a picture?" In the late 1960s and into the '70s, he rendered Dalí over and over. "I started by photographing his ears, then inside his mouth and up his nose." Well, yes, of course. It's the surrealist way.

The pictures Whitaker made of Dalí stirred the photographer anew, and evolved into an aesthetic style that, in the 1990s, led to a concept Bob called the "Whitograph": an extreme close-up with all 36 exposures of a roll of film blended to create a single image. The artist was still playing around, as he had been long before when adorning his photos with peacock feathers in Melbourne. He was, in his seniority, forever young.

Meantime, he tilled the soil on his property in Oxfordshire, where he lived with Sue and their three children. He, like George Harrison, loved gardening, and a calm, outdoor life became his passion. On the periphery, Whitaker fought with Apple Corps over the rights to his Beatles photography. Bob, feeling that the company was saying, "We, the Beatles, own Whitaker's life," was affronted. He wouldn't let go of what he had created, and he ultimately prevailed. Because he did, you have this book in your hands.

Bob Whitaker led a starry life when he was young, and later he led a gracious life. Cancer proved to be his demon. He died at age 71 in England in 2011.

His legacies are several, and they of course include his family: Sue, two sons and a daughter. We wish them well.

One of Bob Whitaker's several legacies is the Beatles—the Beatles from 1964 through 1966. Bob was happy about this being a part of his story, his remembrance. At the time of his death, he was fully engaged in the production of this very special LIFE volume. Bob loved the magazine, and we loved Bob. He (and we) wanted to make certain that this would be the ultimate document of his time with the Beatles.

We can still hear—again—that ringing chord, perhaps from the 12-string Rickenbacker that George was given as a gift in New York City on their first trip to America.

And now, we let the band—and Bob—play on.

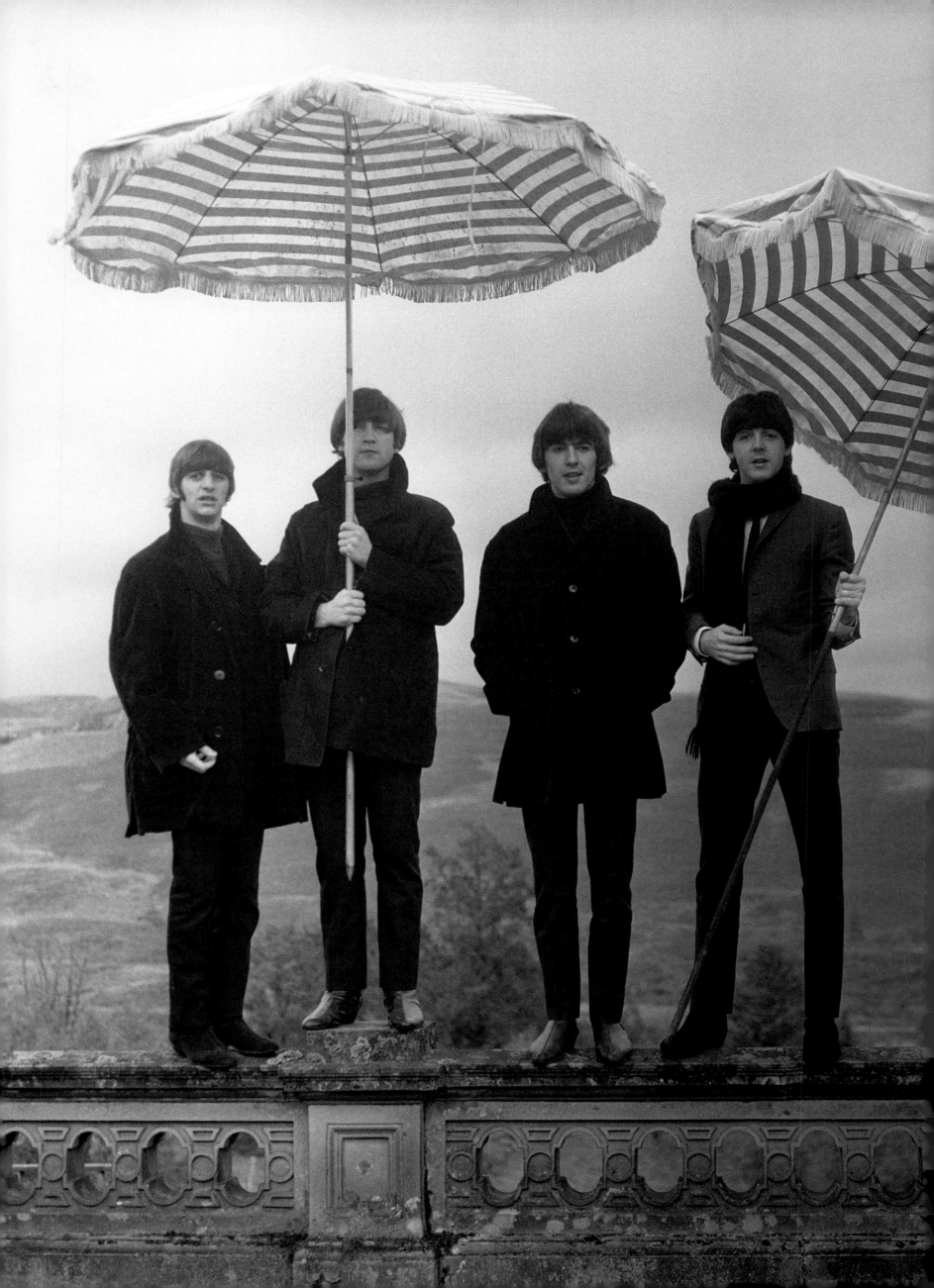

1964

The maelstrom of Beatlemania suddenly had its chronicler.

ON A BREAK from a tour in Scotland, Whitaker asks the lads to climb a garden wall at a country house in Argyllshire. Later, Bob will remember to LIFE, "They grabbed these umbrellas, and then John . . . well, look at him in that photo. He's levitating."

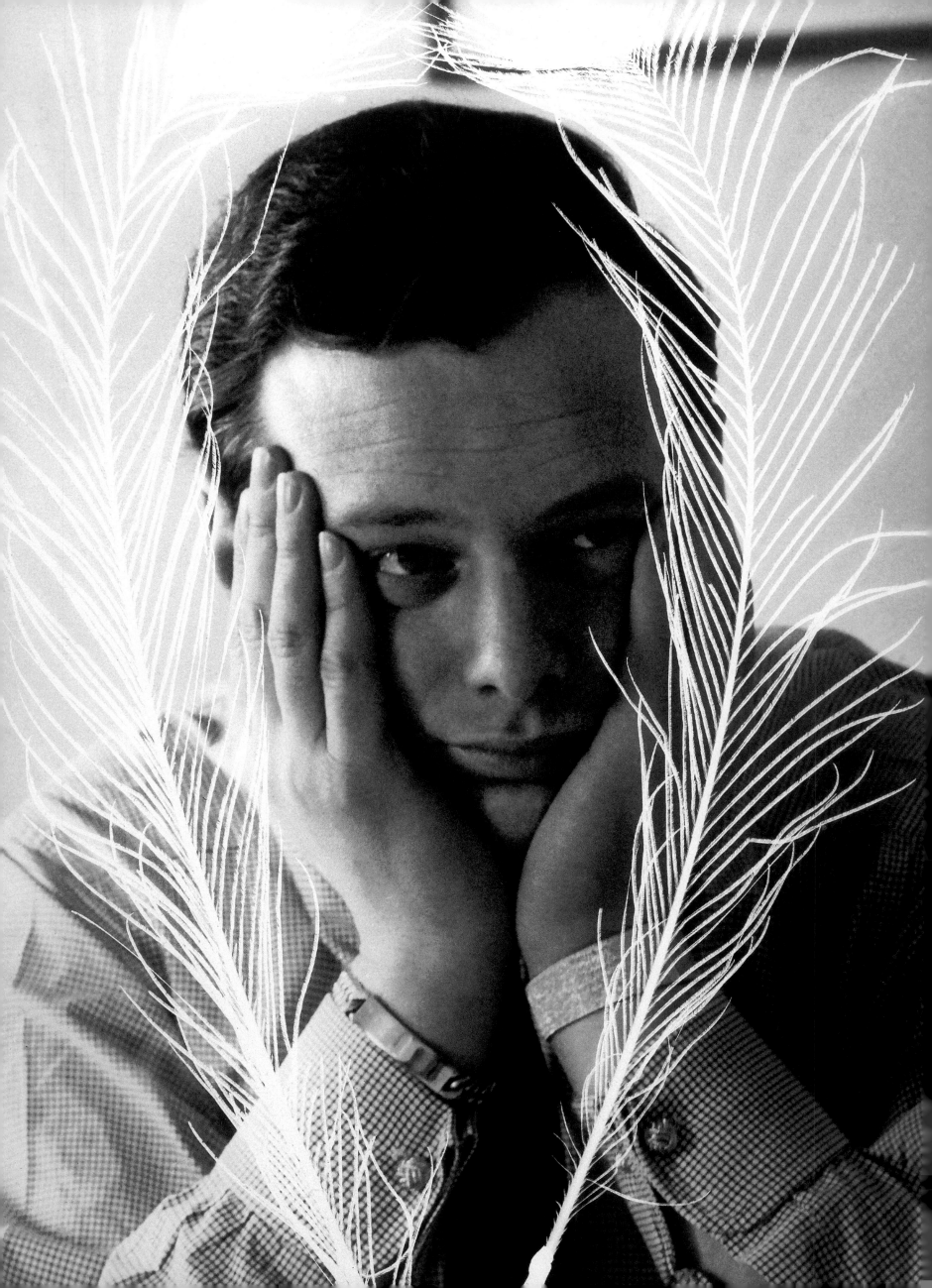

ell, the Beatles in 1964:
What more is there to be
said that hasn't been said
or written—even in previous
LIFE books? They had, months
since, conquered their homeland and had just triumphed
in Paris. While lighting up the City of Light (singing in
English!), playing the Olympia music hall and ensconced at
the George V Hotel, they had been informed that "I Want
to Hold Your Hand" had gone to No. 1 in the United States.
They would not only be at the vanguard of the so-called
British Invasion, they (with the Dave Clark Five at their
heels) would be the great bulk of that invasion in 1964. The
Rolling Stones, for instance, stiffed in America when they
took their first shot.

The Beatles were bigger than big, and they were
worldwide—intergallactic, extraterrestrial—whatever can be
imagined. So when Bob Whitaker saw them play in Australia
in '64, the Beatles were kings, and when he and they came
back to England, he was chronicling the life and times of what
was obviously the biggest entertainment act since Elvis.

He never looked at it that way.

He was much too cool for that.

He was as hip as John and as cute as Paul. He was ready-
made for what he was getting into.

The reason his Beatles photographs—all of them taken
within the white heat of Beatlemania—are so affecting is:
Whitaker was creative, confident, with a wry, unjaundiced
eye, and he fell in with the lads very naturally. Together, they
had a little fun. The association they enjoyed beginning
in 1964 would be impossible today. If One Direction or the
next boy band to come along had an official or semiofficial
photographer, that shooter would be vetted to a fare-thee-well
by marketers, and all pictures that might be released to the
press would be approved by a 15-person committee. Not so
back then. Brian Epstein had hired Bob, the boys in the band
had come to know him, they liked him, and now: Hey, let's
say we make some pictures?

Bob, as mentioned in our introductory chapter, had
other assignments to fulfill for Brian. It is to be supposed
that Gerry Marsden and his fellow Pacemakers were happy
enough with the covers of their *How Do You Like It* and *Ferry*

BELIEVE IT OR NOT, this is the photo that launched Bob
Whitaker's association with the Beatles. Whitaker felt that Brian
Epstein, as manager of this suddenly huge band, was an emperor
who "should be crowned with laurel leaves." Peacock feathers were
an available substitute. Epstein loved the result. You can judge for
yourself, but in those feathers lay Bob Whitaker's fate and future.

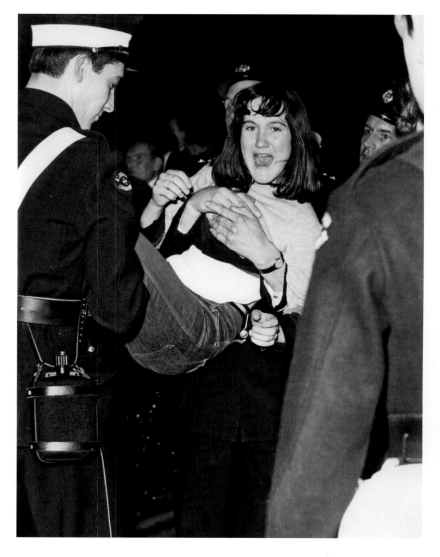

"THE EXCEPTION TO THE RULE," said Whitaker of this
immortalization of a crazed London fan. "I never liked to use flash,
which I felt imposed its own artificial atmosphere on events. Here,
there was no alternative—it was pitch black."

Cross the Mersey albums, and that Cilla Black was over the
rainbow with the cover shot for *Cilla Sings a Rainbow.* But
they—and Billy J. Kramer & the Dakotas and others in the
NEMS stable—might have reasonably been thinking: What's
the deal with the Beatles? Why, always, them?

Now, of course, we know.

Or, actually, we don't.

With all the articles and books that have been written, the
Beatles remain inexplicable. Some rock historians, those with
a sociological bent, look at the band in 1964 and say: John F.
Kennedy had just been killed, the country was in a malaise,
the world was sagging, the . . . *ummm* . . .

What? The planet needed a boost?

But when we at LIFE Books look at Bob Whitaker's photos
nearly 50 years later, we do nothing but smile, and the music
starts to play in our heads.

What's that about?

Might it be magic?

Might it have been, even in the day, magic?

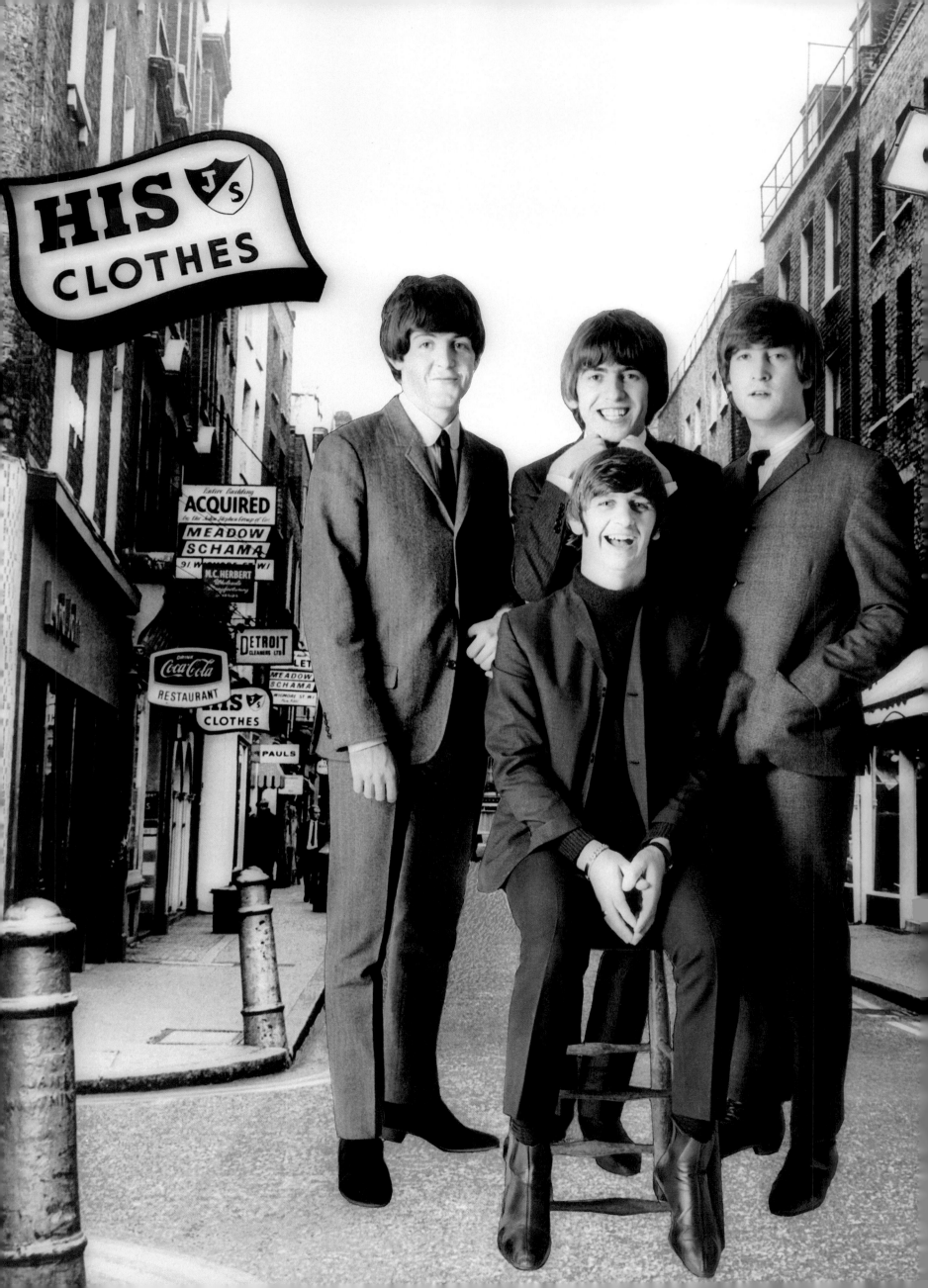

LIFE BEFORE GREEN SCREENS: This shot of the dudes in dapper duds was taken in a studio and superimposed on a scene of London's famed fashion capital, Carnaby Street. The Beatles' Apple store would contribute to fashion trends in years shortly to come, just as the Beatles—and Twiggy, and the others—already had. Paris was plenty displeased that "latest trends" had been conceded to the eternal enemy: England. In the following pages, Paul and John are seen during rehearsal in Donmar Hall in London for the 1964 Christmas Show. These rehearsals start late because George is vacationing in the Bahamas (something unimaginable to these Liverpool lads only a short time ago; the Bahamas might have been Mars) and Ringo is in the hospital to have his tonsils removed. The good news—and, honestly, we're not ragging on Ringo!—as a singer, he came fourth. Keep the chops. Lose the tonsils.

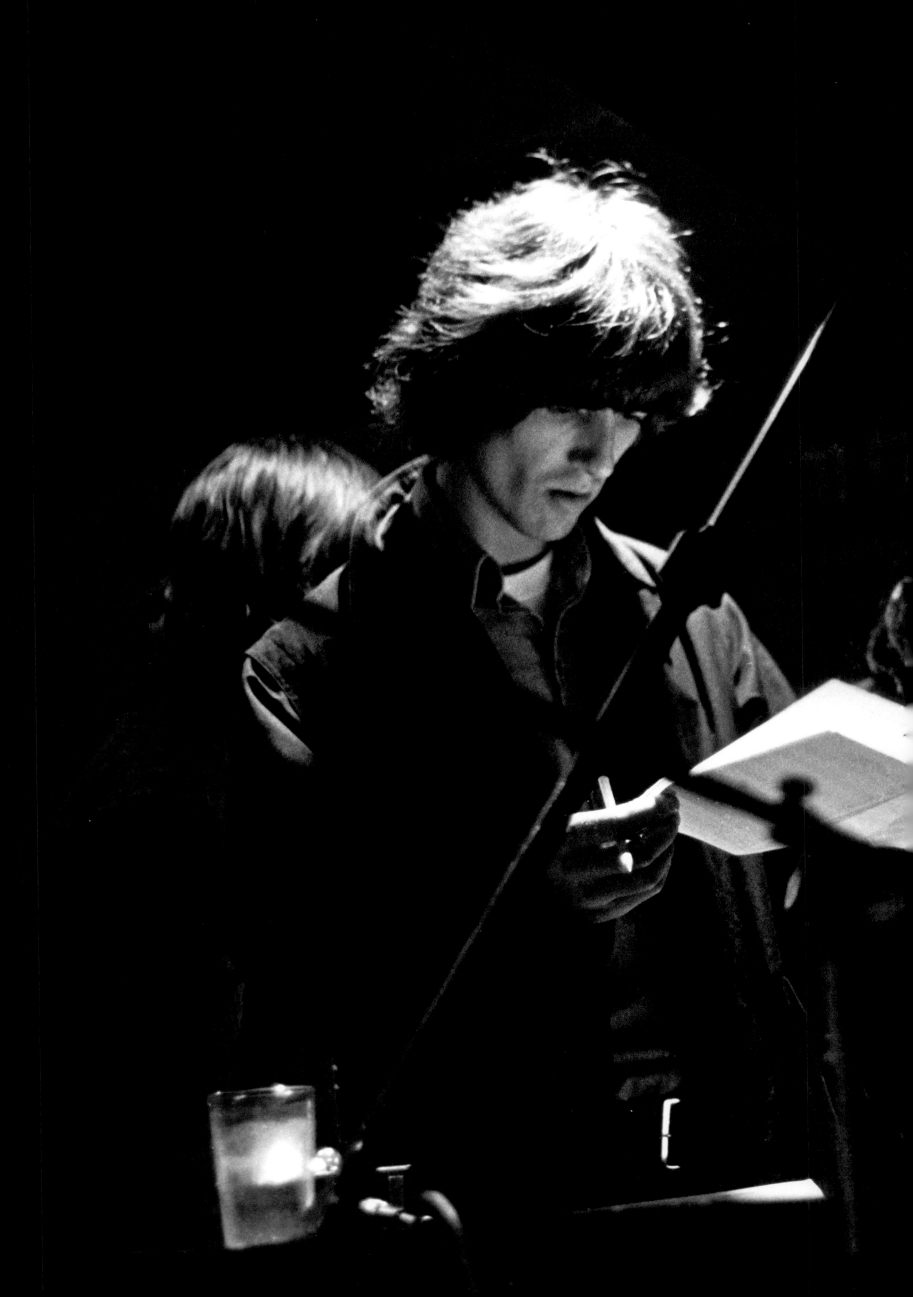

"I'LL HAVE TO wear *what?*" is what George is probably thinking as he reads the script for the upcoming Beatles Christmas Show. During the evening, which will be rife with corny pantomimes and goofy sketches, George will, among other indignities, don a white headscarf while playing a woman. On the following pages: During rehearsal, the boys get a visit—and no doubt some good-natured teasing—from their friend Mick Jagger.

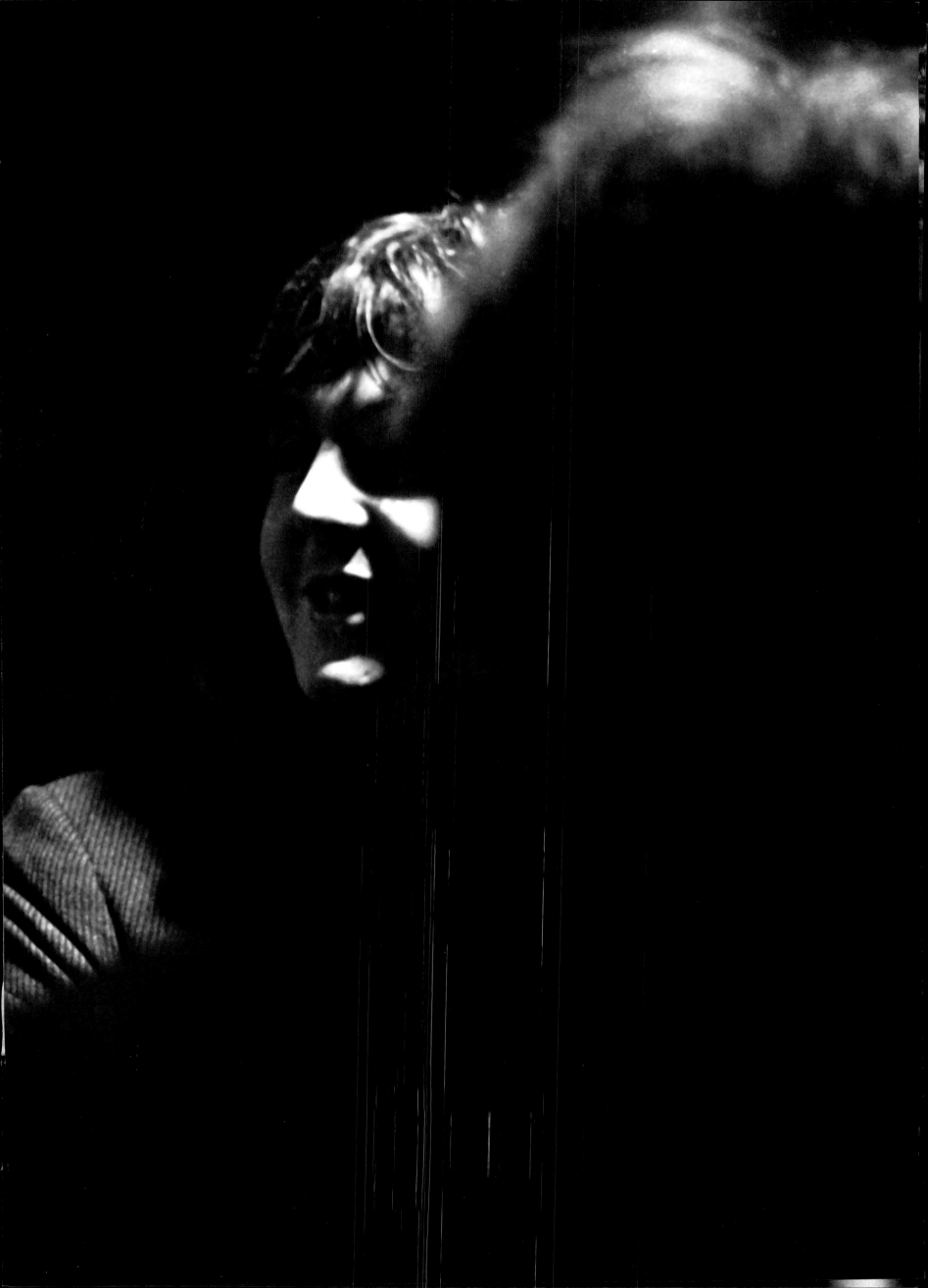

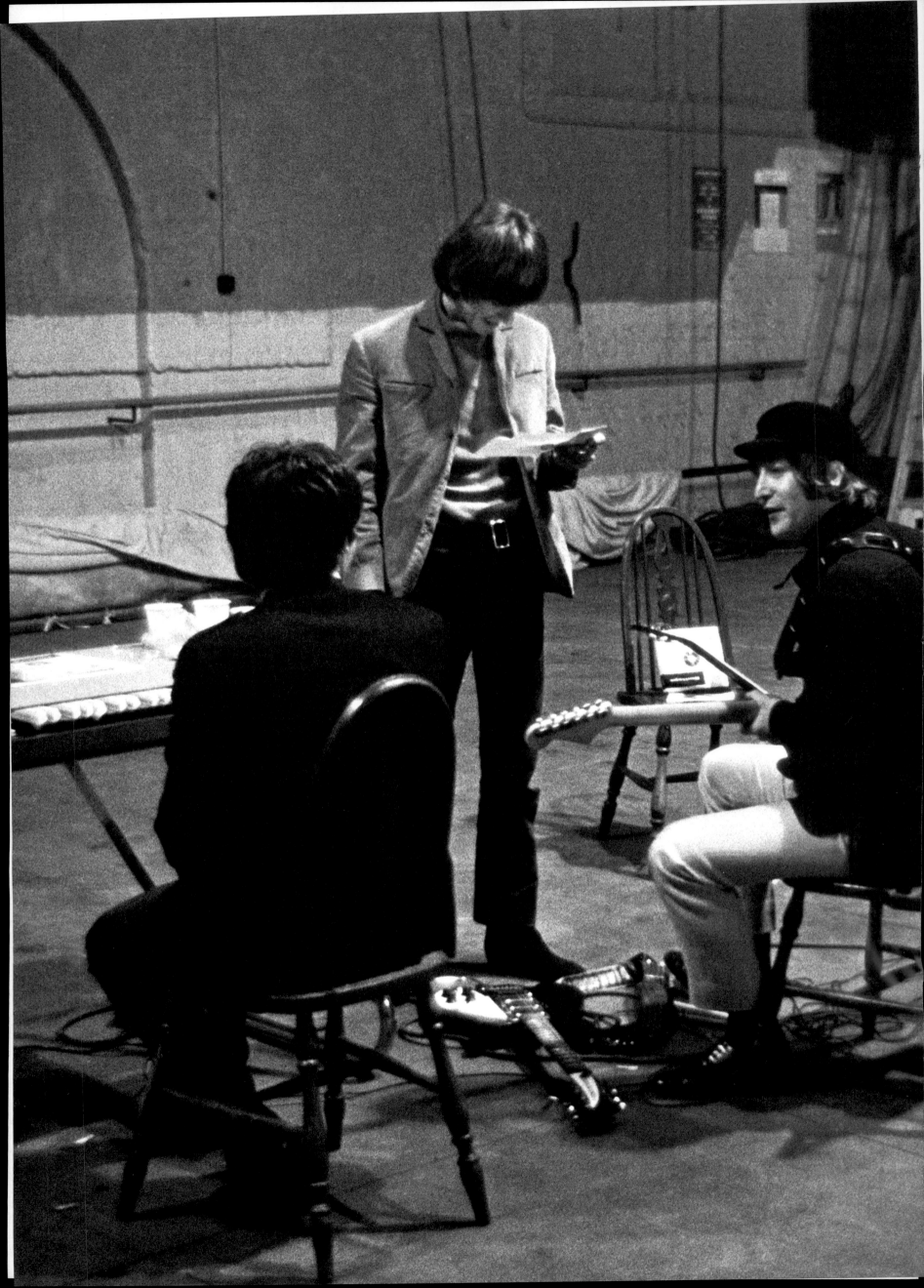

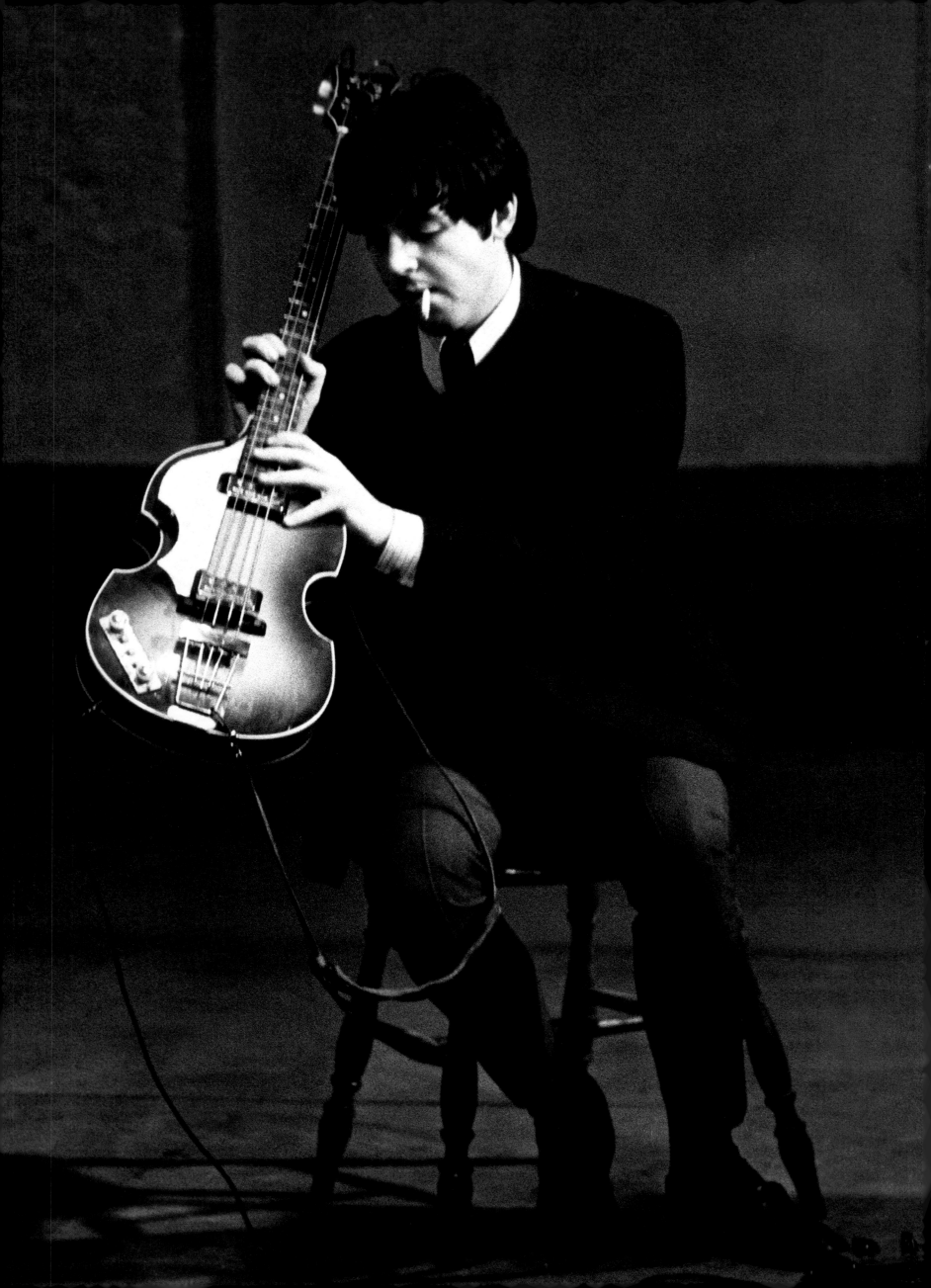

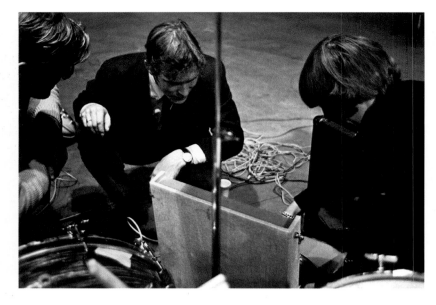

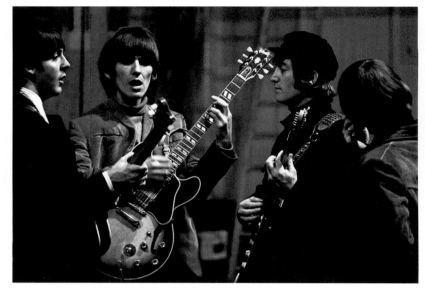

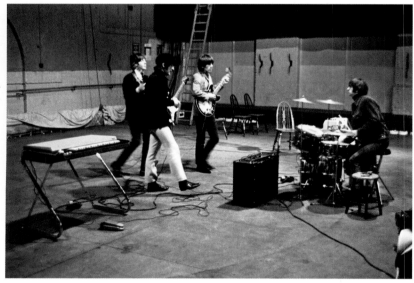

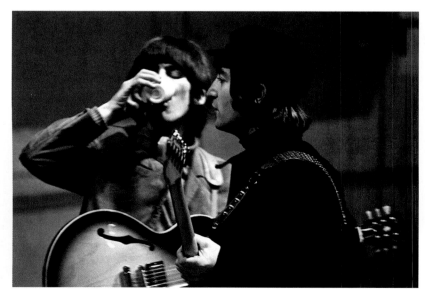

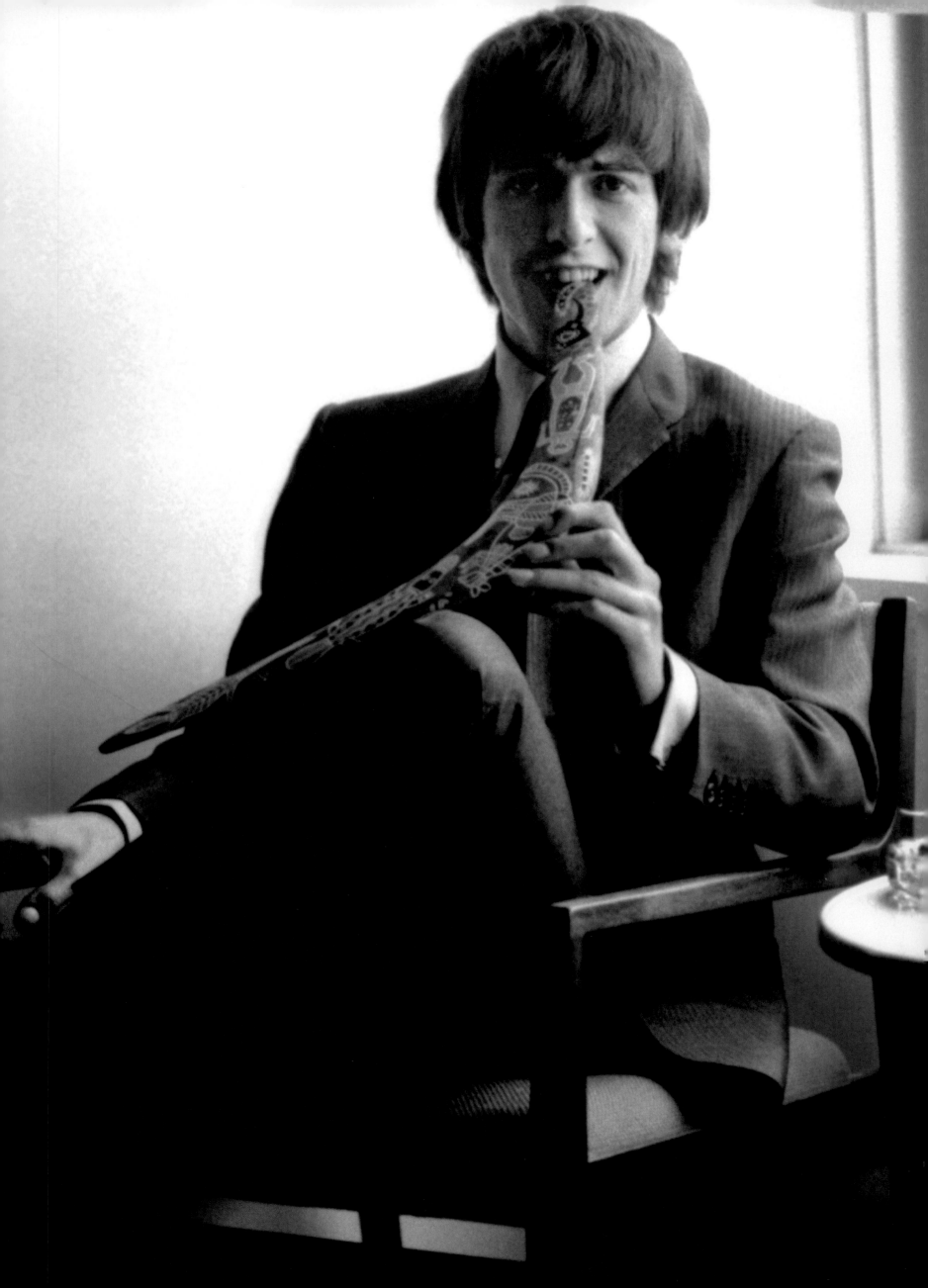

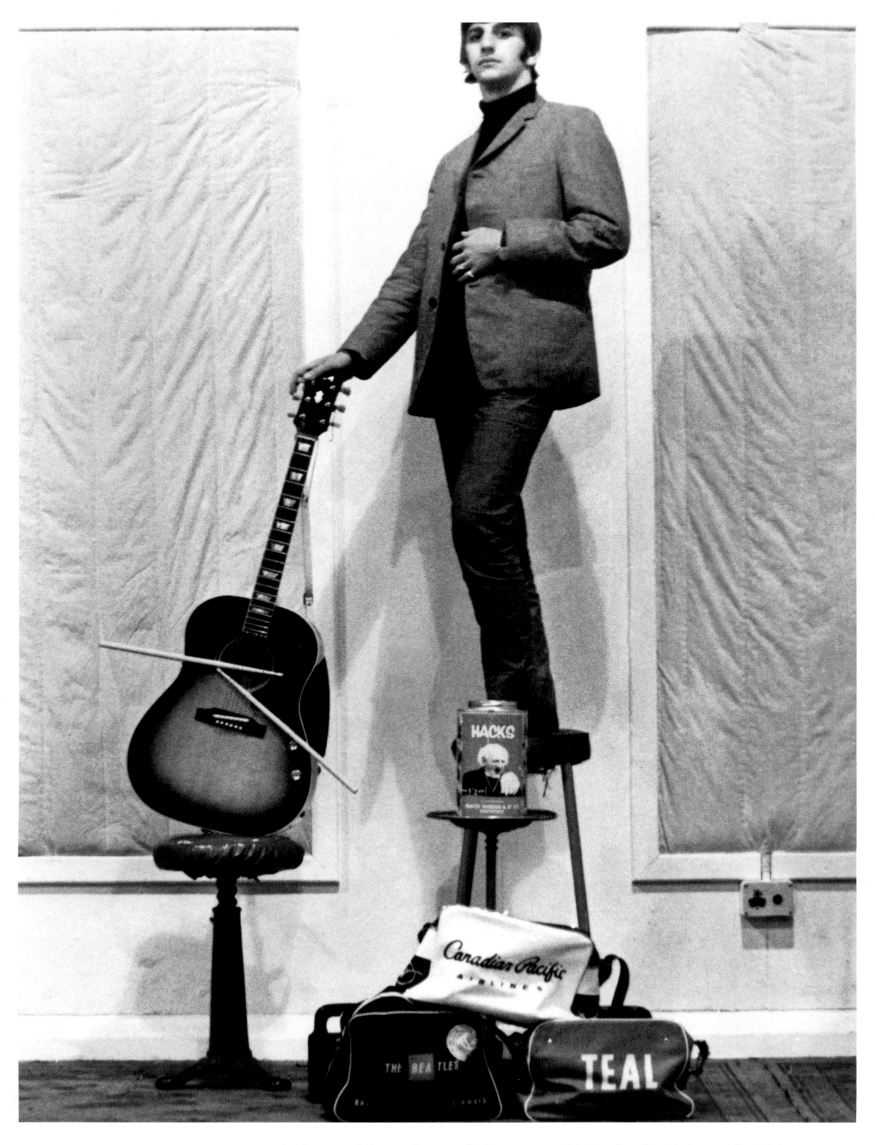

"THE YOUTH OF AUSTRALIA craved culture, and the Beatles were the biggest act to hit the place," Whitaker recalled of the craziness he witnessed when the band from Up Over hit the Land Down Under. In calmer moments, George shows a souvenir boomerang he was bequeathed by an Aussie fan, while Ringo, back from the road, poses with an instrument nearly as foreign to him: a guitar.

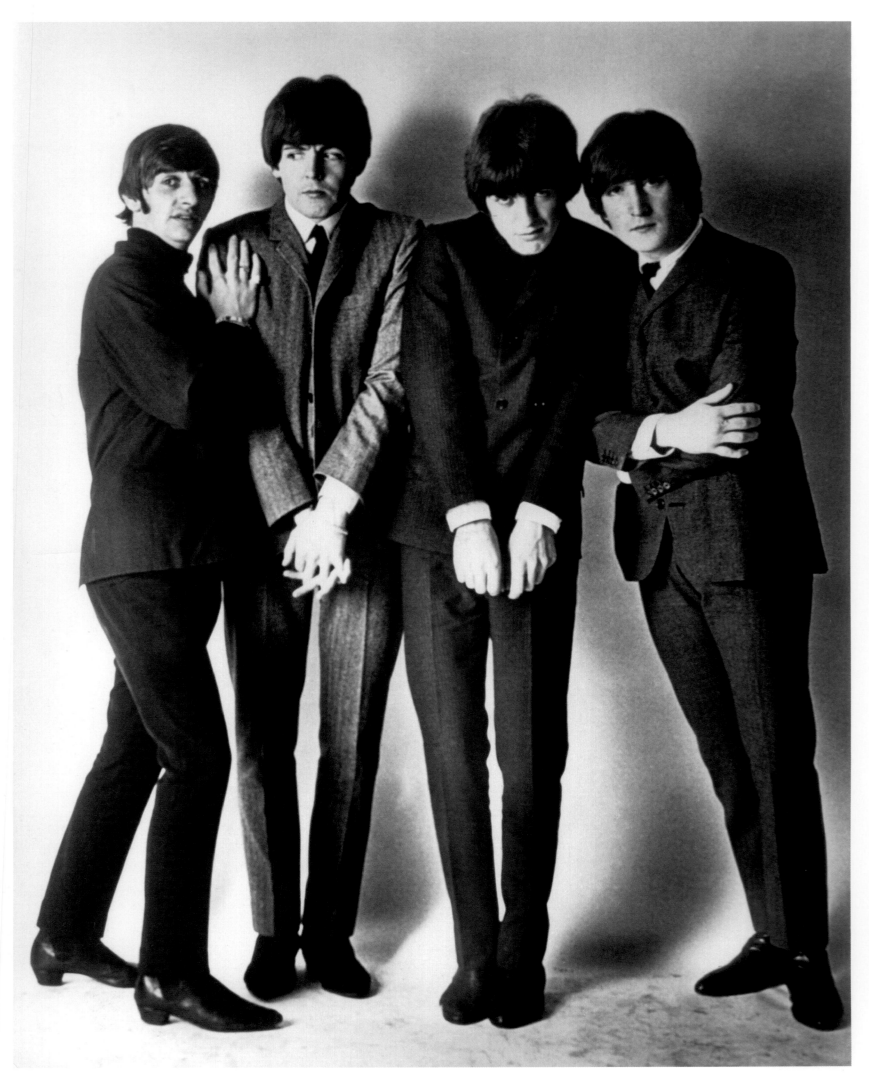

ON THESE and the next several pages are early results of Whitaker and the Beatles in a formal studio setting—some familiar photographs and some less so. The Beatles were famously playful and cheeky, and Whitaker was always coming up with ideas or bringing along props. He told LIFE that he felt the bandmates almost always got it—they quickly played along—when he made a suggestion for any particular portrait.

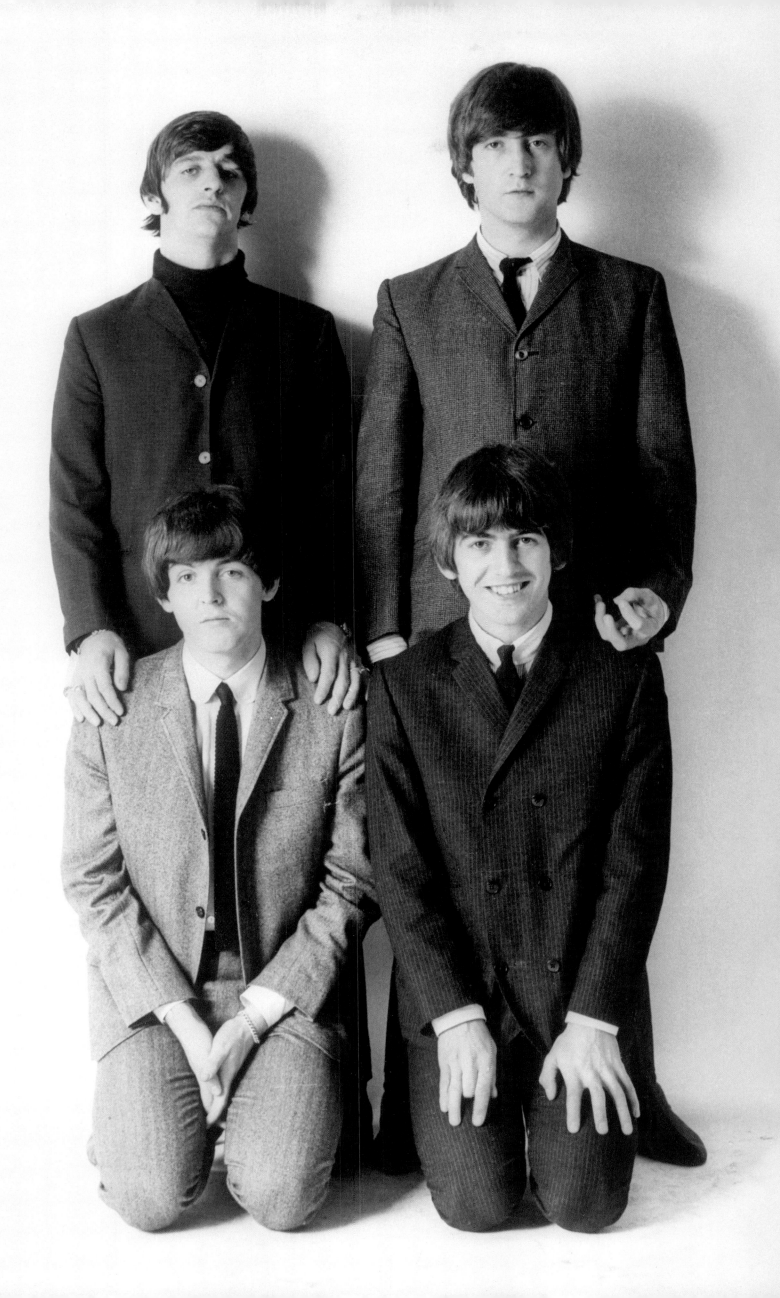

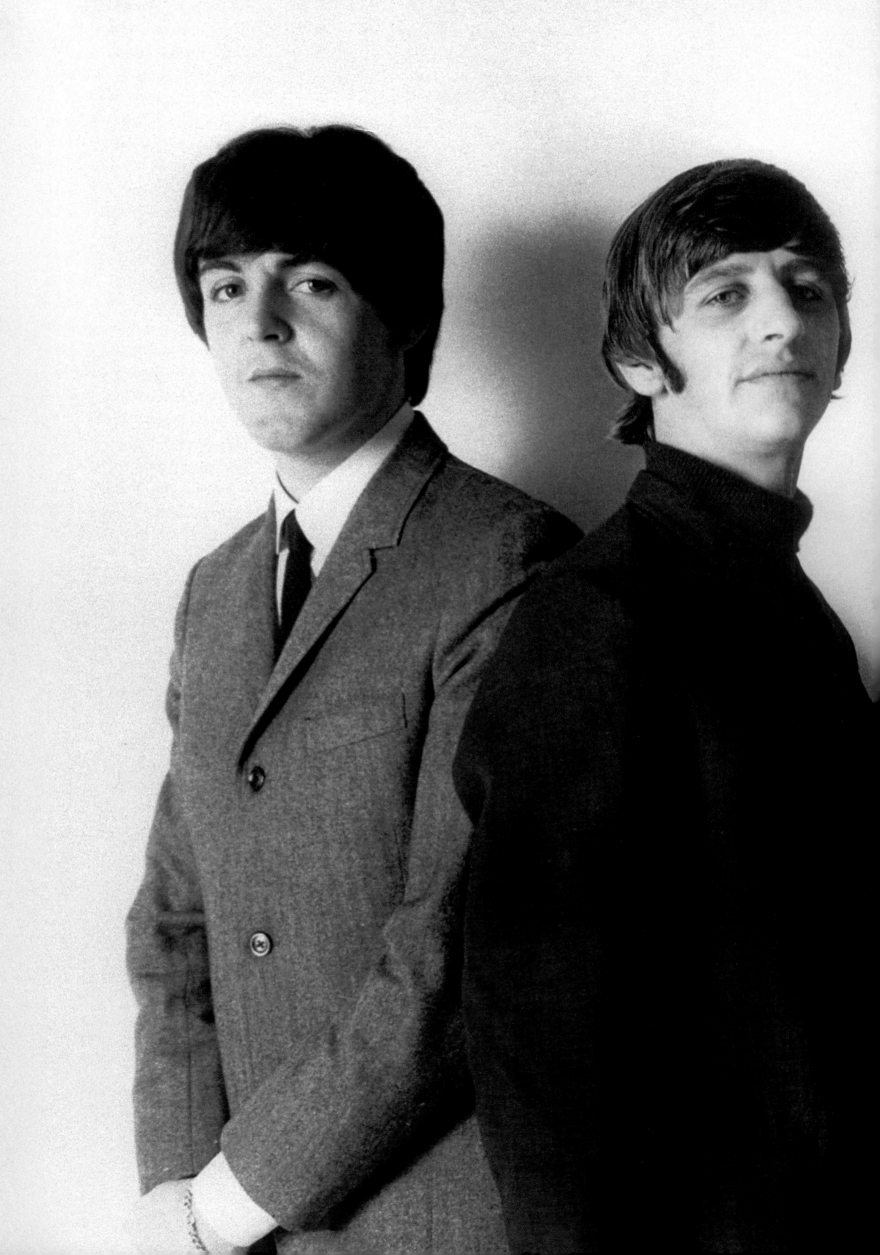

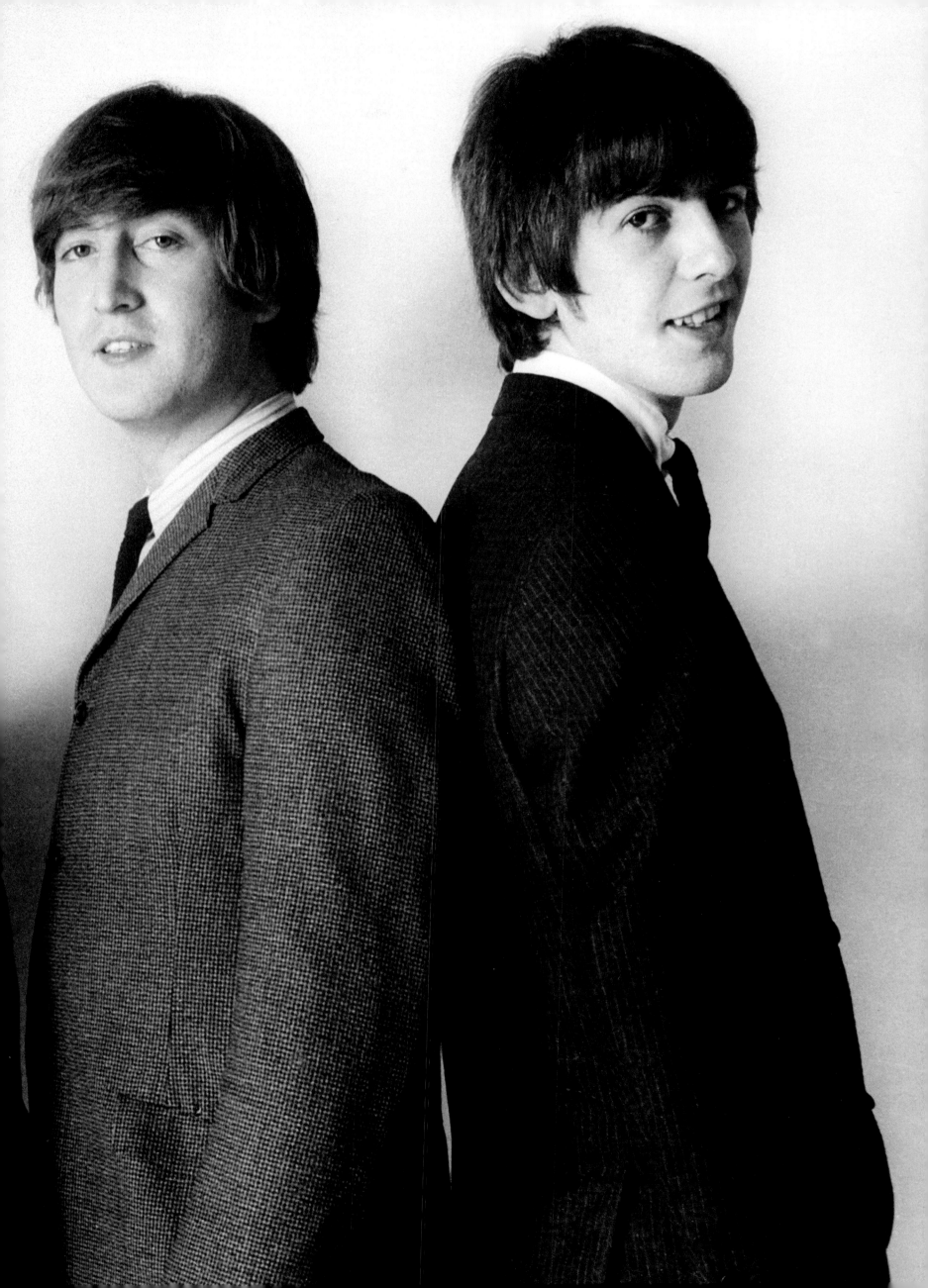

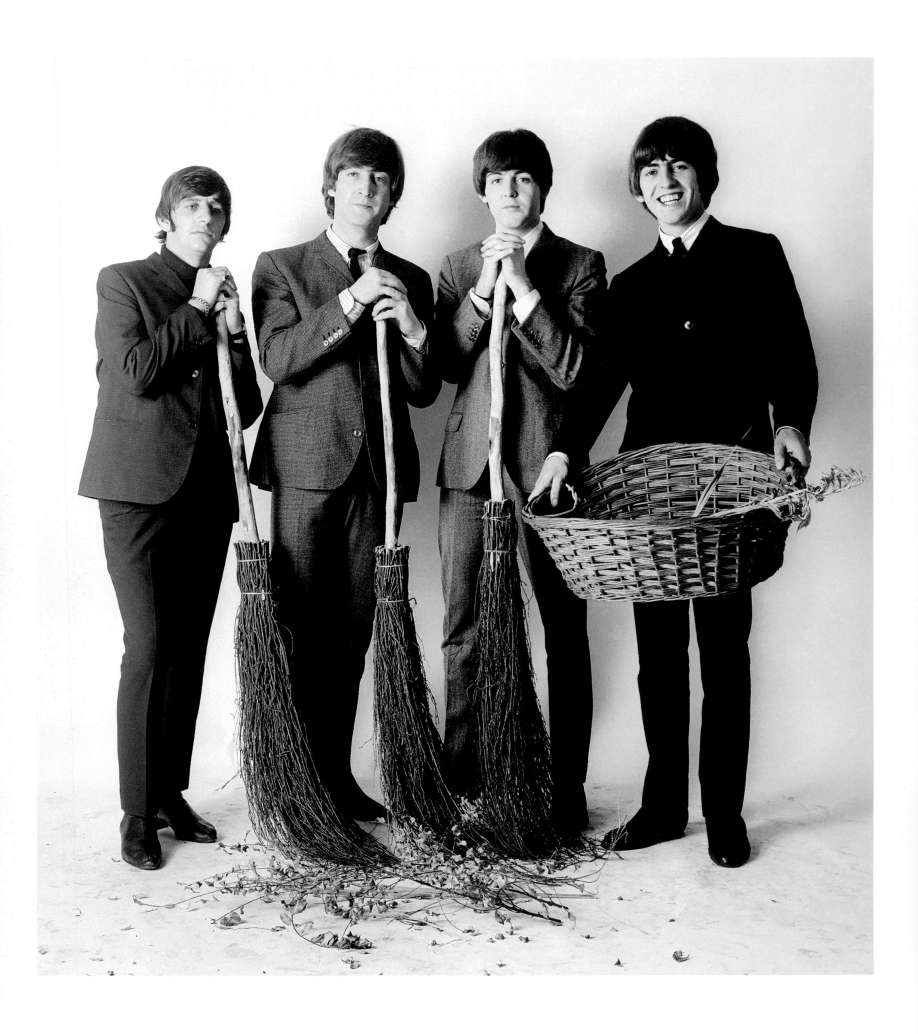

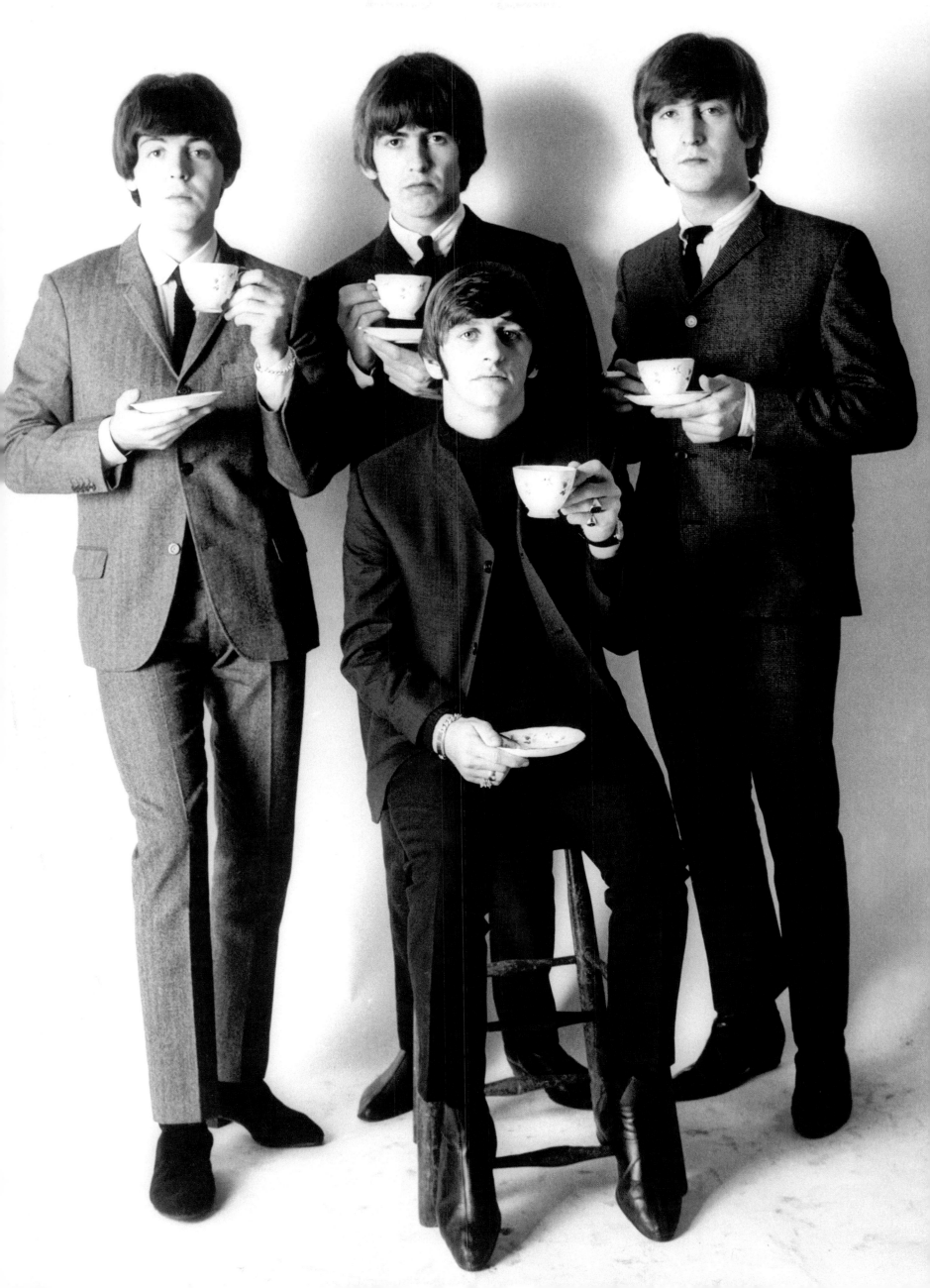

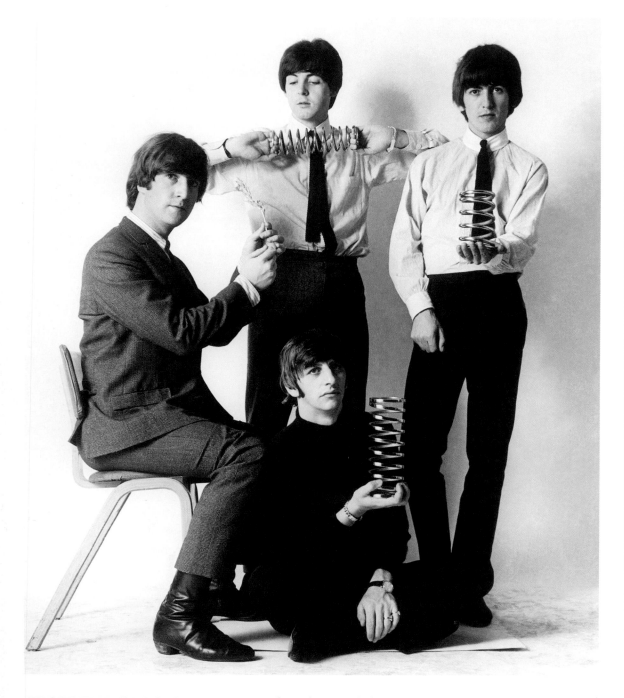

FROM THE SESSIONS represented on these and the previous pages came the shots that would grace the cover of *Beatles '65*, the band's seventh album release in America, which would jump from No. 98 straight to No. 1—at the time the largest leap to the top position in *Billboard* chart history.

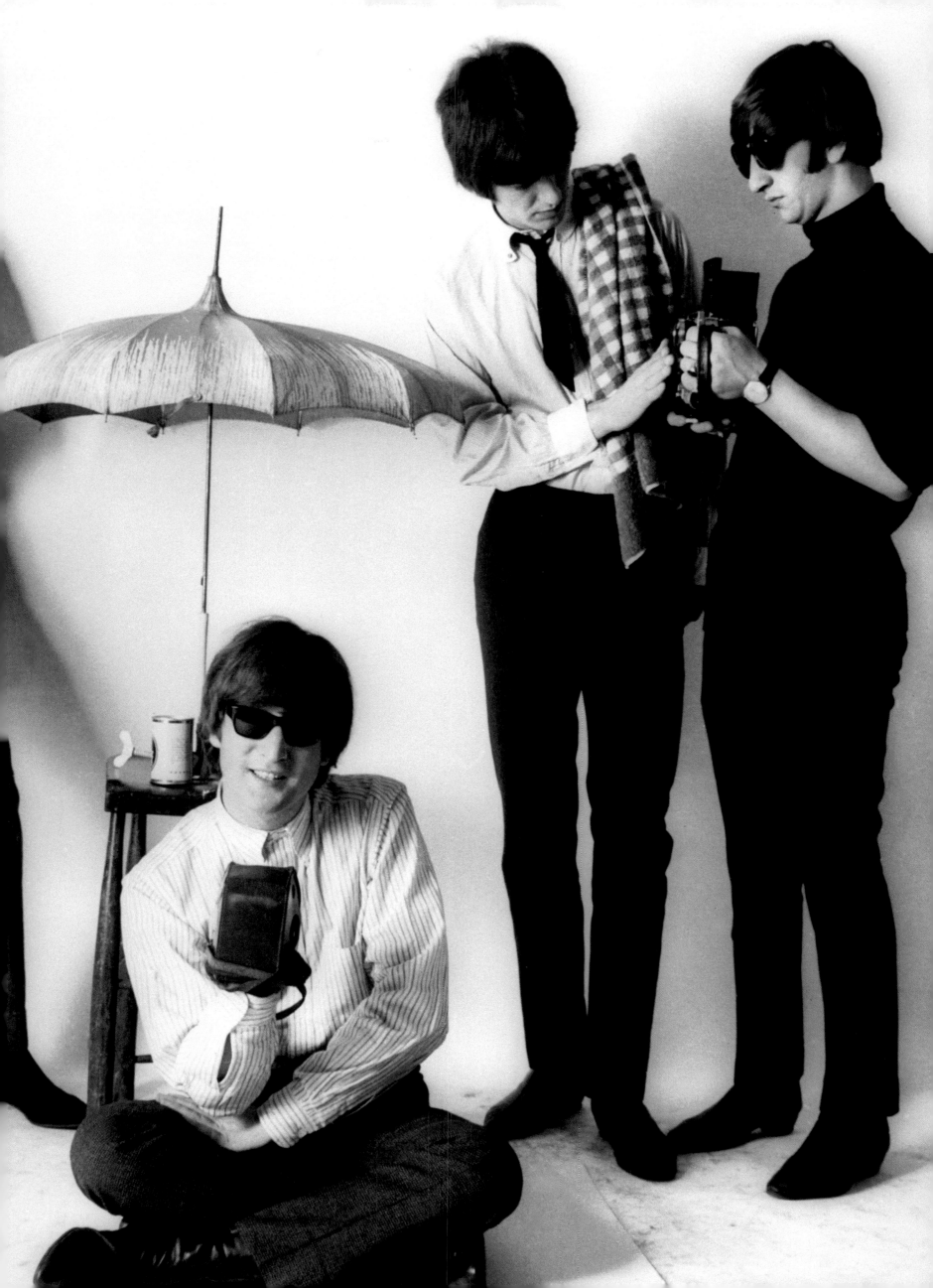

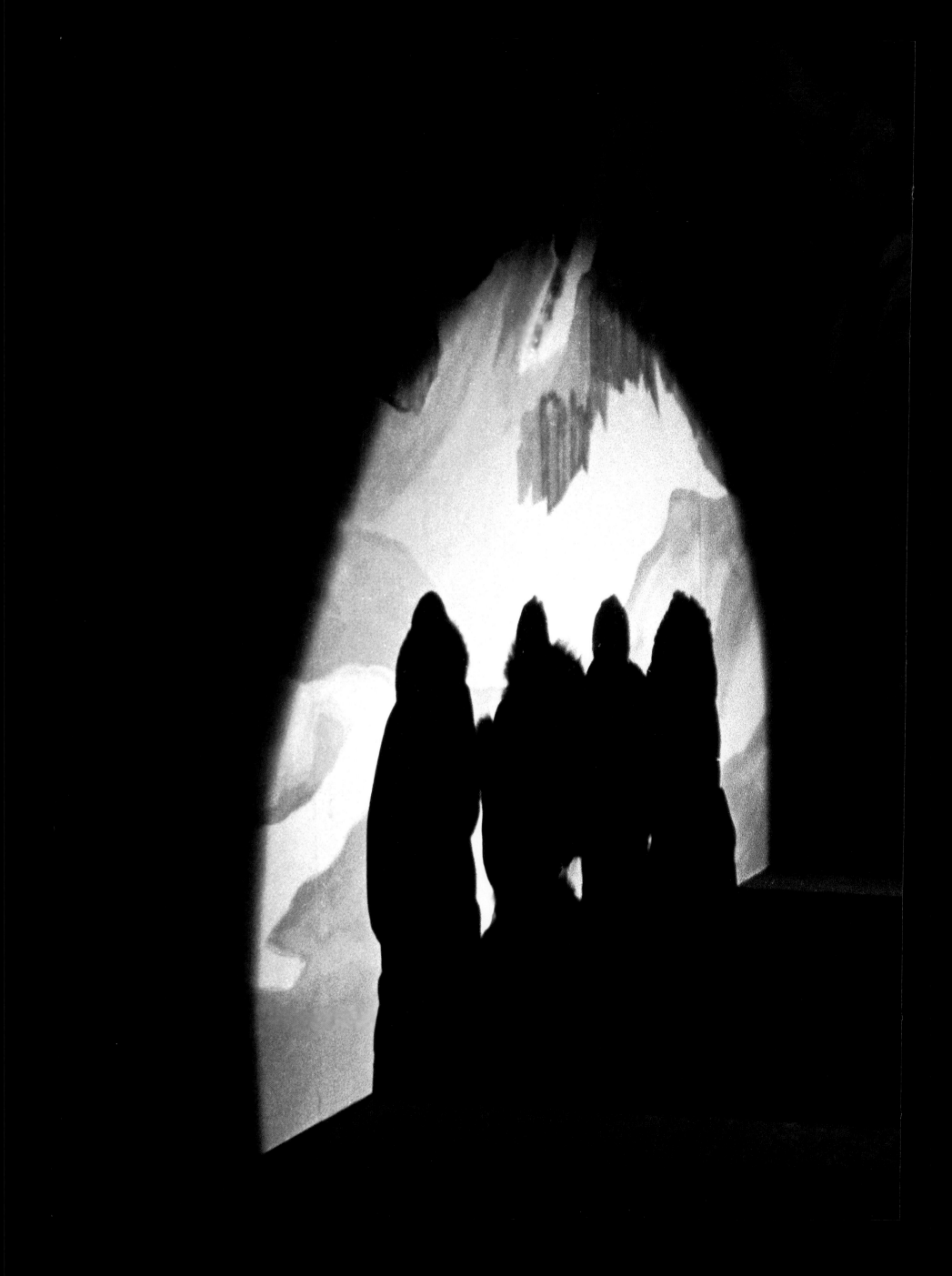

THE GOOFY and—let's face it—tacky Beatles Christmas Show in 1964 turned out to be . . . a huge success! Despite their smiles and cozy Eskimo coats, the Beatles were feeling anything but warm and fuzzy. *Frosty* is a good word. They did not sing "Not a Second Time," but they might have. To no avail: There would be an encore the following year.

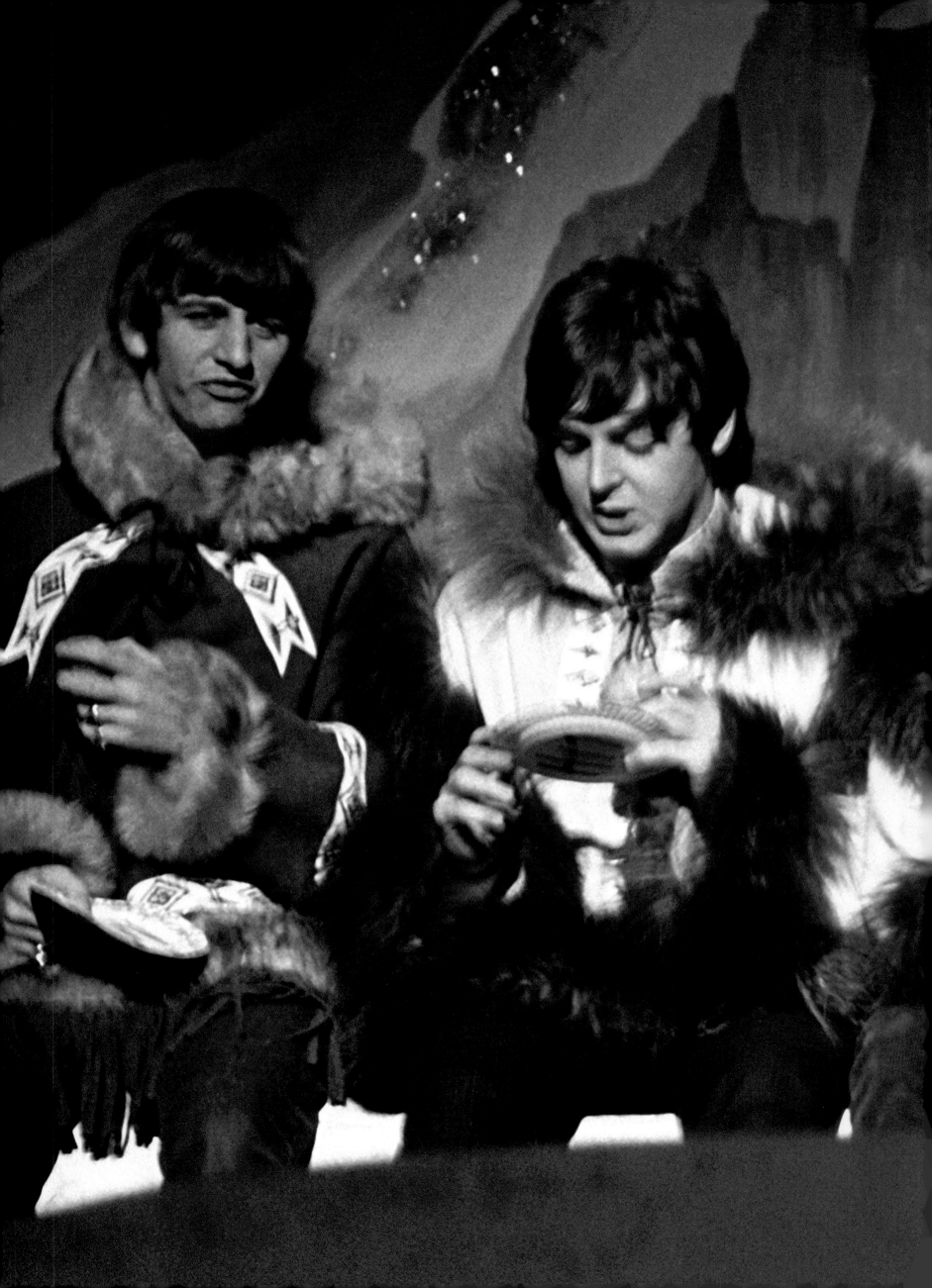

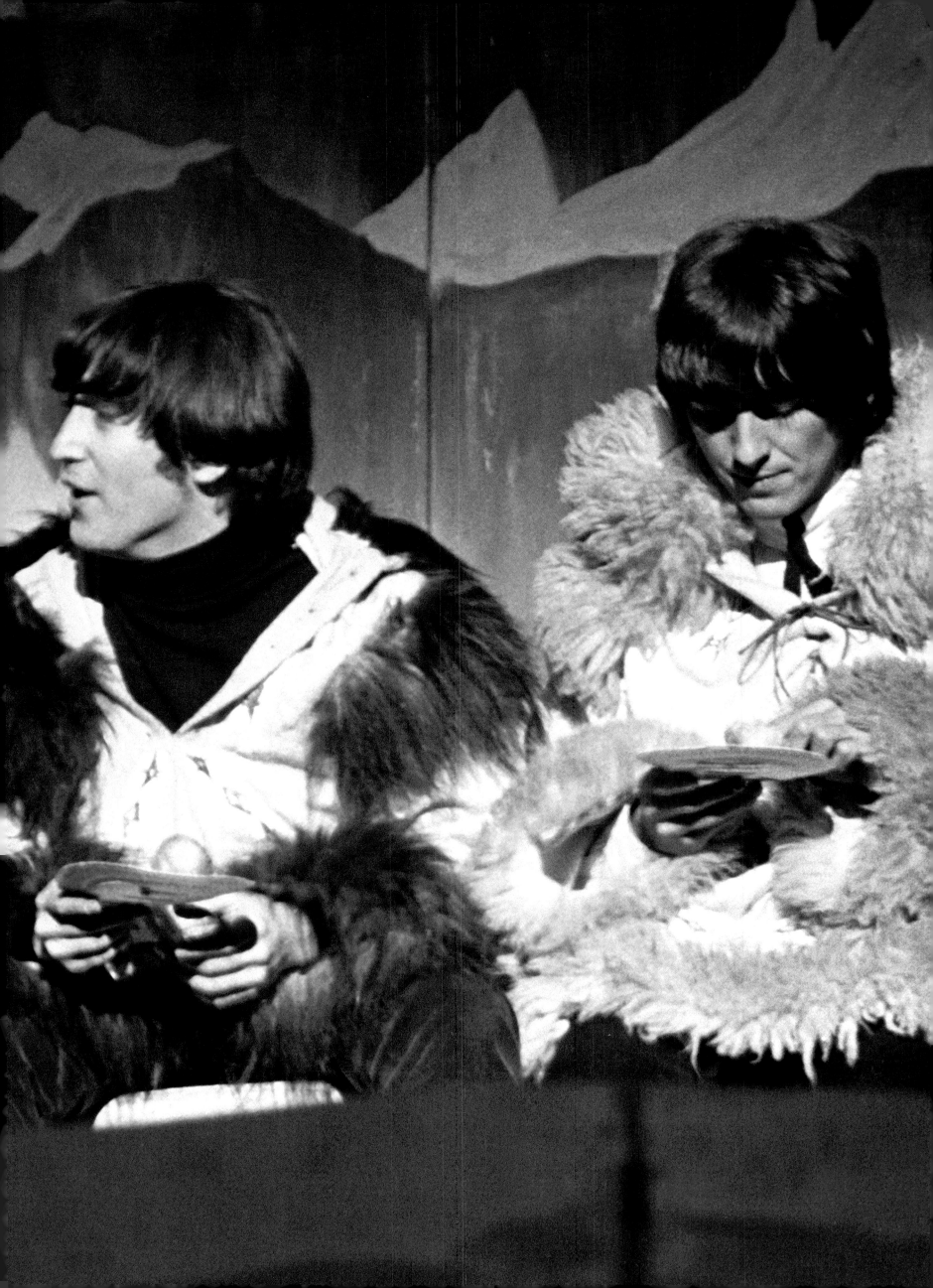

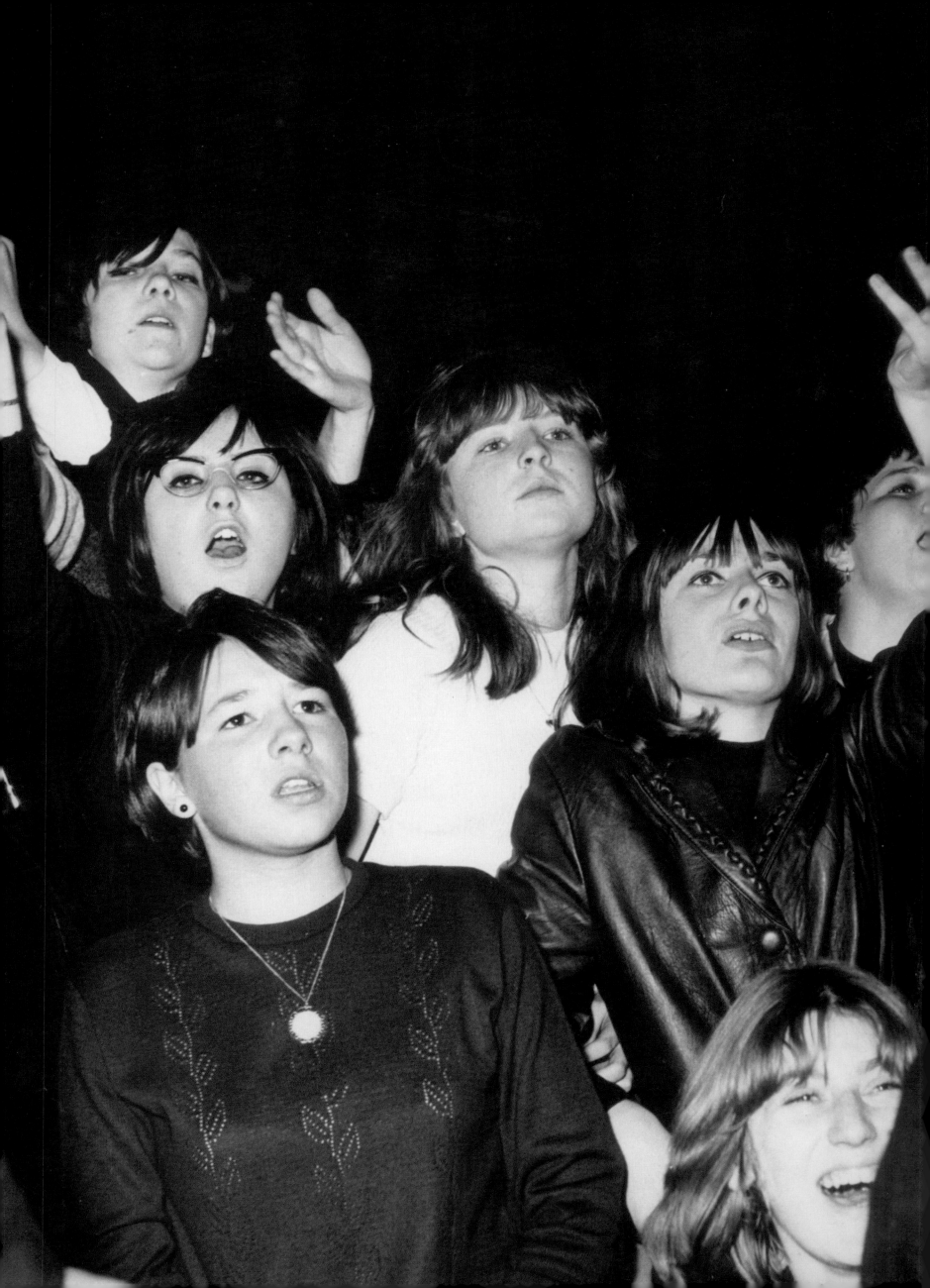

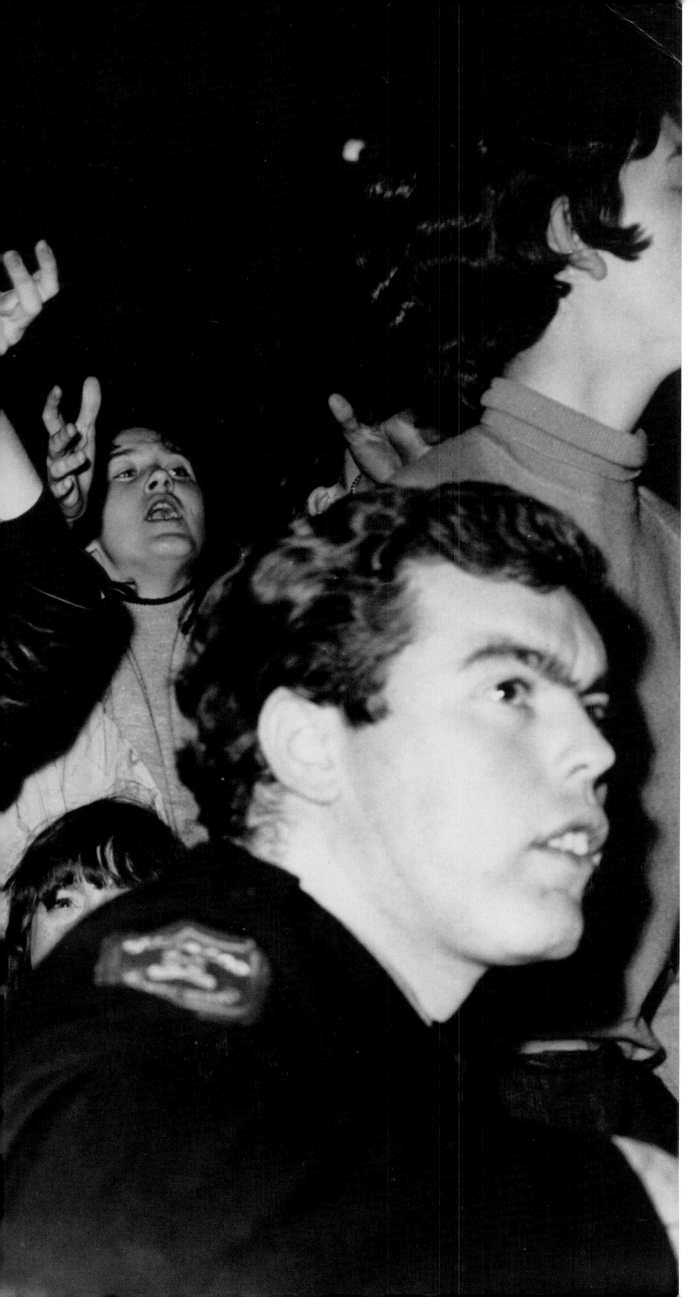

THE FACE of this girl and those of the kids (and authorities) on the following two pages, all recorded by Whitaker at London's Hammersmith Odeon, say all that needs to be said about Beatlemania.

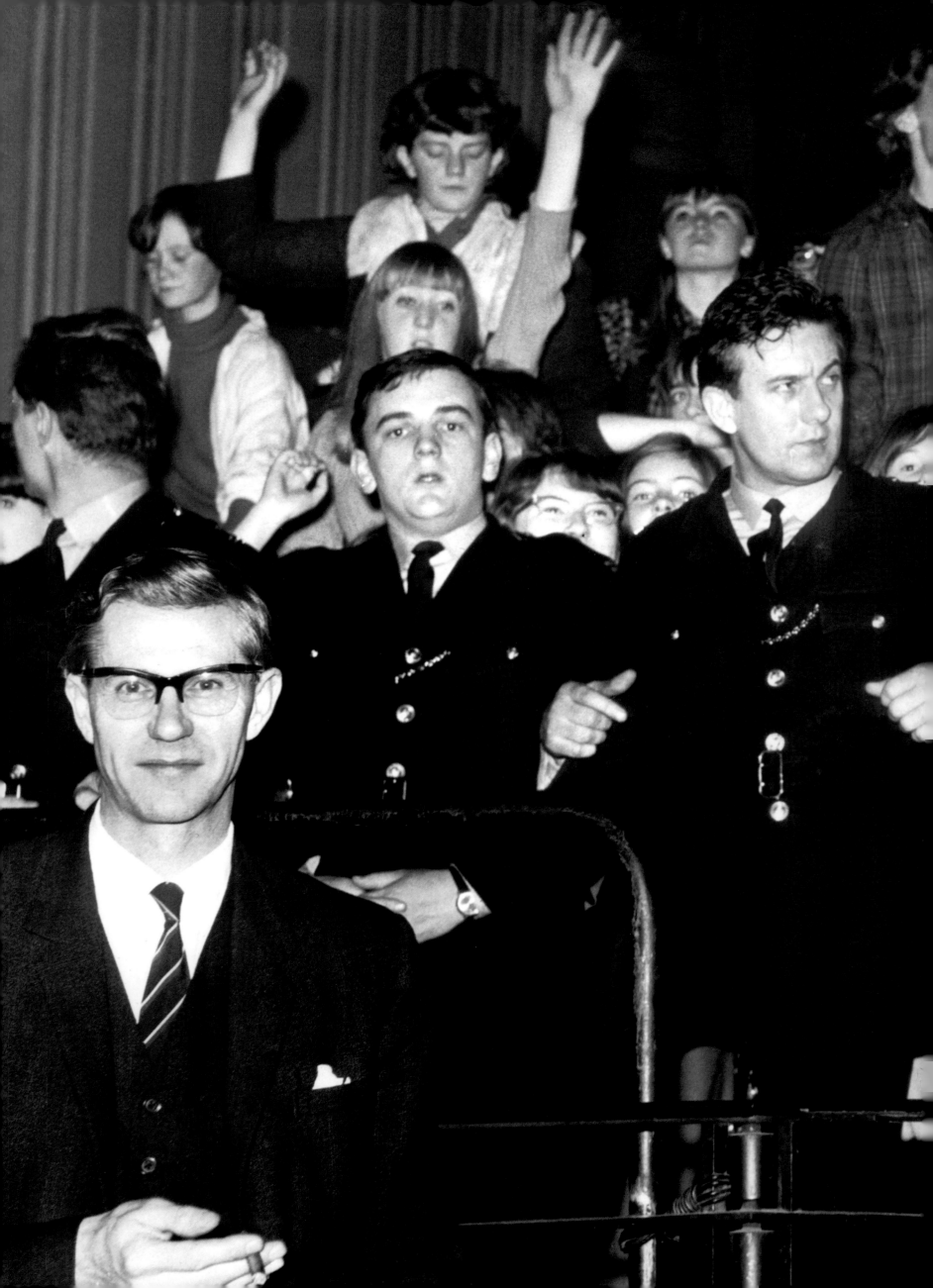

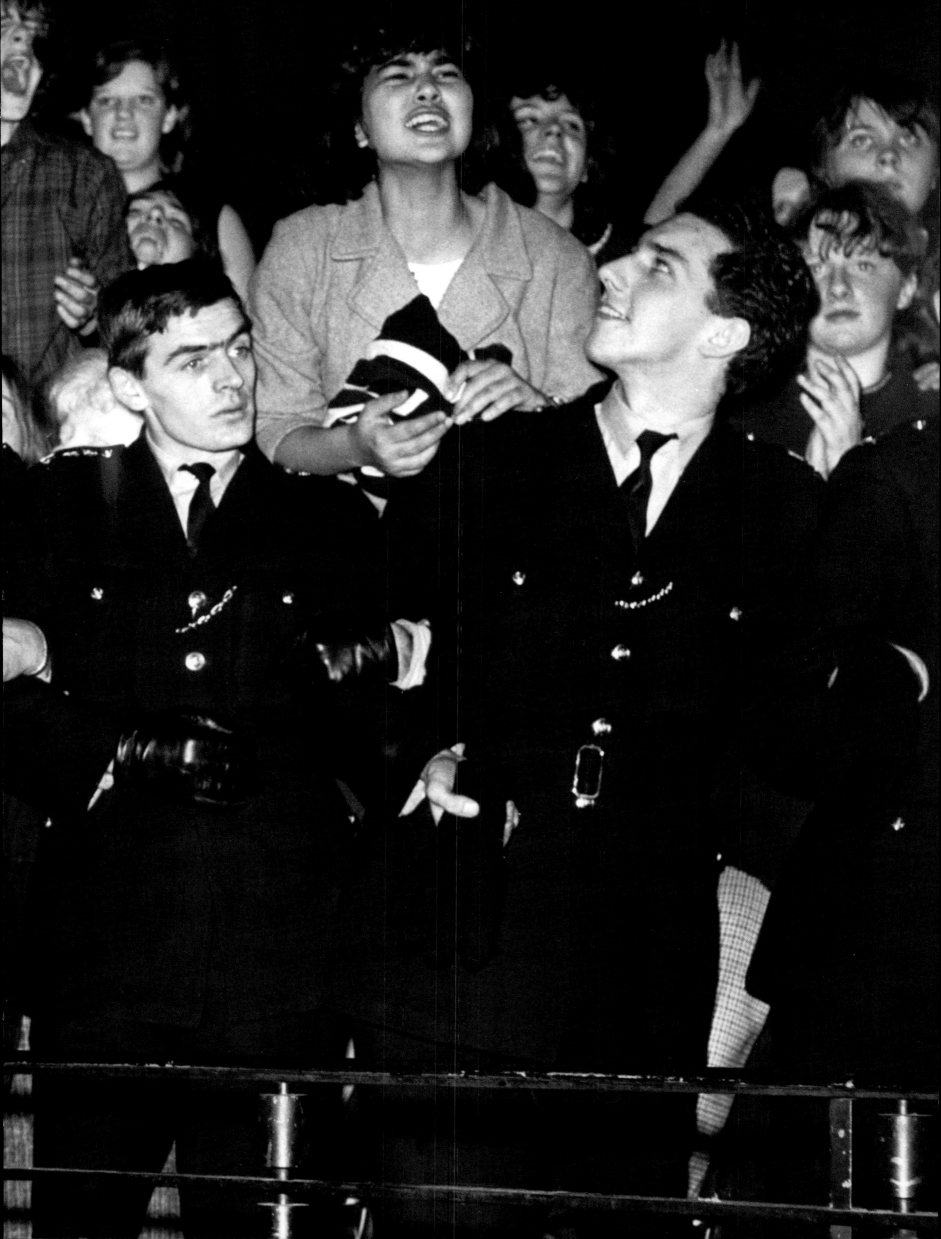

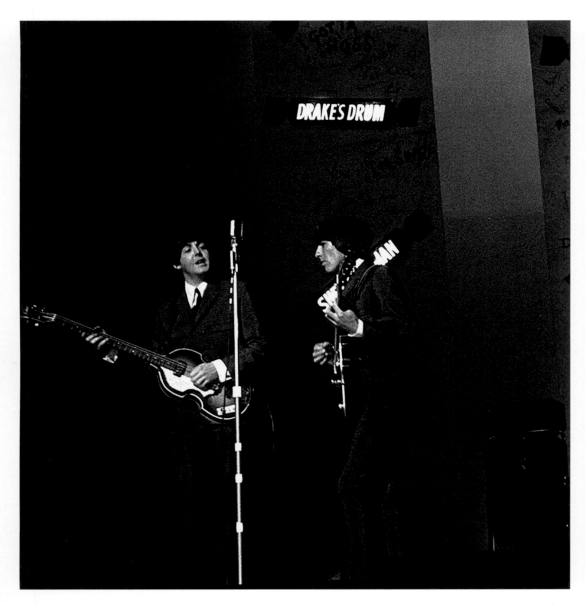

THIS IS AT the Astoria Theatre in the North London district of Finsbury Park. The Astoria was a legendary venue in the '60s where none other than Frank Sinatra, Ray Charles, Aretha Franklin, Sarah Vaughan (and, oh yeah, the Stones) performed. The Beatles were paid £10—fish-and-chips money—to sally forth in two concerts on this particular night. Yes, their playlist suitably included "Money (That's What I Want)"—and John shredded his voice on it just as he had done so many times before in the dumps of Hamburg's Reeperbahn and at the Cavern Club in Liverpool.

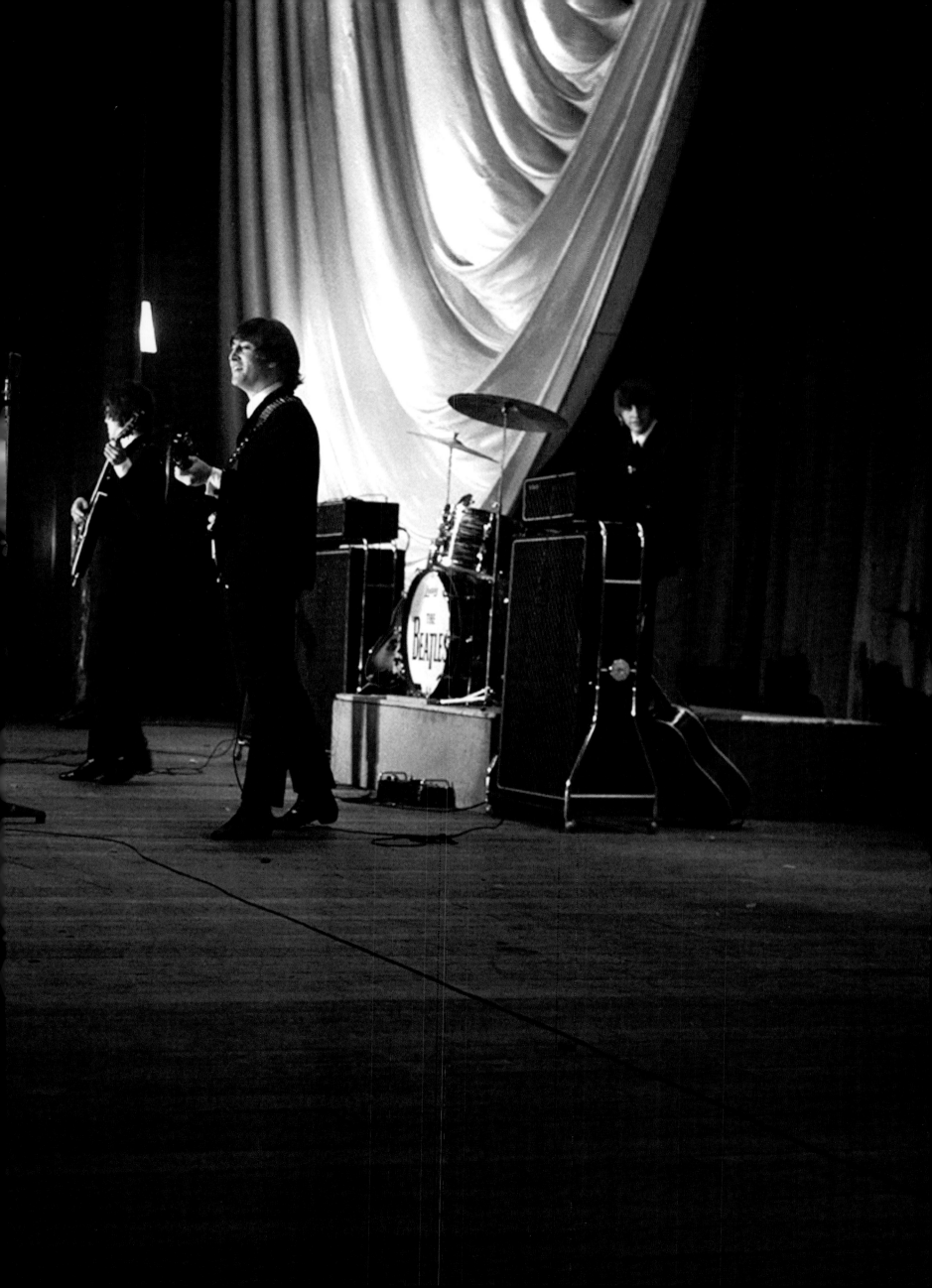

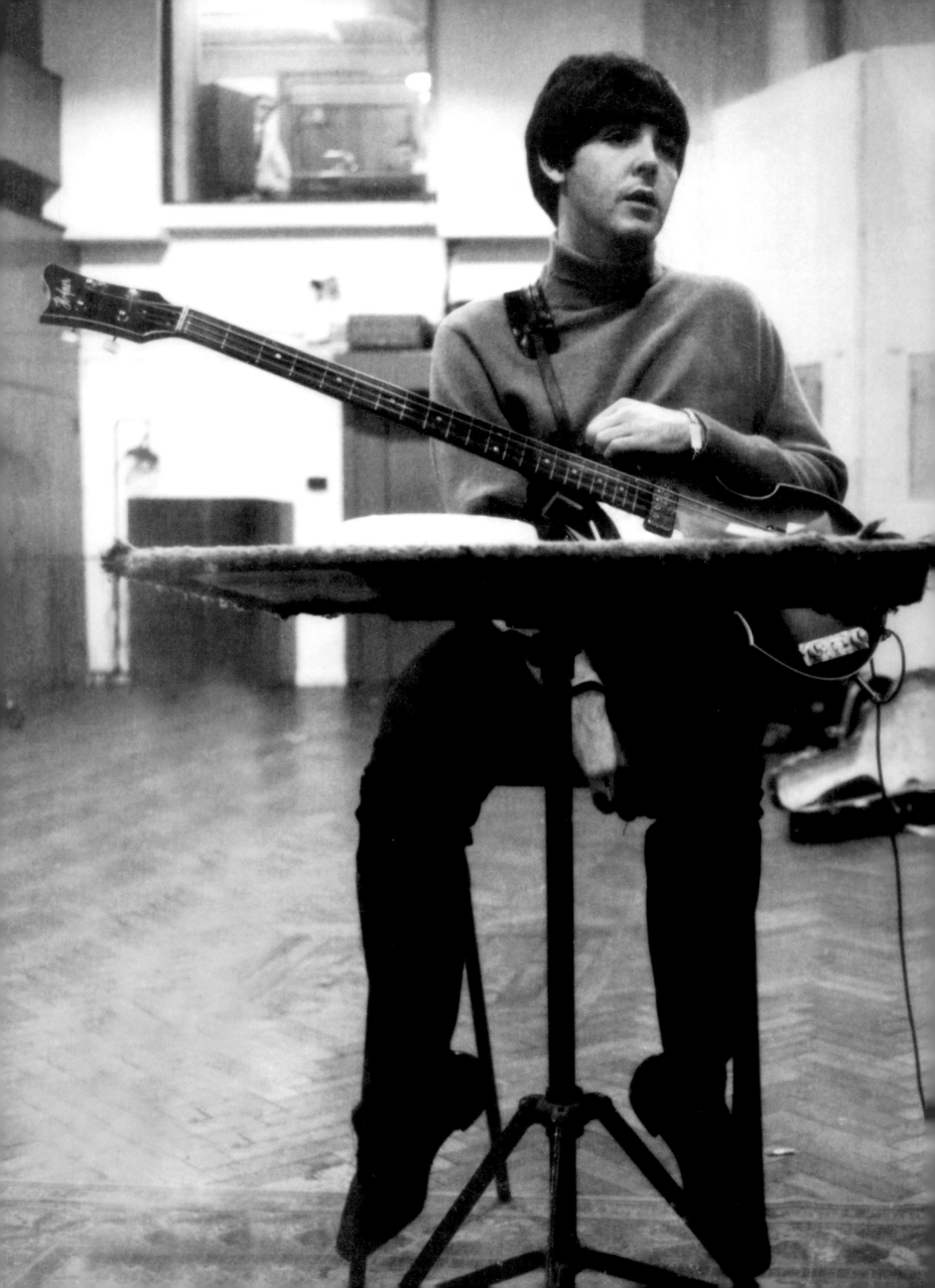

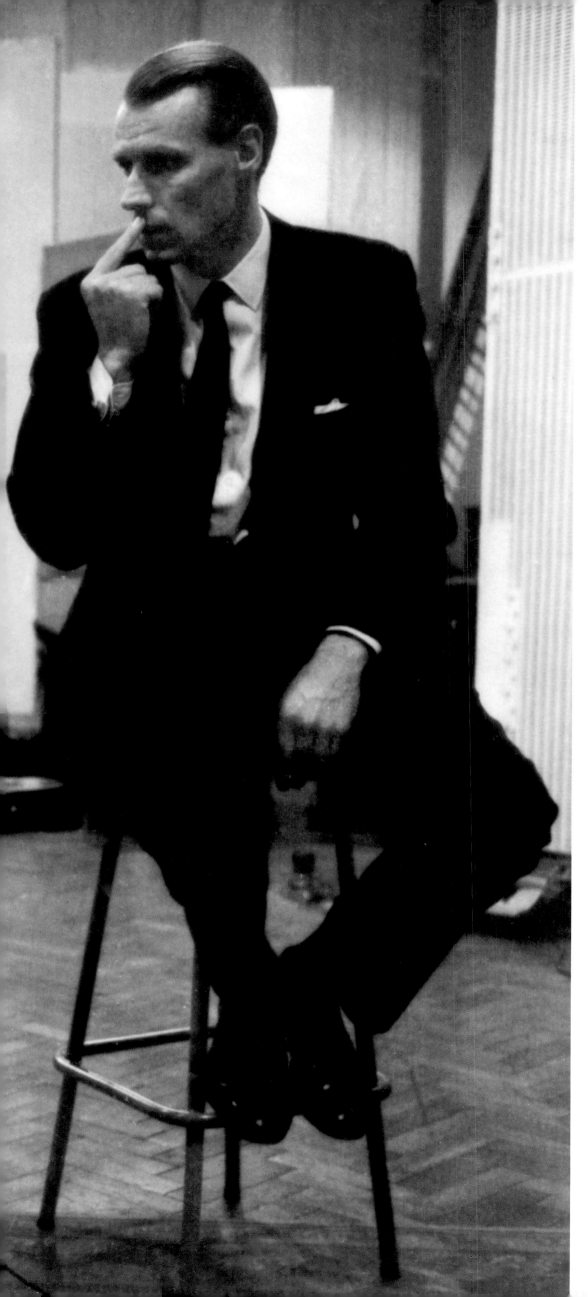

THE PICTURES on the following pages, including this one in which producer George Martin and Paul McCartney confer, were shot at the now legendary EMI Studios at 3 Abbey Road in the northwest London neighborhood of St. John's Wood. The story is rather lovely: In November 1931, this was a Georgian townhouse in the crowded city that was not "purpose built" but was converted for a new use: in this case, as a recording venue for the Gramophone Company. One of its reconfigured rooms could, and did, accommodate full orchestras. Beginning in 1962, when the Beatles and Martin began their work together, almost all of the band's music was waxed here. The Beatles would come and go—arrive as they might when they were hardly speaking to one another during the White Album sessions—and their last-recorded (and wonderful) album was of course named, fondly and nostalgically, *Abbey Road* and featured the cover shot of the Beatles proceeding in lockstep across the pedestrian zebra crossing outside the studio. Whitaker did not take that photograph; by then, his three-year association with Brian Epstein and NEMS had ended. And therefore he is not responsible for the thousands of tourist *Abbey Road* tribute photos that are yearly sent by iPhones or that grace customized Christmas cards each December: "Hey! We went to London this year, and here are the four of us . . ." A few final notes: In 1970 the EMI studio was renamed, officially, Abbey Road, because . . . well, you know; it has recently been preserved from redevelopment because . . . well, you know; the zebra crossing was moved to a new nearby location about 30 years ago because of traffic patterns, and so all those tourist pix are inauthentic; and Paul is not dead, despite being barefoot on the album cover.

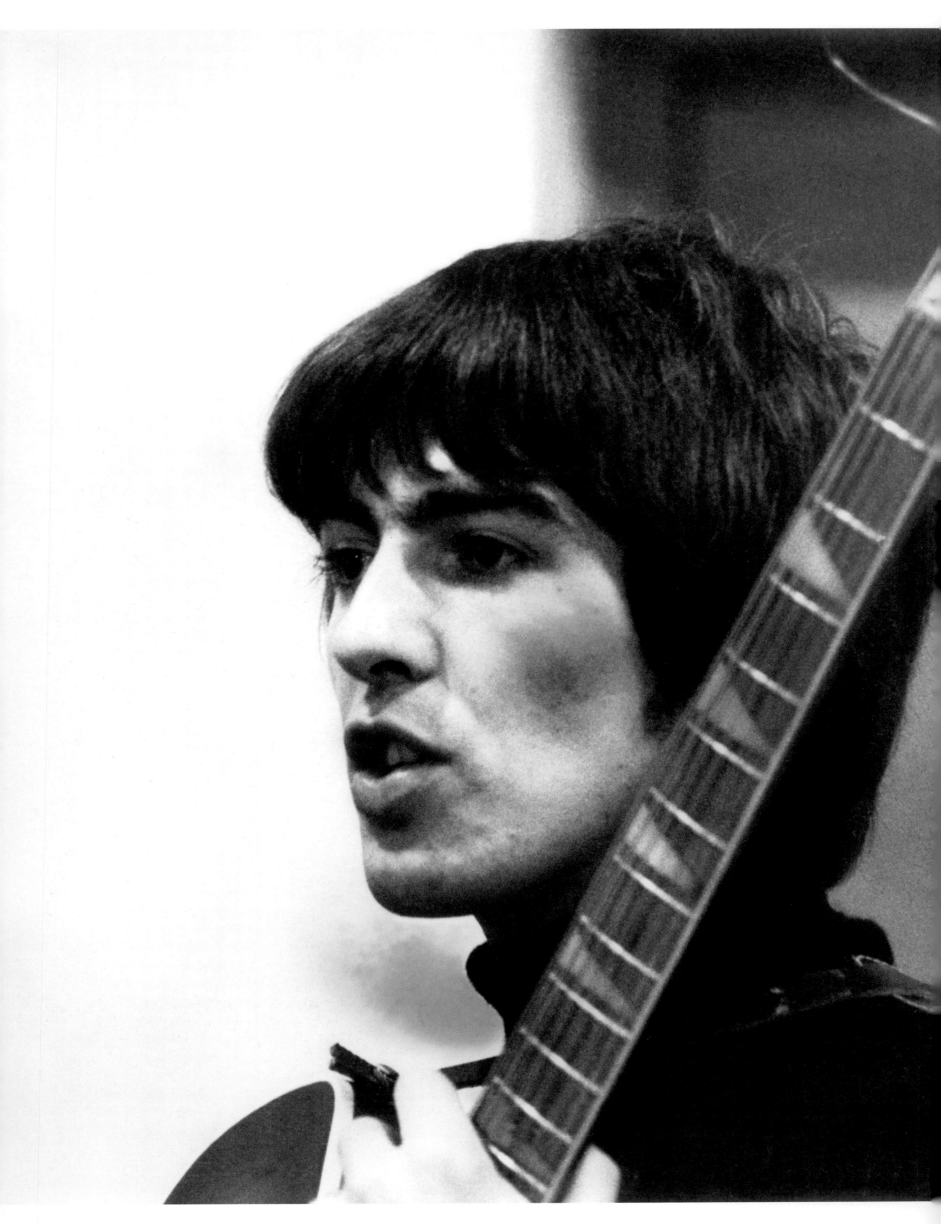

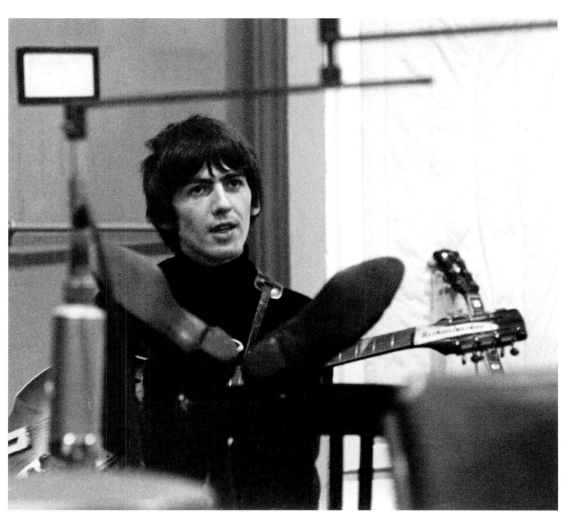

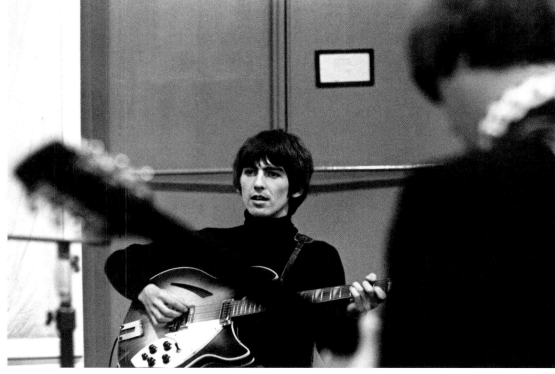

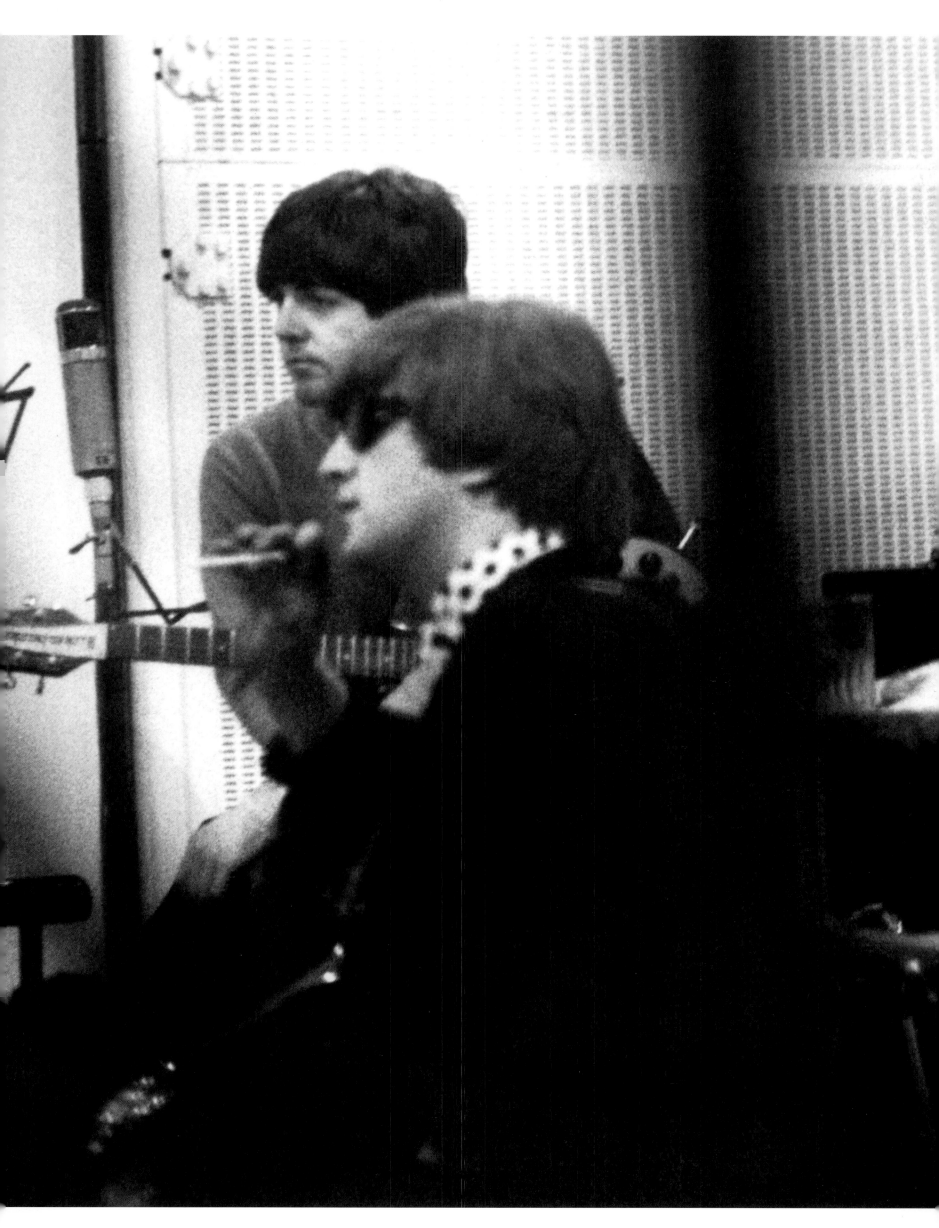

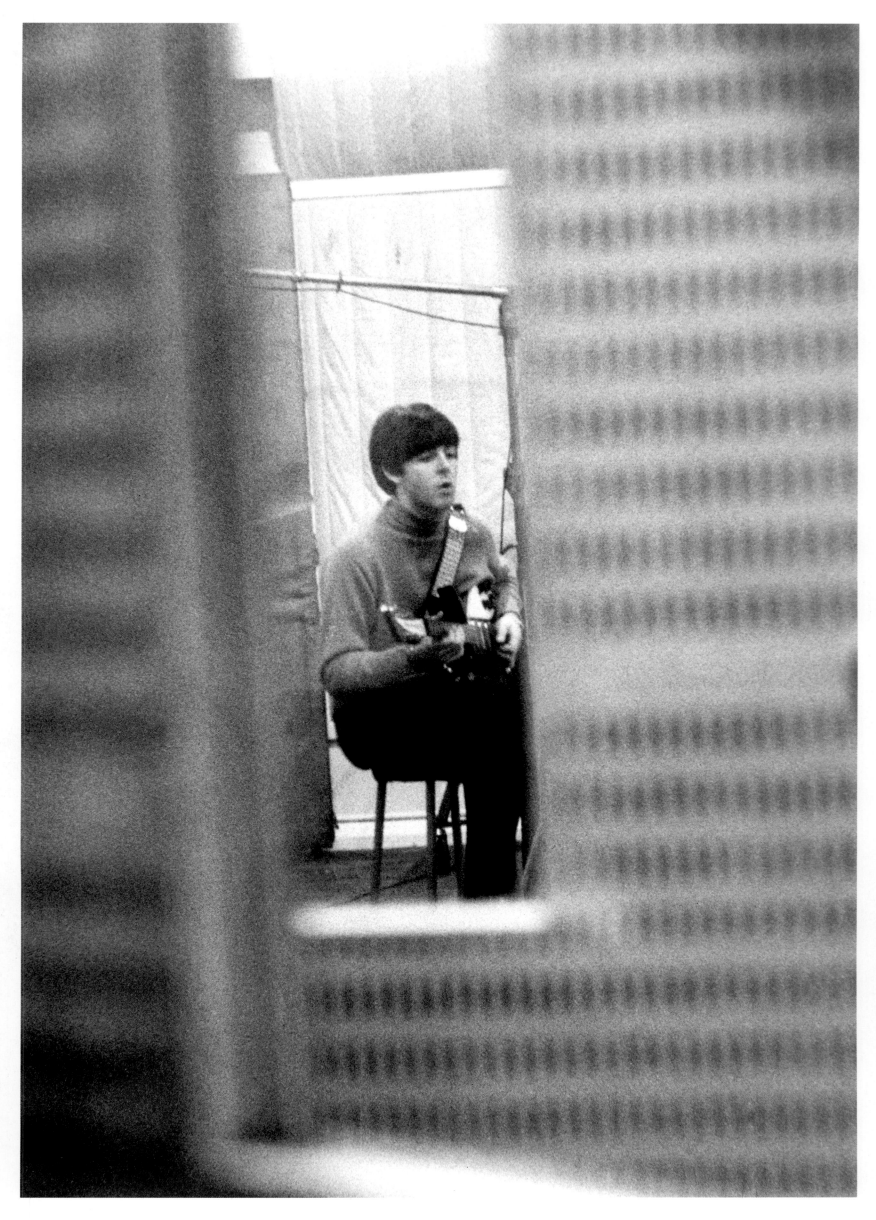

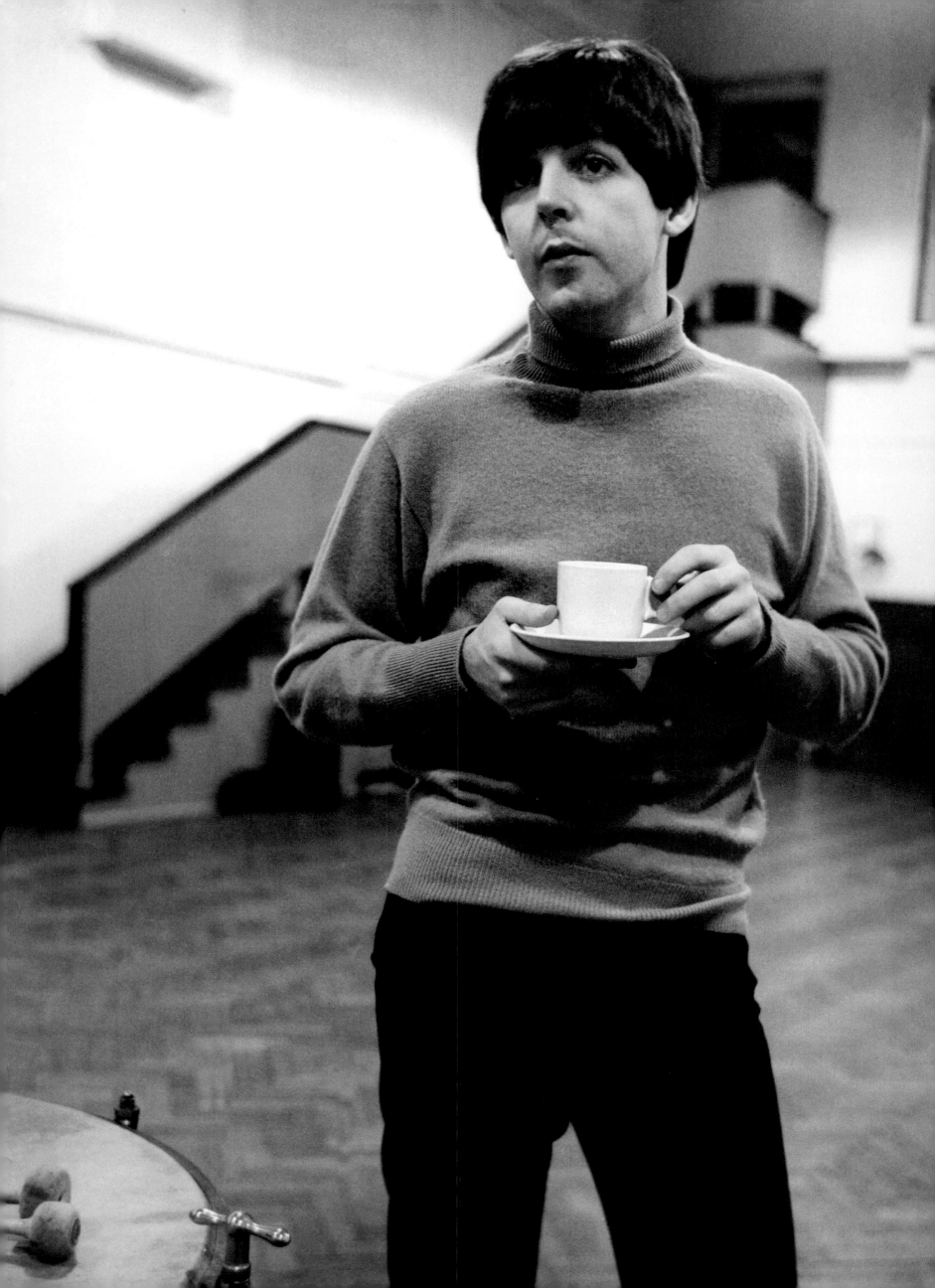

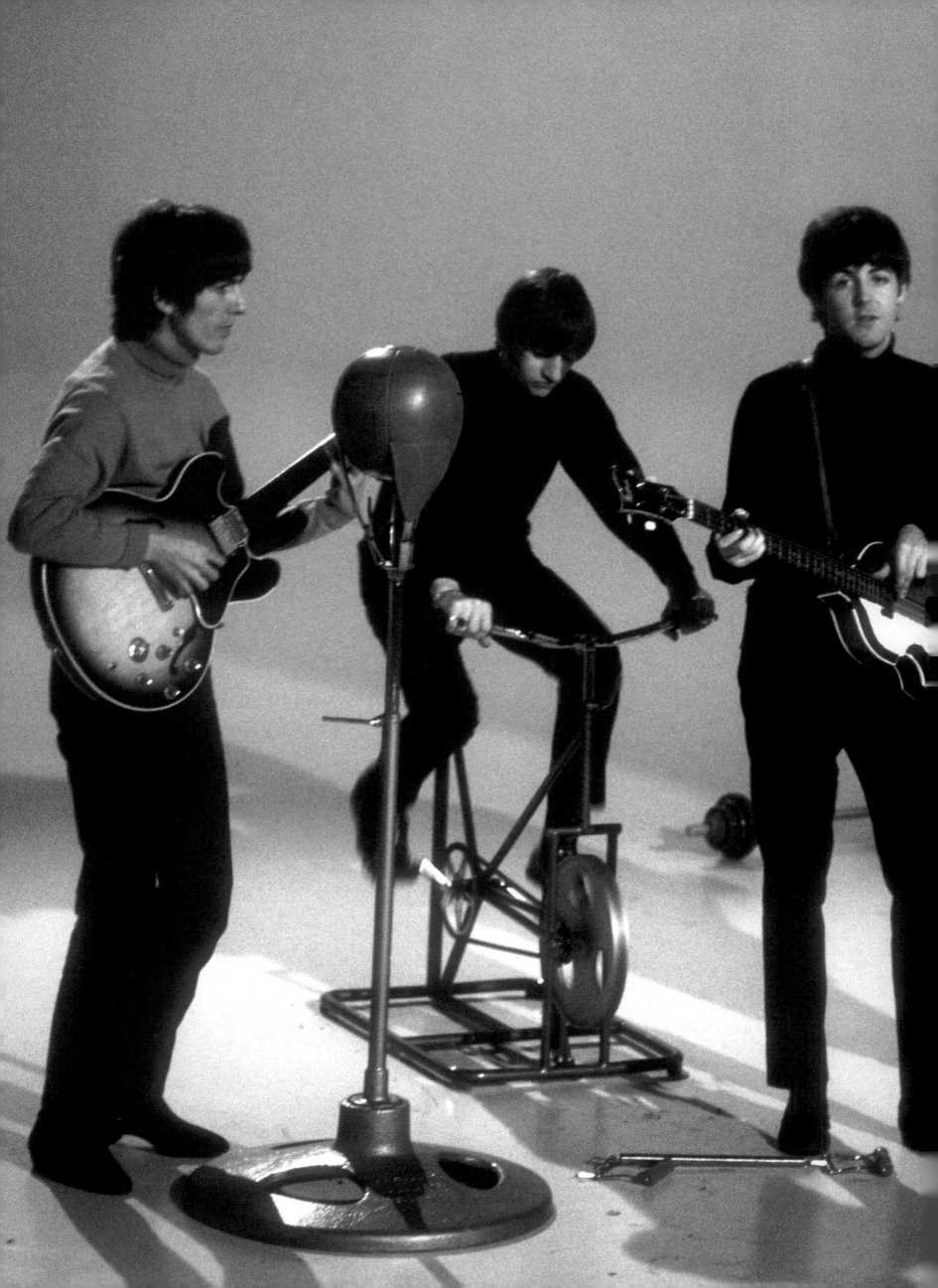

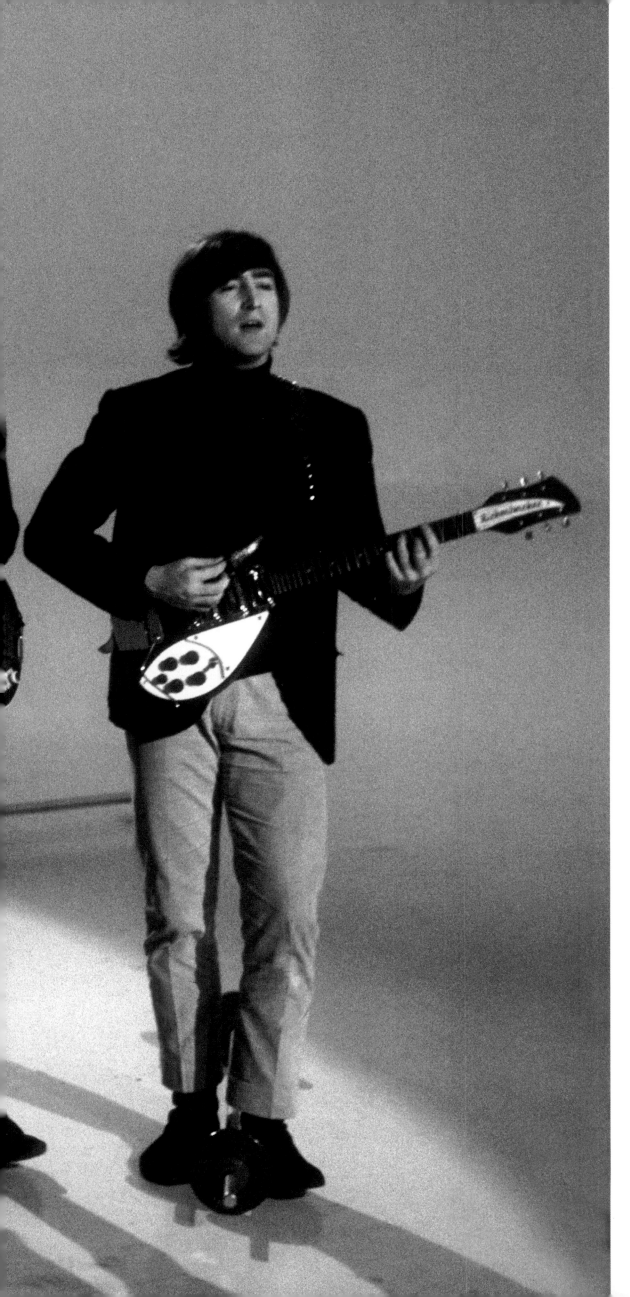

HERE AND on the following two pages the foursome do some light lifting, lip-synching the landmark single "I Feel Fine." John intentionally created feedback from his amplifier at the start of the record, a technique future rock musicians would employ over and over, seldom as well, never as memorably. John, not shy about bragging, later told *Rolling Stone* magazine, "I defy anybody to find a record—unless it's some old blues record in 1922—that uses feedback that way. I claim it for the Beatles." We'll give it to him. On the American charts, "I Feel Fine" started a string of six No. 1 songs in a row for the band, which was then unprecedented. Whitney Houston eventually racked up seven.

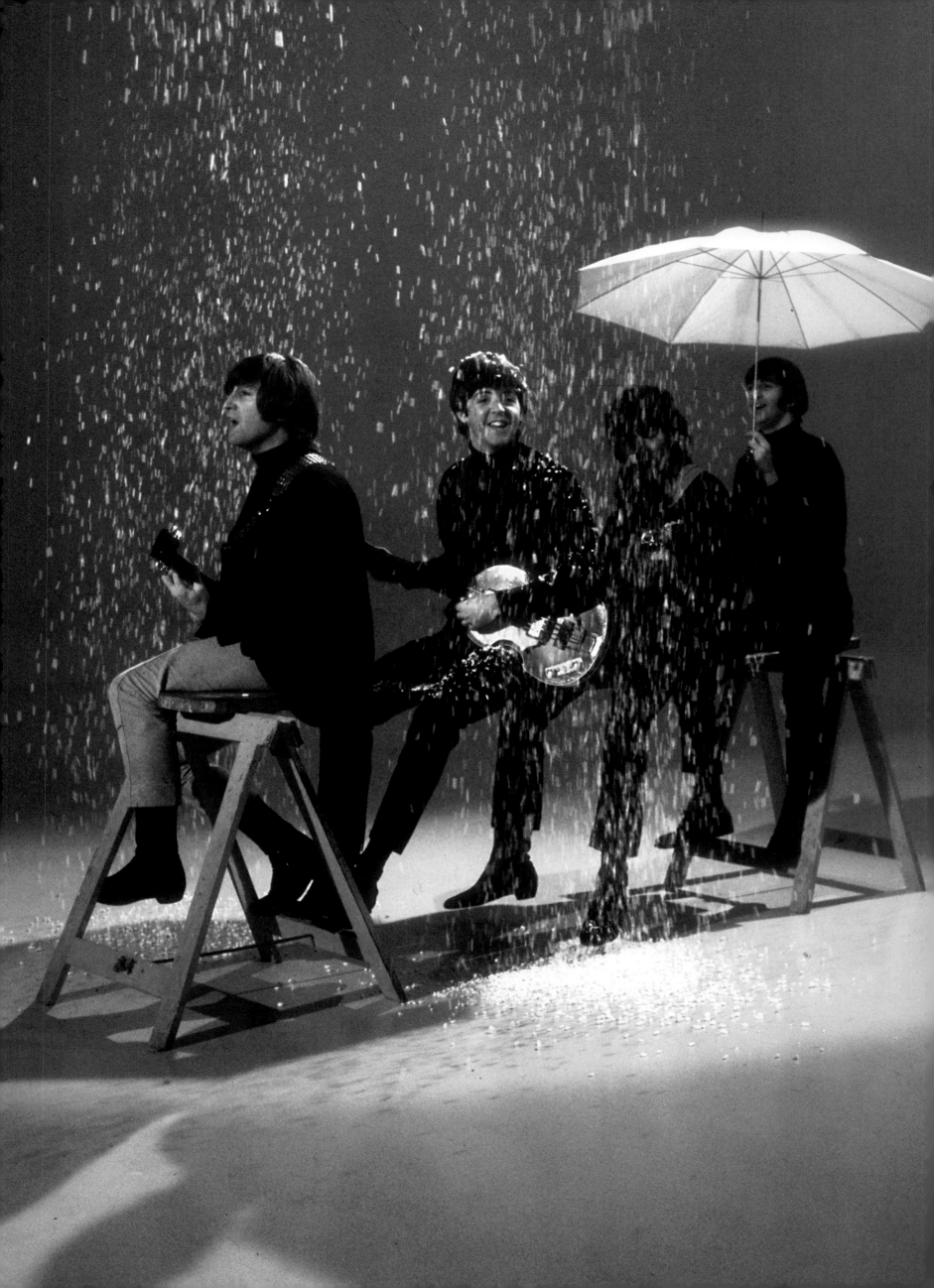

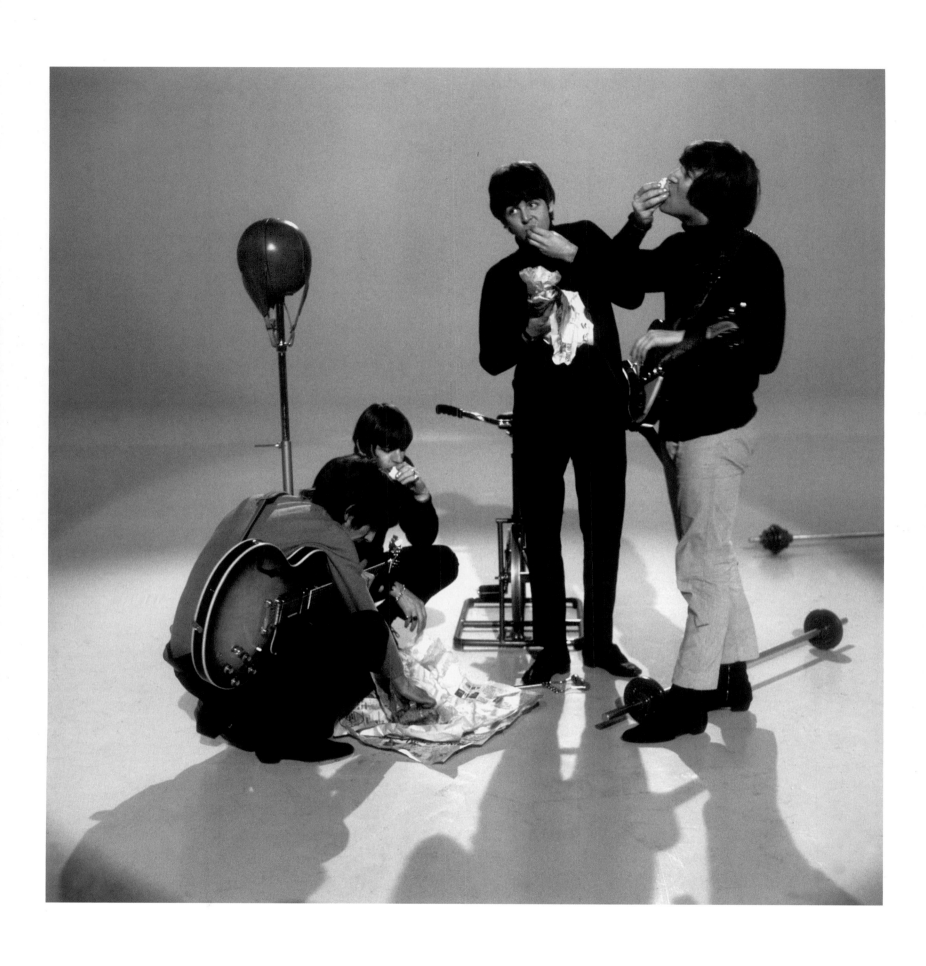

HERE AND on the next page, Whitaker's candid studio shots capture the calmer moments where not a trace of Beatlemania intrudes. All of the band members said they found solace at EMI, and when they chose to retreat from touring altogether after the August 29, 1966, concert at San Francisco's Candlestick Park, 3 Abbey Road became, even more, their shared if sometimes fractious home.

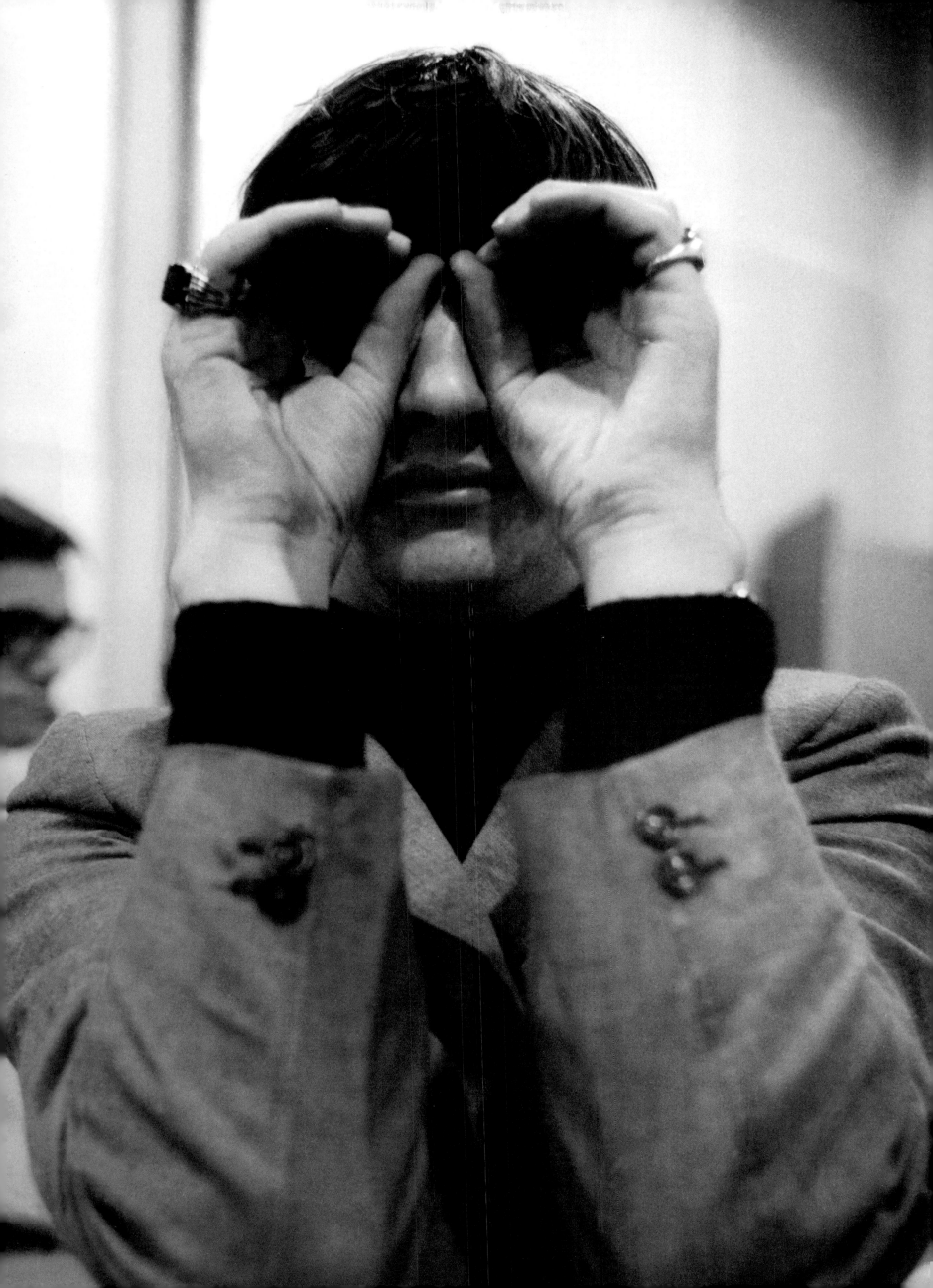

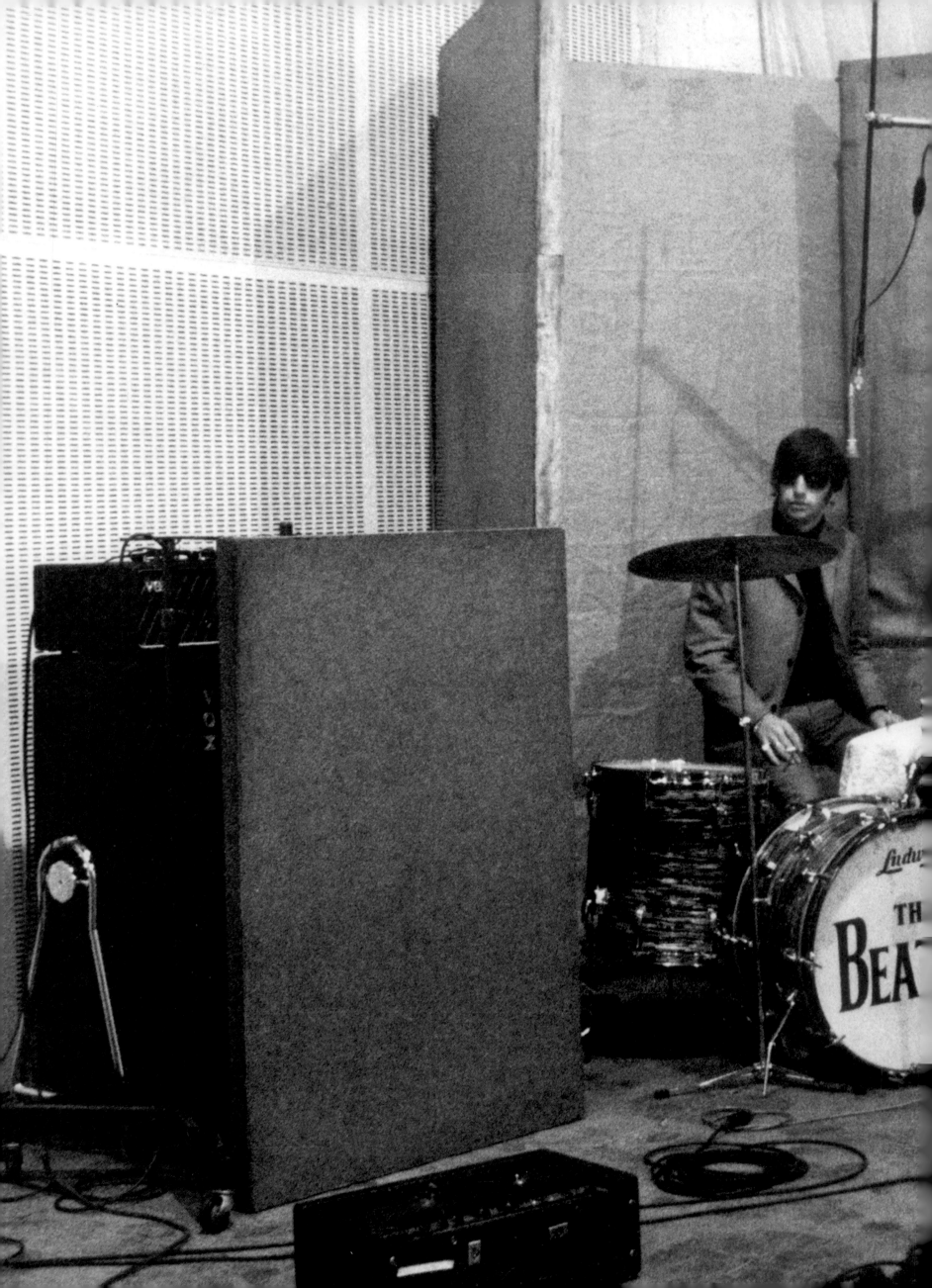

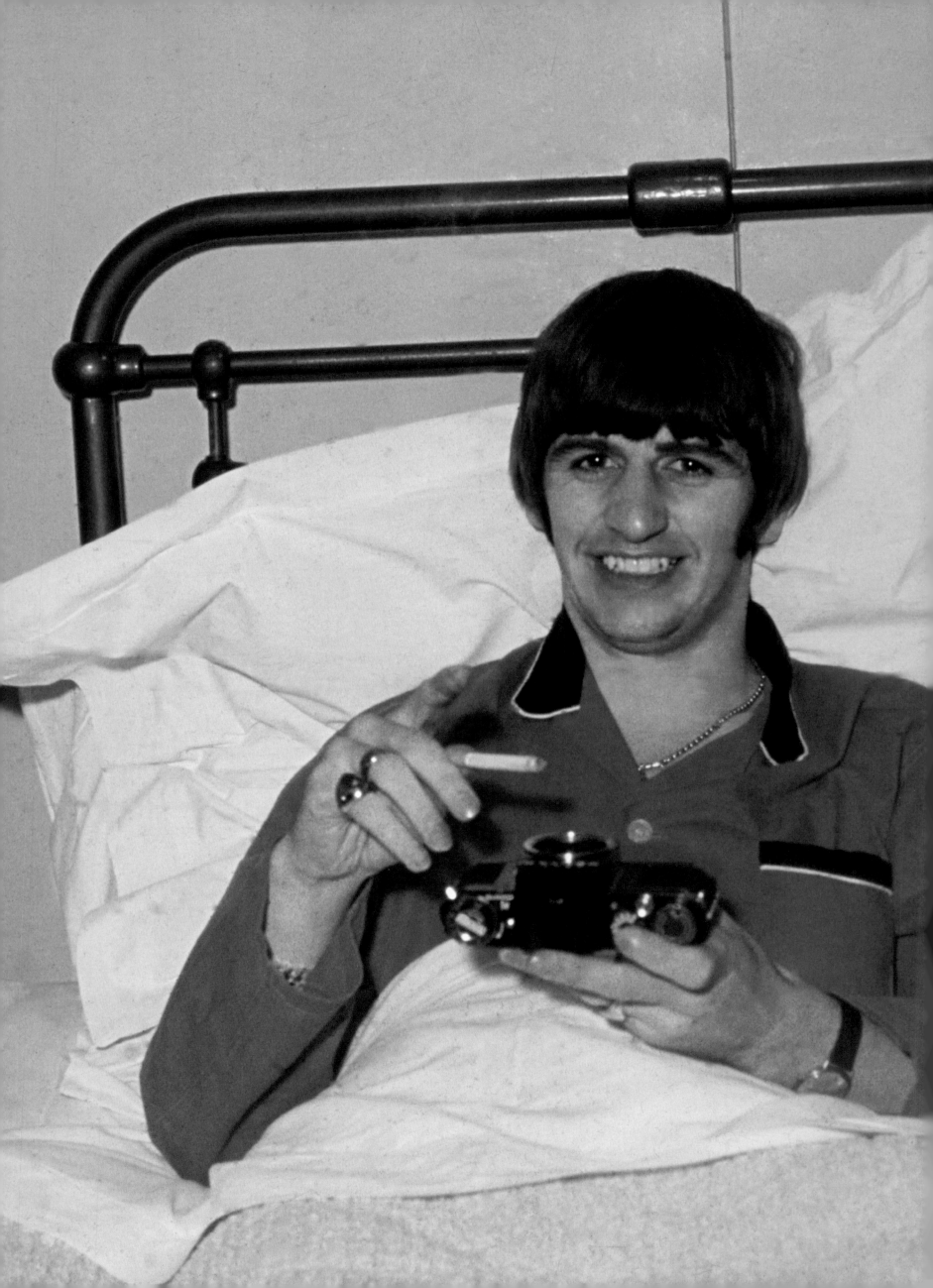

RINGO MISSED some of the Christmas Show rehearsals (lucky bloke!) when he was hospitalized for removal of his tonsils, an episode that of course caused paroxysms in Beatle Nation. Interestingly, Ringo was also laid low at the start of the band's Australian tour (when Brian Epstein met and hired our photographer Robert Whitaker) and had been replaced by drummer Jimmy Nicol. He had been, at the time, fearful that he would simply be replaced in the band: Last one in, first one out, as the rule goes. But the other three liked Ringo a lot, enjoyed his company, and he was talented. So in 1964 and certainly in '65, there was little question which four the Fab Four were. Having said that, if—as we mentioned—tonsil problems had to hit one of them, better Ringo, least of the singers. He hardly dealt with his ailment sensibly, sneaking a ciggy with a makeshift ashtray. On the next four pages he gets a visit from Dr. George, his best mate in the band, and then from his mum.

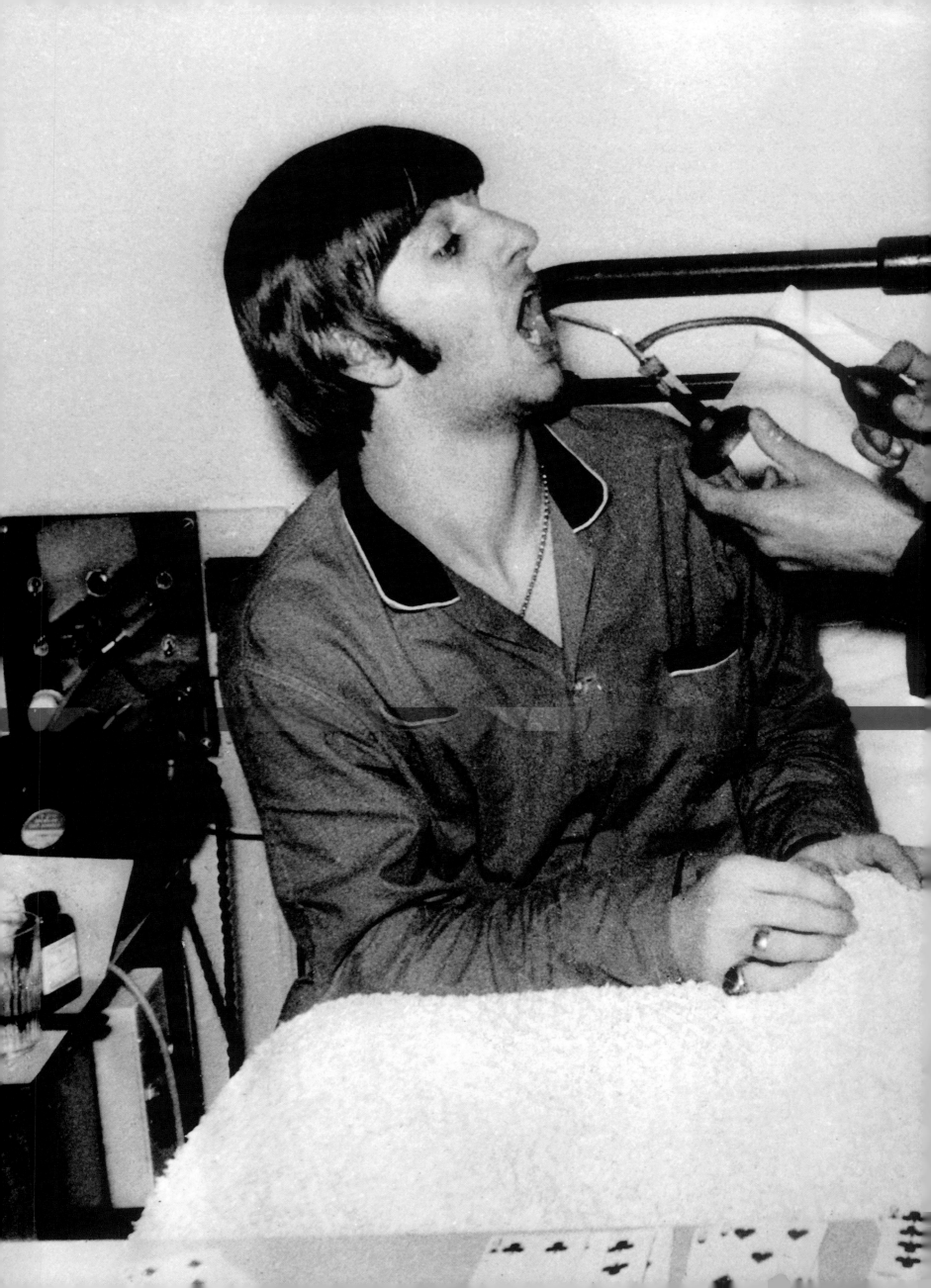

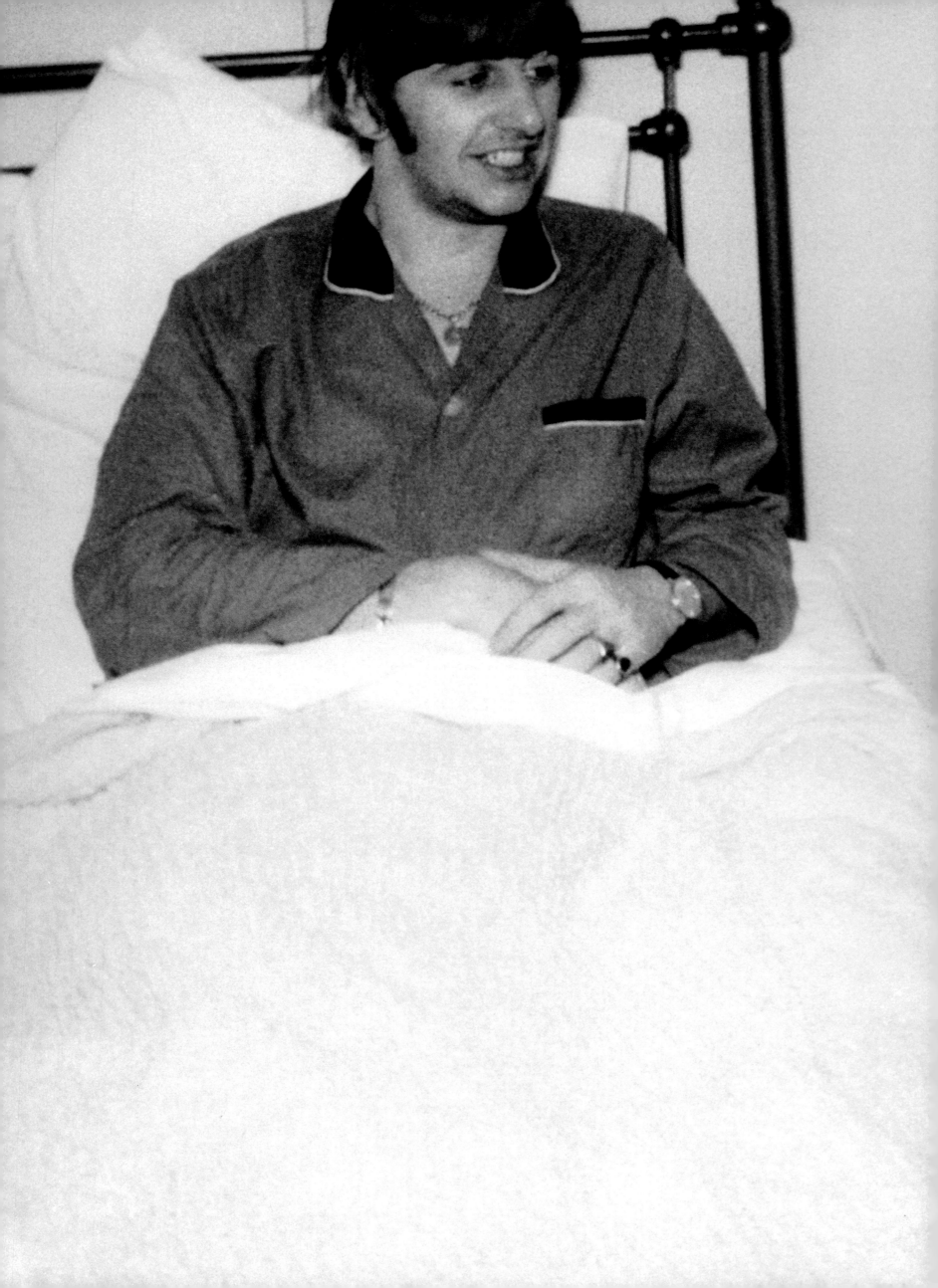

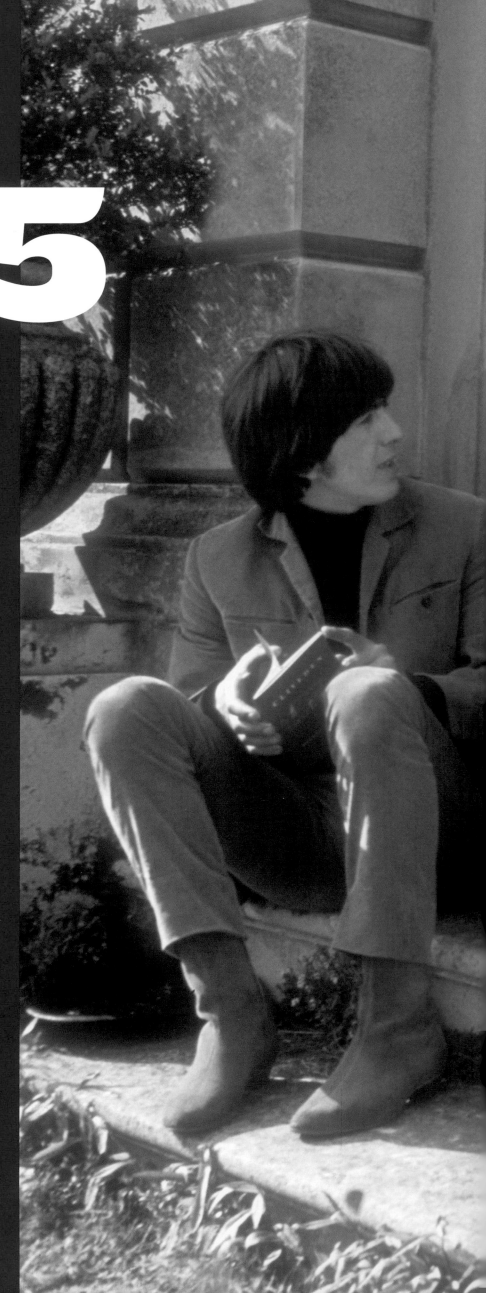

1965

When the four were fab, they were also constantly in focus.

BACK IN THE U.K. After shooting scenes in the Bahamas and Austria for the corny comedy-adventure movie *Help!*, the boys are at Cliveden for more filming. Director Richard Lester has a tough act to follow, given the success of his previous Beatles' film, *A Hard Day's Night*. His sophomore effort with the band is not quite as good, but it is in, as they say, "living color" and is a second solid hit.

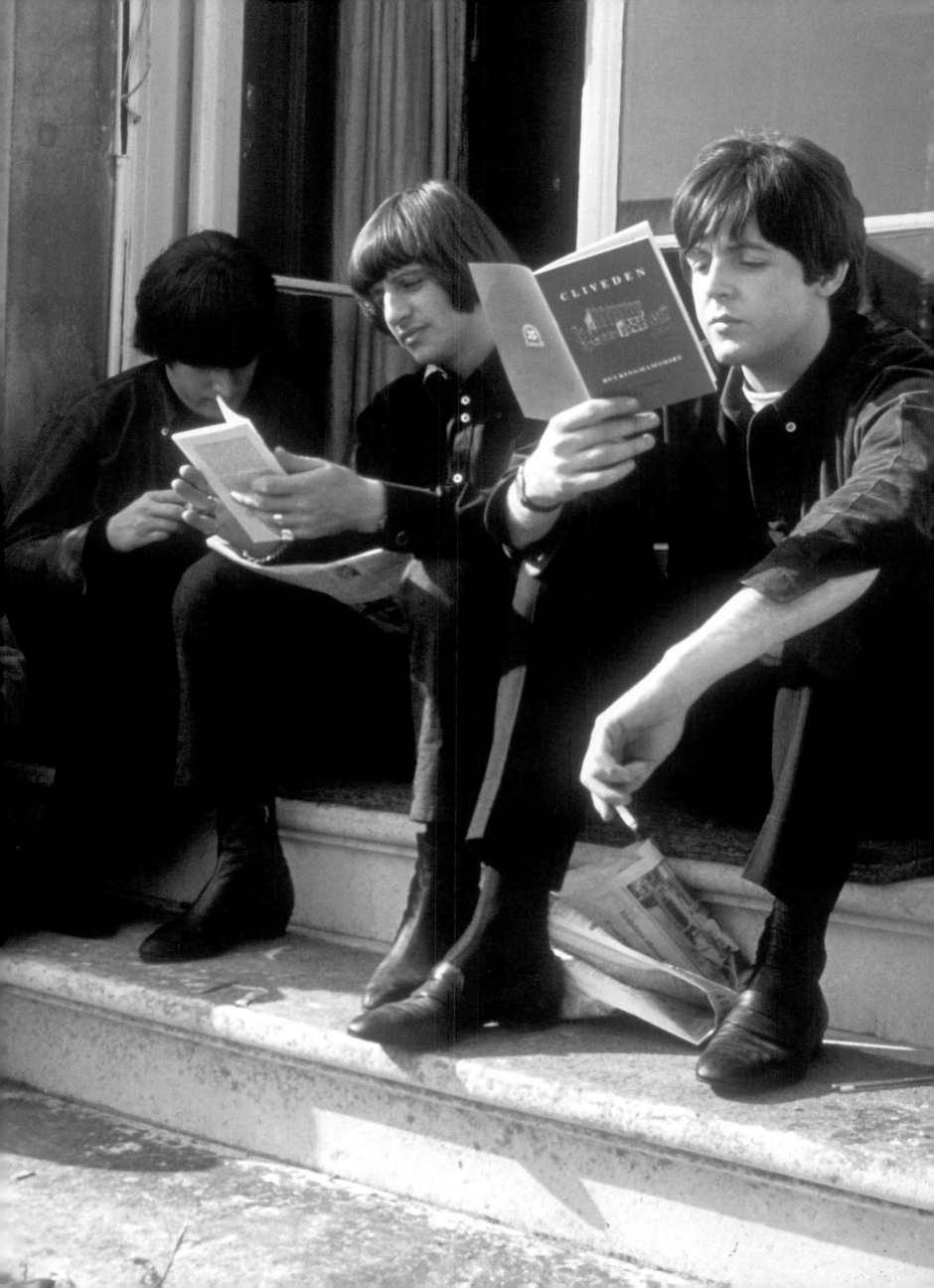

What a whoosh that was! Nineteen-sixty-four went by in an eye-blink. Subsequent years—1968, for instance—would take far longer. But in America, 1964 came and went. Whoosh.

It started with JFK on everyone's mind, of course, and then in February the Beatles appeared on Ed Sullivan's show and, seemingly overnight, the focus shifted from the adult, World War II generation to their children's generation. Vietnam became more of an issue. The times were changing and very quickly. The oldsters on television—Dean Martin and such—started to stumble and look foolish. The Beatles defined everything that was happening. With each new album cover, teenaged boys' hair around the world would grow another inch or two. Dress codes in American public high schools had to deal with a new issue: Girls' skirts, informed by the latest Carnaby Street styles, all but evaporated.

Bob Whitaker certainly did not worry about the minutiae of the issues. He was clicking away, chronicling the band—doing his job—and, thereby, building a record of an important moment in time. He was also, now, on the road with the lads. Surely this was exciting, but it was also harrowing. George Harrison in particular grew terrified of the intensity of the Beatles' fandom, and at certain stops along the way—Shea Stadium in Queens, New York, and other venues in America—the cacophony was unsettling to all. It wasn't just that the songs could not be heard (no one, least of all the teenaged fans, seemed to care), it was: What violent thing might happen?

In the event, nothing did (not during a Beatles tour, anyway; of course there was the infamous deadly violence in the crowd during a Stones concert at Altamont Speedway in California). But almost as soon as the Beatles achieved the raucous celebrity they had ravenously sought, they wanted something else. Something somehow quieter—and perhaps even more important.

It is interesting to watch Whitaker's photography of the band evolve in 1965—certainly month by month, almost week by week. The five of them are in a collaborative relationship now (never more in evidence than in Bob's pictures of John and Cynthia at home), and they are asking their fans to go with them. They are starting to lead in a very willful way. They are still doing goofy things (they are designing the template for the Monkees, for sure, and you can tell in the shots of John and Paul during the filming of the '65 Christmas special how *pleased* they are about this), and they are also pushing, interestingly, against boundaries. They are changing the culture.

As Whitaker told LIFE, as is noted in our introduction, and as is evident in this next chapter, he grew close to John Lennon in this period. Meantime, he did become something of a Fifth Beatle. He was always in the room. And he always had a camera.

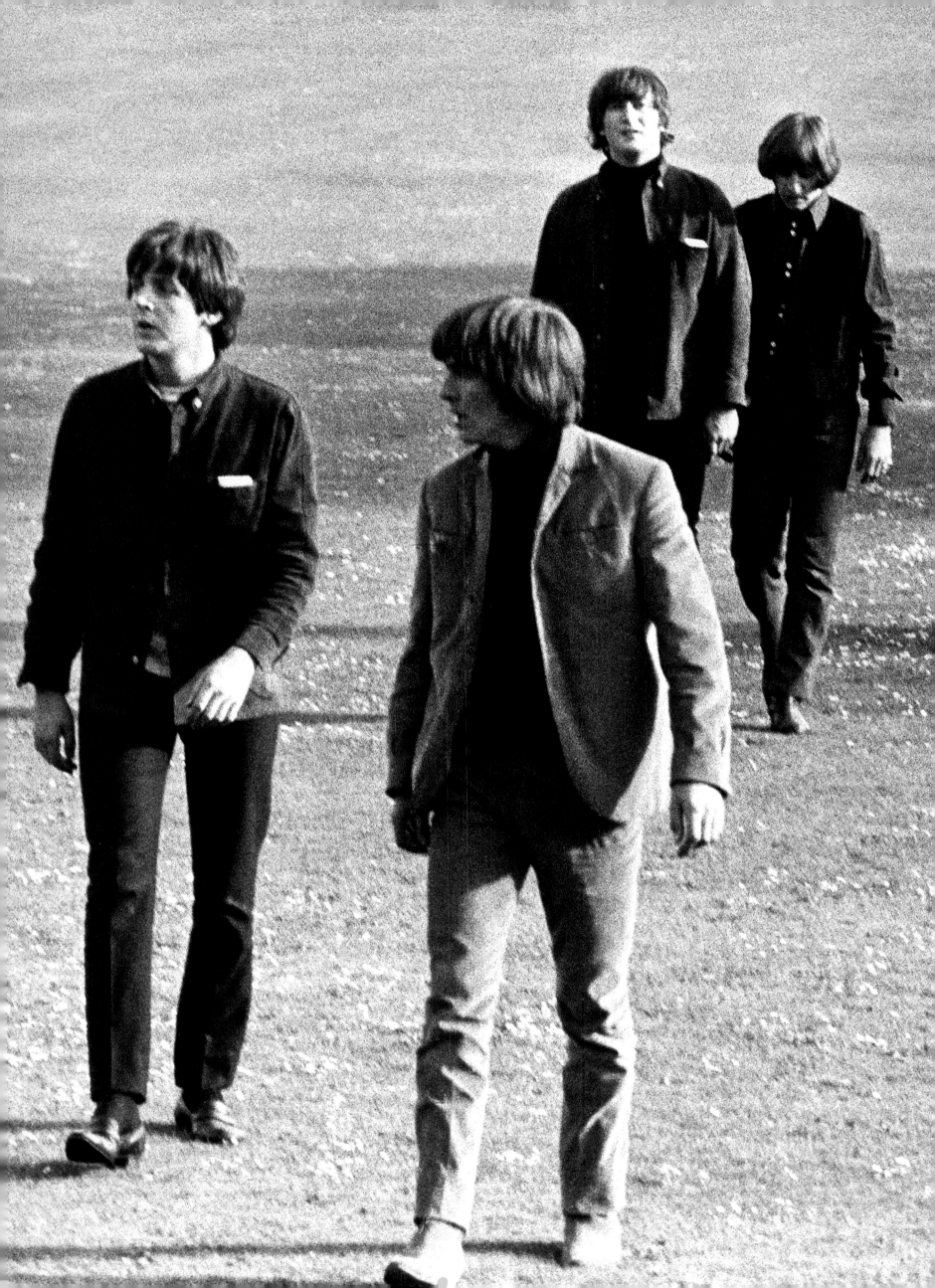

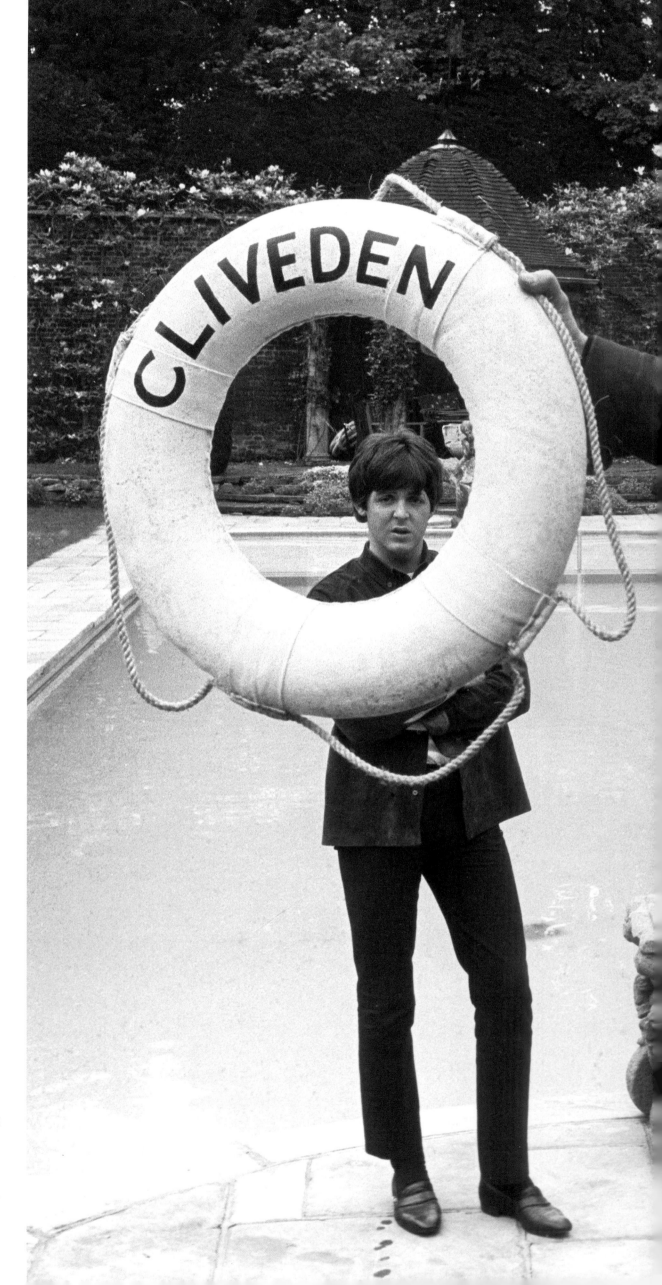

ON THIS AND the next page, the boys take a much-needed break from *Help!* From 1964 through 1966, when Whitaker was with the band, everything with the Beatles moved very, very fast: songs and albums produced constantly, tours arranged in an eye-blink, TV shows and specials piling up, and then— what say?—we knock off another movie.

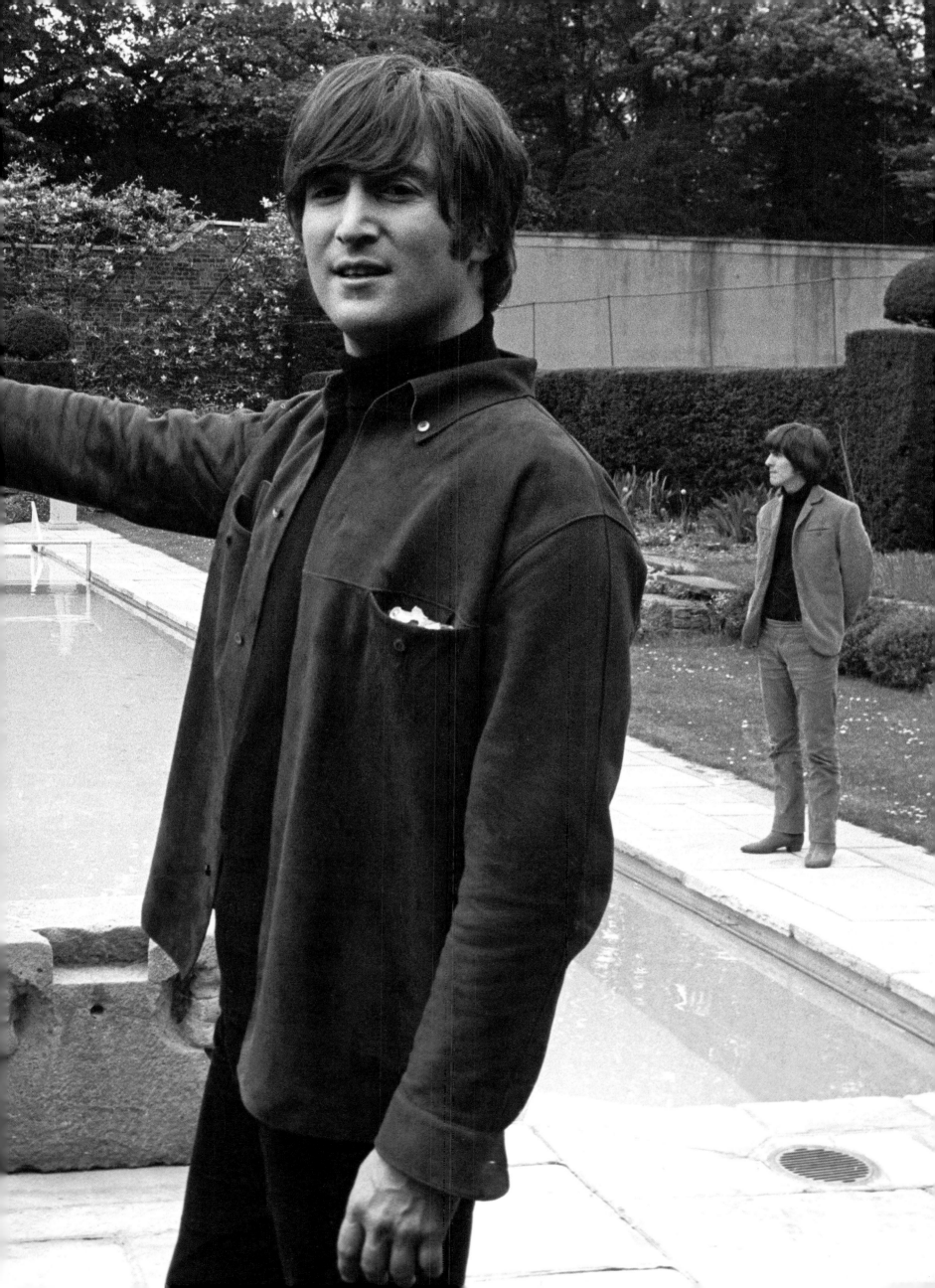

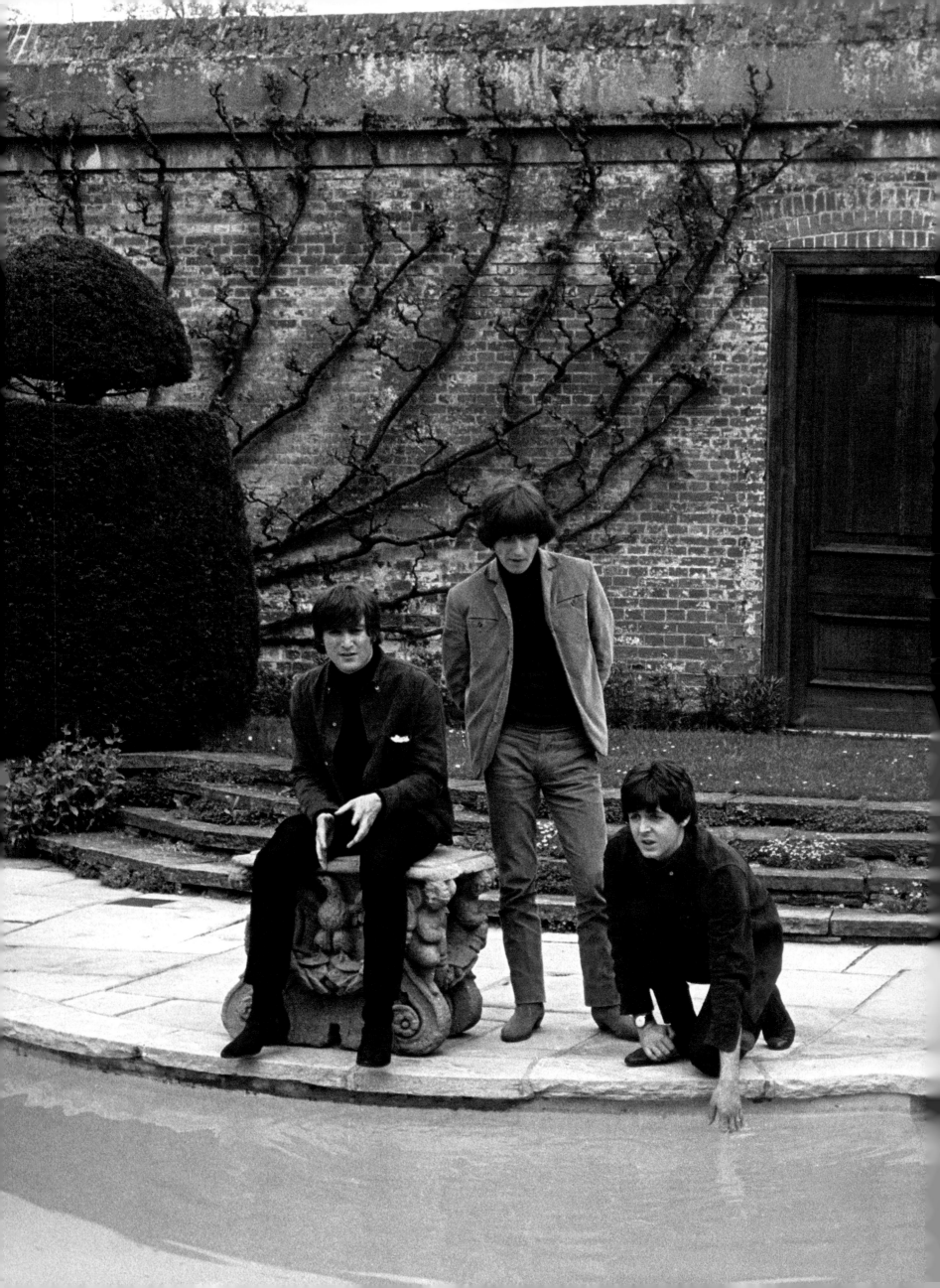

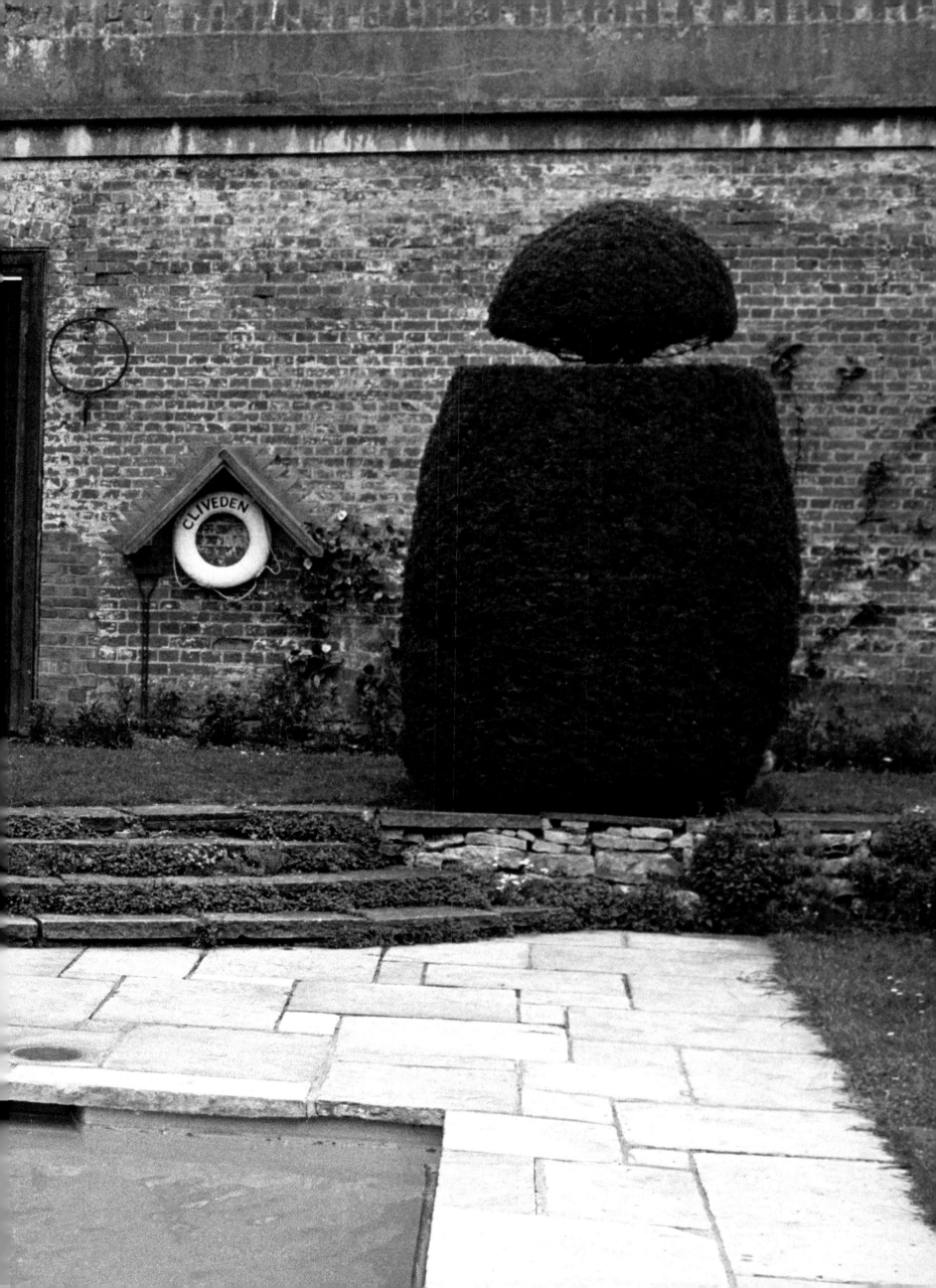

SOME "HELP!" TRIVIA:
(1) The palace scenes in and around famed Cliveden House were meant to substitute for the way-more-famed (and way-more-off-limits) Buckingham Palace. (2) During the filming, George's interest in Indian music and instruments was spawned when Indian musicians were brought in to supply some zippy chase music. (3) Paul claimed that *Help!* actress Eleanor Bron was the inspiration for the song title "Eleanor Rigby." (4) The scenes in the Bahamas were shot first, though they come at the end of the movie. From Neil Aspinall: "They couldn't get tanned because afterward they had to go to Europe to shoot scenes that would appear earlier in the movie. They always had to sit in the shade or wear hats." (5) John's performance on the title song was earnest in the extreme: crying out for help as the craziness of the Beatles and his own tumultuous personal life began to engulf him. He shredded his voice like he hadn't since "Money (That's What I Want)." On the following four pages, more from *Help!*

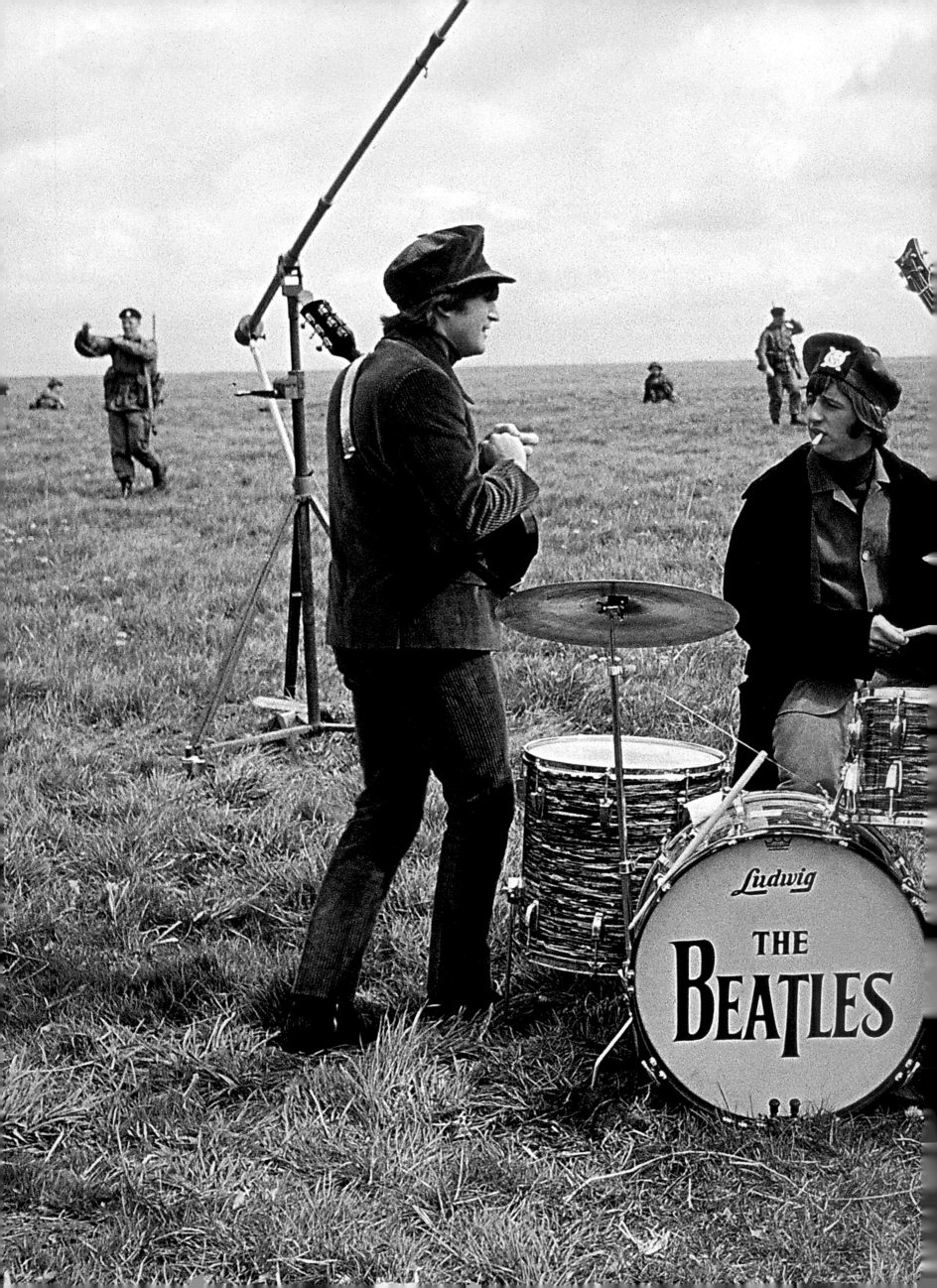

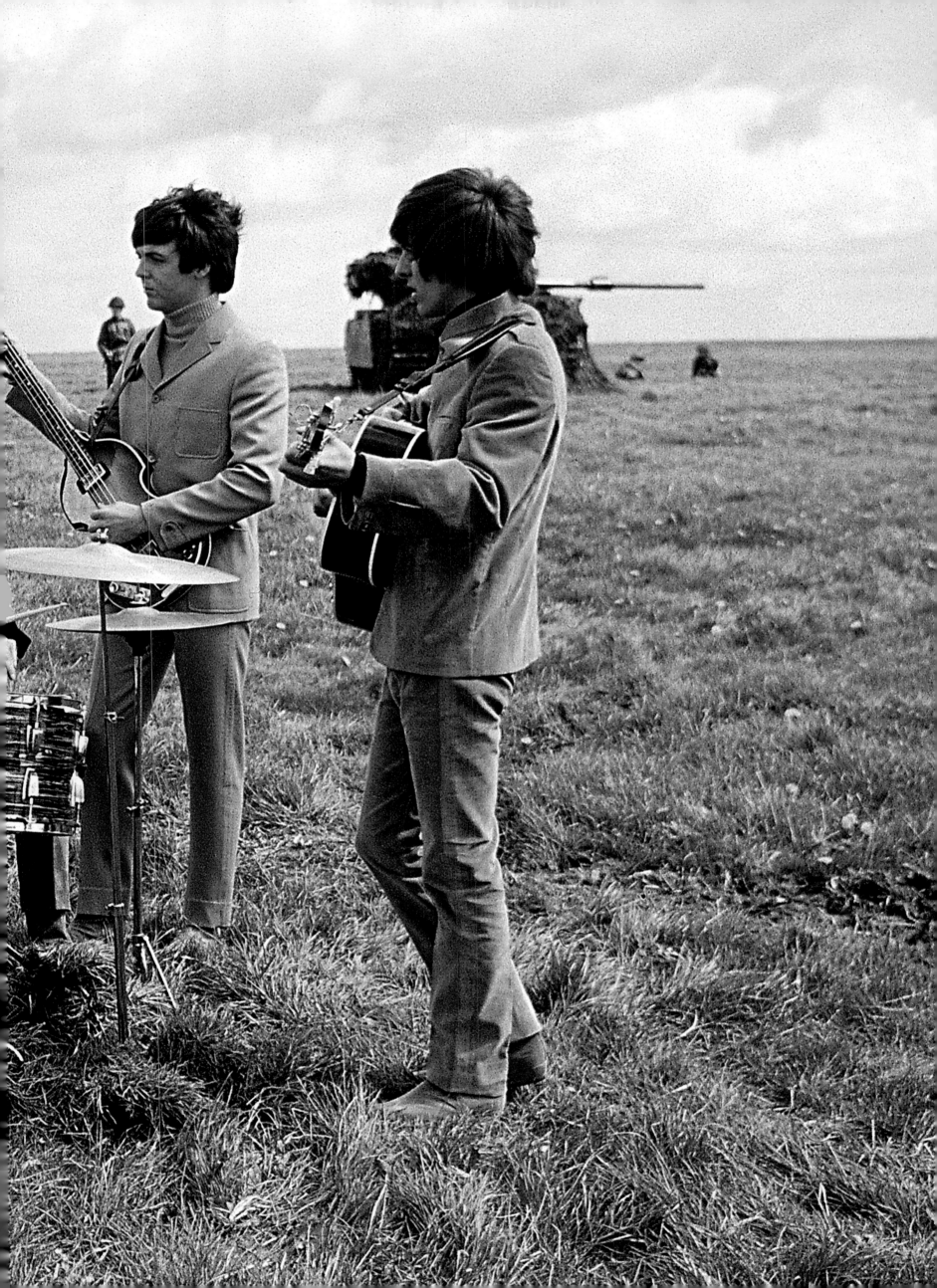

DURING BREAKS from *Help!*, Paul drove director Lester to distraction by repeatedly playing a song he was working on, called "Scrambled Eggs," anytime he was near a piano. The melody that had come to Paul seemed so fully fledged, he asked John, George and Ringo where or if they had heard it before—convinced he was plagiarizing. After *Help!* premiered, Paul sent Lester a copy of the record with a note: "I hope you like 'Scrambled Eggs.'" The song title had, in the interim, been ditched, and some simple, romantic lyrics written. It had become, famously, "Yesterday." It remains one of the two or three most covered songs ever.

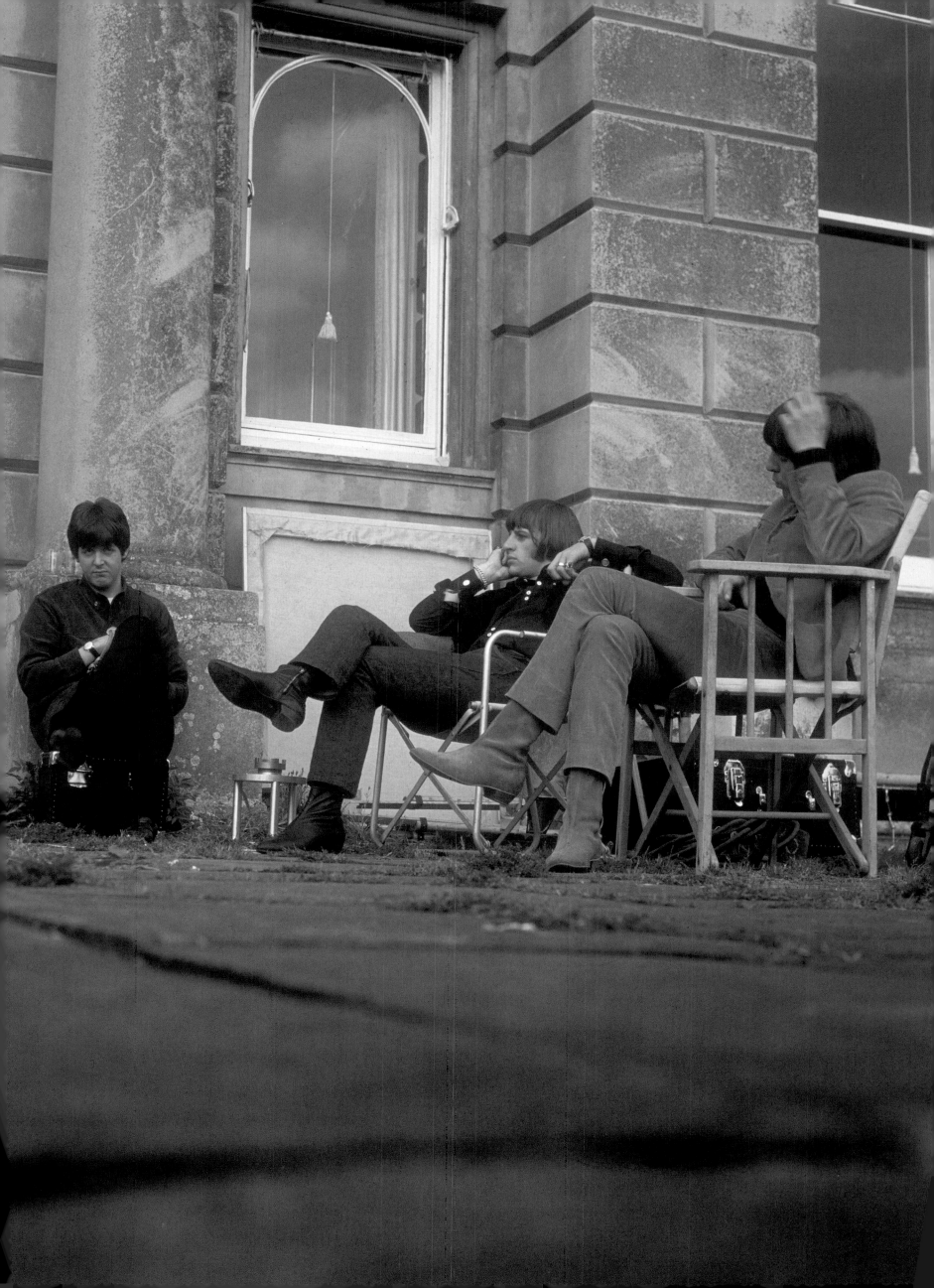

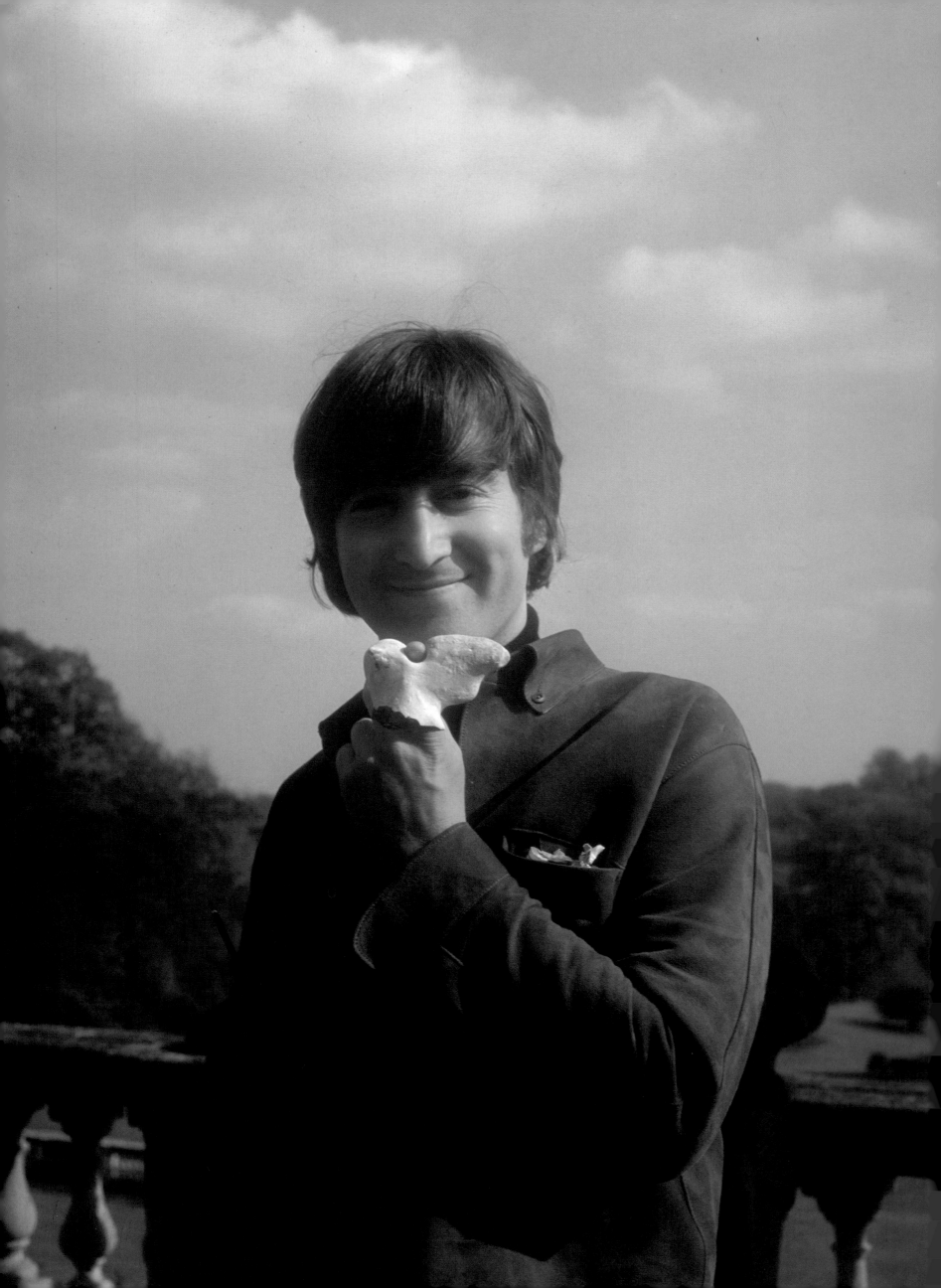

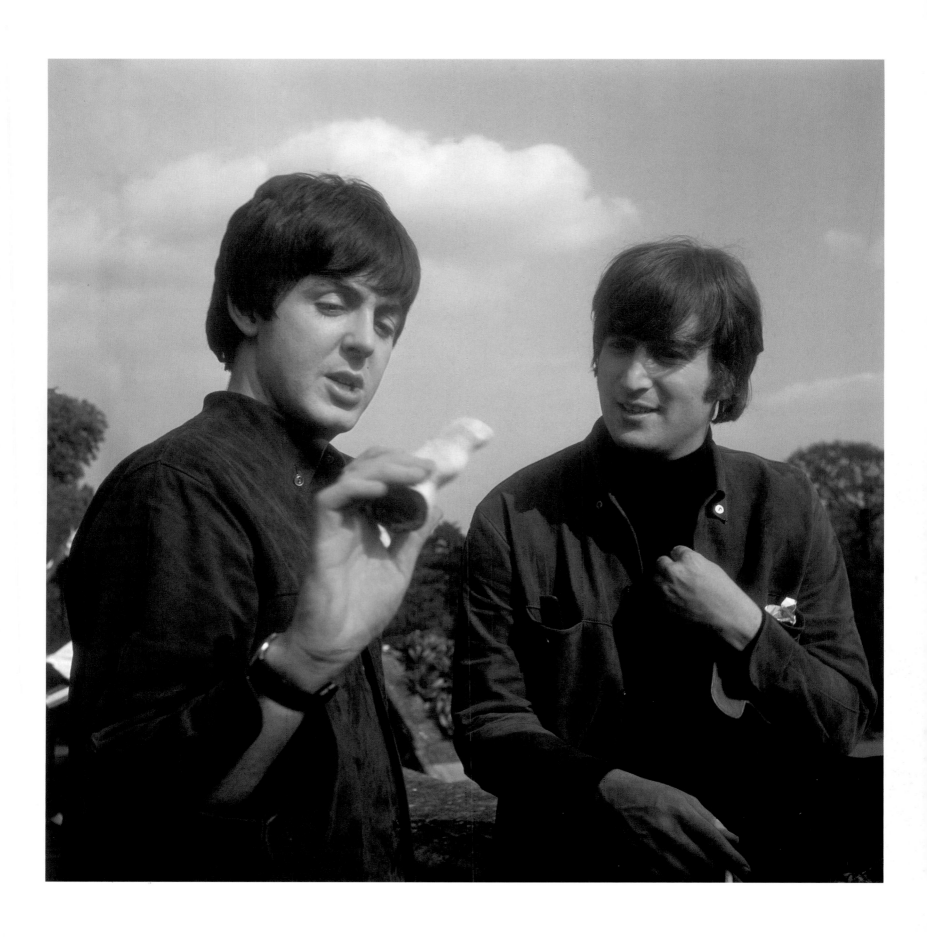

THIS PAGE and the several that follow feature photographs that were taken on the set (or behind the scenes) of *Help!* Even at this relatively early point, as all Beatlephiles well know, John and Paul were composing with ever-greater independence, and John had written the song "Help!" before the movie shoot began. The film originally had the working title *Eight Arms to Hold You*, believe it or not, but the song "Help!" seemed to fit the movie's storyline, such as it was. John's unenthused expression here seems to reflect the band's overall feelings about working on the movie—they were entering into their not-happy-campers phase. *Help!* would be their second and final scripted feature film. The documentary *Let It Be*, which wound up telling the story of the band's dissolve, would be sadder by much more than half.

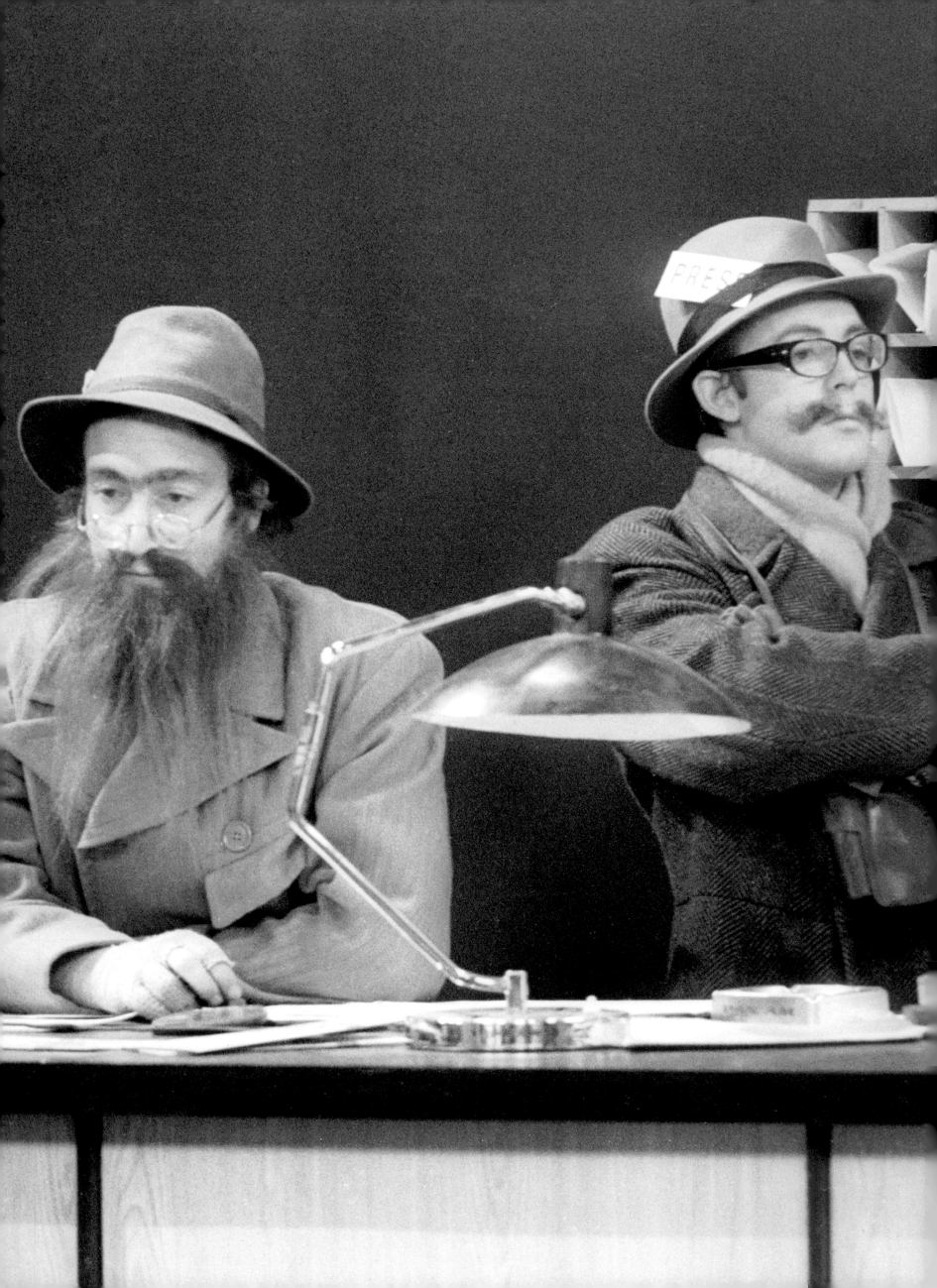

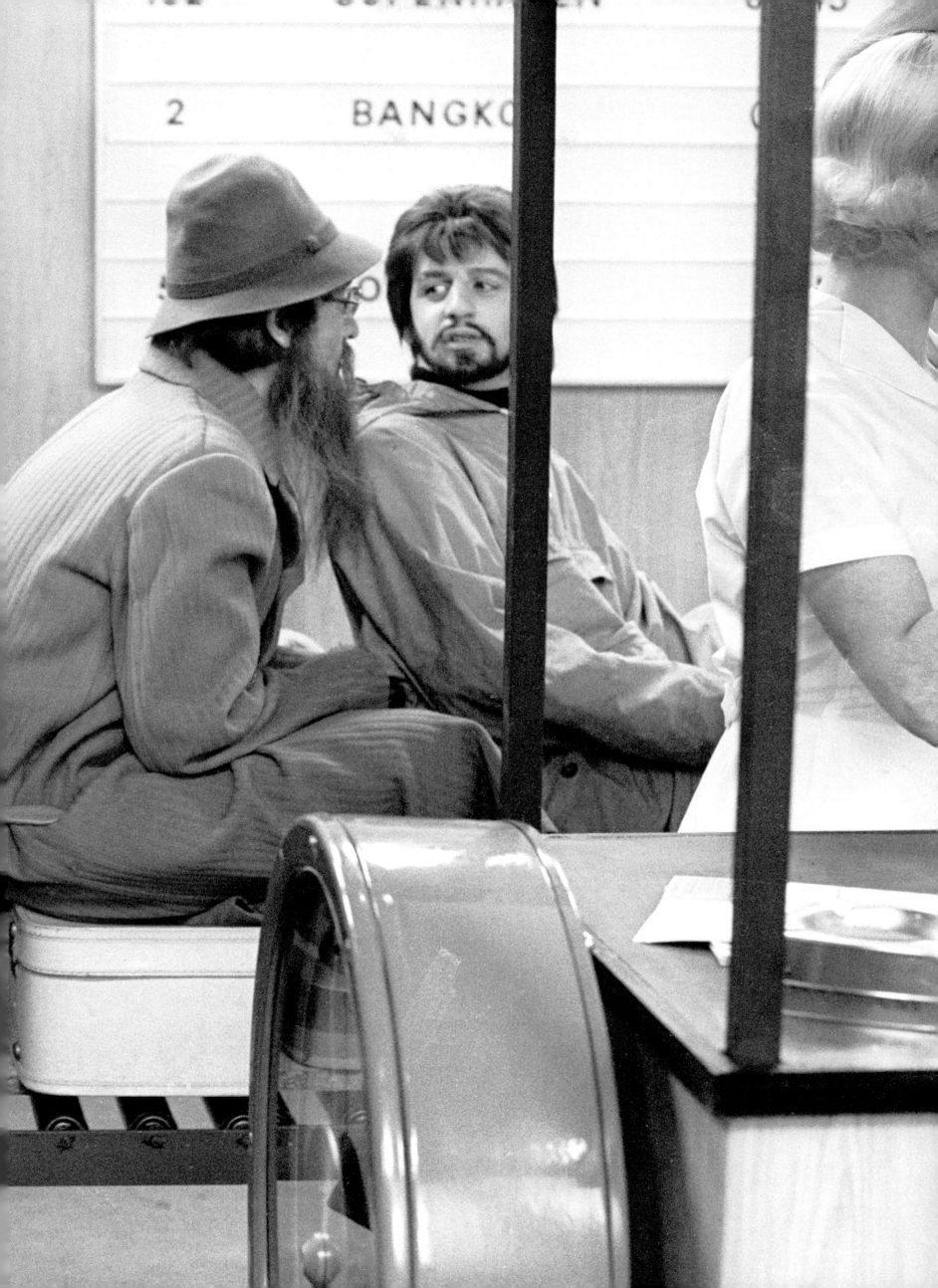

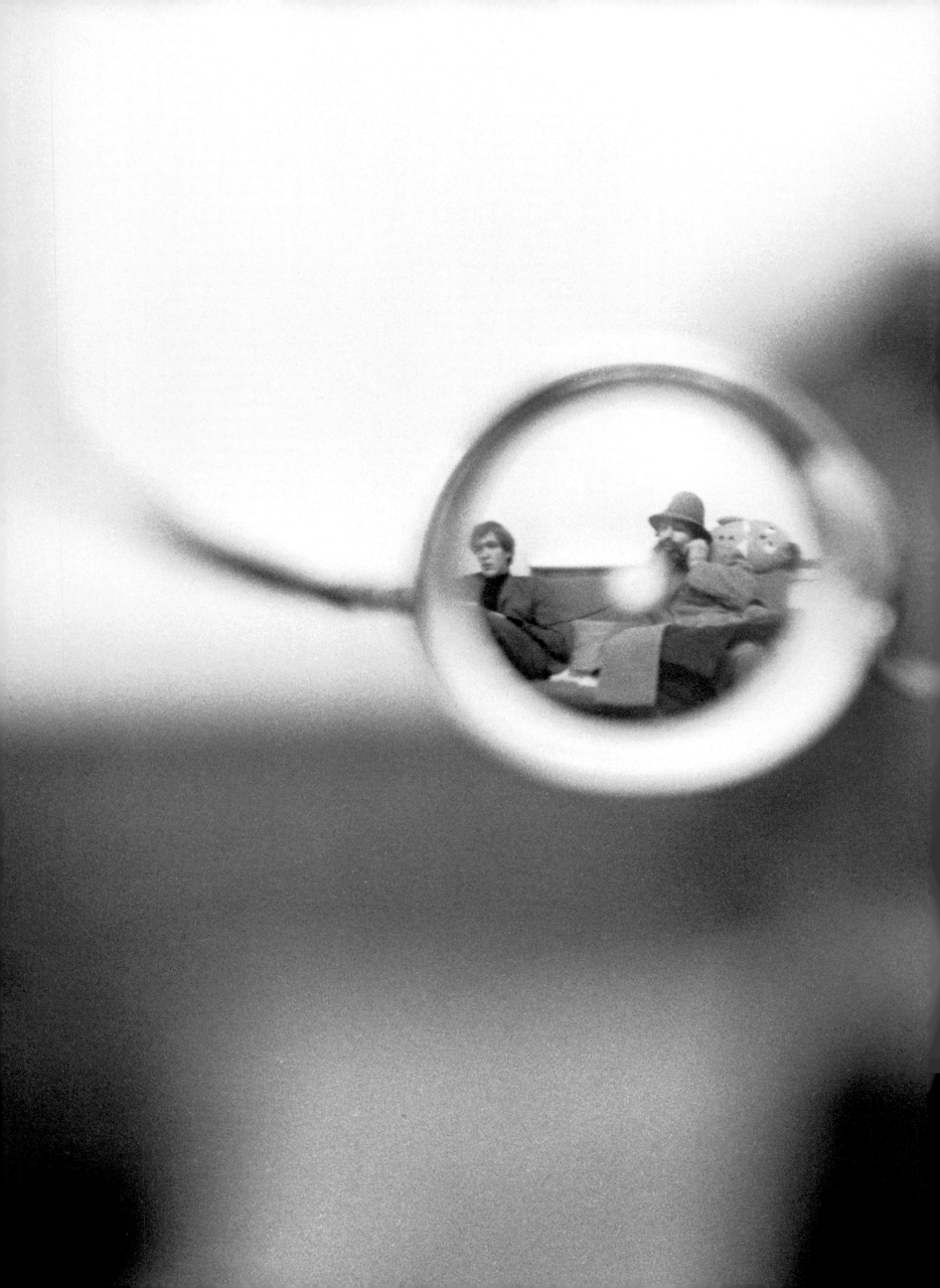

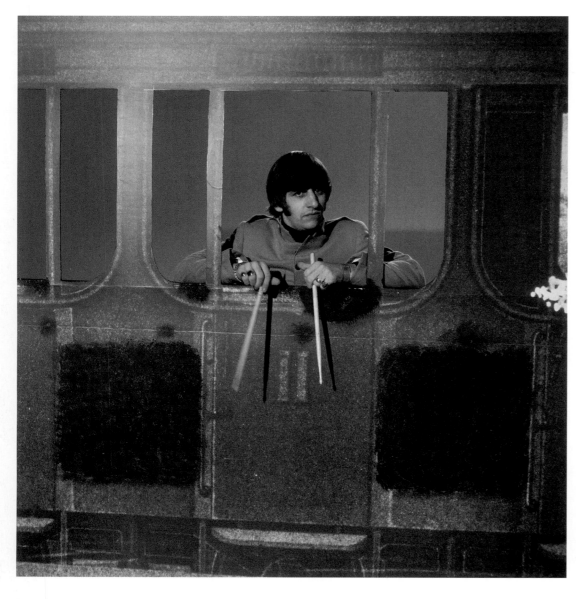

HERE THE BAND rehearses for a promotional film for "Ticket to Ride." The song would be included on the *Help!* soundtrack and stands, these many years later, as a pivotal rock record. It was the first Beatles song of more than three minutes, its drum patterns were new and inventive, its lyrics were obscure—a cool thing back then—and music critics have since cited "Ticket to Ride" as a turning point in the band's development. John wouldn't disagree, later saying he considered the song "one of the earliest heavy-metal records made."

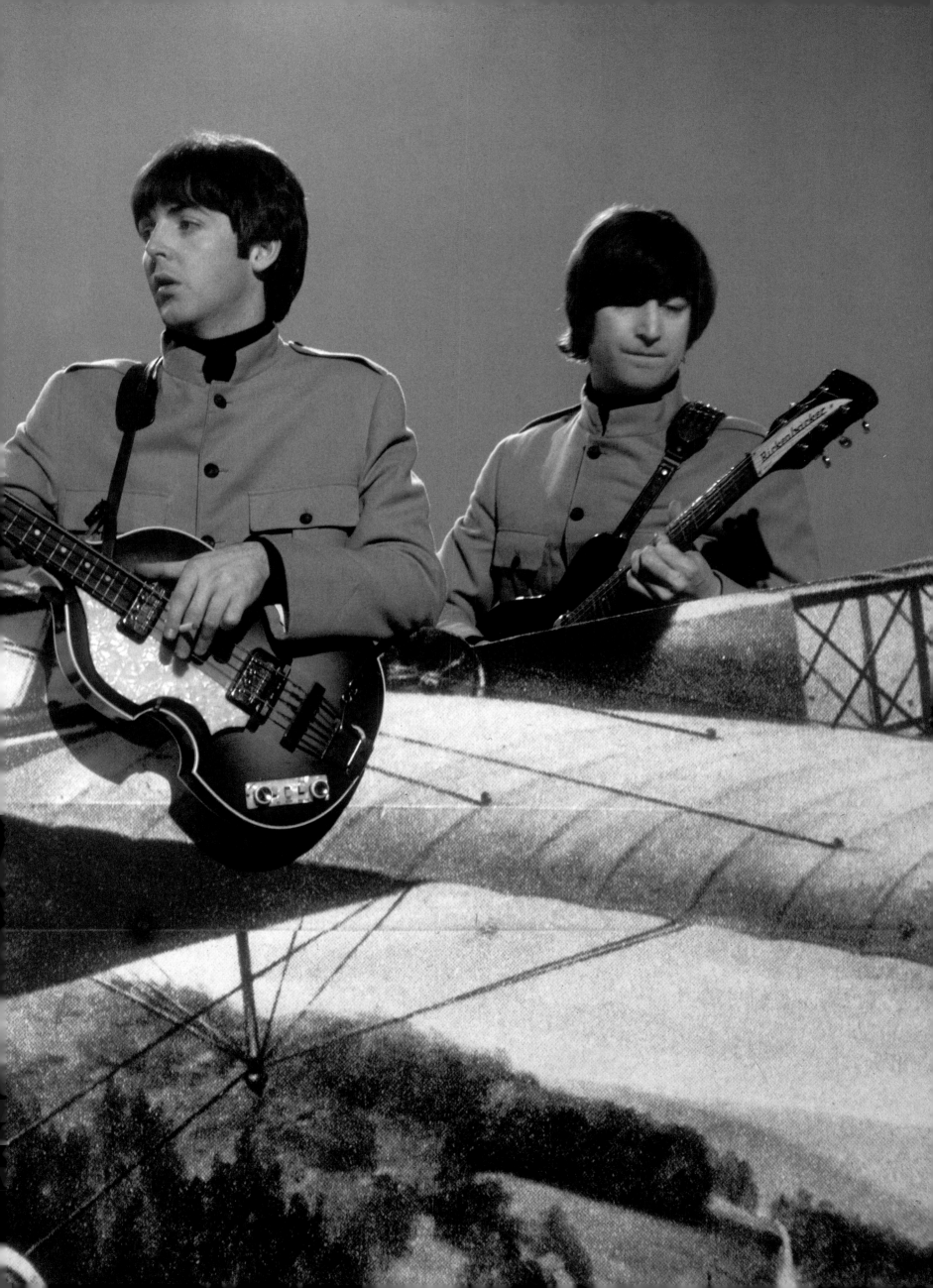

WHITAKER ONCE COMMENTED, "Portraiture of four Beatles gleaming their white teeth at you bored me senseless." If you filter through the book you have in your hands, you will find Whitaker's persuasive alternative: There are wonderful pictures of the quartet together, but never the fanzine shots—the gleaming-teeth shots. On this page and the following two, we have "Studies of Paul." "A lot of these photos never ran back then because the papers wanted all four boys: John-Paul-George-Ringo was one person," Whitaker later reflected. "And a lot of the best moments, of course, had only one Beatle. Or two, or three."

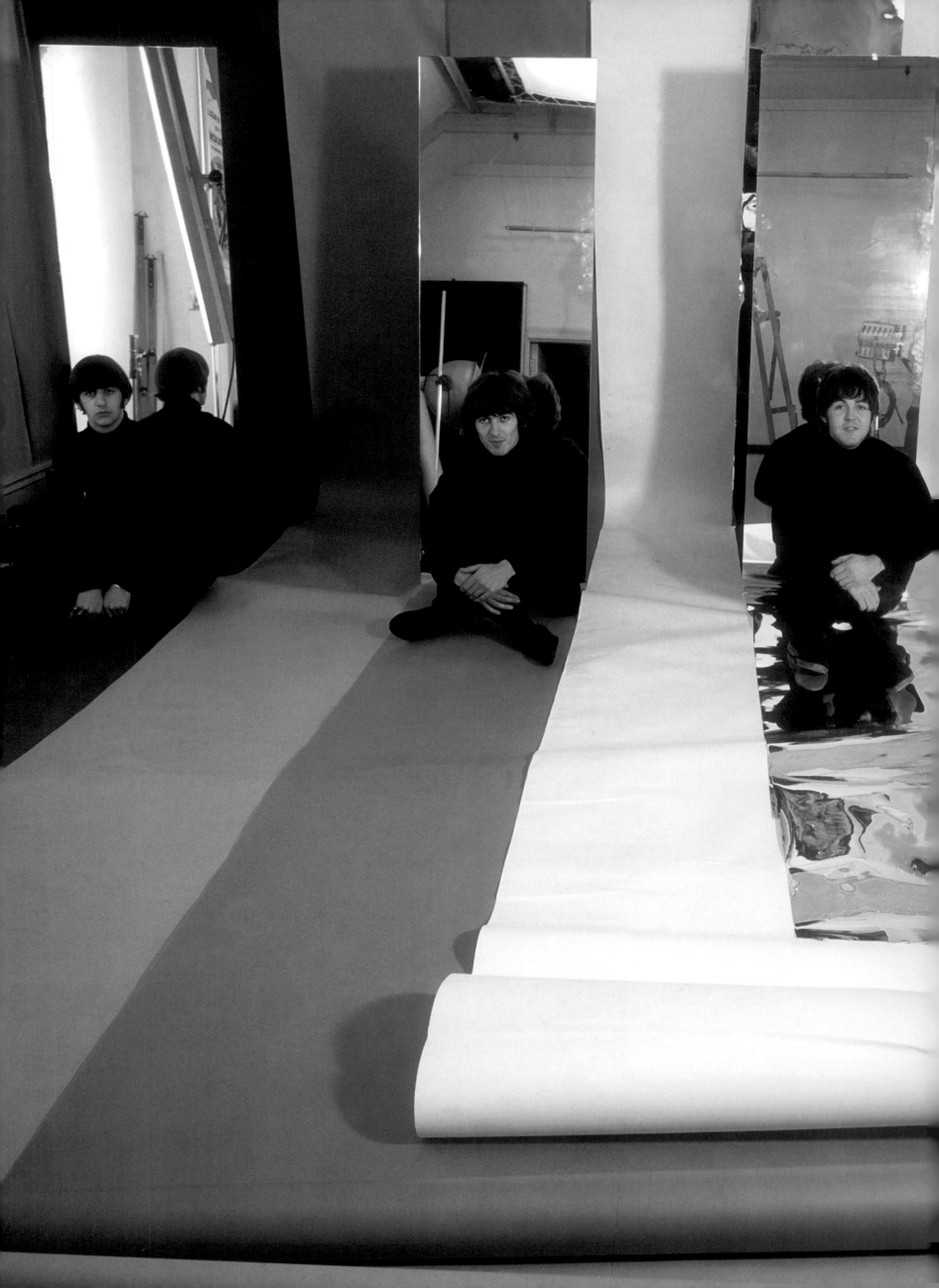

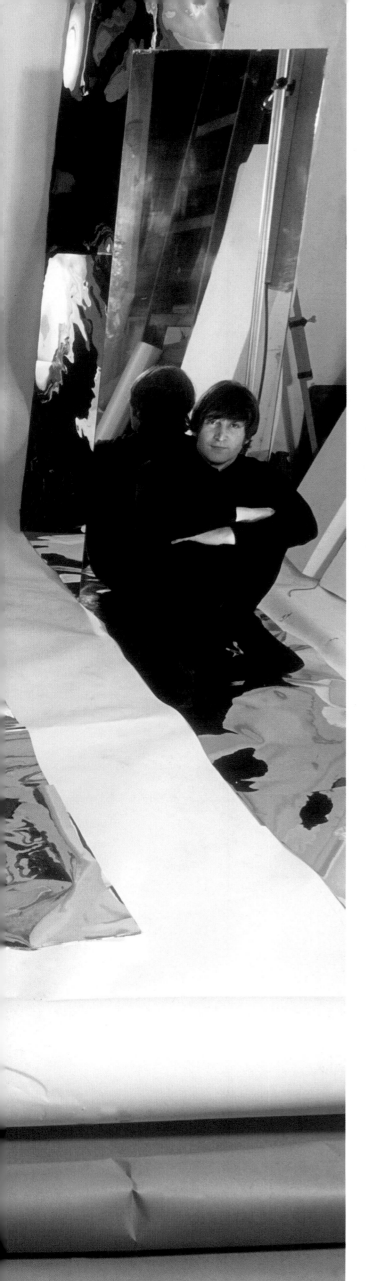

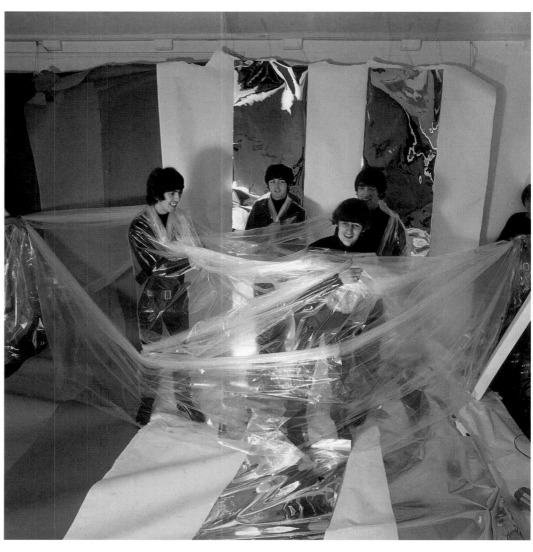

THE BEATLES are fooling around here during a shoot for a program cover that will be used for their upcoming U.S. tour. Though shorter than their 1964 invasion of North America, this sojourn will also see them playing in Canada, on both U.S. coasts and at various sites in between. The funny and poignant thing is: Back in the day, trying to get noticed in Hamburg and at the Cavern Club, screaming their lungs out till all hours, it was thrilling for the lads. Now, world famous, it seems so much harder.

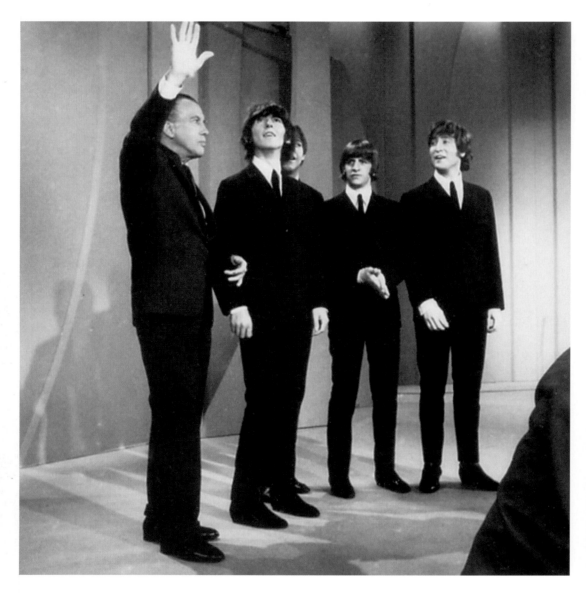

THE BEATLES, often referred to as "youngsters from Liverpool" by Ed Sullivan, tape their final appearance on his show on August 14, 1965; it will air the next month and would feature the songs "I Feel Fine," "I'm Down," "Act Naturally," "Ticket to Ride," "Yesterday" and "Help!" In those days, *The Ed Sullivan Show* was must-see TV every Sunday night, averaging 50 million viewers. The four appearances by the Beatles featured 20 songs in all, seven of which went to No. 1. The programs attracted a cumulative quarter billion viewers. After bidding a final adieu to Ed in Manhattan, the band headed crosstown to a helicopter by the East River. They had another gig to get to.

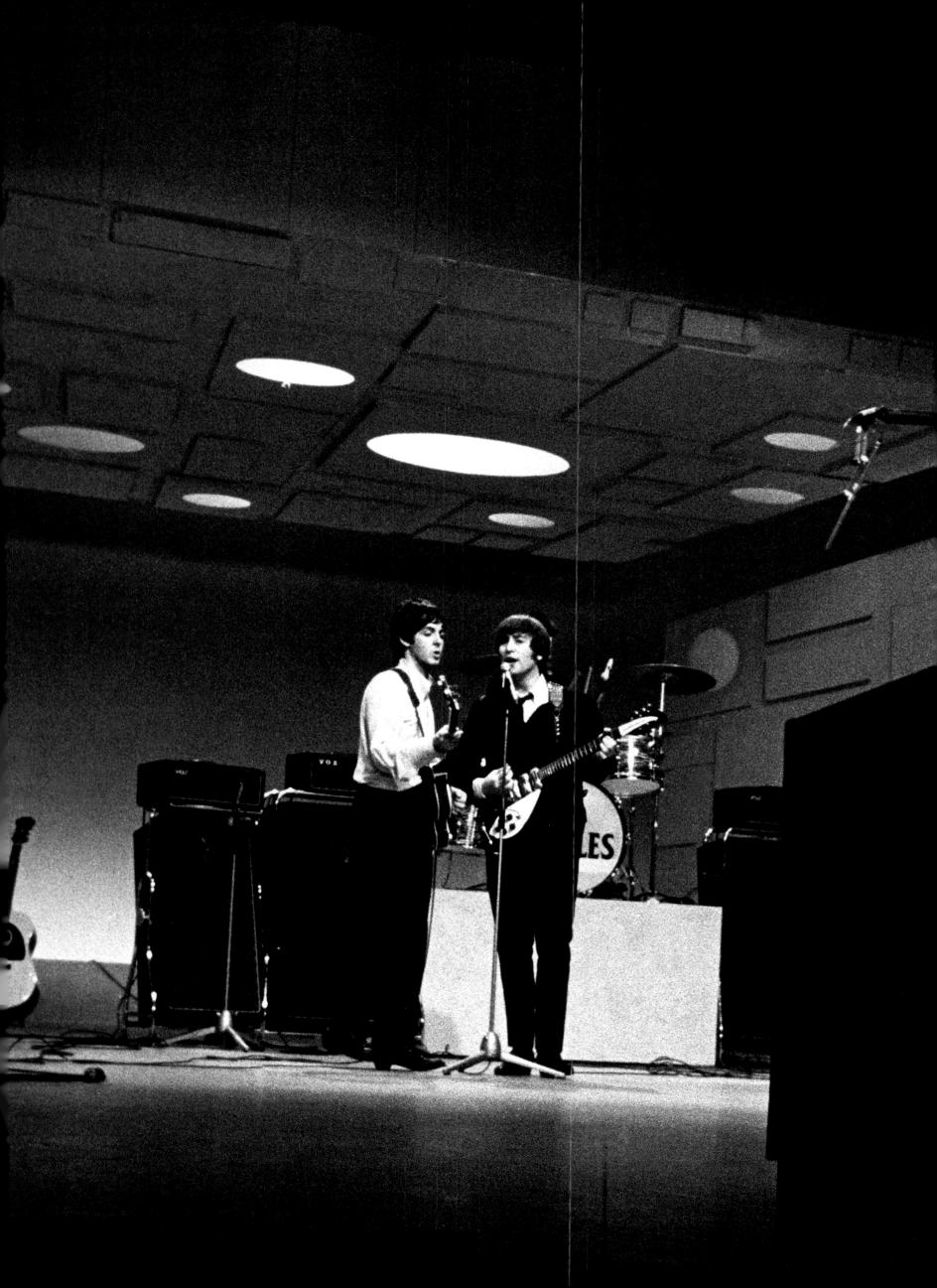

THIS WAS NOTHING

more than a cross-river commute to a concert, but it was wild, and more than a little frightening, as was the show itself. Whitaker later remembered: "The journey to Shea Stadium had to be organized like a military operation. We flew by helicopter from Manhattan and transferred to an armored Wells Fargo truck near the stadium. It had no windows and the kids were hammering on the outside and rocking it; the noise was deafening, the screaming and screeching really terrifying. At one stage we thought the truck was going to tip over and we were all going to get dragged out and torn to pieces." And that was before a note was played! (Not that a note would ever be heard.) On the following two pages, the scene at Shea is seen, from on high, and on the pages just after that, Brian Epstein, impresario of the evening, is seen seeing the scene. It really was one of the wildest rock 'n' roll nights ever, and thank goodness nothing like the tragedy at Altamont occurred. The show broke records for rock-show attendance (55,600), gross ($304,000) and fee ($160,000 to the band). If sheer pandemonium could be measured, the figure would be beyond the charts. Fans screeched, thrashed, cried hysterically, passed out. What was missing? Only the music, as the roar of the crowd completely drowned out the Beatles. More than a few fans were terrified by the chaos. Among those shaken was a Brit in attendance named Jagger. His seatmate, surname Richards, was far cooler.

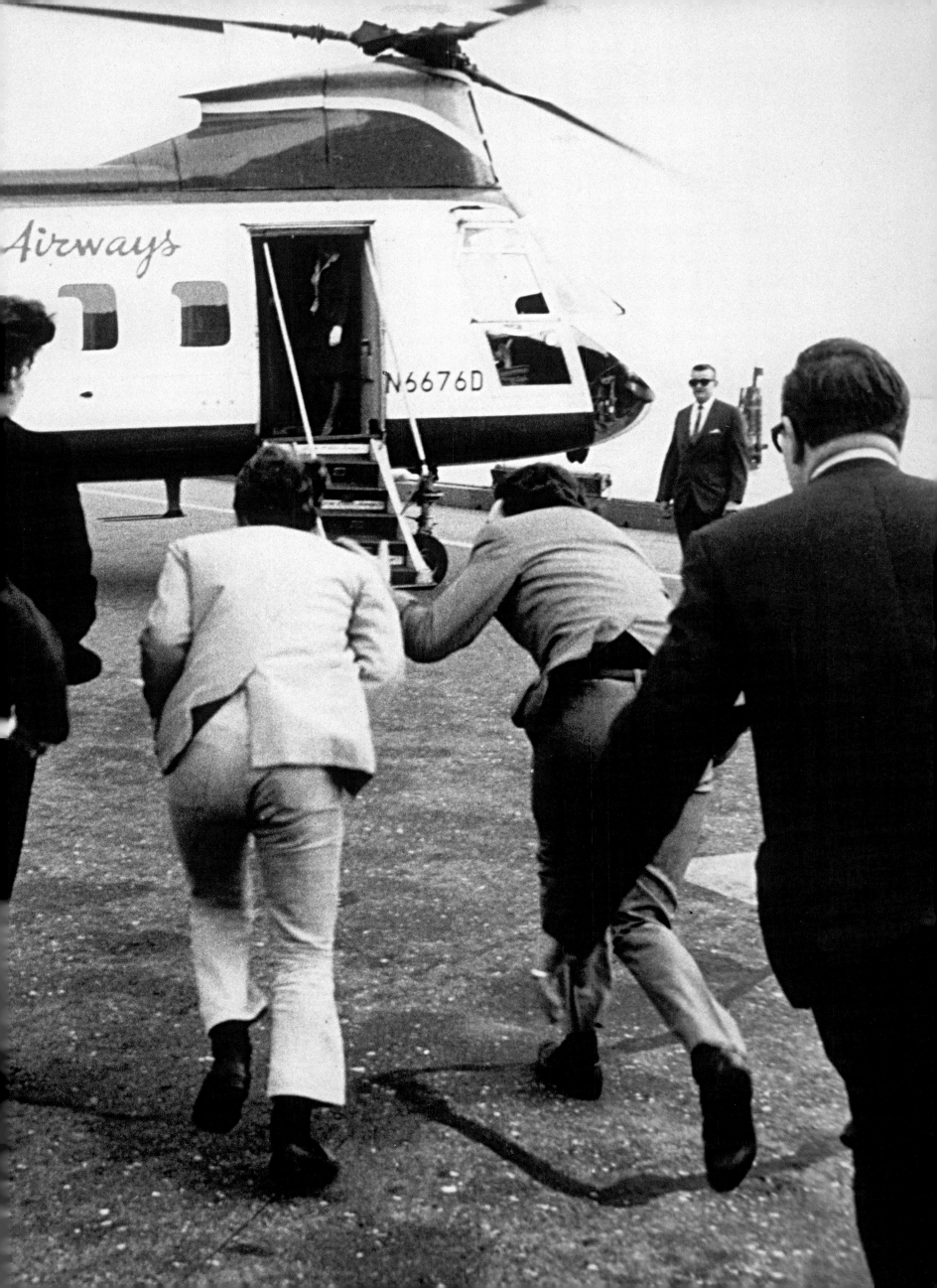

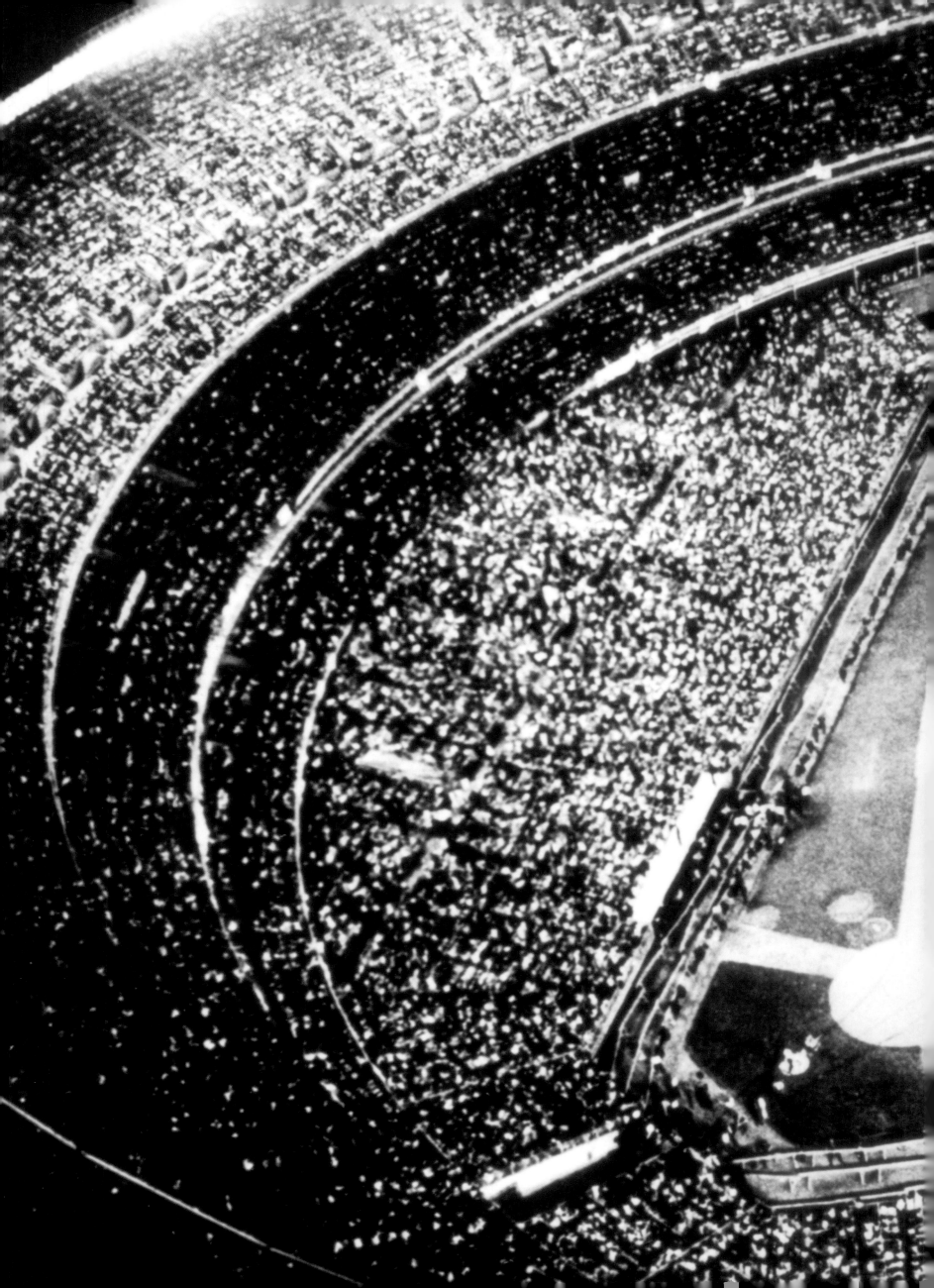

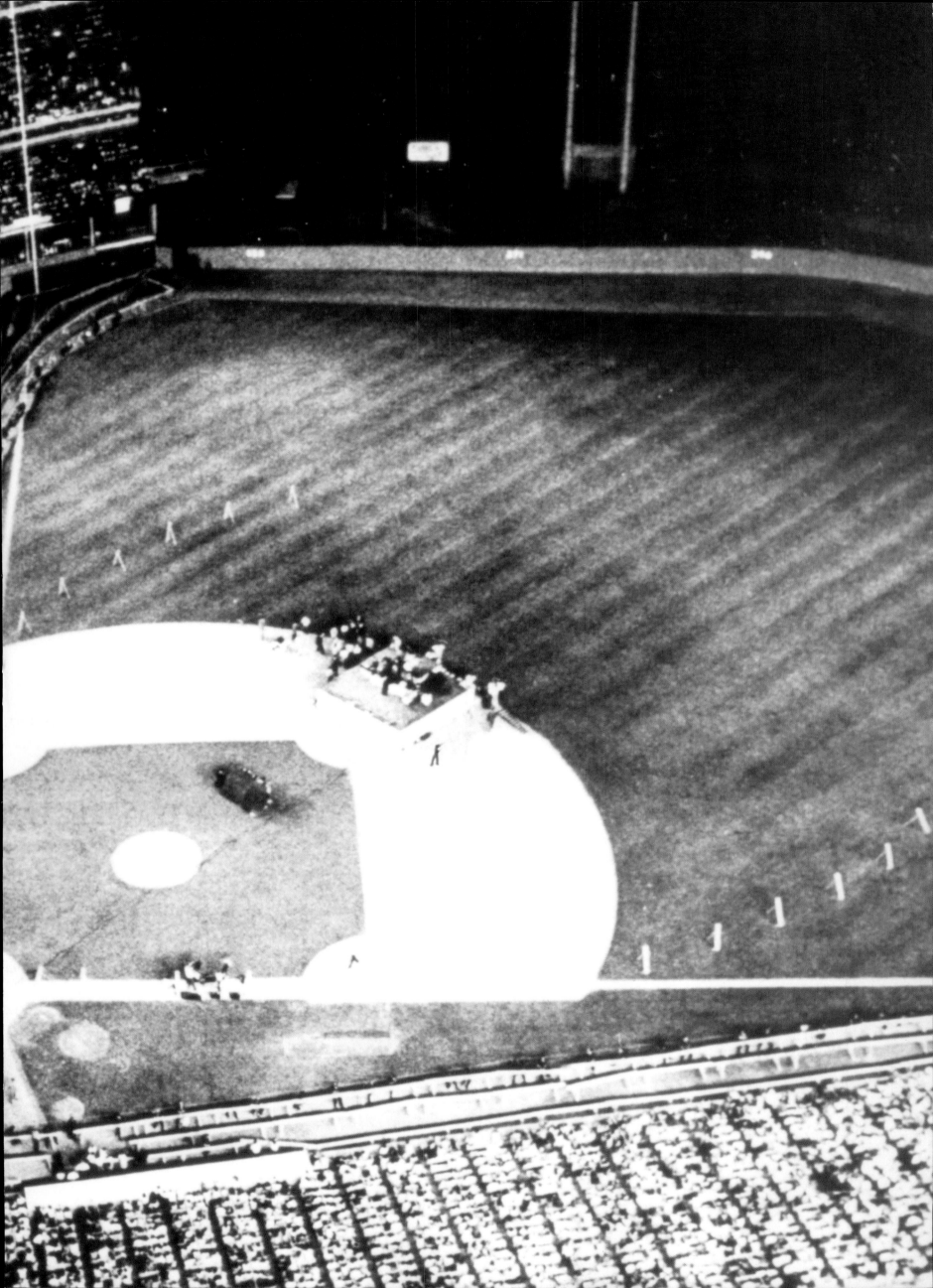

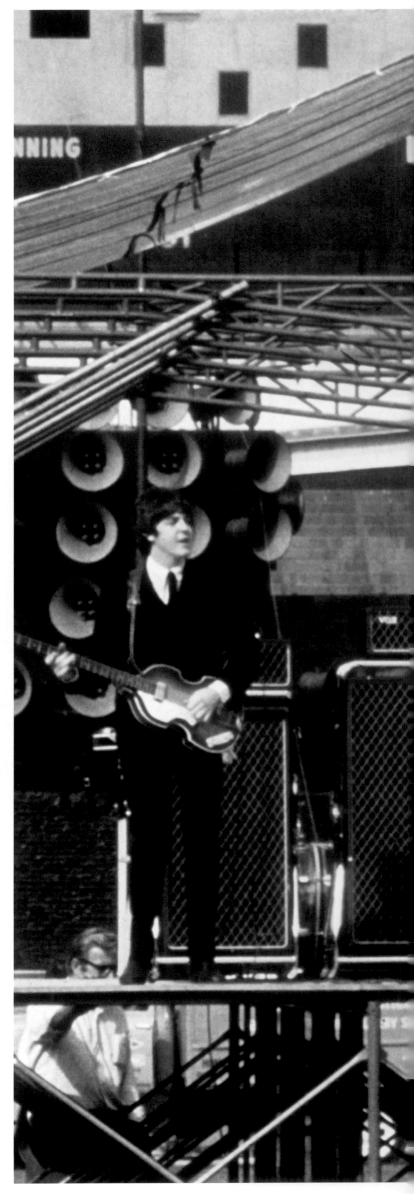

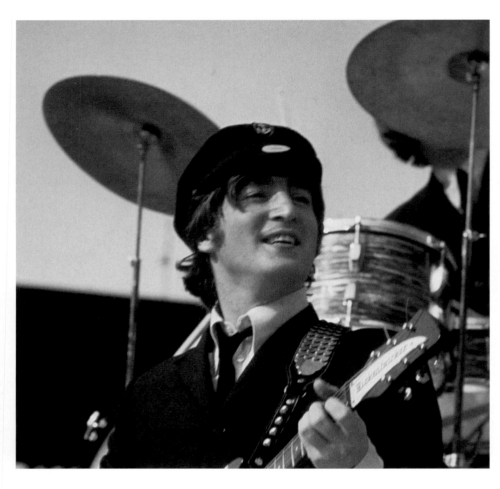

PLAY BALL: The band performing at Chicago's Comiskey Park. The ticket price for the best seat in the house on this night is $5.50 (and you get the fabulous Brenda Holloway as an opening act!). Adjusted for inflation, the $5.50 is about $40 today. Just for fun, we note that from online resellers in the year 2012, One Direction tickets can be secured, if you're lucky enough, for prices in the hundreds. They're cute boys too, but . . . Well, you be the judge.

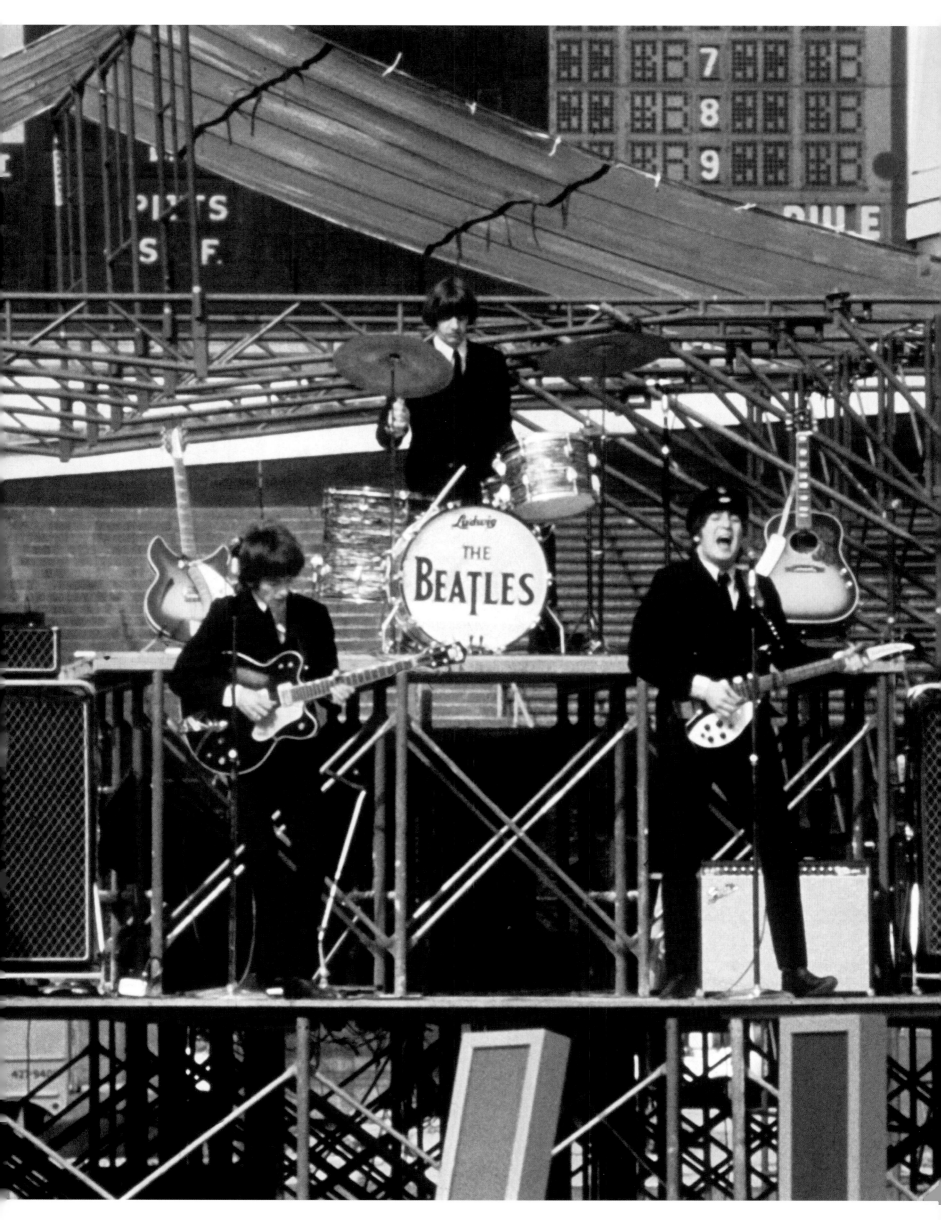

JOHN TAKES a breather after the Beatles perform two 35-minute shows at Comiskey. The sets included "I Feel Fine," despite the way John looks in this photo. Perhaps he got an energy boost a bit later when he and the boys headed to the famed Margie's Candies and wolfed down an Atomic Buster, replete with several scoops of ice cream, fruit and fudge.

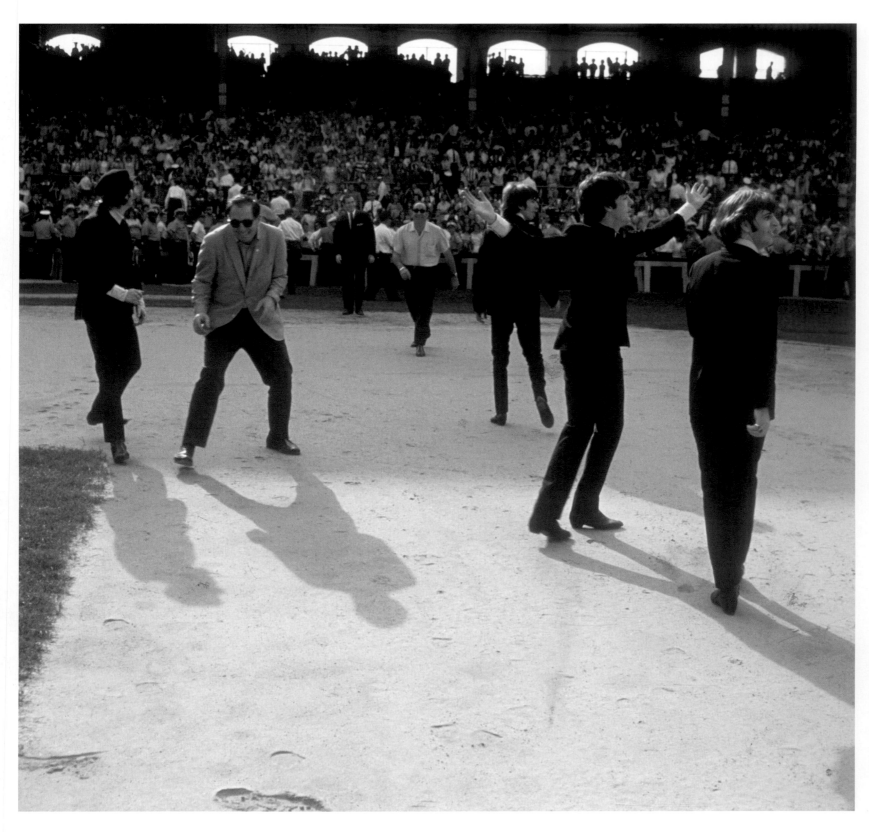

DURING THEIR MIDWEST ROAD TRIP, the Beatles play Comiskey and, opposite, Metropolitan Stadium (where Paul warms up) in Bloomington, Minnesota, the home of baseball's Minnesota Twins. The band gets a break there, performing only one show instead of a double-header. And there are other perks. The Beatles are given access to the Twins' locker room, where they take a sauna for the first time. It's been a long and winding road from Liverpool. After the concert, though, the relaxation of the sauna yields to a return to the madness: Fans surround what they believe to be the boys' limo as the band speeds away inside another vehicle—a laundry truck.

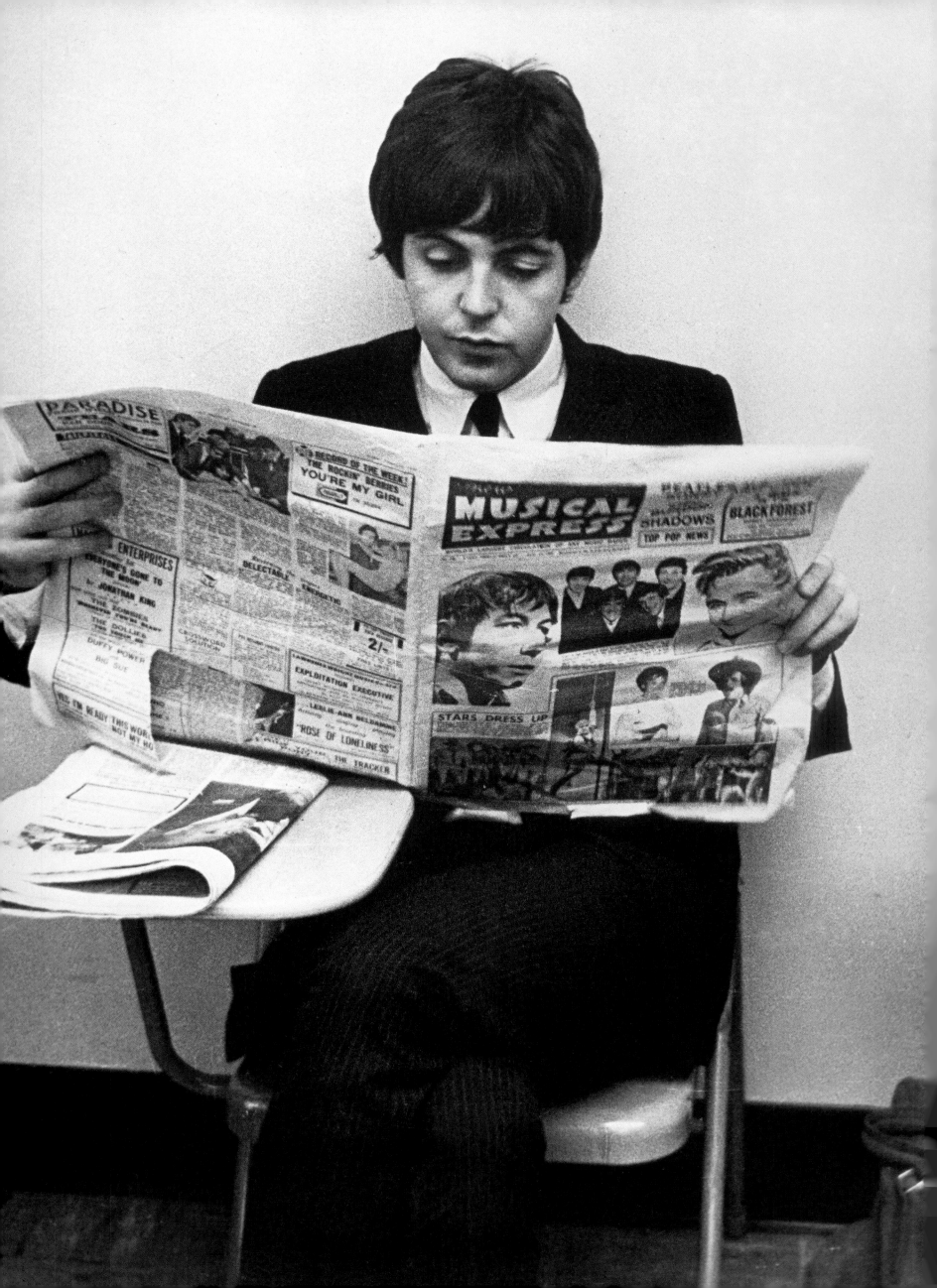

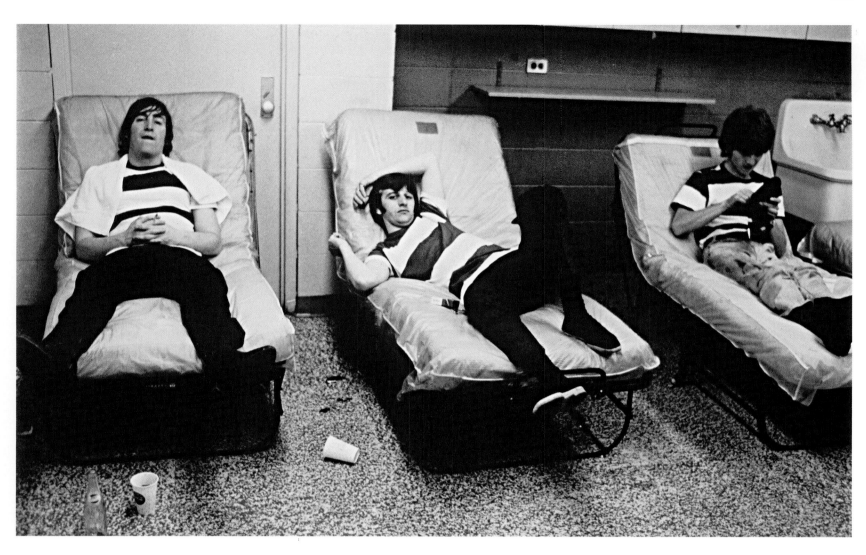

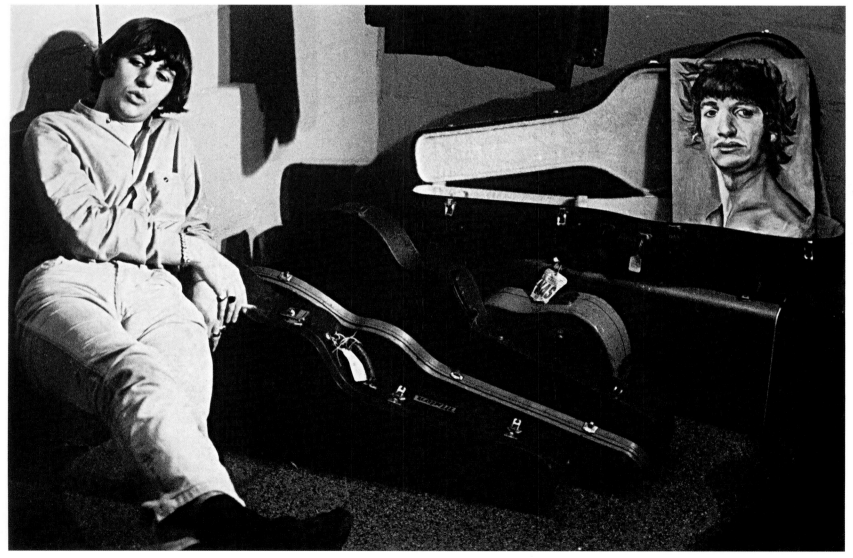

OPPOSITE: Paul reads the *New Musical Express,* perhaps checking up on the competition. The Stones? The Who? The Dave Clark Five, still hanging in there? At top on this page, three sleepy Beatles wait to go onstage in Toronto while, above, Ringo relaxes alongside a painting presented to him by a devotee. "In every dressing room there would be piles of gifts the fans had left for the Beatles," remembered Whitaker later. Well, yes there were. Piles of gifts, piles of people. Everyone wanted to be close to the Beatles.

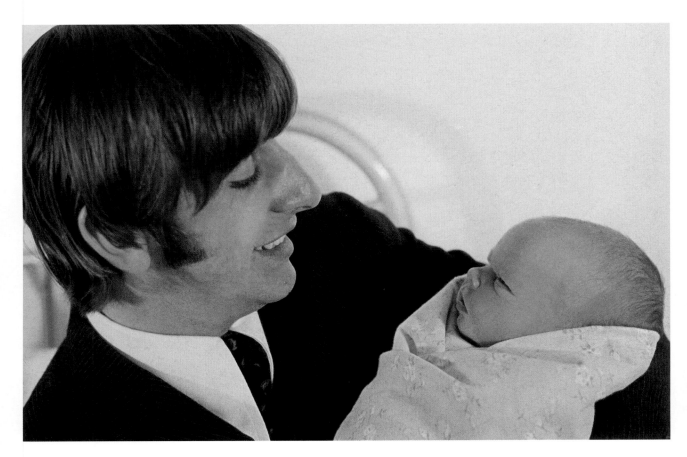

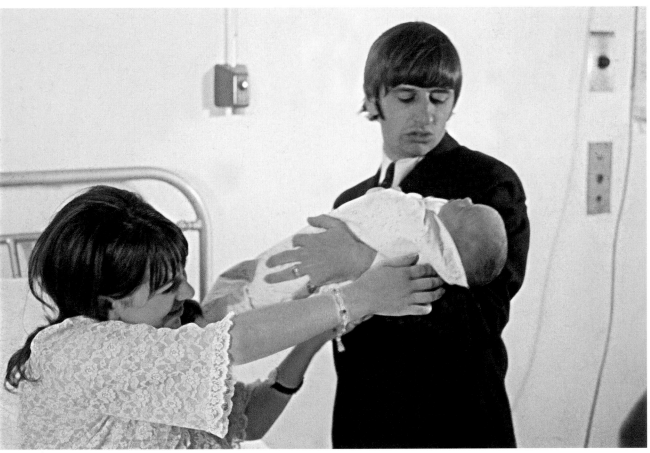

THE MAMA AND THE PAPA: Ringo and his first wife, hometown sweetheart Maureen, with their new baby, Zak (who is today one of the world's preeminent rock drummers, starring with such as the Who and Oasis). Whitaker would later write about the original Starkey star: "I got on very well with Ringo, who's a wonderful guy and one of the most humorous people I've ever met. I liked the way he could diffuse an awkward situation with a well-timed quip, and I also admired his dress sense." Of course, that might be important to a photographer. What was important to the fans in 1965 was that Ringo seemed genuine, happy and fun—as he certainly was in this period. And why wouldn't he be happy? The last Beatle aboard, he was surely the luckiest drummer, perhaps the luckiest guy, on the planet.

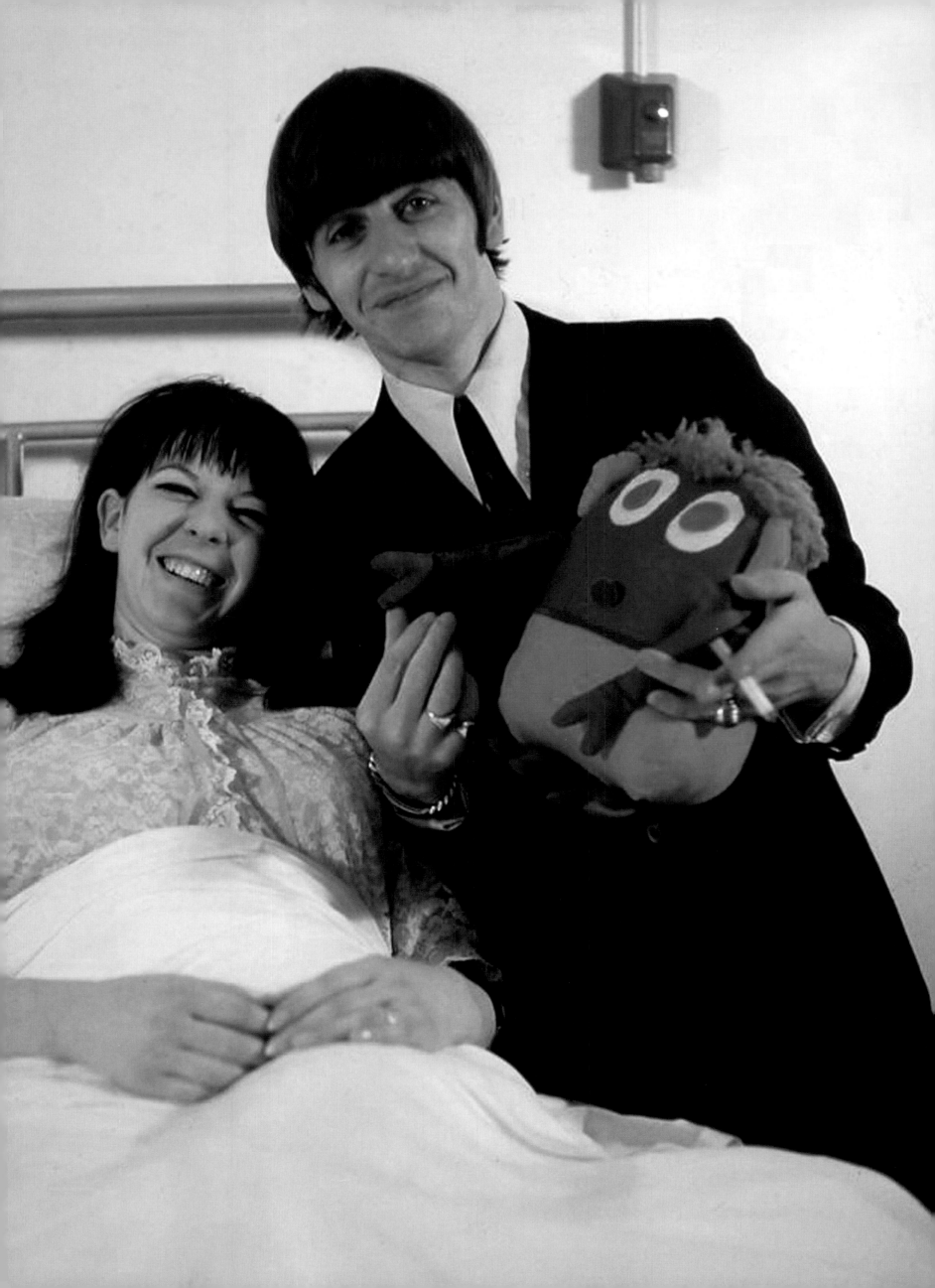

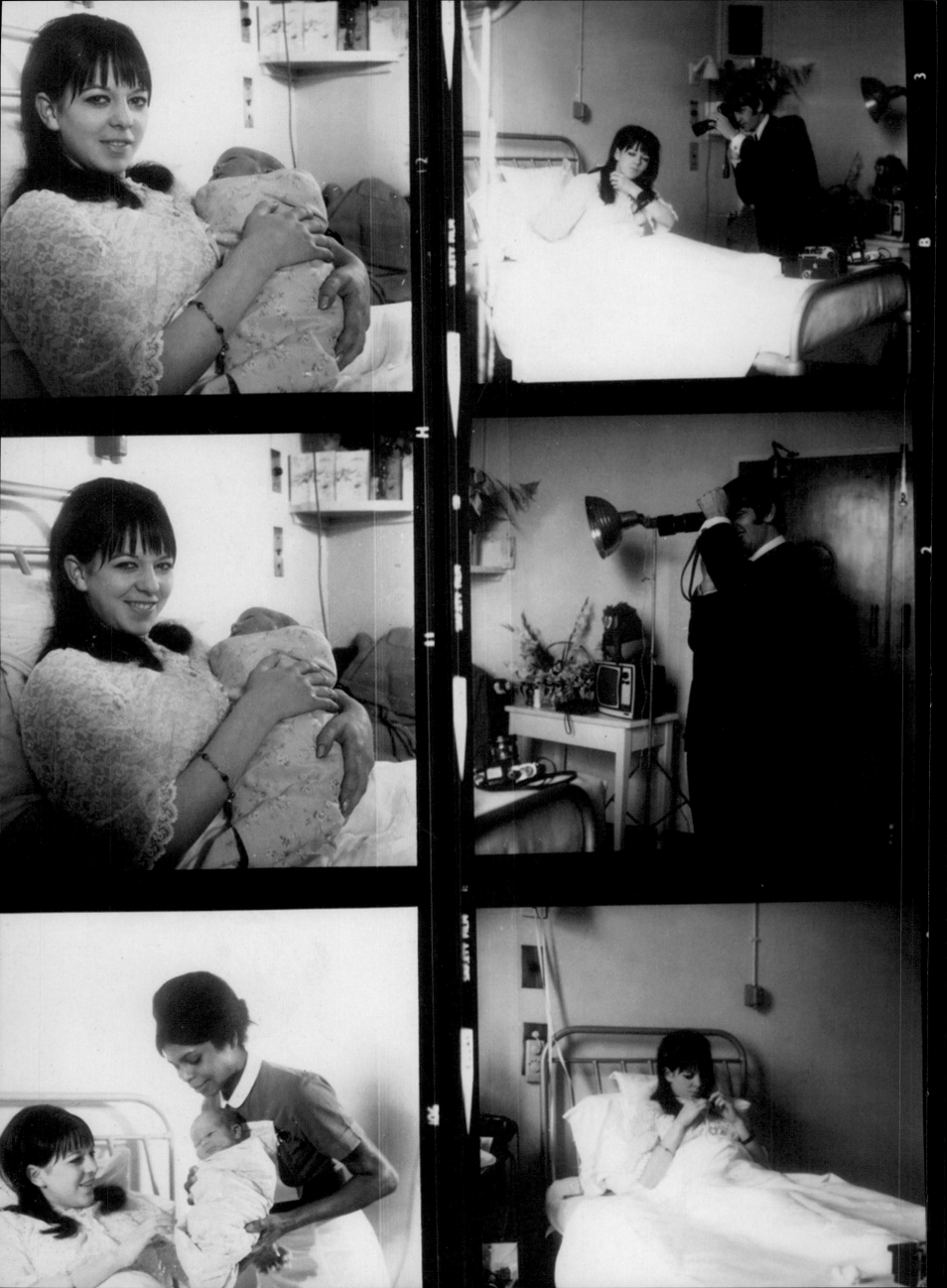

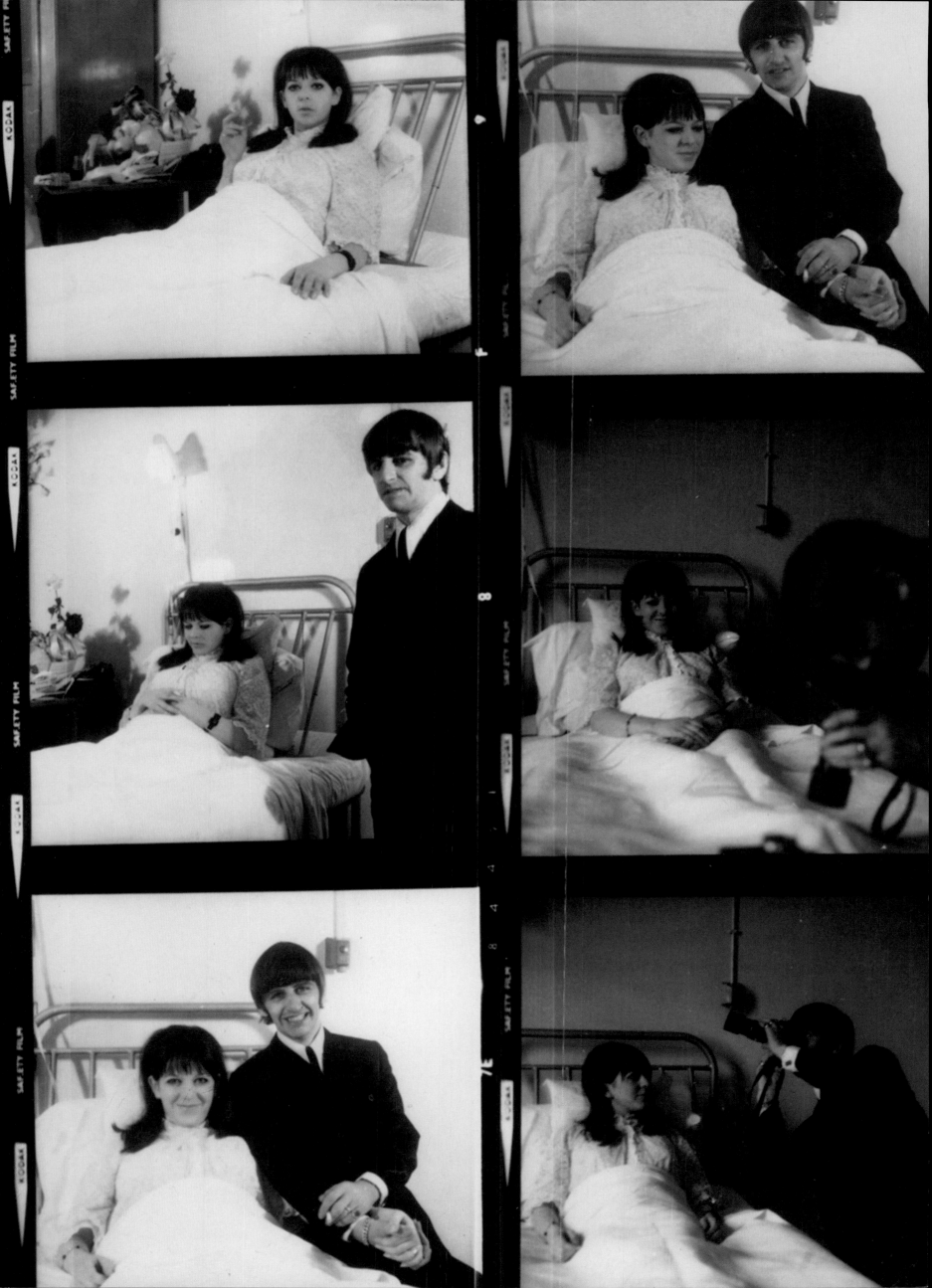

ON THESE and the following two pages: a serene John Lennon, the Beatle Whitaker was closest to. "It was John I felt quite at home with, and we got to be very friendly," Whitaker would later tell LIFE. "We'd talk about Dalí or Magritte or other painters. We used to paint together, discussing odd things—the solidity of objects here and in space. I think that one had to do with LSD. I found John humorous, warm, very witty. His art—the drawings and poetry—is humorous beyond belief. Very Spike Milligan, but also beautiful."

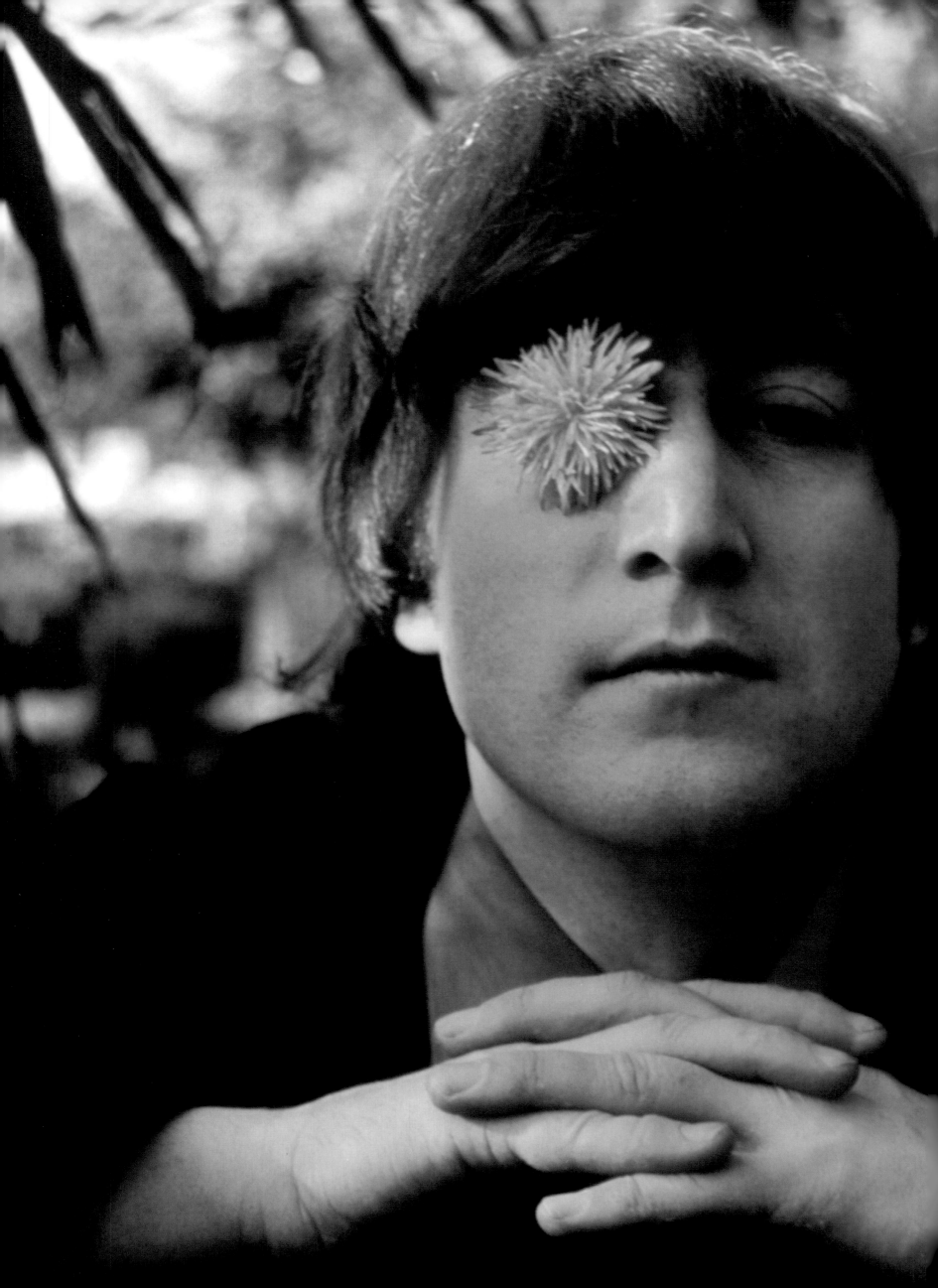

WEYBRIDGE: a town in Surrey in the southeast of England where flow the River Wey and the River Thames. It is curious, the settings that rock stars like John Lennon or George Harrison or Keith Richards chose to make their homes in: rural, quiet, idyllic. But anyway: Here, in one of Whitaker's most famous portraits, John is quite the flower child, posing in Weybridge, as he does on the several following pages. He has happily invited Whitaker to his home, and it results in a historic session. On the following pages, John and his first wife, Cynthia, are the original chia pets. In the early throes of Beatlemania, shots like this were downplayed or even verboten; it was thought that all four boys should be seen as "available" by teenaged girls, and John's marriage was something not to be discussed. John, always opinionated and often forceful, would break rules and—sometimes—include Cynthia in, just as he would pose wearing his eyeglasses so that his young fans who needed to wear glasses would know that specs could be cool.

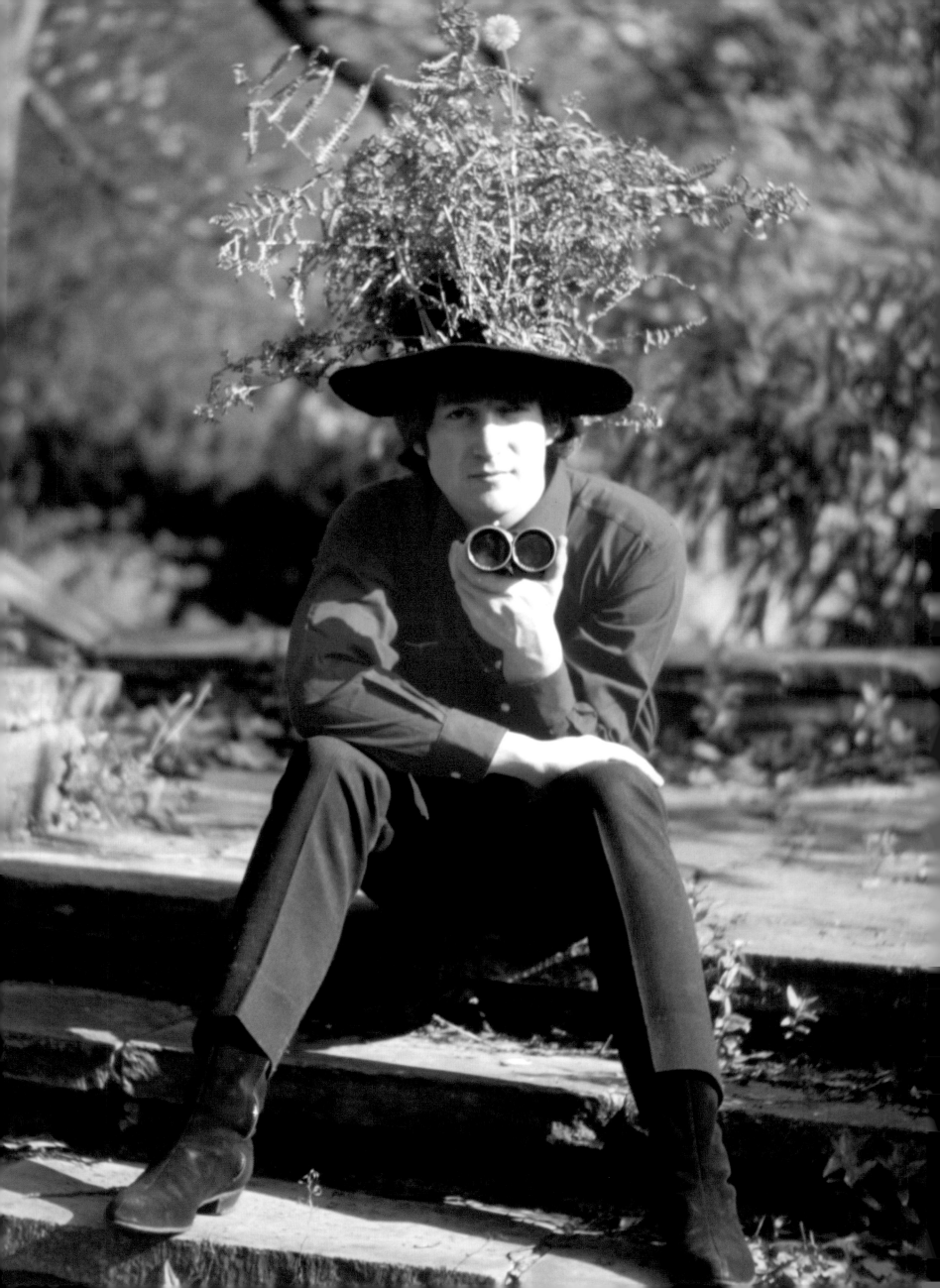

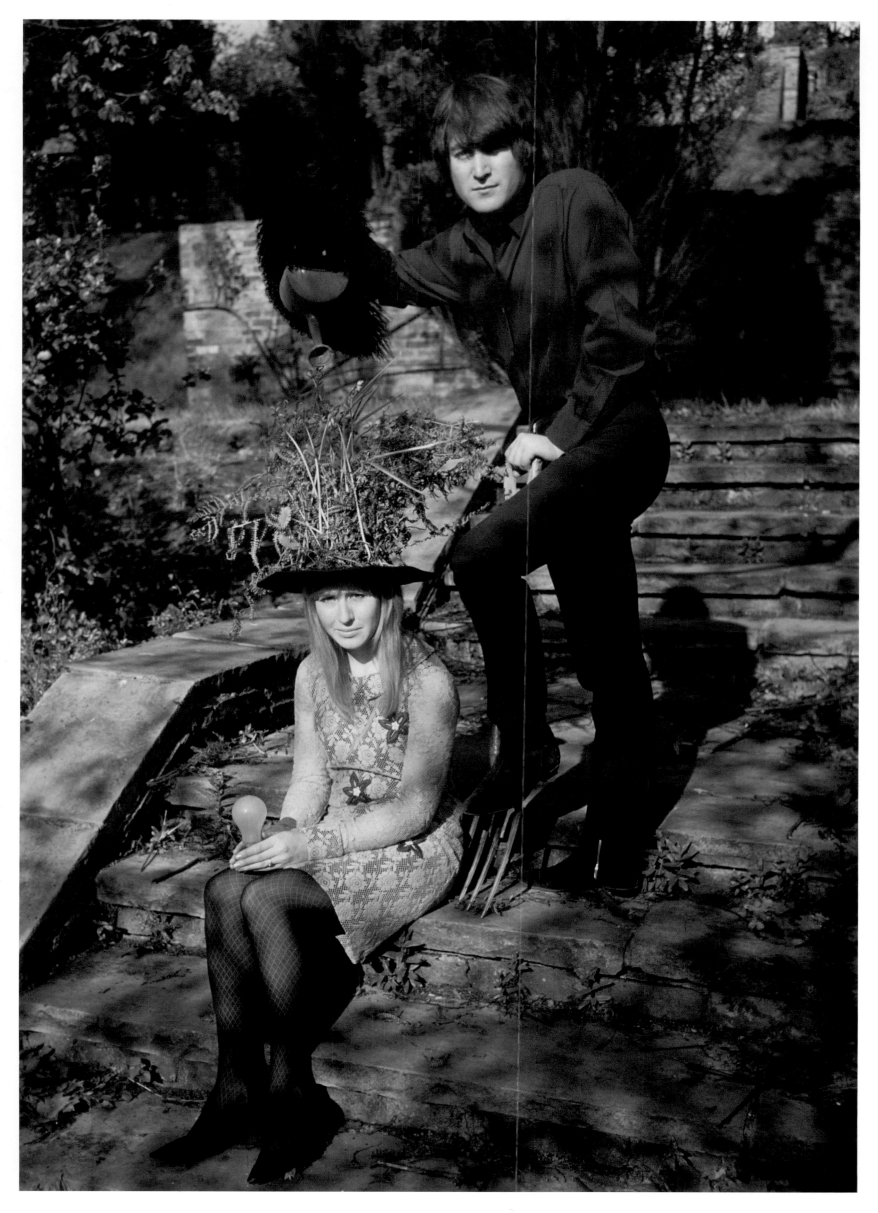

"I HAD BEEN studying the Greek myth of Narcissus," Whitaker told LIFE, "and one day at the Lennons', I got John to look at his reflection in the water." Nineteen sixty-five, John Lennon—or Paul McCartney, for that matter—as Narcissus? Not a far leap.

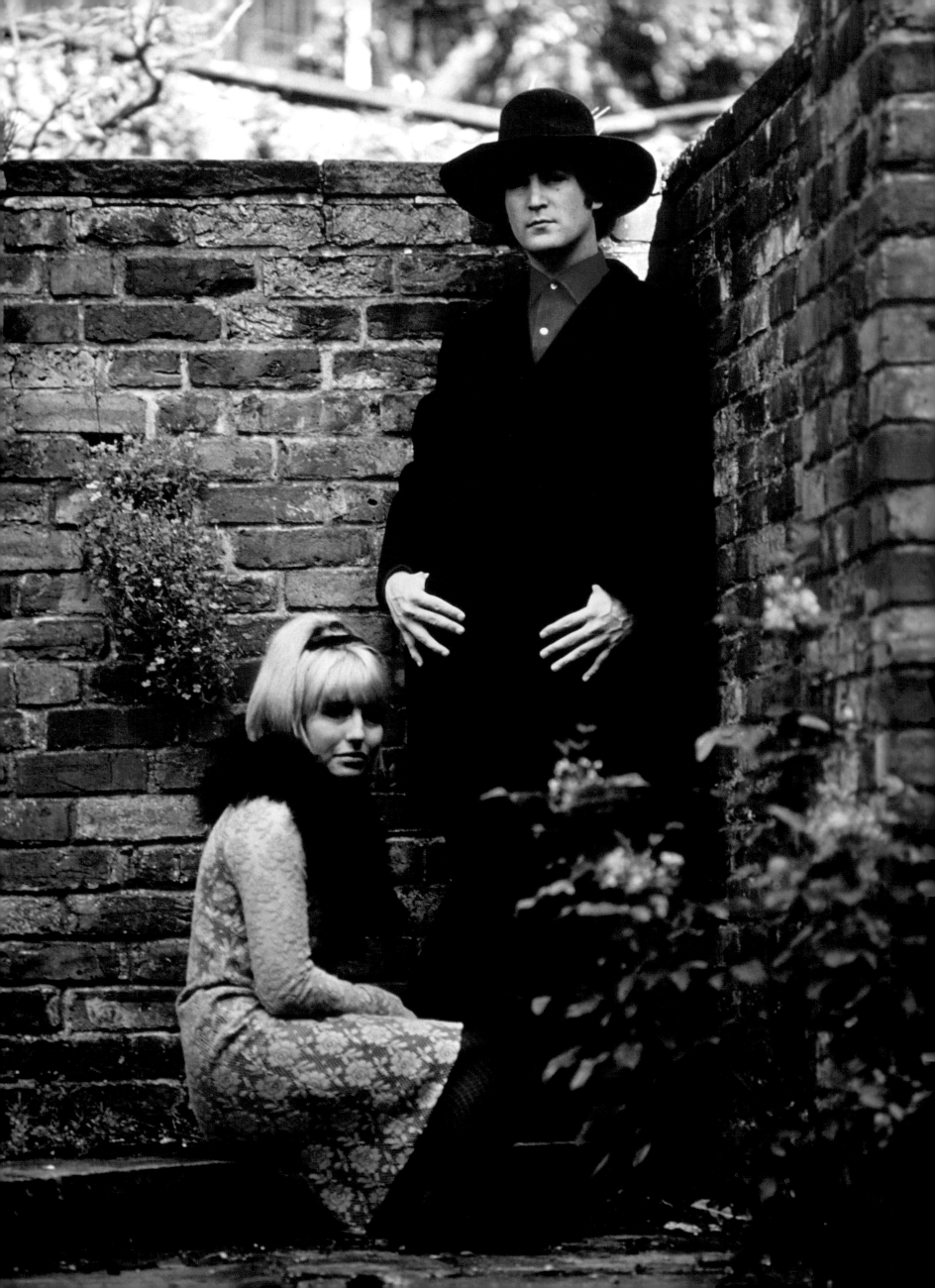

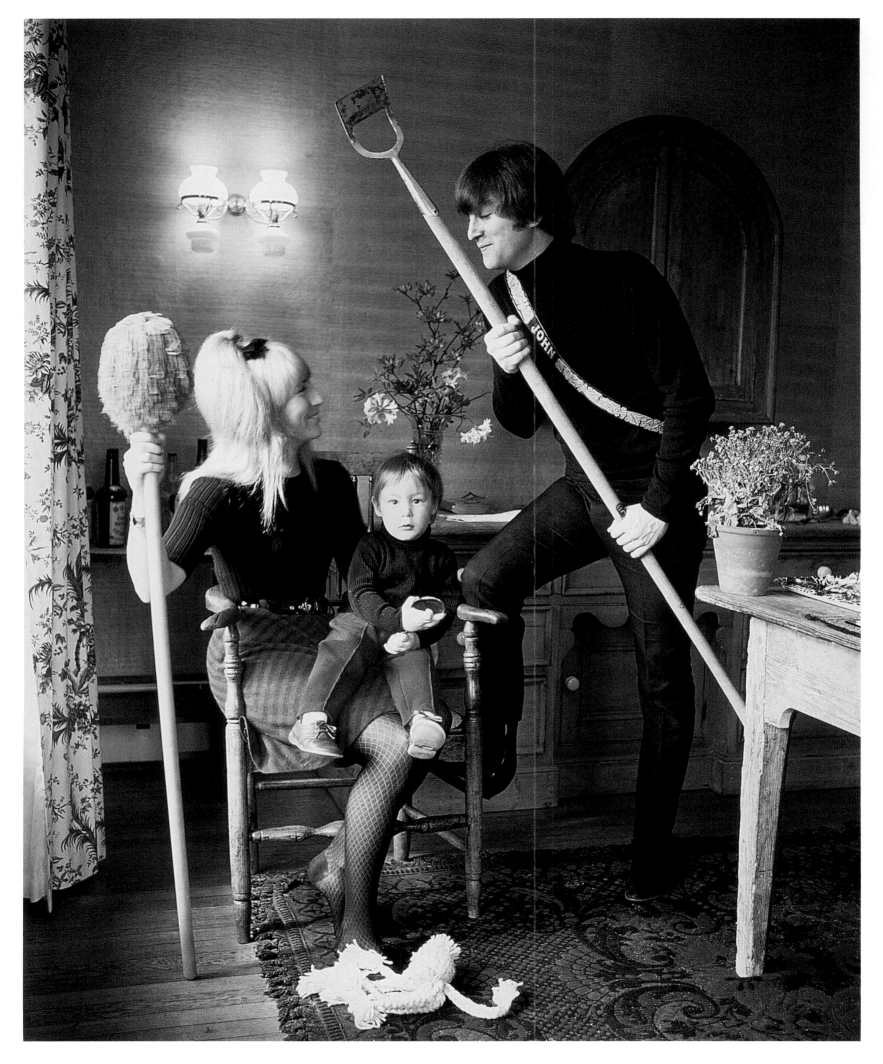

JOHN AND CYNTHIA POSE, propless on the opposite page, and fully propped above. Though it may appear otherwise, the latter shot was not inspired by Grant Wood's painting "American Gothic," but rather by a photo that Whitaker had made, involving other subjects, in 1963. As he later told LIFE, "I gave John a hoe and Cynthia a mop, and tried to turn them into something very real: pioneers." The boy on Cynthia's lap is of course their son, Julian.

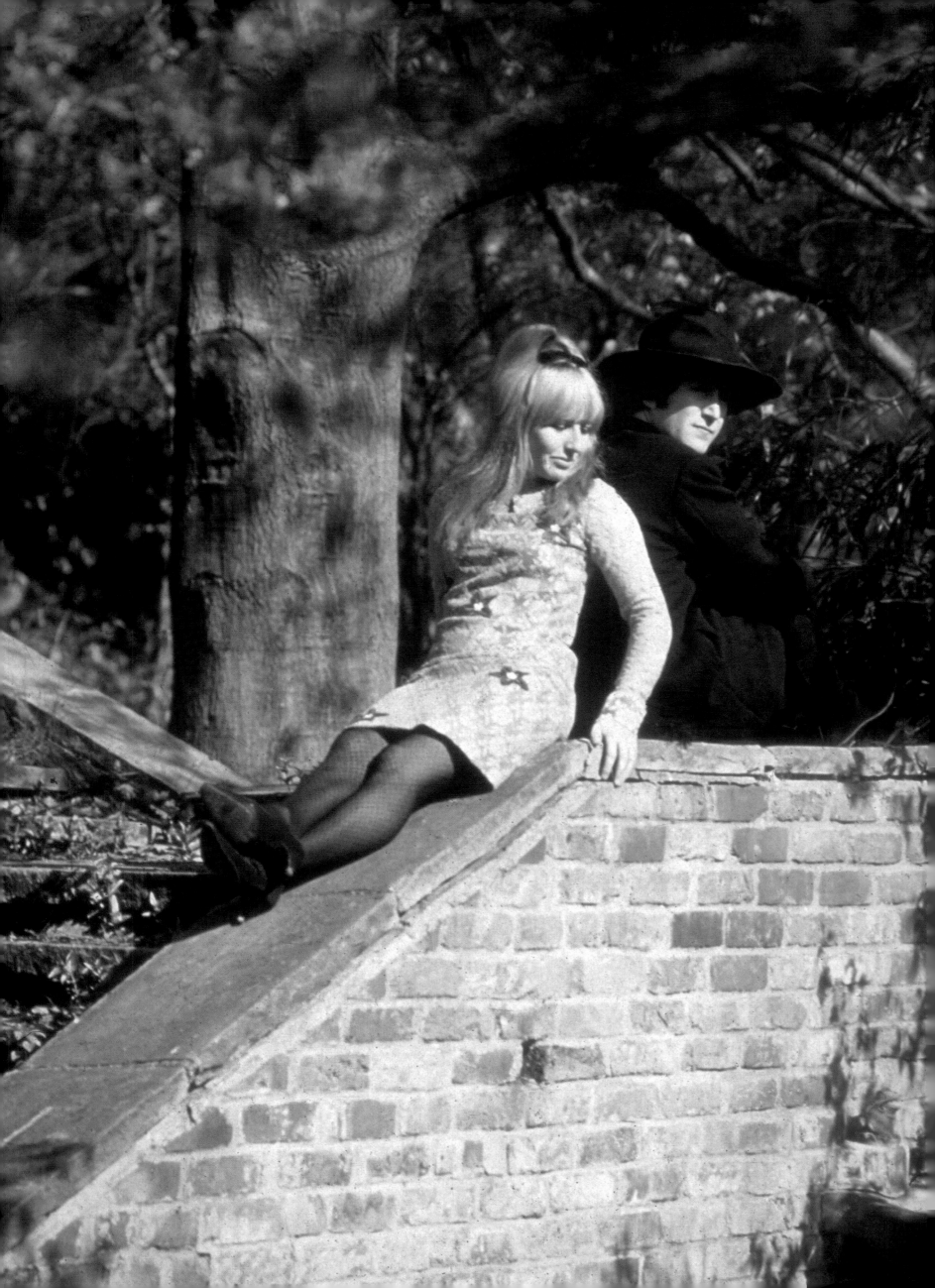

AT LEFT: John and Cynthia have each other's back. Below, a lovely expression of their love, which as we know would not last. Whitaker, reflecting on his time with the couple and Julian, later recalled to LIFE, "I thought the three of them were a fabulous family. I never discussed with John why he left Cynthia."

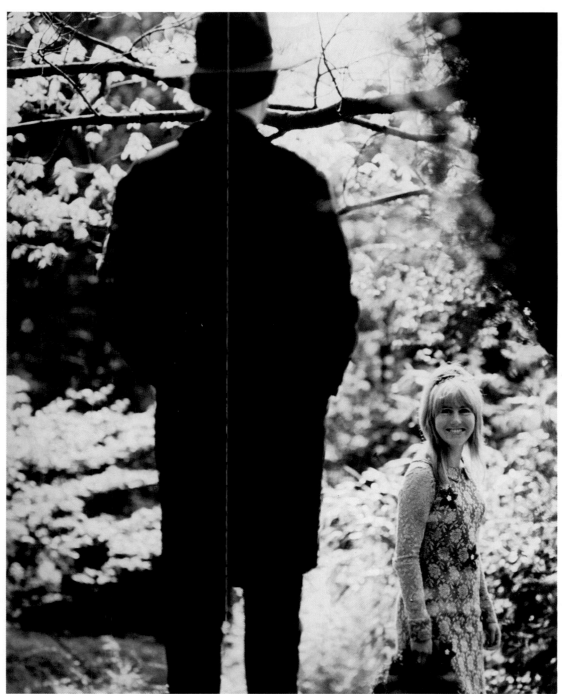

BY 1965, the Christmas Show was old hat to Paul and John, and also to their friend and trusted lieutenant Neil Aspinall (left). Aspinall and other aides—chiefly Mal Evans and Derek Taylor—were emblematic of a truth about the band (obviously run by Lennon and McCartney): The Beatles stuck for a long time with those who had brought them to the dance. And who was Neil Aspinall? He was an old school chum of Paul and George's, and had driven the band's equipment in his Commer van to gigs around England and Scotland back in the day. He would eventually become head of Apple Corps, the Beatles' company. In that role he would be a defender of all things and all rights pertaining to "Beatle"—including, it can be supposed, the rights to the old Christmas Shows. He died of lung cancer in New York City in 2008, seven years after the death of his friend George Harrison.

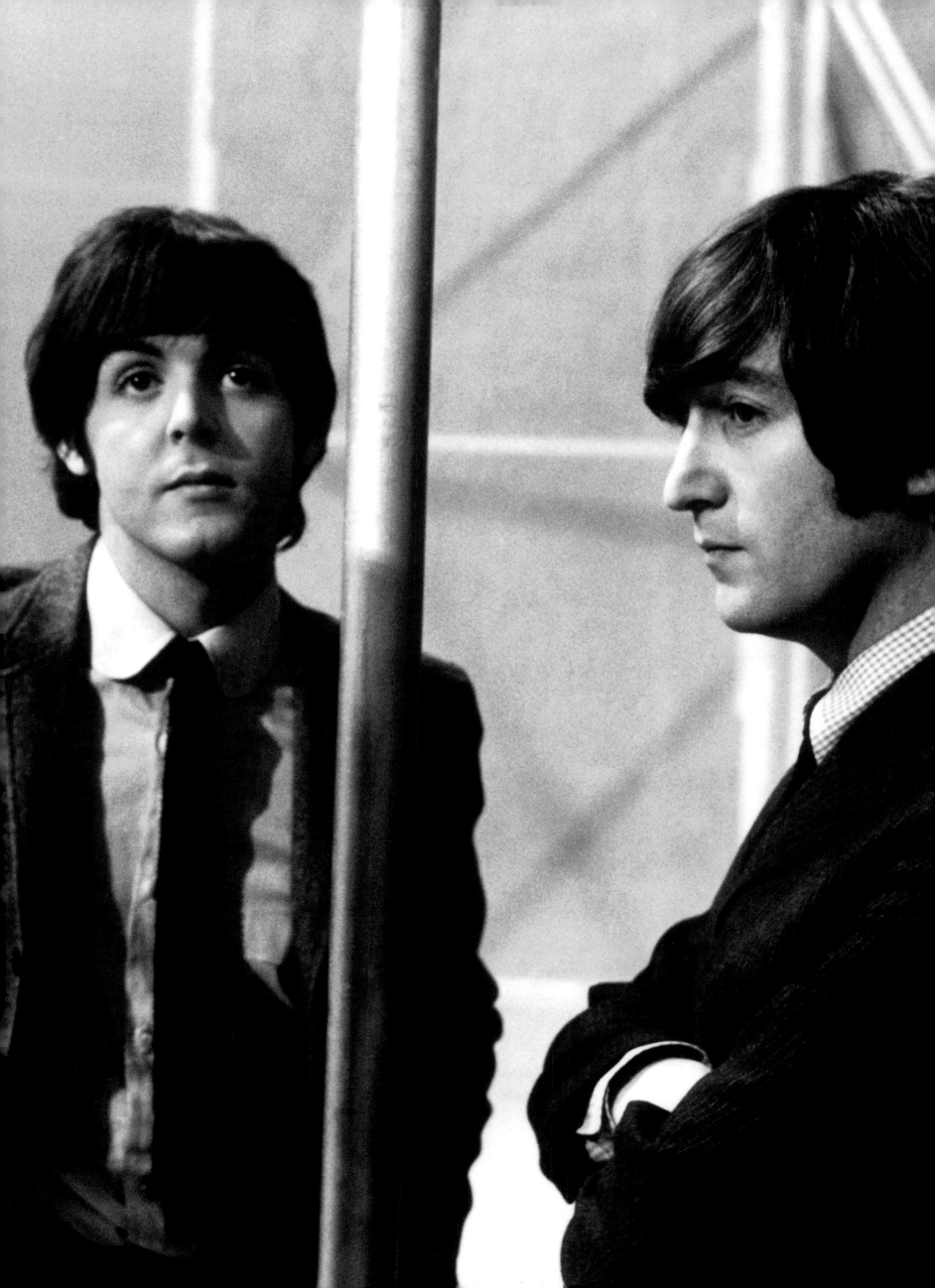

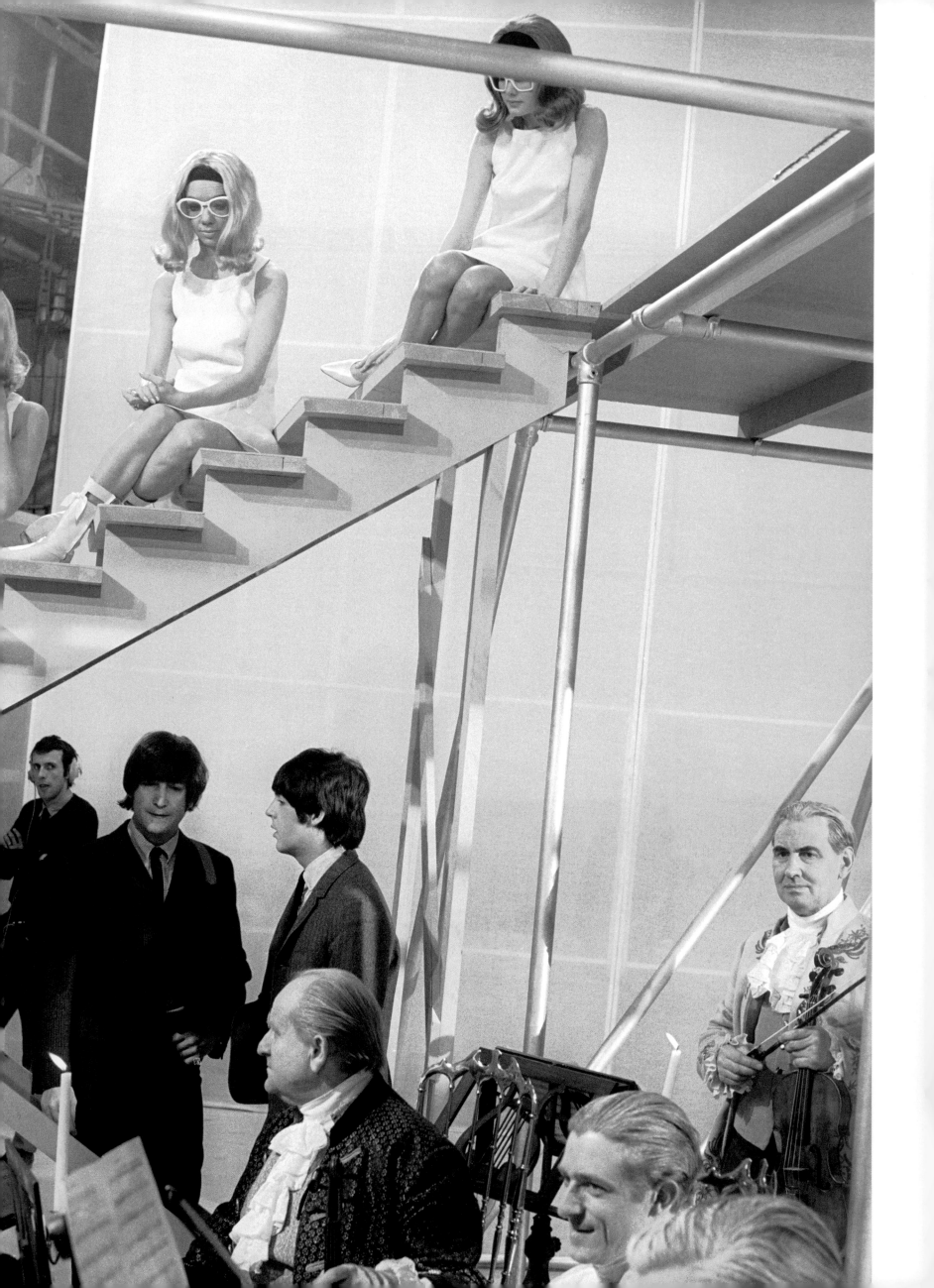

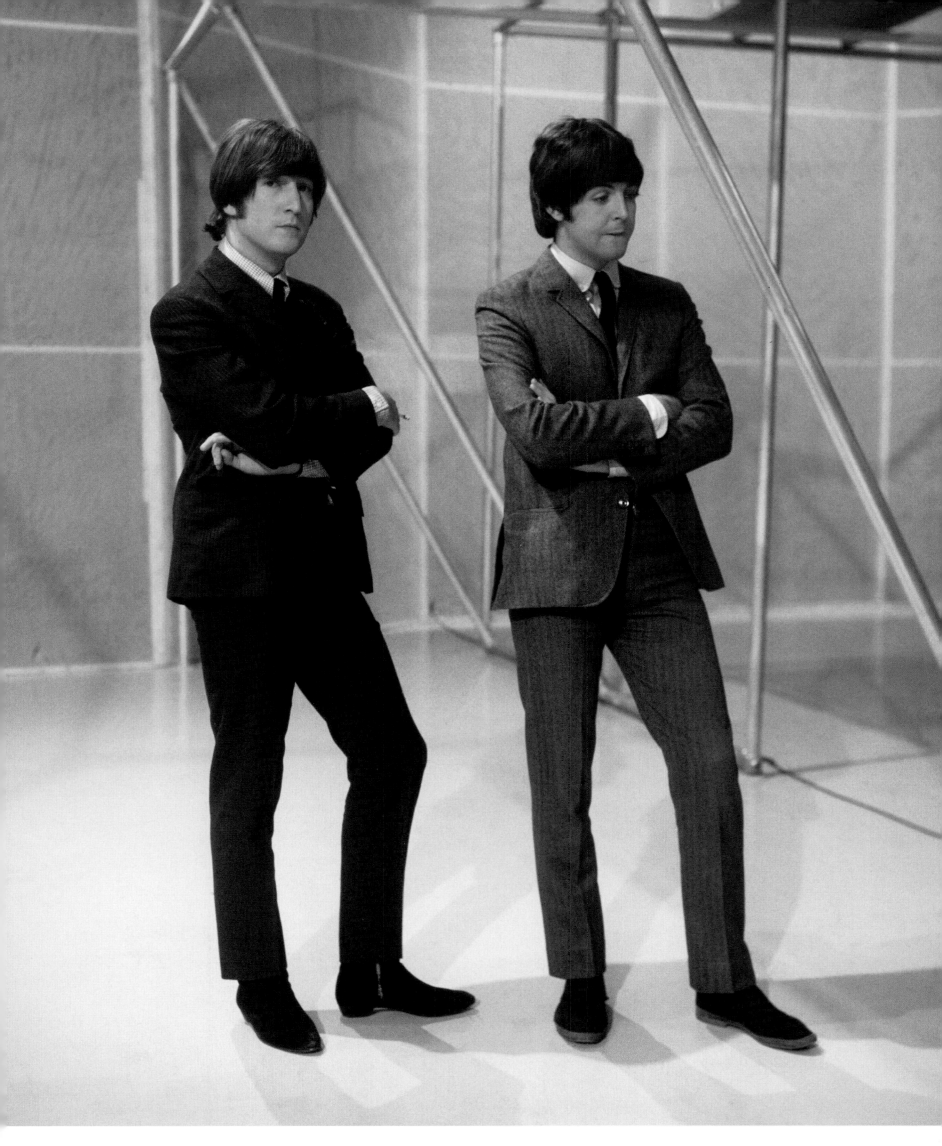

THE CHRISTMAS SPECIALS were (moderately) funny, and they are really funny in retrospect. Parts of them were taped much earlier than Christmas season each year, as was sensible. But therefore there wasn't a lot of Dickens in the air in London. We present them in our book at the year's end because that's the way the Beatles presented them. We ncte here, in 1965, that the boss Beatles are showing the strains of time, fame, pressure and all else (drugs, home life, et cetera). John and Paul are not on the way out, yet, but each is imagining the end, and Whitaker captures the mood.

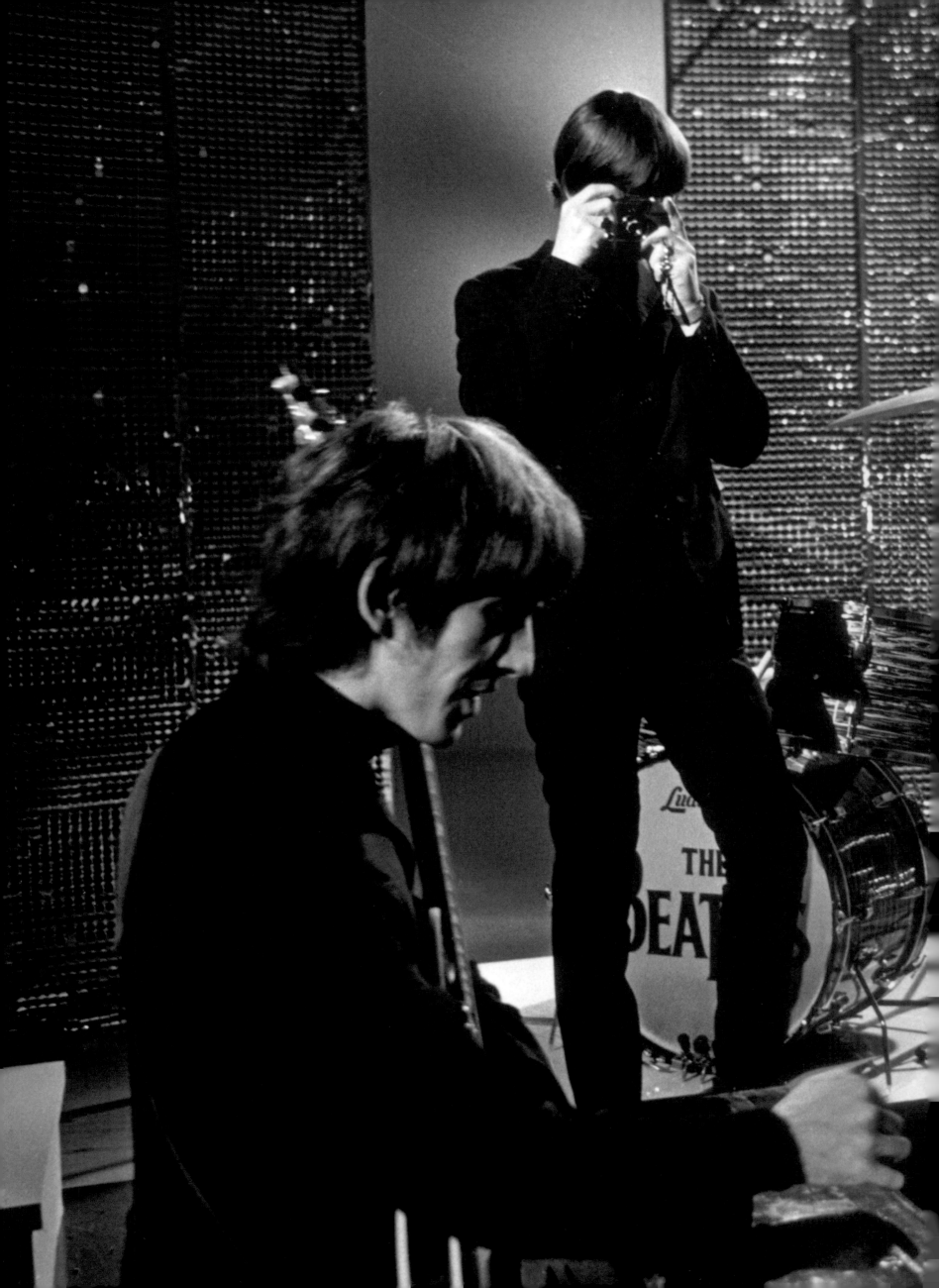

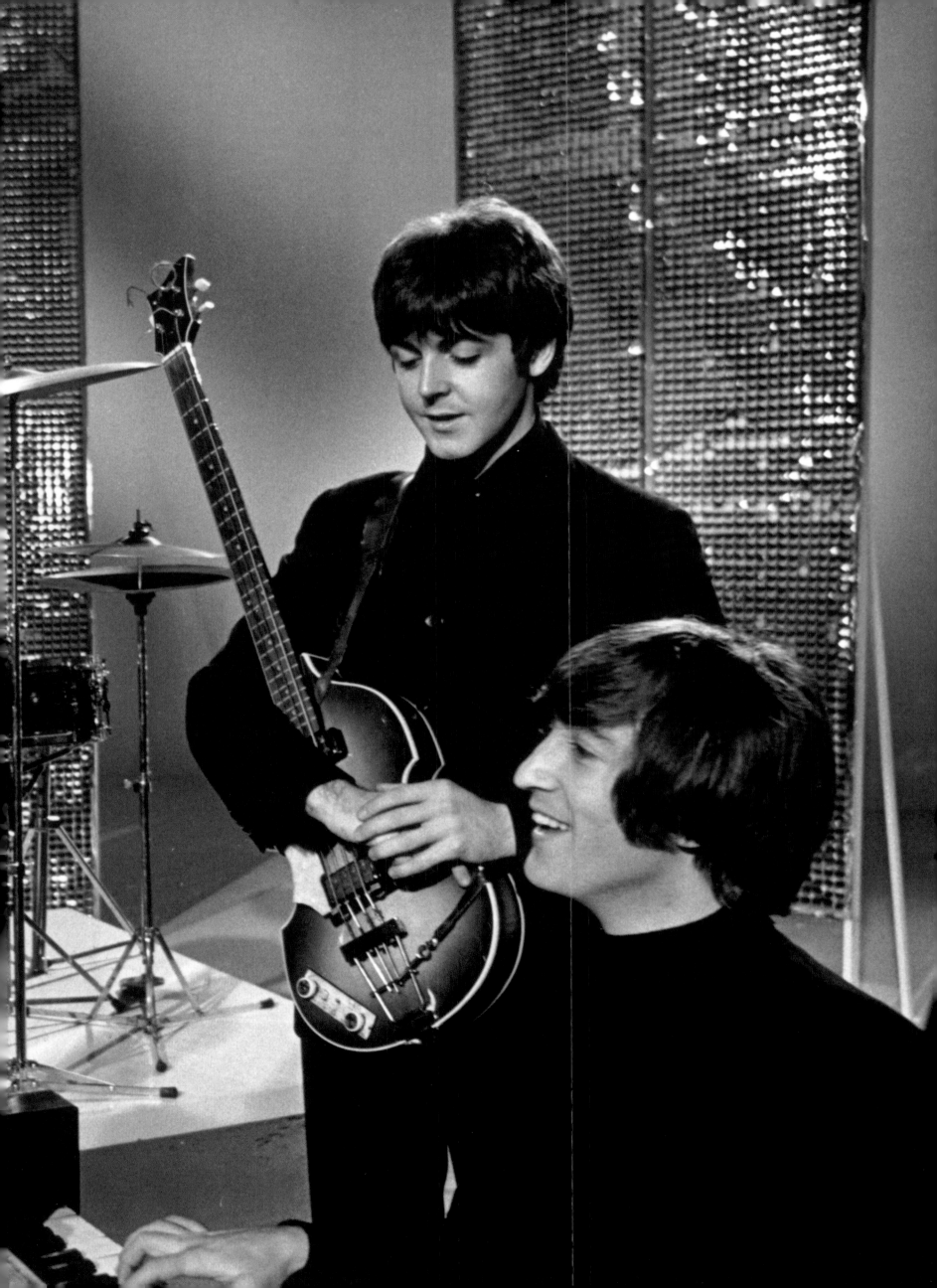

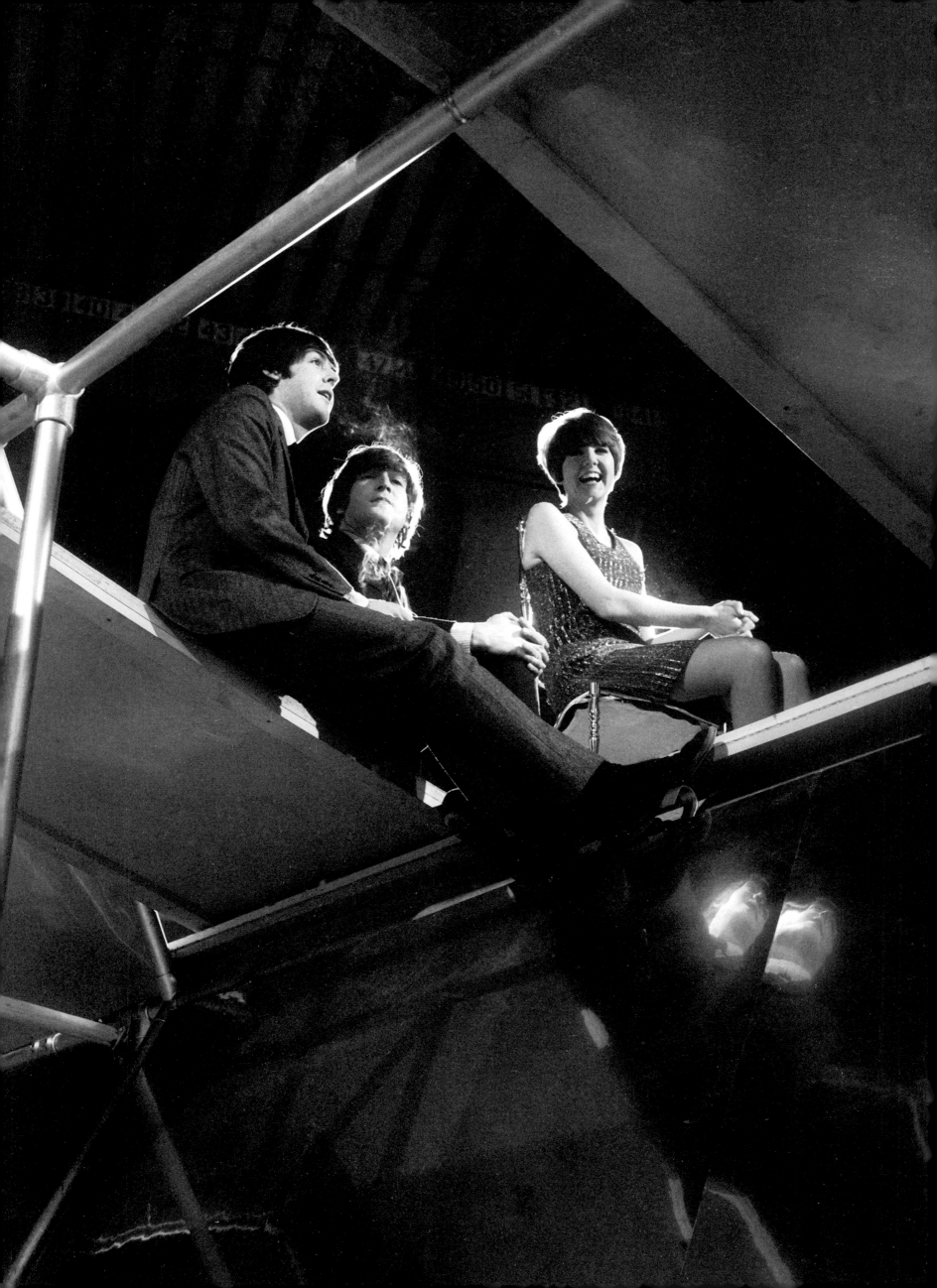

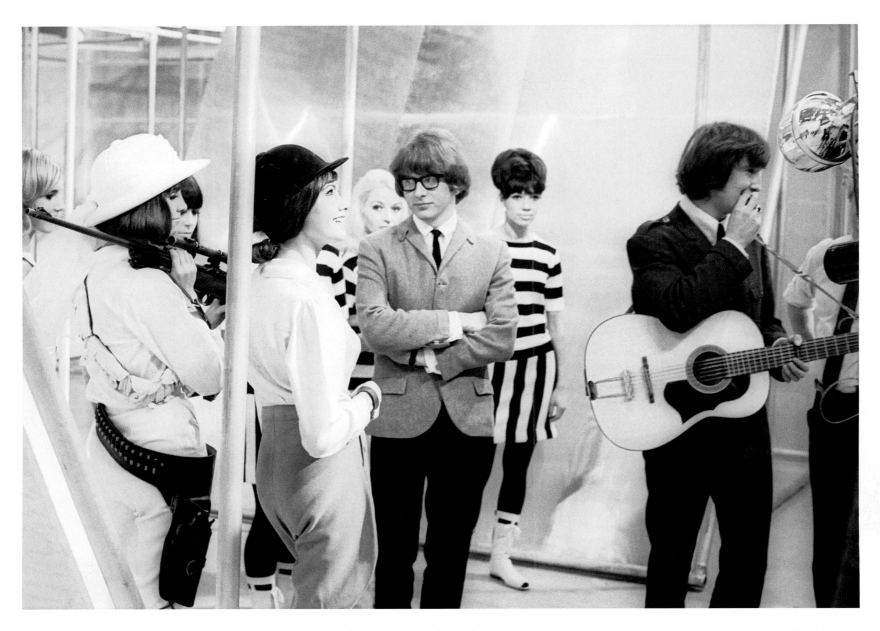

THE BEATLES were always Liverpool loyalists, and Brian Epstein's stable at NEMS came to include not only such Merseybeat classicists as Gerry and the Pacemakers but the singer Cilla Black (opposite, with Paul and John), who was introduced to Brian by her friend John Lennon. Also starring on this Christmas special was the twosome Peter and Gordon (Peter with glasses, Gordon with guitar, above), and here, too, connections played a part: Paul was famously dating Peter Asher's sister, the lovely actress Jane Asher, and he gave P&G a song he had written in his teens, the ballad "A World Without Love," which became their first single and a No. 1 hit for the duo. It was all very cushy, back when it was all very cushy. On the following pages: A marvelous captured moment from the '65 special where the leg and boot at right say all you need to know about that place in time.

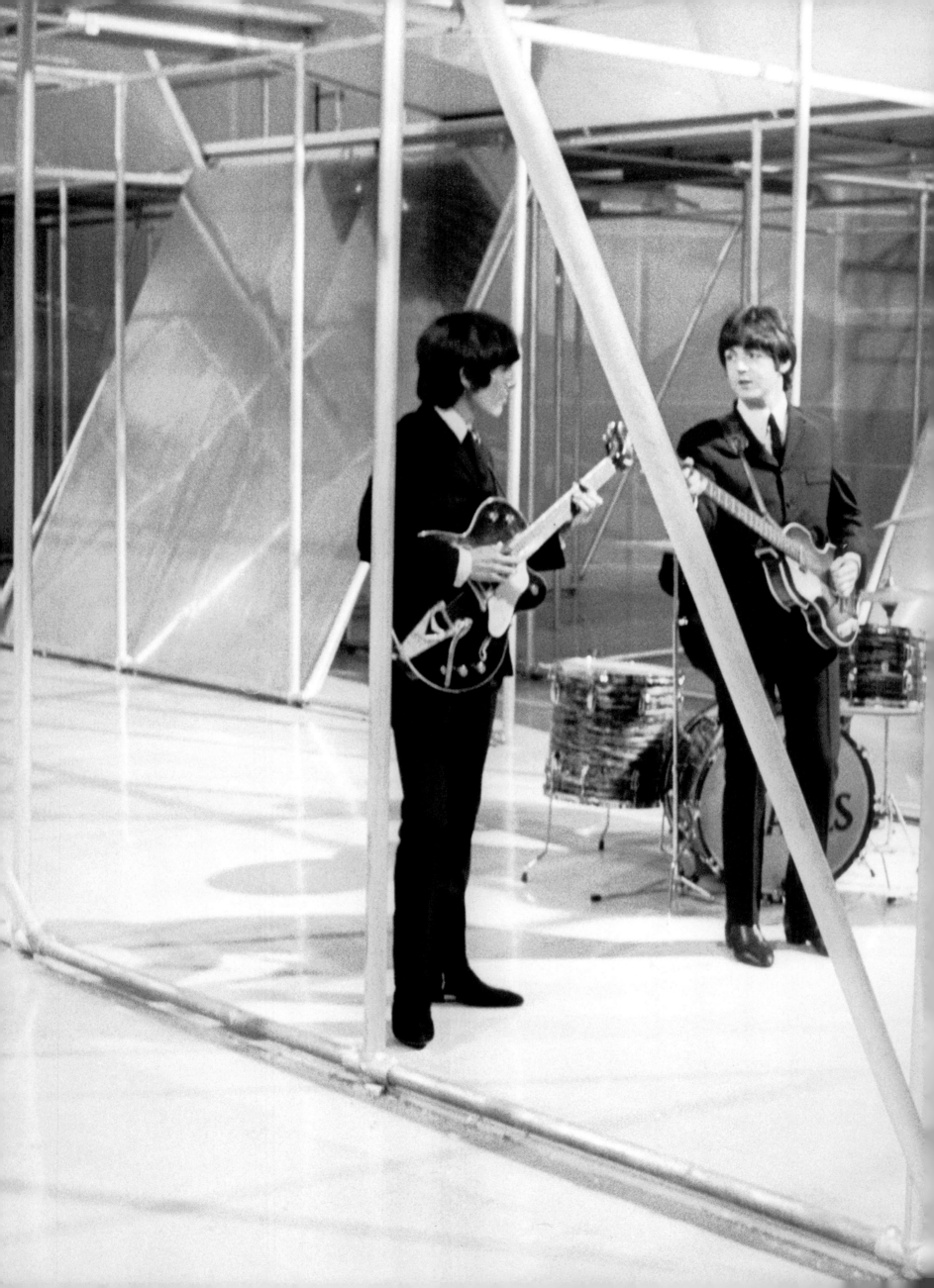

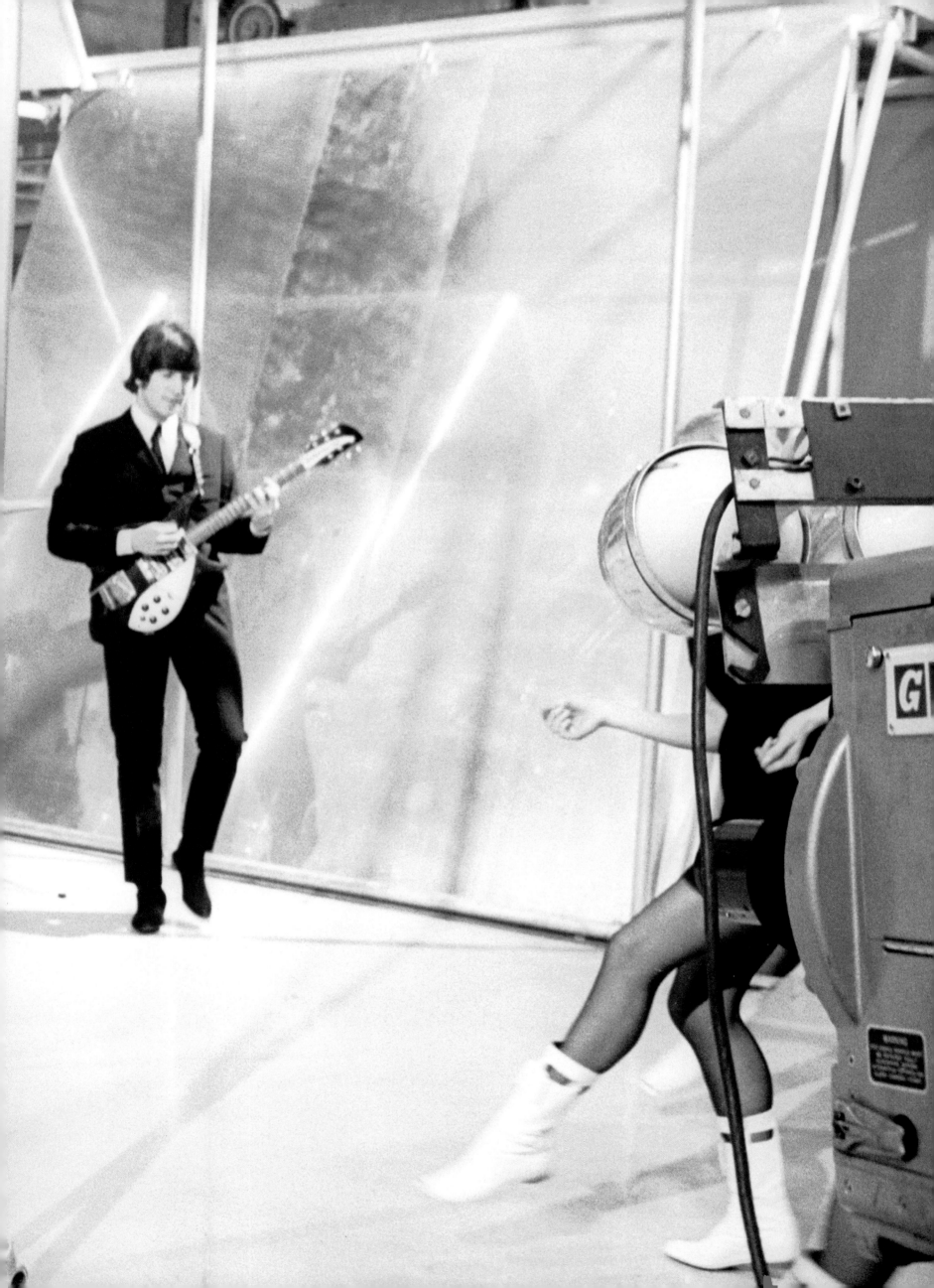

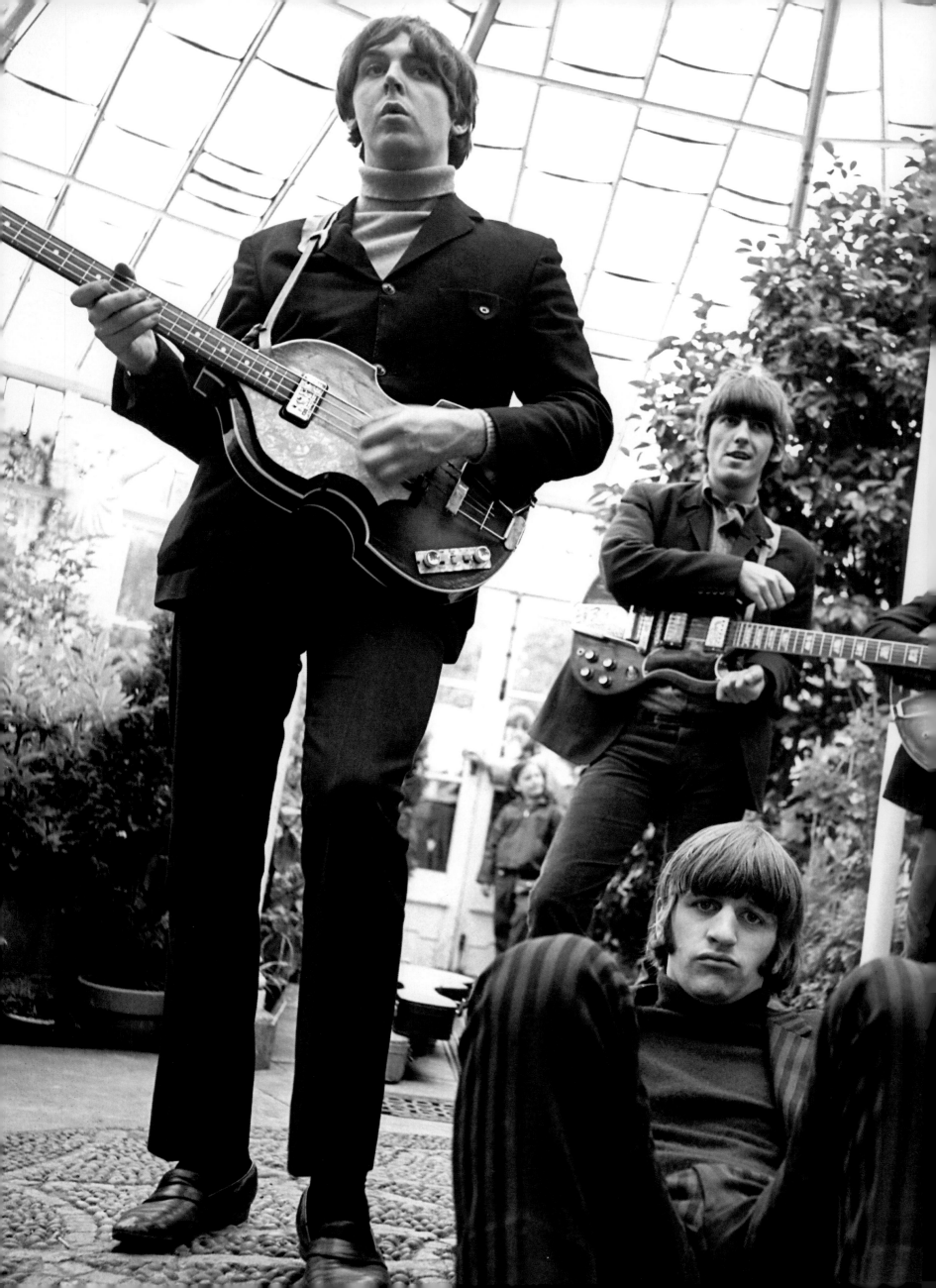

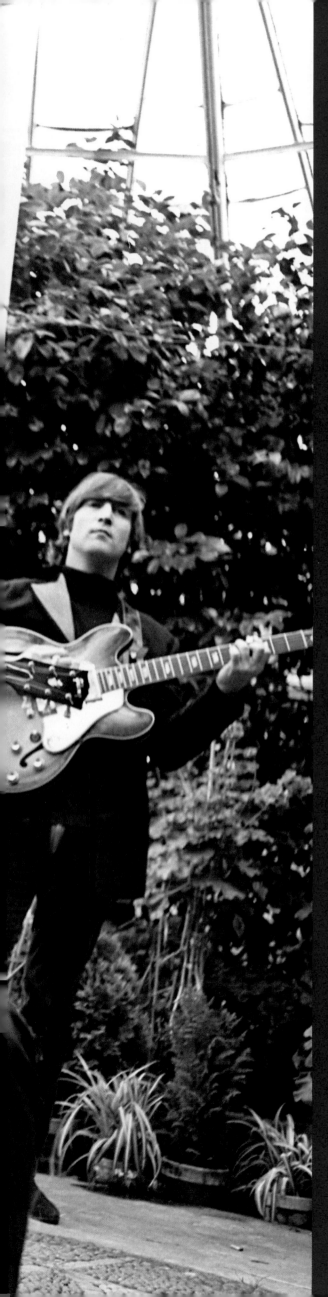

1966

As the wonder wore off, Whitaker still made images to be remembered—including his most famous ever.

PIONEERING YET AGAIN: The band here and on the pages immediately following are at the villa Chiswick House and Gardens in West London. So what's so cutting-edge about that? Sounds pretty fusty: *Chiswick House and Gardens.* Sounds like *Downton Abbey.* Well, they are there to shoot a short promotional film for "Paperback Writer" and its B-side, "Rain." (Or as John fans would say, "Rain" and its B-side, "Paperback Writer"; it was one of the great and entirely unique yin-yang, Lennon-McCartney two-sided singles, like "Strawberry Fields Forever" and "Penny Lane.") Anyway, the resultant films from Chiswick House later caused George to remark, "I suppose in a way, we invented MTV." Any surprise? They invented so much else. Why not that, too?

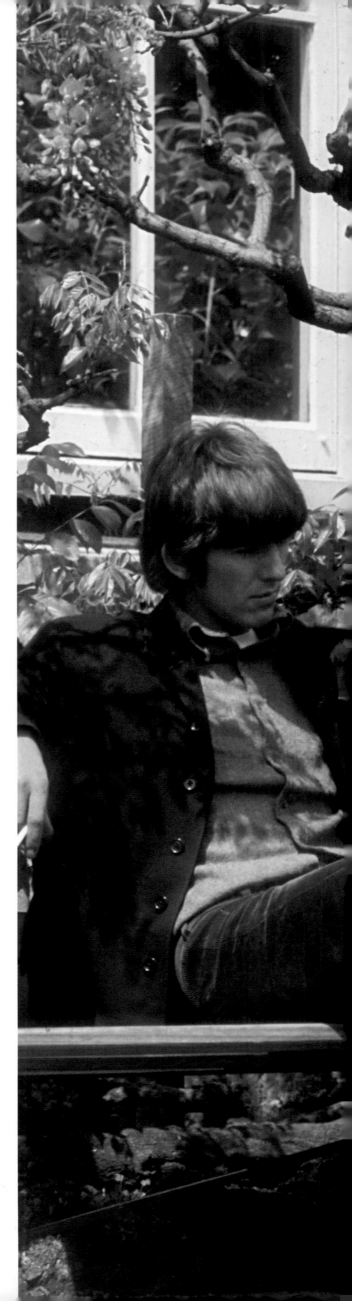

The enduring significance of Bob Whitaker's Beatles portfolio—the main thing that lends the whole of it an importance beyond being just a collection of rock star shots, which clearly it is not—is that he was there at the crucial time; he was of the same approximate age as his subjects; he spoke the same cultural language as John, Paul, George and Ringo; and he was equally as attracted to the power of the imagination as the Beatles were.

In this chapter, we will see the band tiring of the road, even as the global adulation grows more outsized—in fact, impossible to contain. As opposed to the conventional wisdom that the band "broke up" or "disintegrated," the band simply found its conclusion. Ringo later said, to LIFE and others, that as the pressure from outside grew greater in the mid-1960s, the band in fact became tighter, more insular. Yes, John and Paul would write their own songs, and yes, the recording of what would become known as the White Album was fraught, and yes, *Let It Be* was worse still. But even as they quarreled, the four of them had one another's back. As they ended their life as a concert act, they would hide together in bathrooms for relief, just to be with one another and no one else. They would tune up before a concert in a shower stall. In Tokyo, in 1966, they were imprisoned in their hotel, and Whitaker alone could go outside since he was not, after all, a Beatle. It was crazy, sure. And it was clearly an unsustainable—an untenable—life.

Before Bob Whitaker would say farewell, and before the Beatles would retire from the road, following their concert at Candlestick Park in San Francisco on August 29, 1966 (thereby rendering the need for an official photographer not a need at all), Whitaker and the Beatles would collaborate on a few more interesting sessions, including their most famous. Is it unfortunate, or inevitable, or something in between that Robert Whitaker is best remembered for the "butcher" cover. He did lots of other interesting and out-there stuff—all the photos that were cobbled together for the *Revolver* sleeve, all those that became part of *Disraeli Gears*—but it seems somehow natural, at the end of the day, that his association with the Beatles will forever be remembered for the butcher cover.

Whitaker didn't even know it would be a cover (albeit a short-lived one). The lads had come over, the lights were aimed, he had brought some slabs of meat and some dolls and some lab coats. It was 1966. Things were wacky. When one of the shots wound up on the cover of the American version of a compilation album called *Yesterday and Today,* Robert Whitaker was suddenly famous—infamous—and the Beatles, "more popular than Jesus," according to John in that season, were suddenly more infamous by half.

"Were you aware when you shot it that Capitol Records was going to use it as a record cover?" Whitaker was asked later.

"No."

"Were you upset when they did and then when they pulled it and replaced it with another photo?"

"Well, I shot that photo too, of them sitting on a trunk, the one they pasted over it. I fairly remember being bewildered by the whole thing."

Of course he was. It was a bewildering time. Nineteen-sixty-six, after all. Here is 1966: the final year Bob Whitaker and the Beatles would be together, and the last year the Beatles would be out in public. Whitaker was there for all of it. What a time it was.

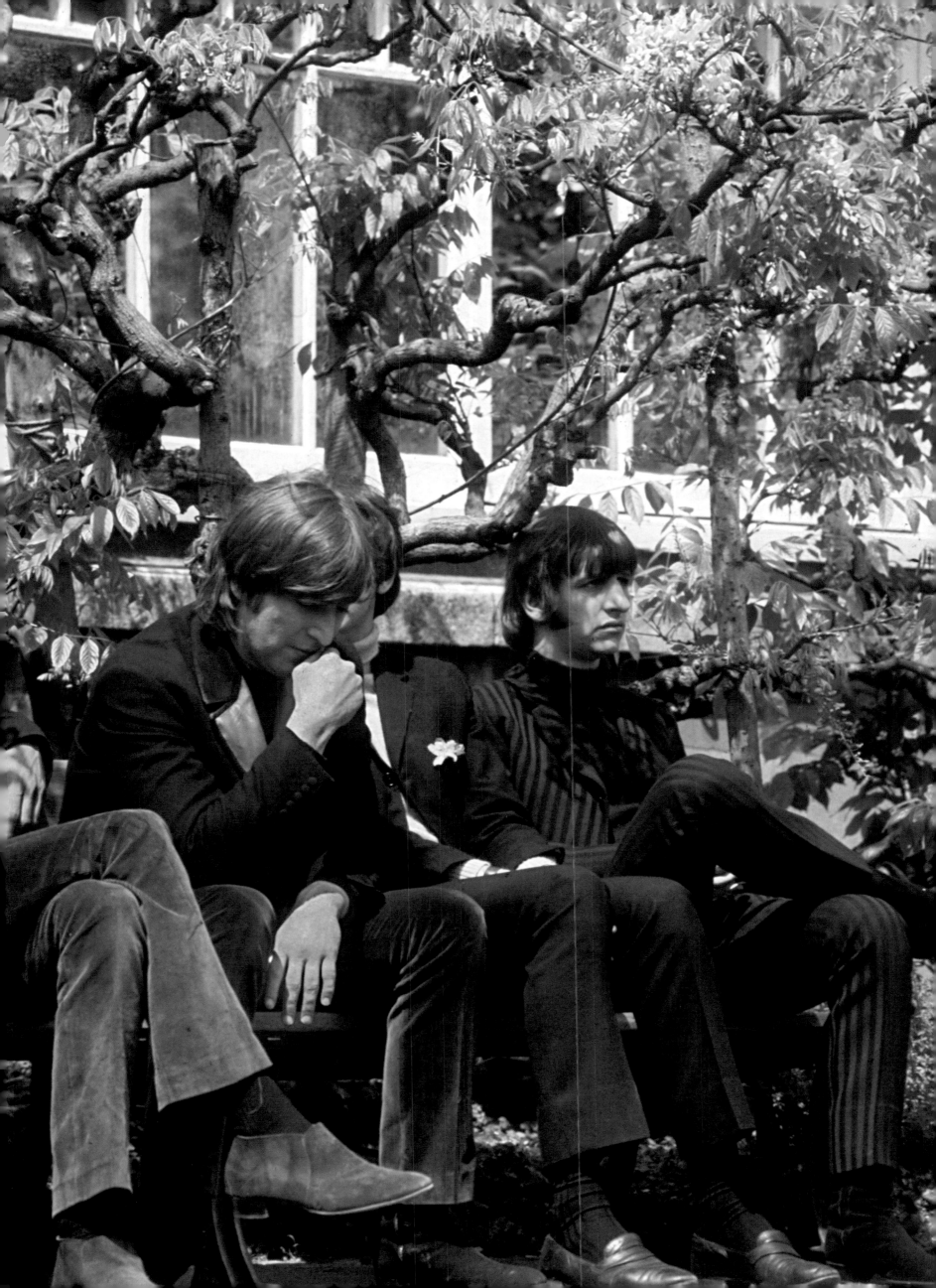

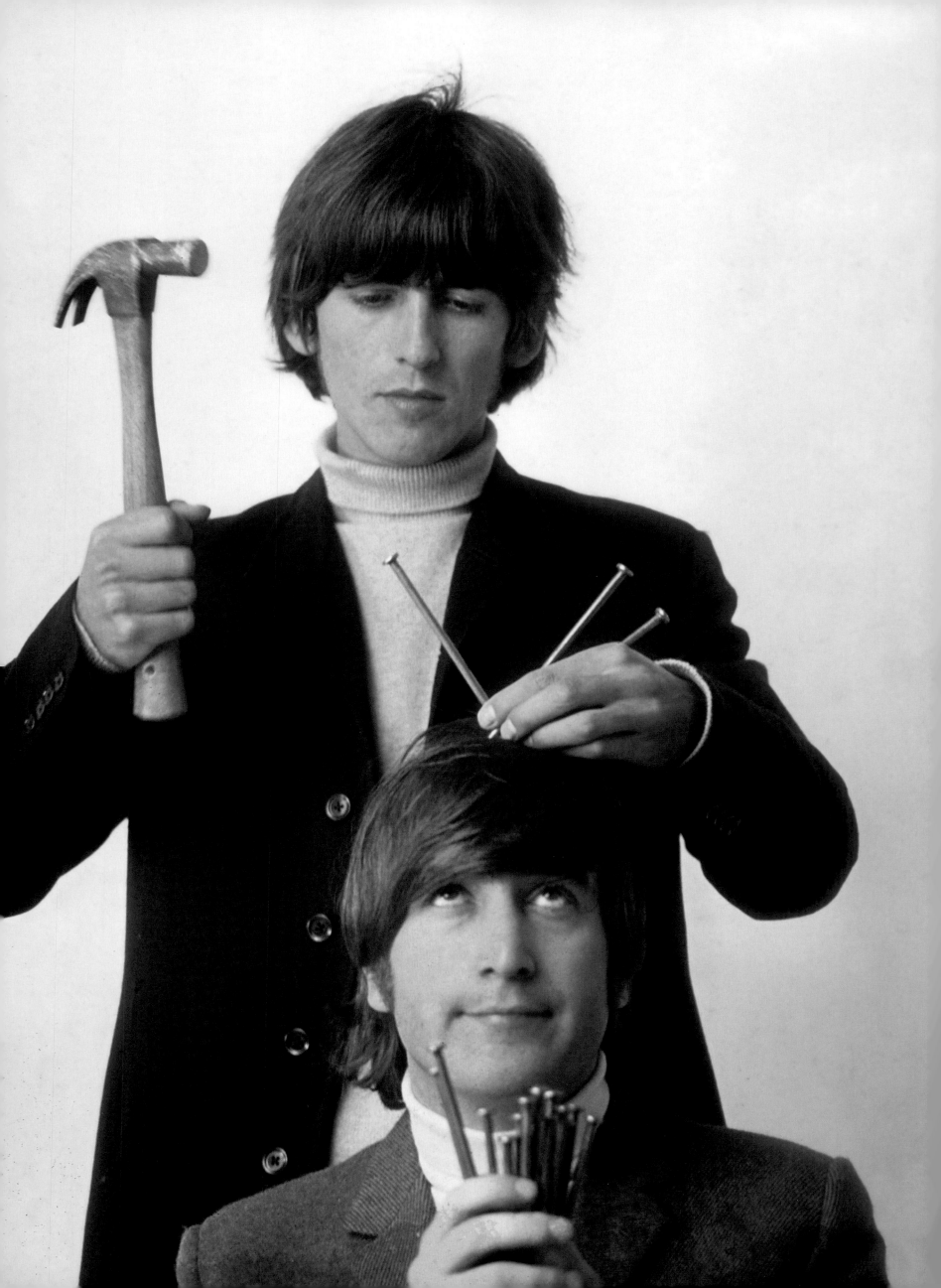

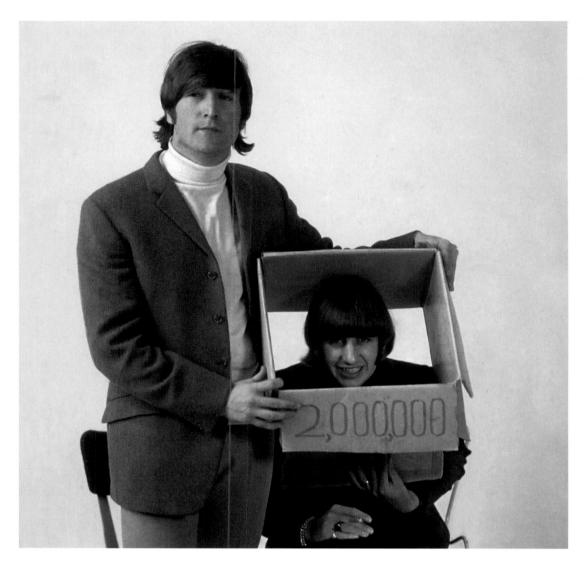

AS THE RAMONES, no associates of the Beatles (but certainly fans of them), later pronounced with great r 'n' r eloquence: "Hey ho, let's go!" That is to say, we have arrived at Bob Whitaker's most famous photo session, which he called the "Somnambulant Adventure." We start with nails and hammers and progress to . . .

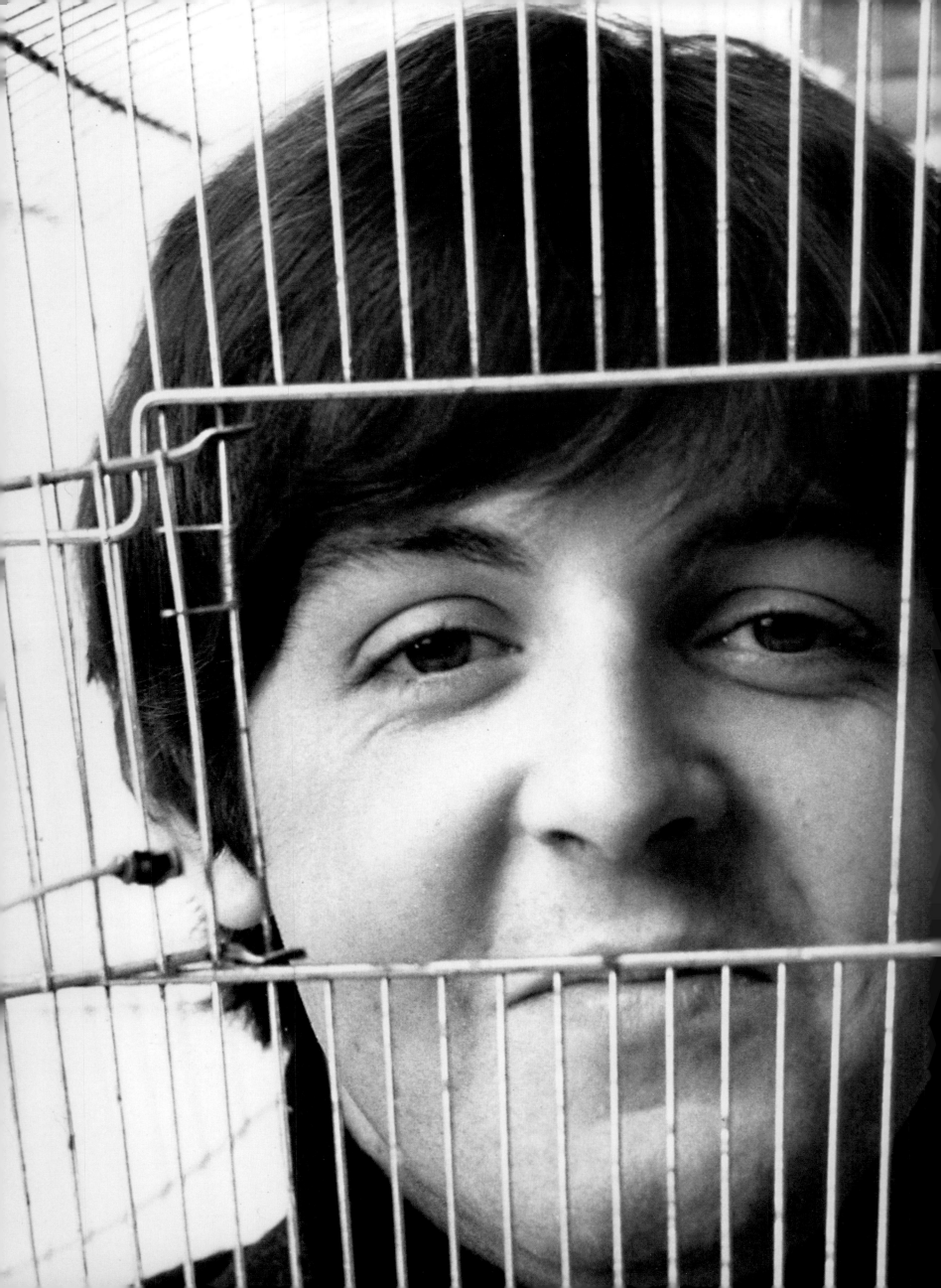

. . . WE PROGRESS

to birdcages! Paul is seen here, and George also tweeted during the session. Whitaker maintained that the photos he made that day were meant to express his view on the outsized worship of the Beatles. He wanted to "emphasize that even Beatles are flesh and blood like anyone else . . . I wanted to illustrate the idea that, in a way, there was nothing more amazing about Ringo than anyone else on this earth. In this life he was just one of two million members of the human race. The idolization of fans reminded me of the story of the worship of the golden calf." And also, with the birdcages, he wanted to say not only that these poor guys were imprisoned day-by-day, but that they "had beautiful singing voices—they literally sang like canaries." (A side note: One of the many fine songs on *Yesterday and Today* was "And Your Bird Can Sing.") On the following pages: One of Whitaker's contact sheets from the day, which can say as much as you want it to say, or as little—and sing as sweetly as you want it to sing.

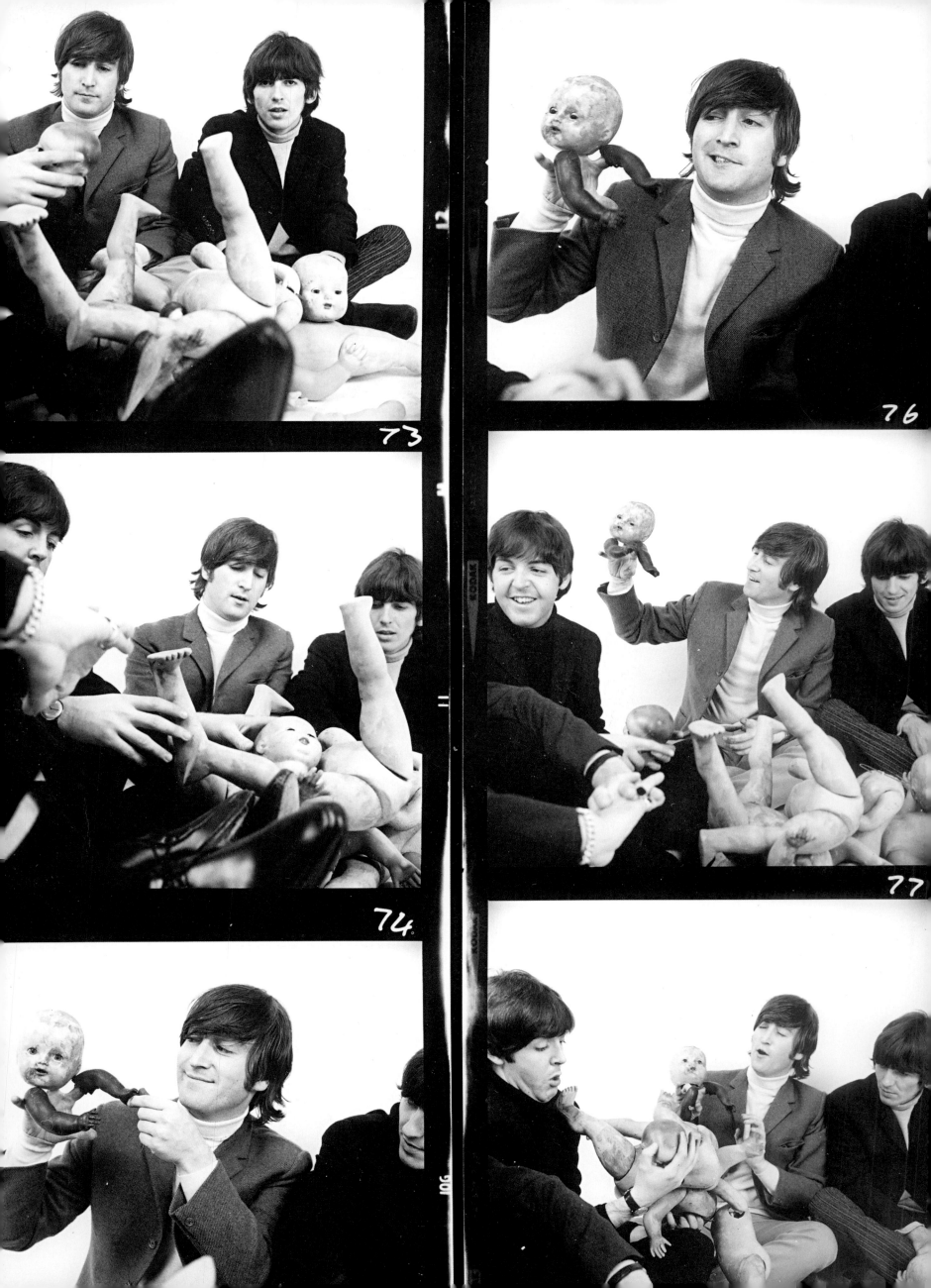

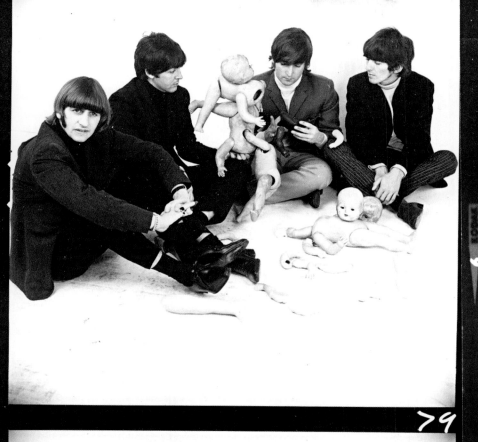

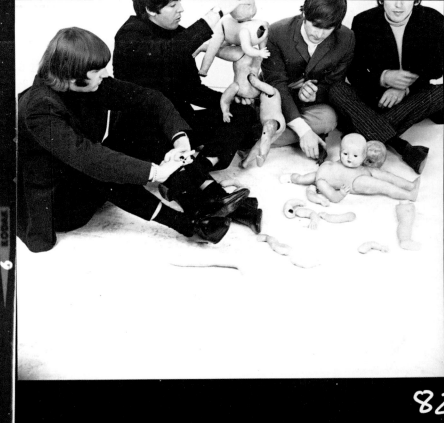

82

79

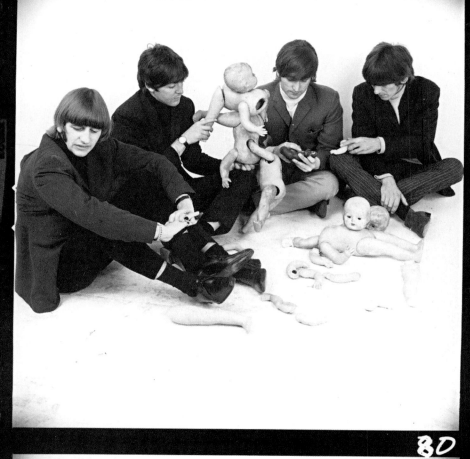

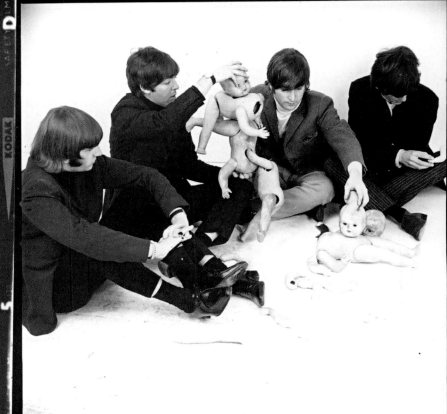

80

83

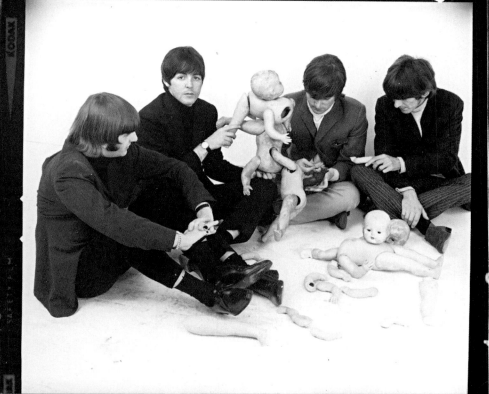

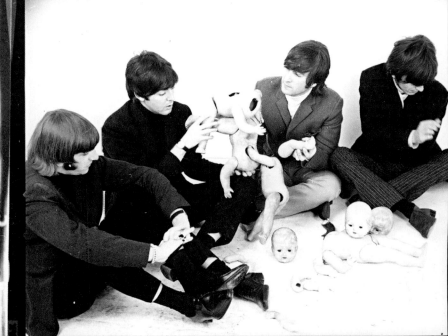

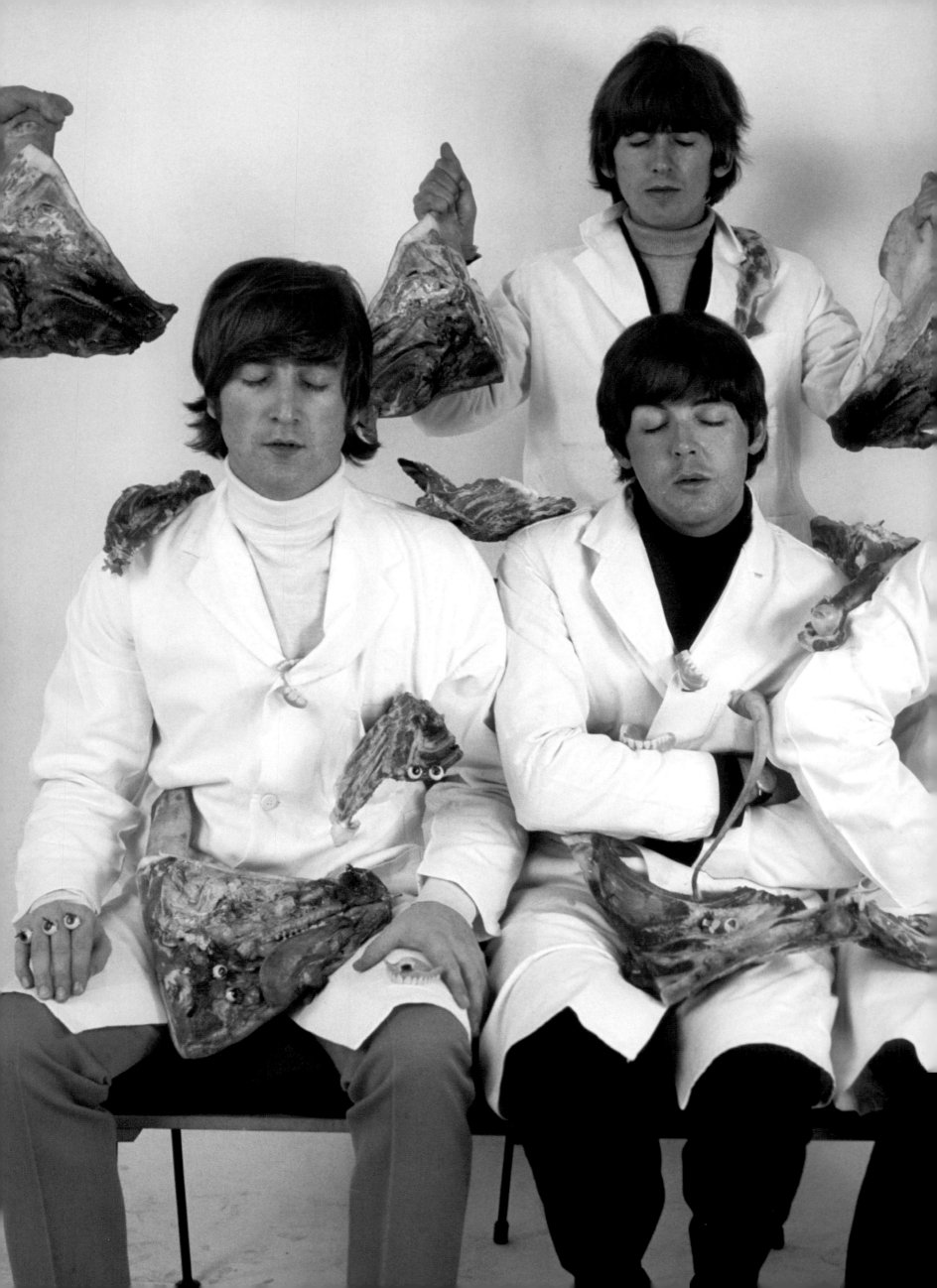

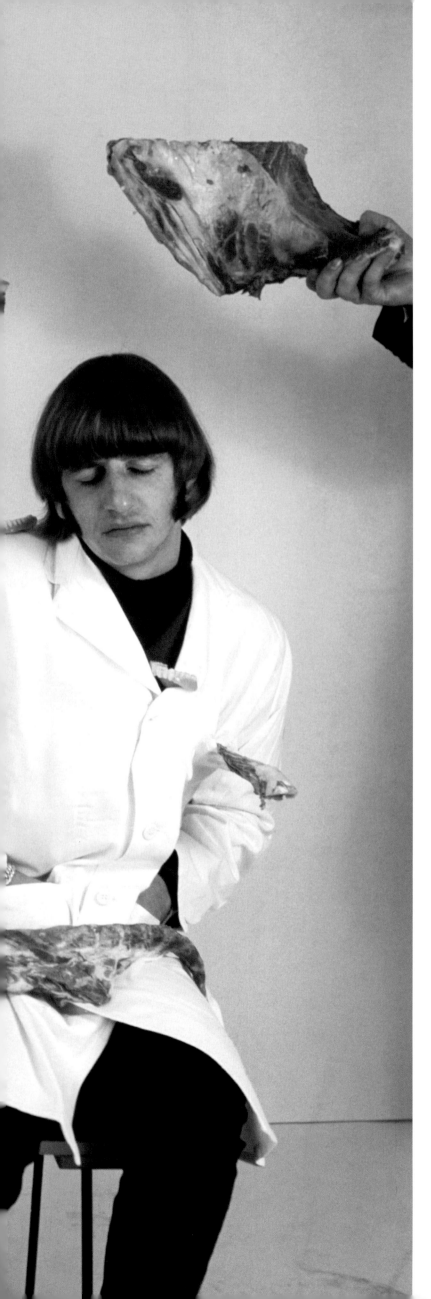

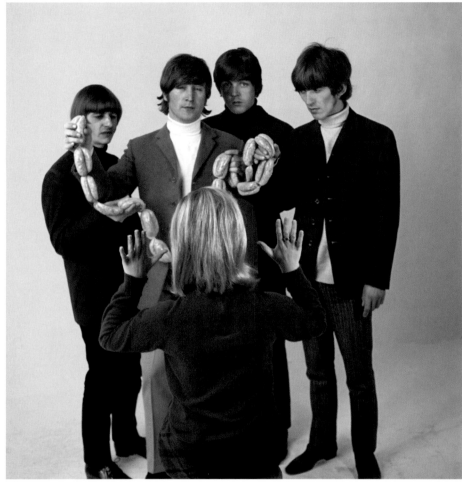

AFTER A WHILE, the going got weird. Make that: even weirder. Whitaker had brought more than a few sausages, which, you see, represented umbilical cords, which hearkened to, you see, the *birth* of the Beatles. That's Bob's take. And then there were all the dismembered dolls, which you'll enjoy on the pages immediately following. John and Bob had shared their psychedelic moments before, and maybe John was into it, but initially this wasn't going very well. The poses felt "stupid" to the collective, as Bob Spitz wrote in his definitive biography of the band. "Eventually, however, the Beatles 'got into it' smirking like schoolboys when Whitaker placed four decapitated dolls in between each of them and handed them the heads." Ha, ha, ha. Jolly good fun.

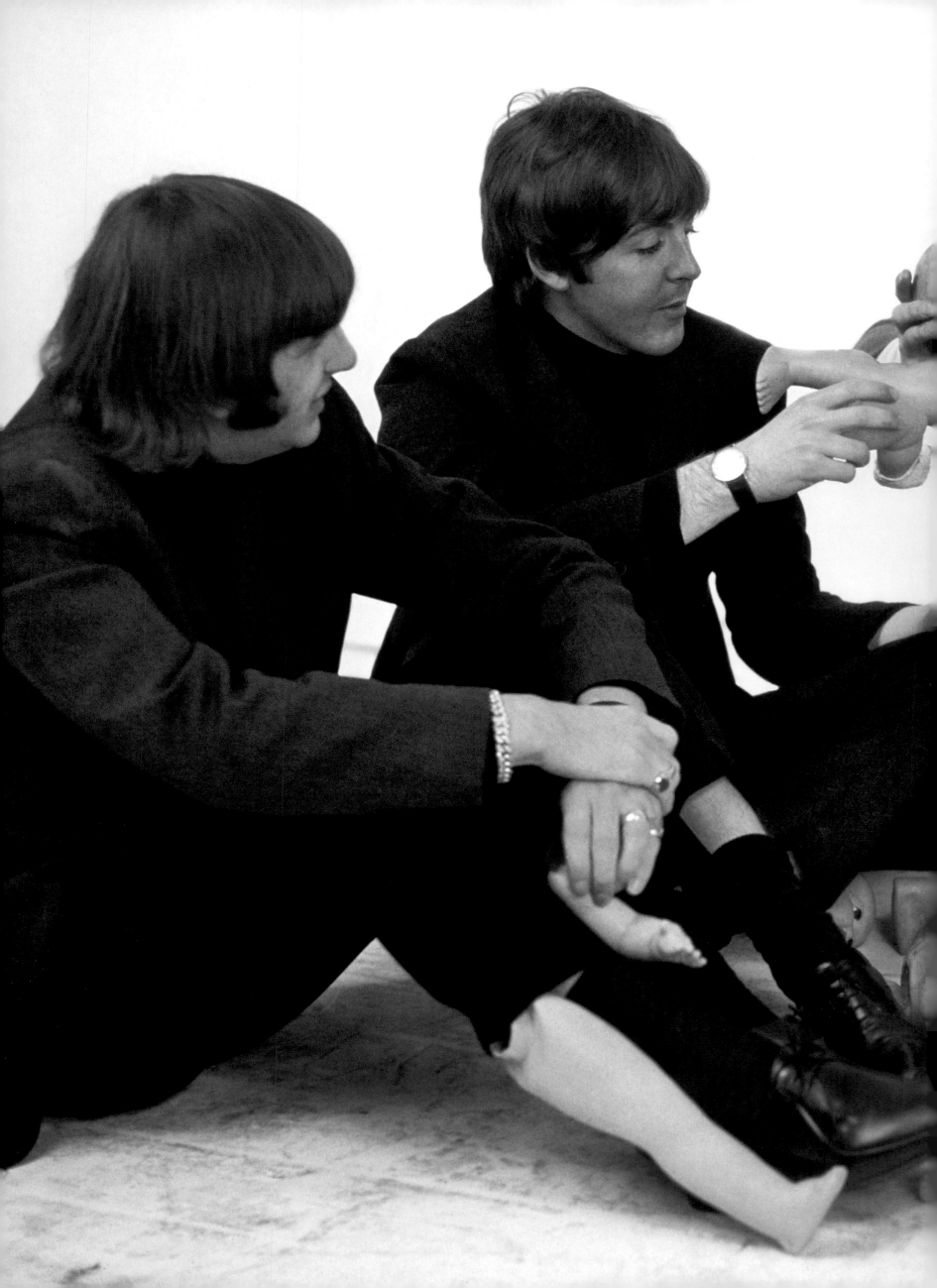

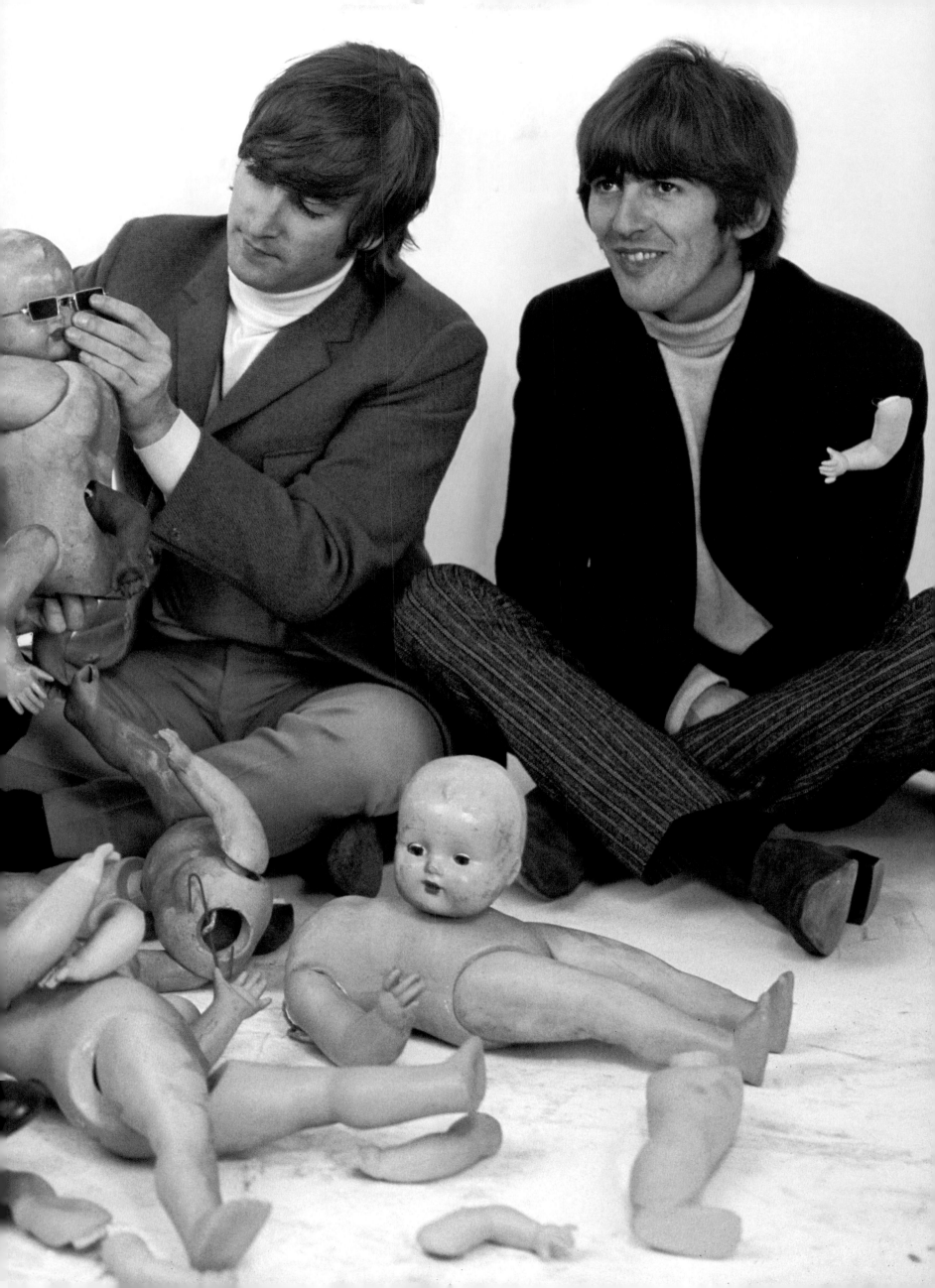

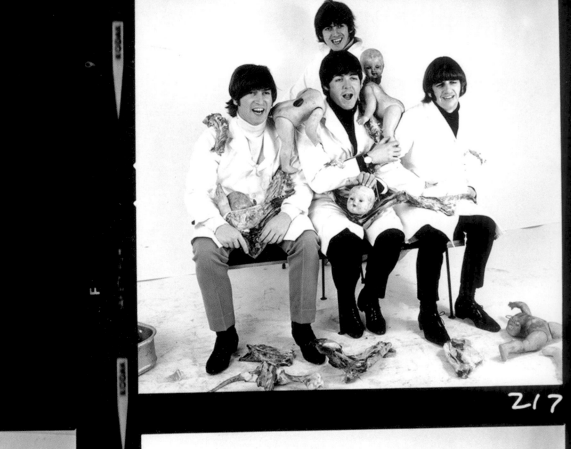

217

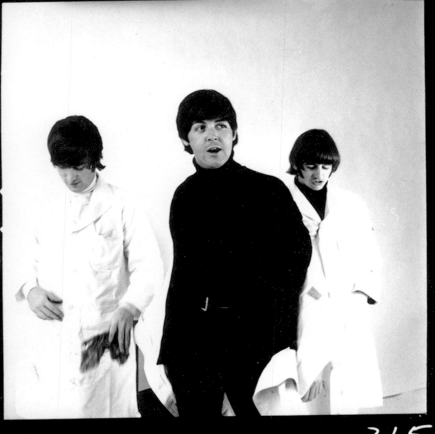

215

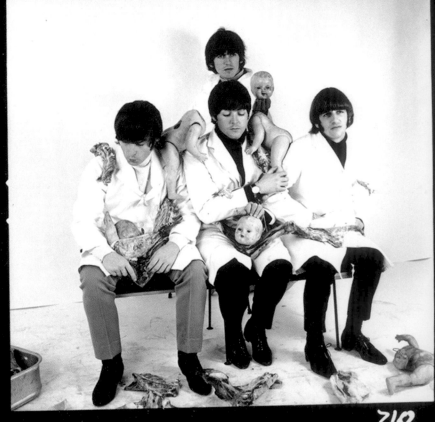

216

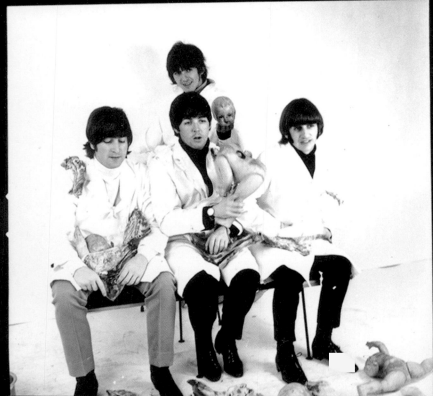

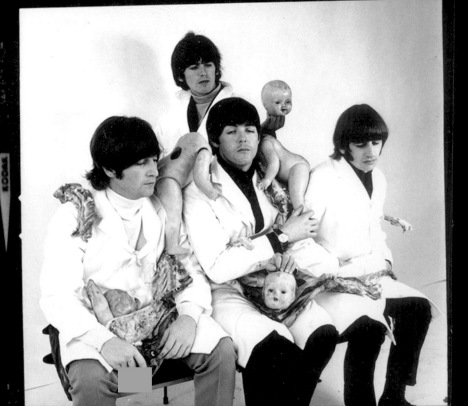

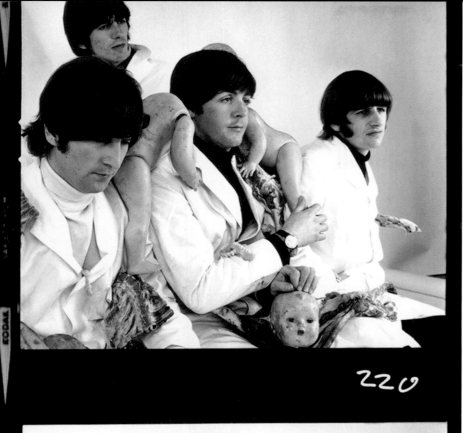

220

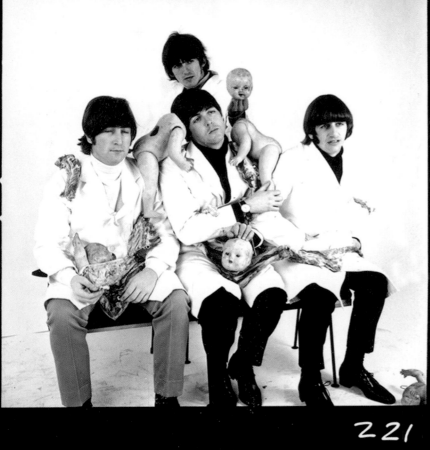

221

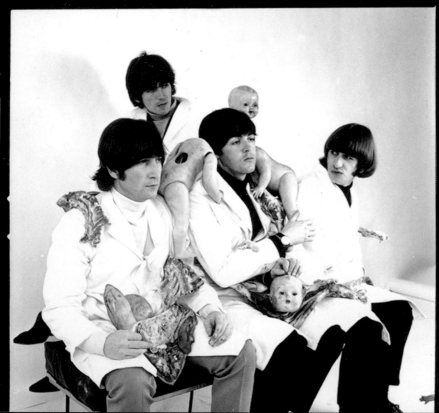

THE BEATLES and Bob Whitaker were headed for "an incident," or "an episode," or . . . *something*. It is remembered today as the "butcher shot" or the "butcher cover," but back in the whirlwind day, it was remembered in the U.S. as "Did you see the cover of the latest Beatles album!?" The Capitol record company in the States was still cobbling together collections of Beatles hits rather than letting the LPs speak for themselves, and the latest, anchored by the biggest hit of all time, was going to be called *Yesterday and Today*. For a short while, everyone thought it would be cool to use one of Whitaker's butcher shots on the cover. Then the meat hit the fan, and Capitol pulled any copies still out there. The cover was replaced by a photo of Paul in a trunk with the blokes sitting and standing around (both covers can be seen on the following pages) that Whitaker shot in Brian Epstein's office in London when desperately searching for something. Anything! He always felt it was one of his more insipid Beatles photos. The postmortems on the butcher cover will never be reconciled. We know what Whitaker thought he was doing in that session—all that pressures-of-fame stuff—and John Lennon, years later, said the cover "was inspired by our boredom and resentment at having to do *another* photo session and *another* Beatles thing . . . We were sick to death of it . . . that combination produced that cover." The legend has it that John, the edgiest Beatle, insisted it be used by Capitol. But actually it was, by some accounts, Paul who was firm that it should be used in the States, as it was clearly making a statement about the Vietnam War. It was a strange time, 1966. The Beatles were in the thick of it.

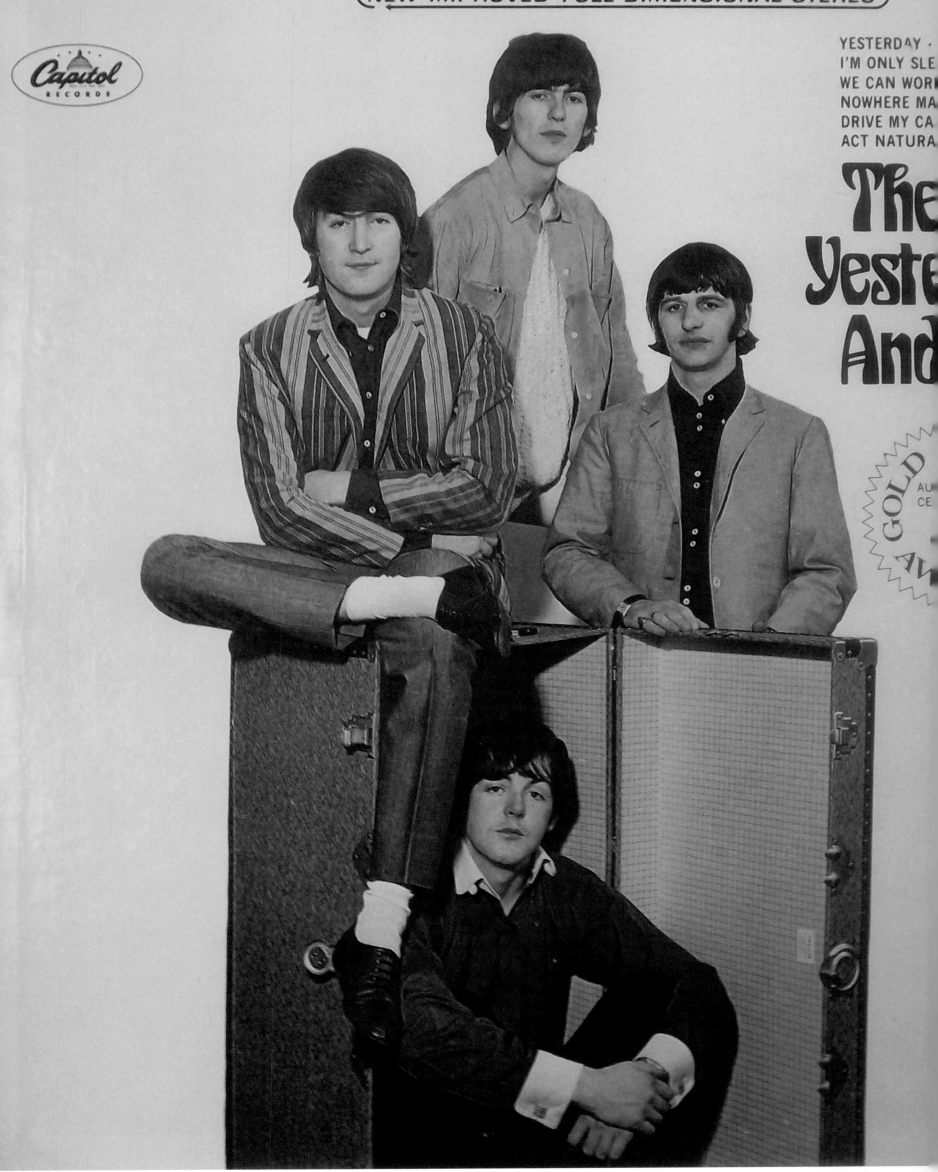

NEW IMPROVED FULL DIMENSIONAL STEREO

Capitol
RECORDS

YESTERDAY ·
I'M ONLY SLE
WE CAN WORK
NOWHERE MA
DRIVE MY CA
ACT NATURA

The
Yeste
And

A GOLD
AW

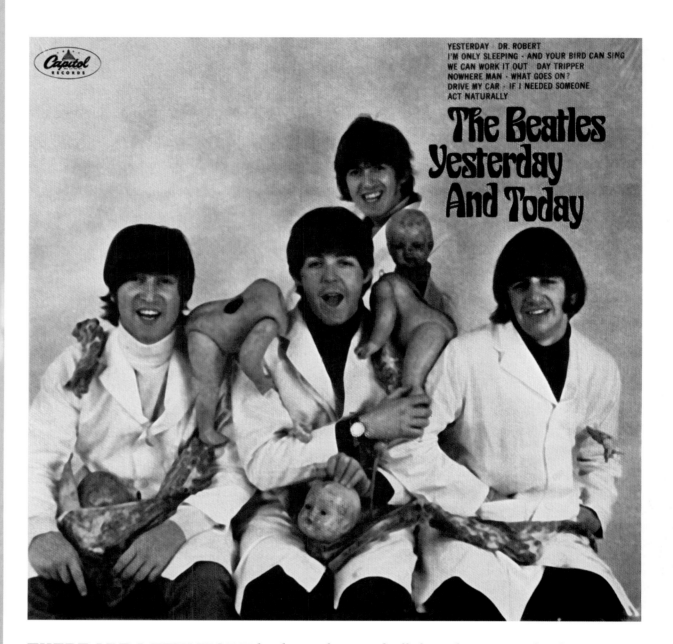

THERE ARE A FEW MORE fun facts to know and tell about the notorious butcher cover (above). It never did get a Gold certification badge as did its replacement (opposite), of course. Interestingly, the photograph was used elsewhere before appearing on *Yesterday and Today* in the U.S. and Canada, and didn't cause any stink. The Beatles used the same shot in promotional advertising for "Paperback Writer" in the United Kingdom, and no one raised much of a fuss, so when the picture was shipped across the Atlantic, nobody in the Beatles camp was particularly worried. It was only when the record hit the stores in the polyglot United States that some customers and dealers recoiled, and Capitol very quickly backtracked. John did side with Paul in defending the shot's use: "It's as relevant as Vietnam." But lots of money was at stake, Capitol made its decision, and the album shot to No. 1. Although the 750,000 butcher covers were printed, far fewer, as indicated earlier, were actually distributed on a record sleeve; Capitol ordered its printers to ditch the covers as soon as controversy arose. Today, sleeves that remain, with the disc inside, are prized collectibles. So-called "first state" covers—not ones that had had the trunk cover pasted over the butcher version—are particularly valuable. In the 1970s, a butcher cover might fetch a few hundred bucks, but in recent years there have been reports of sleeves, some still sealed in their original plastic, being auctioned for more than—believe it—$30,000. Lastly, as we leave the Beatles/Whitaker butcher episode behind, John once said that he had suggested an even better idea for the cover: Cut Paul's head off. Paul demurred. Down the road, that really would have become Exhibit 1A for the Paul Is Dead conspiracy theorists.

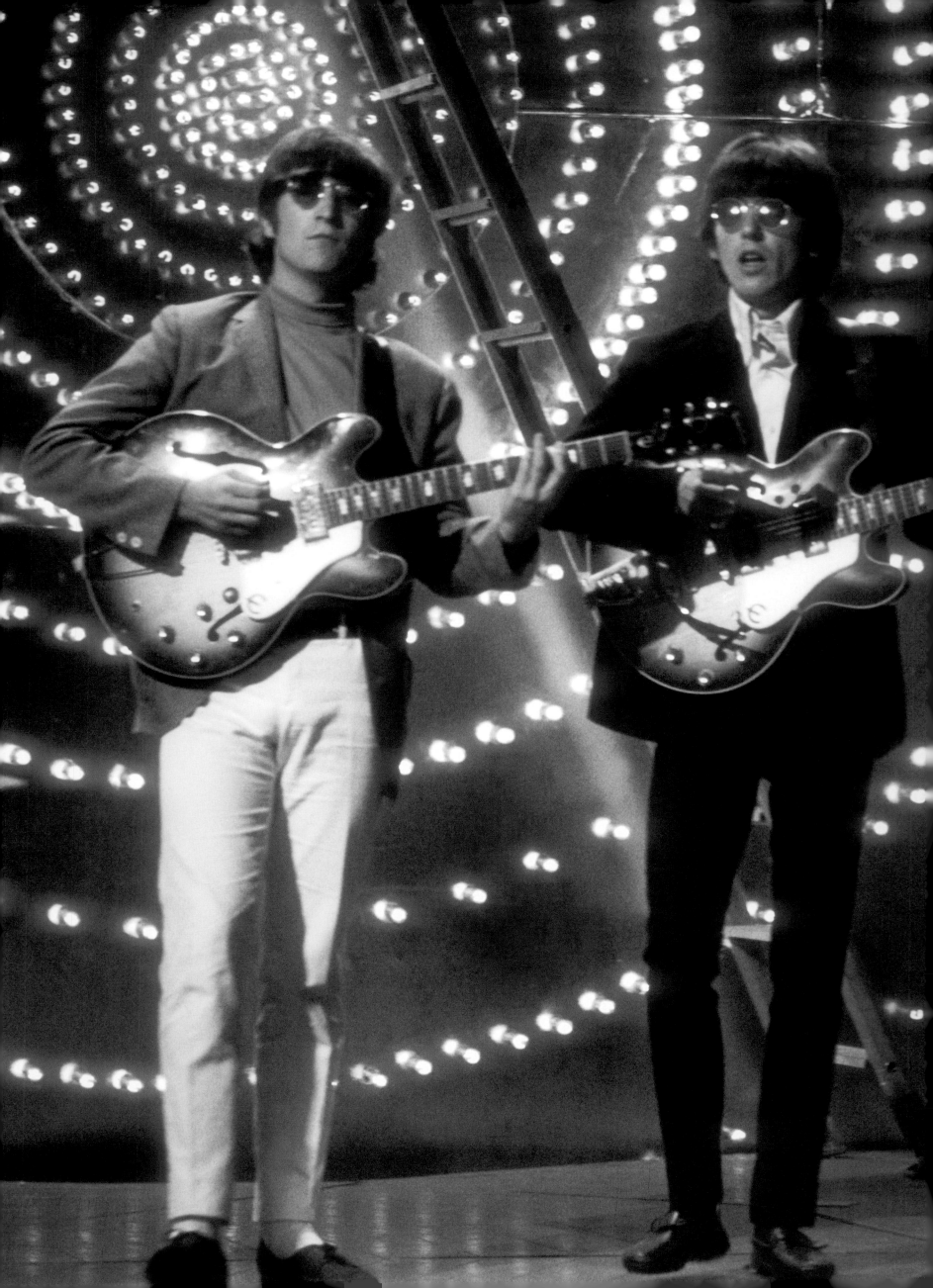

HERE ARE JOHN and George playing live on the English music TV program *Top of the Pops*. This was a "chart show"; you can regard it as a Brit *American Bandstand*. Although it was televised live, the singers lip-synched their tunes. The Beatles certainly were not above this; they were thoroughly engaged in stoking the star-maker machinery behind the popular song—they were engaged in becoming as famous as humanly possible. Because of shows like *Top of the Pops* and *Ready Steady Go!*—plus the fact that they couldn't be heard over the crowds at their stadium shows—a conception has circulated in some corners that they weren't much of a live band. Nothing is further from the truth, and certainly some of the Beatles' ultimate frustration with touring was that they fully realized nobody was listening to them as they strutted their stuff. How good were they? The Beatles' early front line of John, Paul and George, first with additional guitarist Stu Sutcliffe (who would leave the band before dying young) and with Pete Best, replaced by Ringo, on drums, had honed their craft during raucous gigs at Liverpool's Cavern Club and endless, drug-fueled sets on Hamburg's rough-and-tough Reeperbahn. They evolved between 1960 and 1963 into what can be seen as one of the world's earliest, and certainly tightest-ever, punk bands (way before that was a term). John once said, "I was raised in Liverpool, but grew up in Hamburg," and George averred that he felt the shows the Beatles played in Hamburg were perhaps their best-ever for a live audience. Despite the miming on *Top of the Pops* and other shows, there is solid evidence of how musical and exciting the Beatles were in this period. Once they had become the toast of London, they regularly dropped by the studios of the British Broadcasting Company to entertain their fans. Some cognoscenti consider *The Beatles at the Beeb* sessions to include some of the band's very best tracks—and not just live tracks either—of the early months and fast-moving years of the mania.

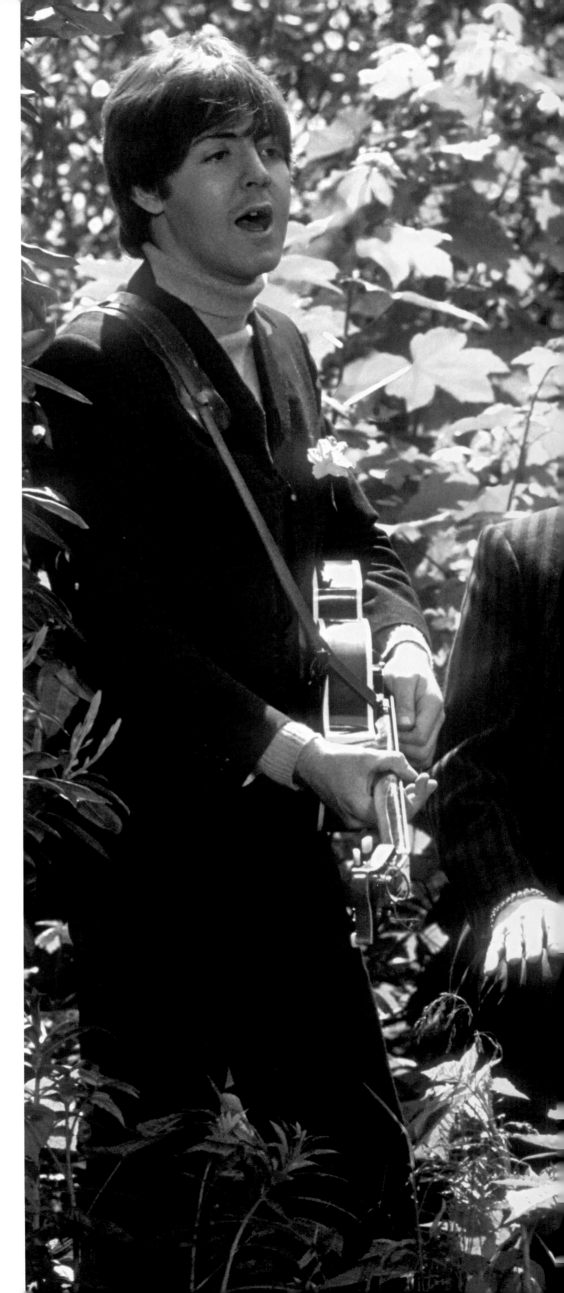

THE BAND, or their film crew, obviously felt London's Chiswick Park was a swell place—well, it was an available place, and it seemed nice, too. There they collaborated on historically prototypical music videos for the songs on both sides of one of their hallmark two-sided singles (that is, both cuts were rated the A-side; there was no B throwaway). Many of these singles, as mentioned earlier, featured a John song and a Paul song. In this portrait in the park and those on the following four pages, the band is at work on John's "Rain." (Okay, technically, "Rain" was considered the B-side, but Beatles lore and legacy is so deep now—so many years have passed, and aesthetic assessments have been made or rearranged—that "Rain" is largely considered the equal of Paul's "Paperback Writer," and thus precisely half of one of the finest Beatles Middle Period singles ever made. Interestingly, it was their only No. 1 hit in the U.S. that year, topping *Billboard* for two nonconsecutive weeks with—get this!—Frank Sinatra's "Strangers in the Night" interrupting.) Anyway: "Rain" was released in May of 1966 and was immediately stunning—it pointed directly to the innovation of the *Revolver* album, to arrive three months later. It's fun to note that "Rain" was inspired by a torrential downpour in Melbourne, of all places, where the band had found Whitaker in 1964; John said he hadn't seen it rain that hard this side of Tahiti, and then wrote about everybody complaining about the storm. Life on the road: You take what you're handed. As for who actually had the bright idea of foozling with the tapes and playing John's vocals backwards to create the weird soundscape that closes the cut, well, Lennon staked a claim, and so did producer George Martin. No matter who made the suggestion, the Beatles' studio games, which would inform everything thereafter and would change 1960s culture through psychedelia and all that attended, were firmly afoot. As revolutionary as such manipulation would prove to the music itself would be the music video. The Beatles made several promotional movies for "Rain." In one they walk and sing in the garden outside Chiswick House, as we see at right. The others were shot on soundstages. Of the Whitaker pictures on the following four pages, they clearly show George (first) and then John, sporting shades and enjoying their cigarette breaks during filming. The picture of George on page 201 became one of Whitaker's most famous, and one of the most famous portraits of Harrison. Aside from Whitaker's obvious play on the words, the irony of WAY OUT at the time concerned the fans being kept at bay by the Chiswick Park gate, while George is very much "in." The later irony was unknown by the fans in mid-'66: George already very much wanted a way out of Beatlemania.

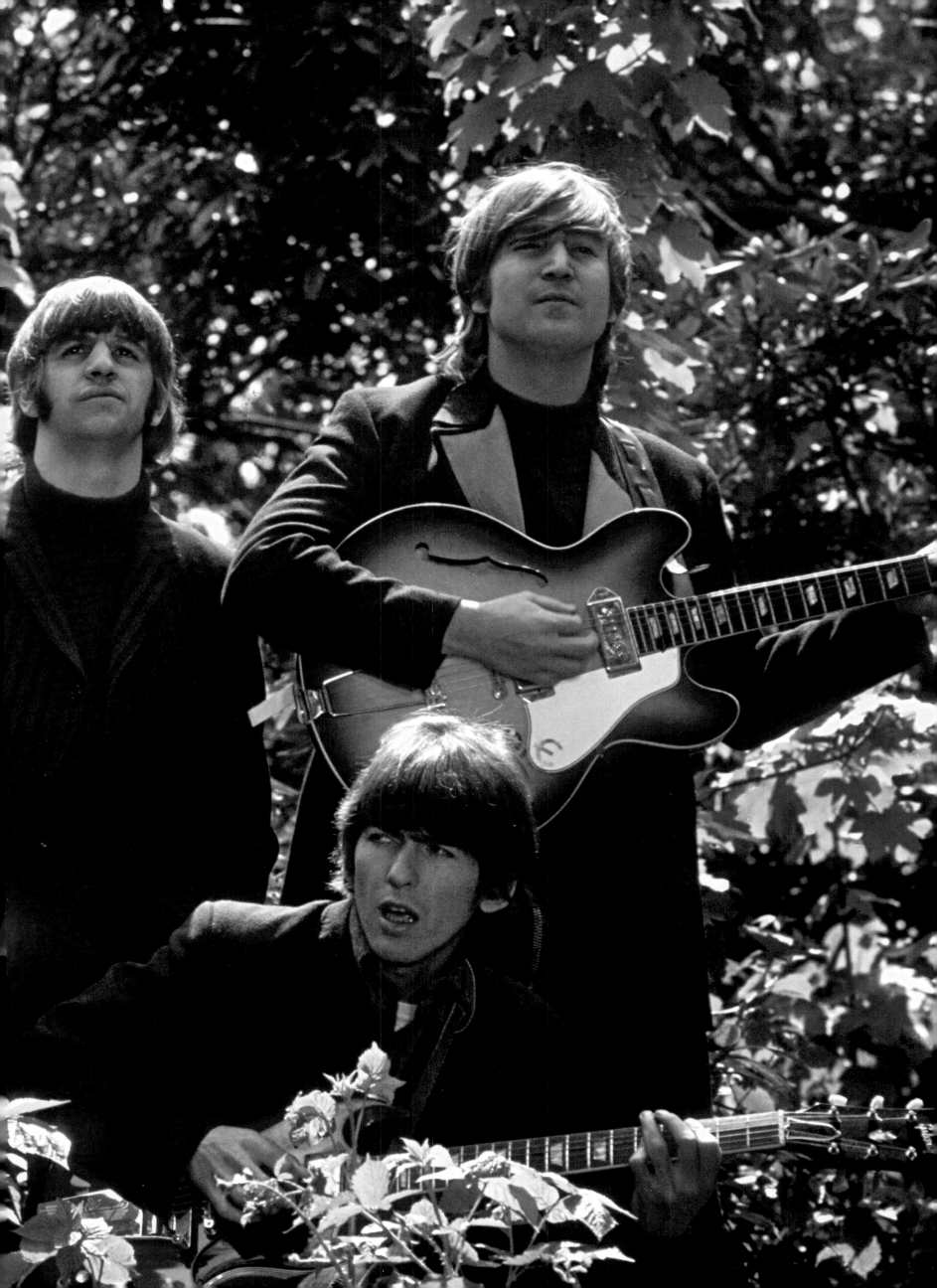

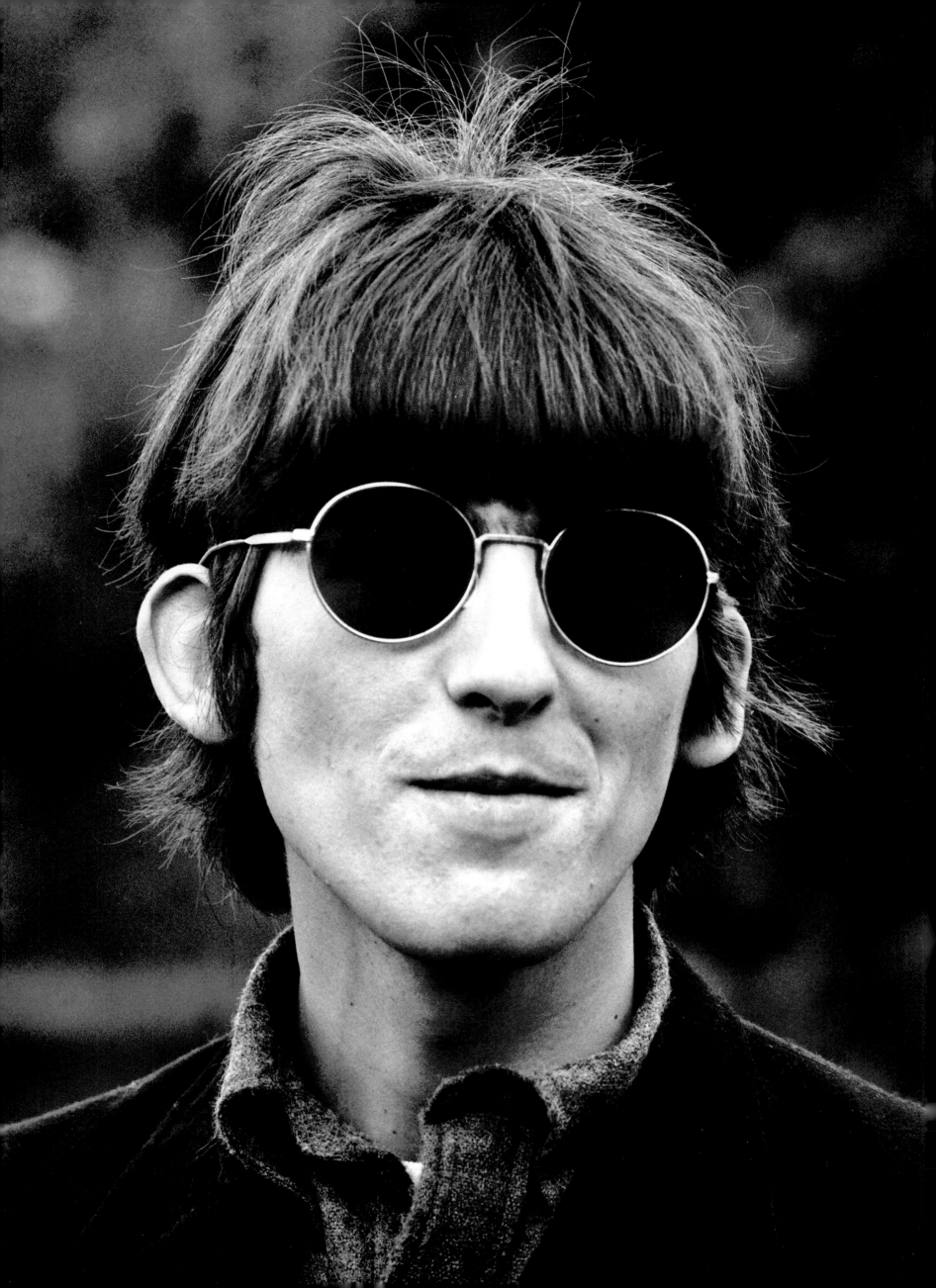

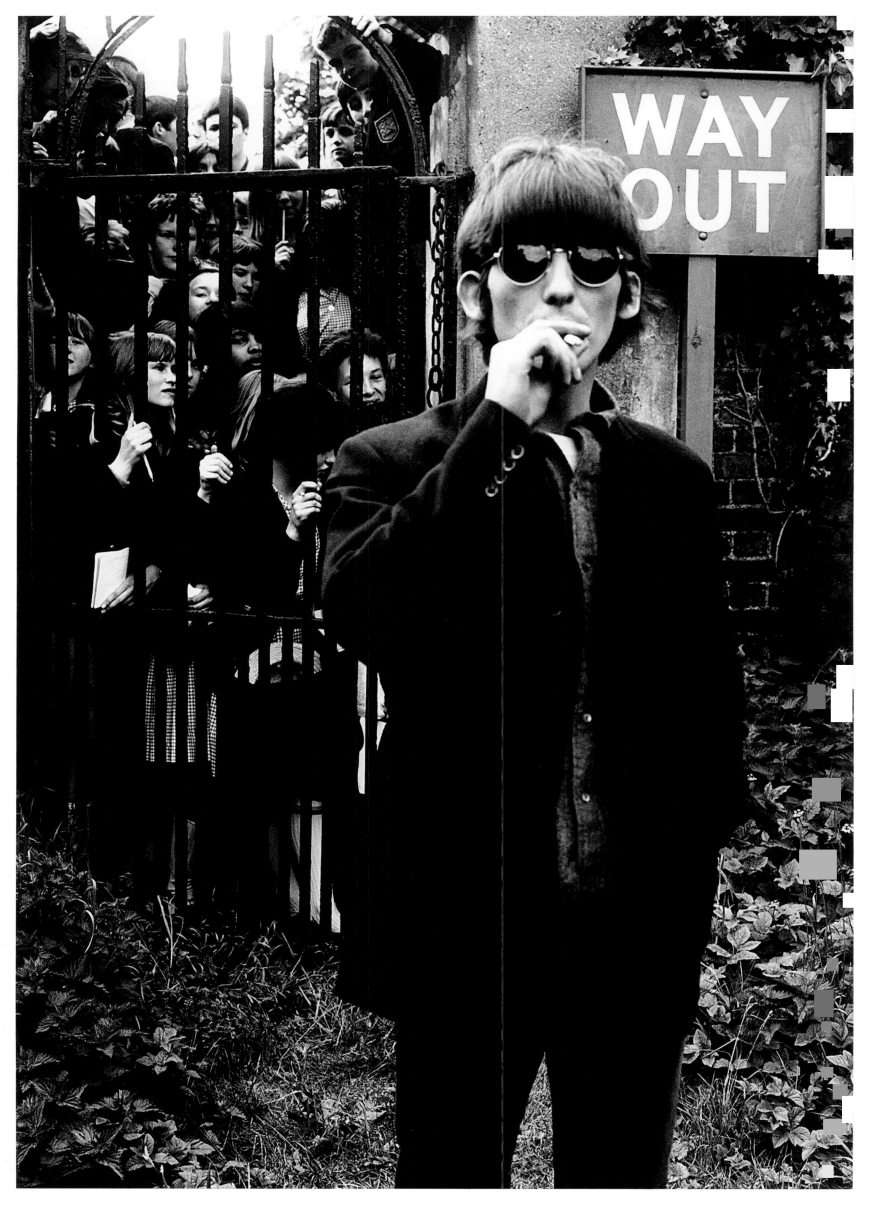

WAY
OUT

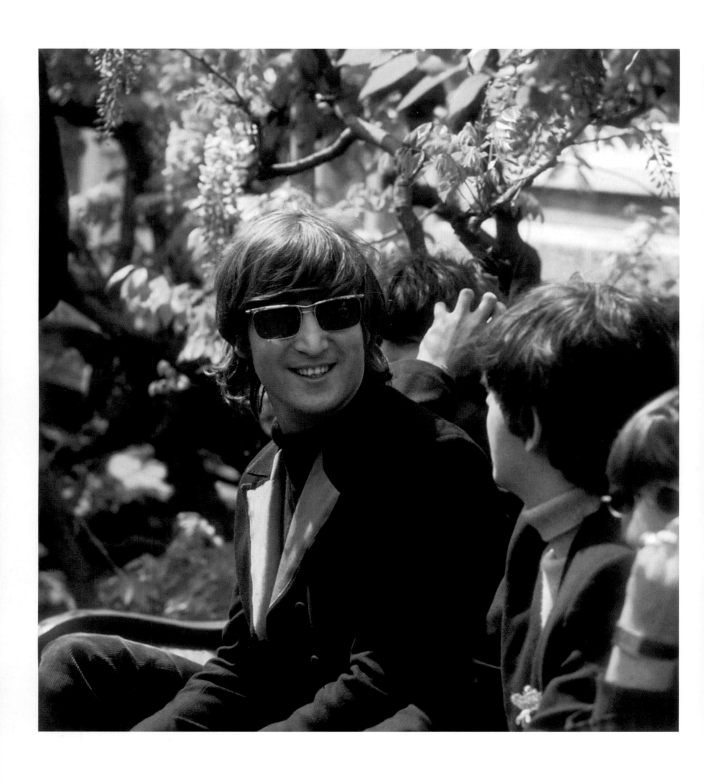

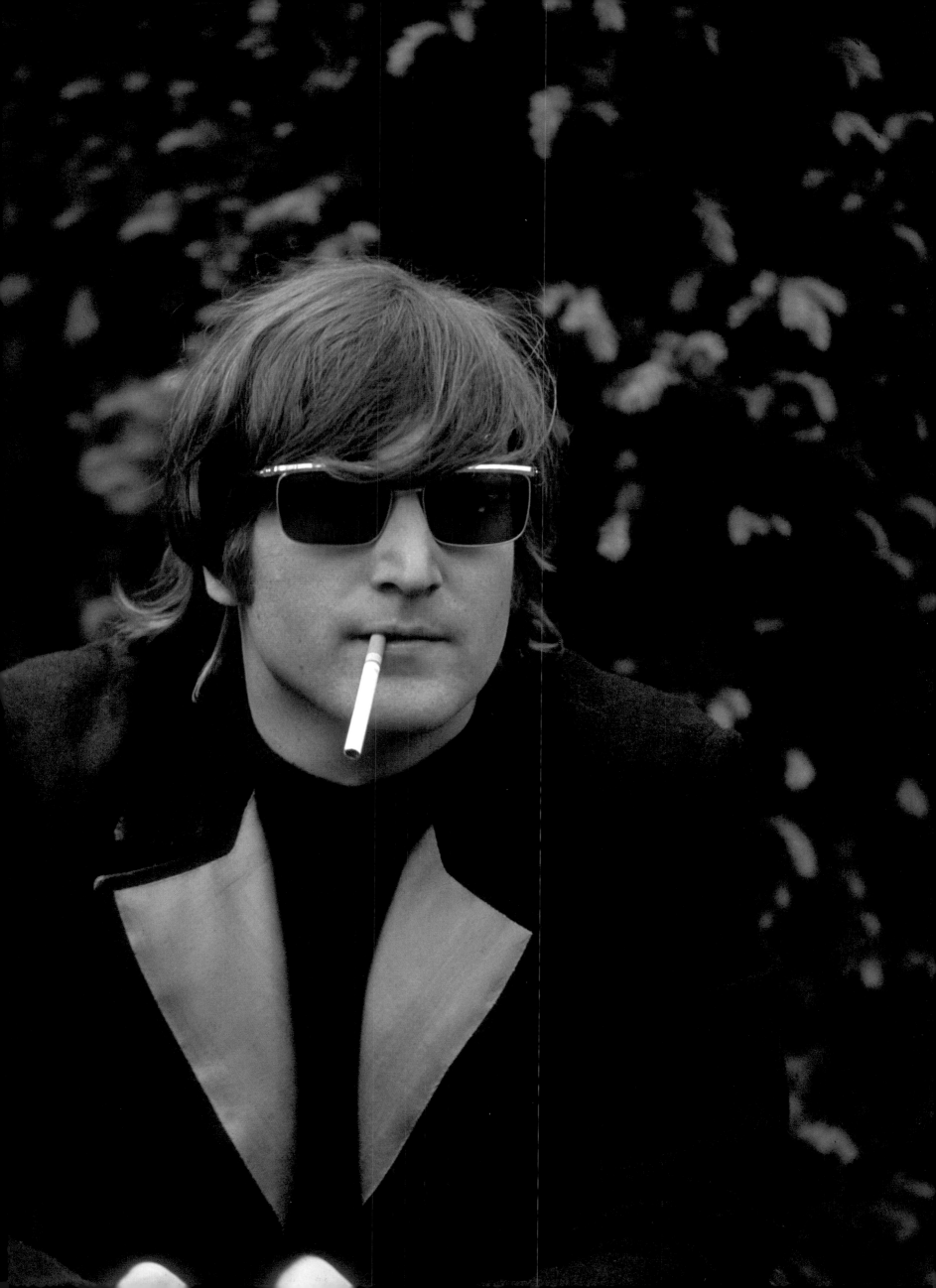

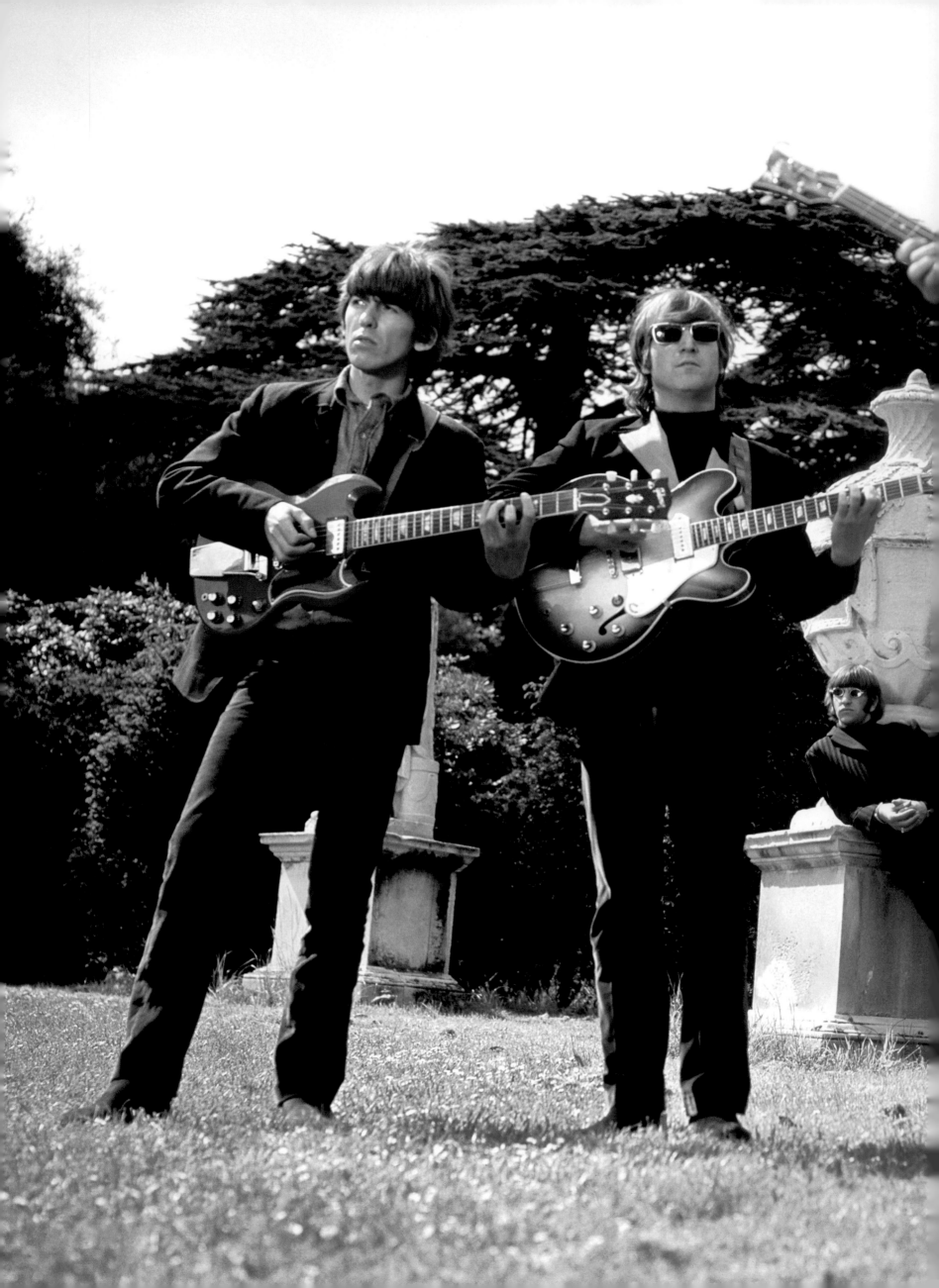

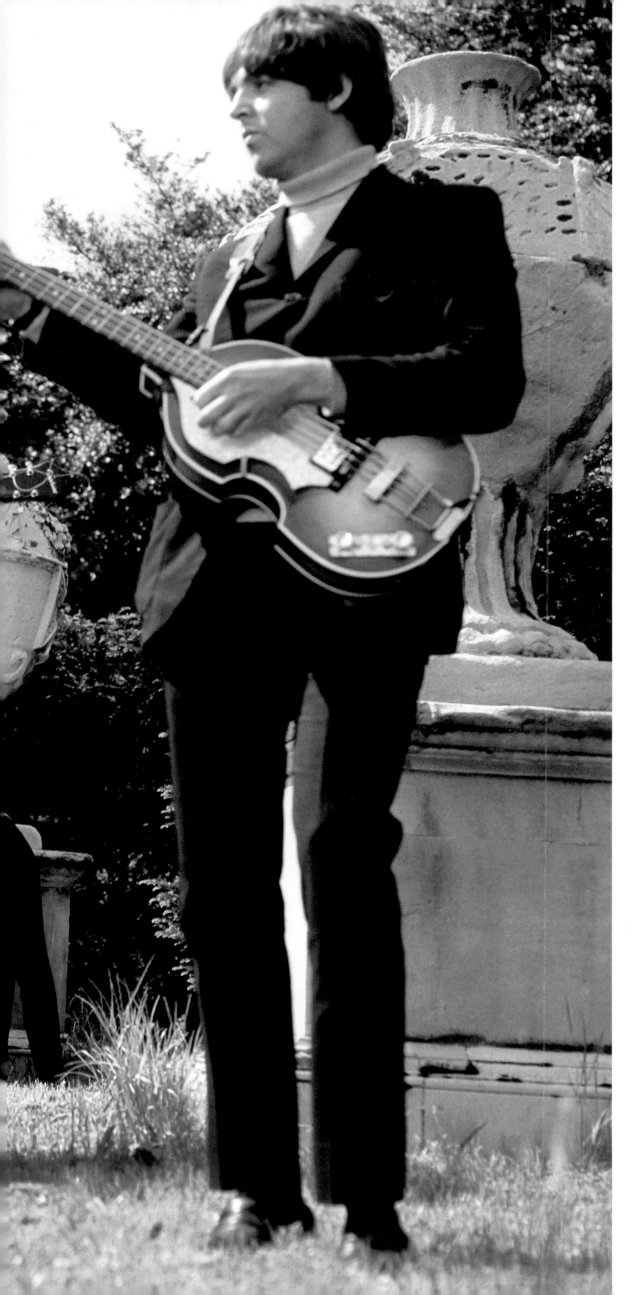

RECORDED IN MID-APRIL during the same sessions as "Rain" at the studio on Abbey Road was Paul's "Paperback Writer," a much different kind of song but with more than a few things in common. It shows the Beatles were still of one mind, even as they were reaching a place in their personal growth where they would diverge. Another similarity: "Paperback Writer," too, was a song about the seemingly mundane: a rain shower in John's case; and now here a song about an aspirant writer of dime-store novels. Apparently Paul's aunt had asked him if he could compose tunes about anything except boy-girl love, and he'd taken up the challenge. He saw Ringo reading a book and was instantly mesmerized by the bright light of inspiration. Paul would later tell London's *New Musical Express*, "When we did the song, we wrote the words down like we were writing a letter. We sort of started off, 'Dear Sir or Madam' then carried on from there. If you look at the words you'll see what I mean, the way they flow like a letter." Yet another shared aspect between "Paperback Writer" and "Rain": These two songs, which blasted out of the radio in the summer of 1966, were the first Beatles songs recorded as loudly as this, thanks to the folks at EMI Studios developing some new technology. John certainly dug that volume, but wanted to pump it up even further, and wondered why the bass on a Wilson Pickett record he had heard made many Beatles' bass lines sound smaller. Paul agreeably forwent his hallmark Höfner violin bass for a meatier Rickenbacker model, and the famous, bubbling Beatles bass sound of "Paperback Writer," and so many more songs to follow, was born. The Beatles again made multiple promotional films (in the day, they were known as that, or known as "filmed inserts"—not yet "videos") for "Paperback Writer," including one in Chiswick Park—where Paul returned to his famous Höfner for the visuals. Obviously there was a lensman besides Whitaker present. He was the film director Michael Lindsay-Hogg, who had first worked with the band on the telly show *Ready Steady Go!* (where some of these new filmed inserts were headed). He would later direct the poignant feature film documentary of the Beatles' breakup, *Let It Be*.

IT NEEDS to be admitted in a book such as ours that many of the settings and situations do repeat; it was the Beatles' life at the time. They were recording at EMI, they were living at their homes, they were performing onstage, their fans were going nuts on a daily if not hourly basis, they were making iconic album covers—one after the other—they were looking lonely or bored in hotel rooms, they were looking thrilled in one another's presence. The actual breakup of the Beatles (beyond the decision to leave the road) was, in 1966, still a ways off, and they were still a band of brothers. As alluded to earlier, Ringo once recalled how they used to love to huddle together in a fancy hotel bathroom, just to get away from it all. Not two or three of them, said Ringo, all four, and he remembered it as one of the best times of his life. They would sometimes tune up, harmonize, make their Beatles jokes and quips, and generally relax (as much as was possible). Now then: The great good fortune for a book such as ours is that Robert Whitaker was there—but also that he had an uncommon talent and could make like situations fresh. Imagine that: fresh Beatles photos in 1966. Of this picture of George, Whitaker later recalled: "This was not posed—it was something that just happened before my camera. I simply moved in close and framed as tightly as I could." Whitaker always said he would avoid posing the boys, if it might be avoided, and hence the charming photos from Chiswick Park, which are not stills from the promos. As seen on the following few pages, if a pose was called for, Whitaker was always thinking and liked to set his subjects with representative objects (and sometimes, of course, props, even including meat). But then would come a real moment, and the real Beatles would be joyful—as they are on page 212, taking a schoolgirl who had broken through the park's security under their arm. This was a knee-melting moment for her, and so refreshing for them. Whitaker recalled the scene fondly: "You can imagine how thrilled she was. It was quite touching— the Beatles were so friendly towards her and behaved like perfect gentlemen."

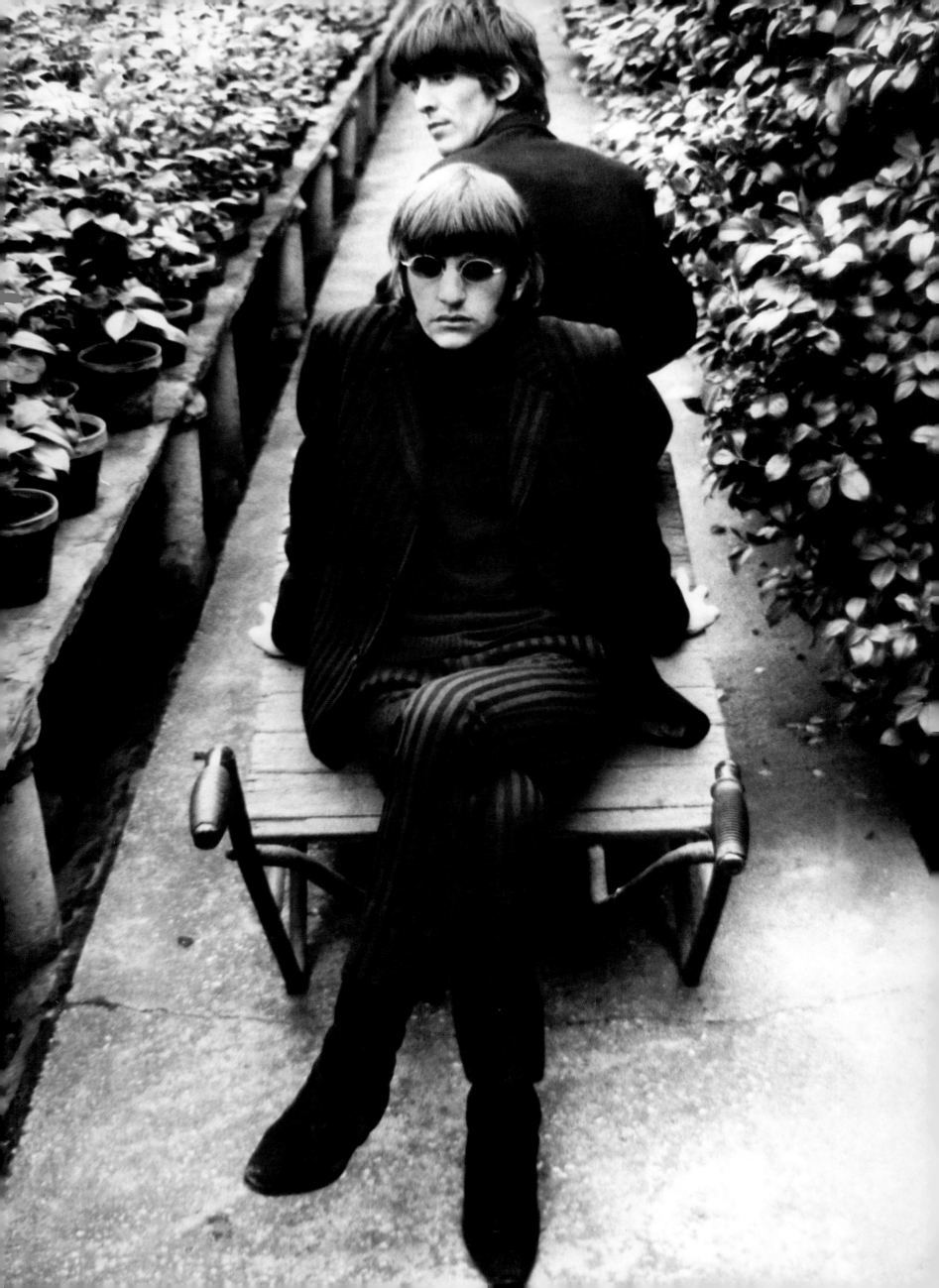

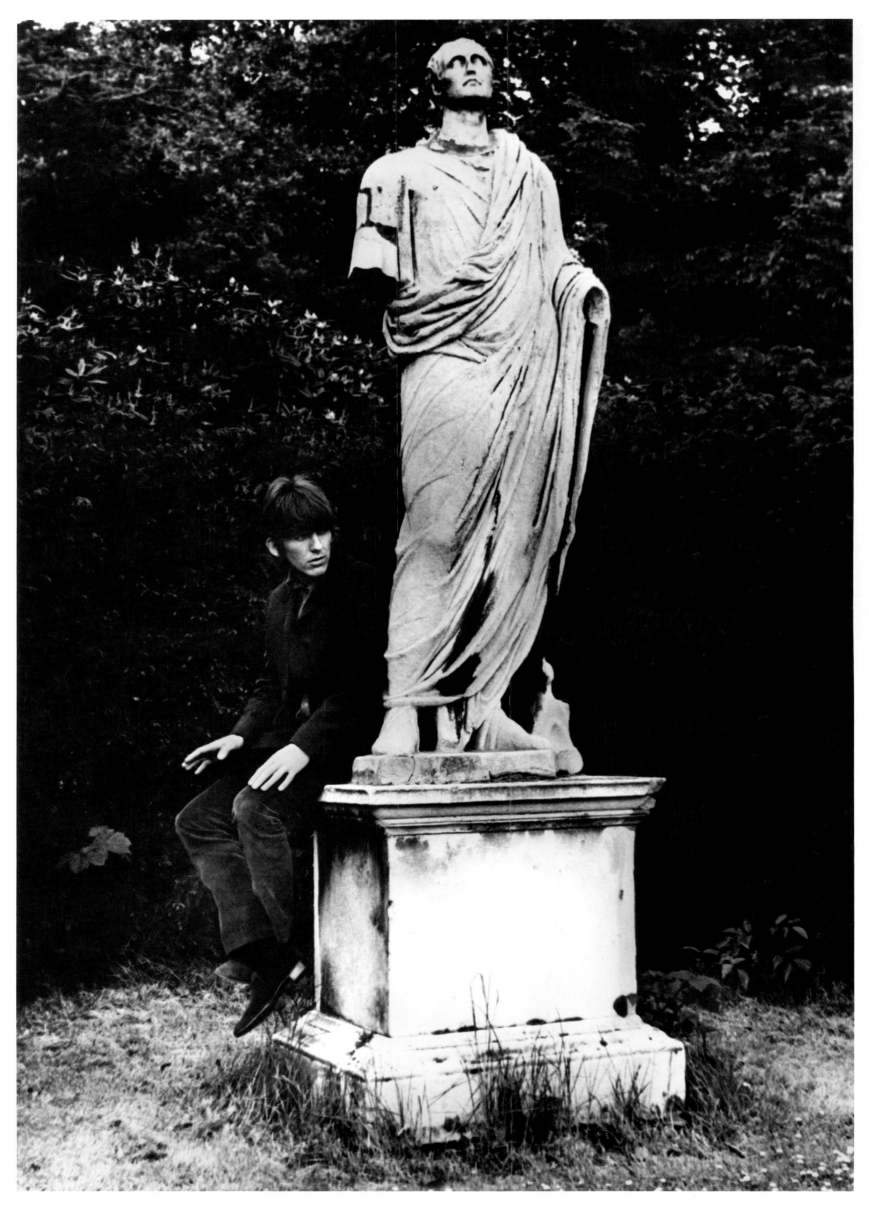

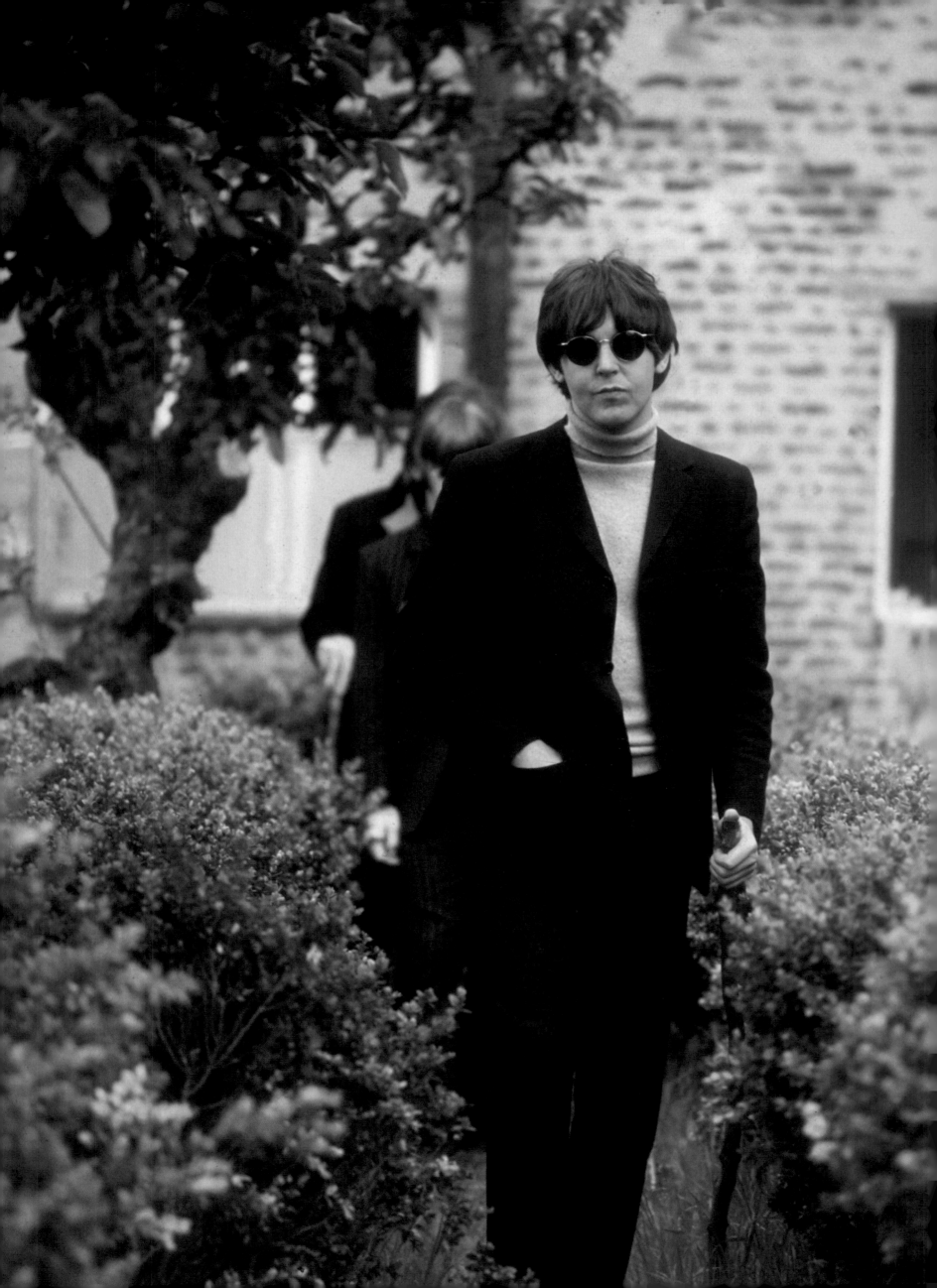

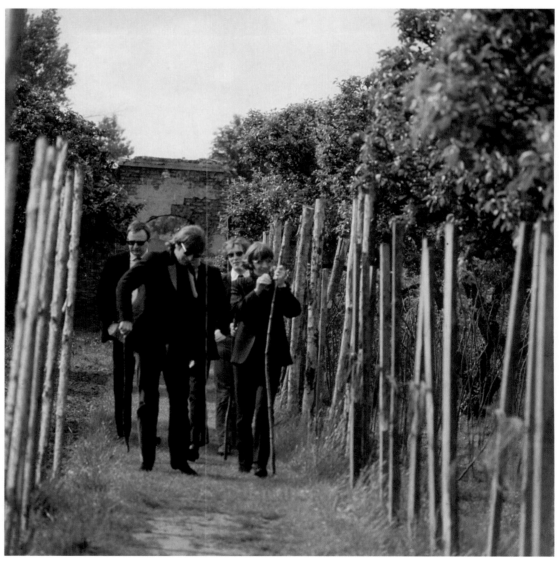

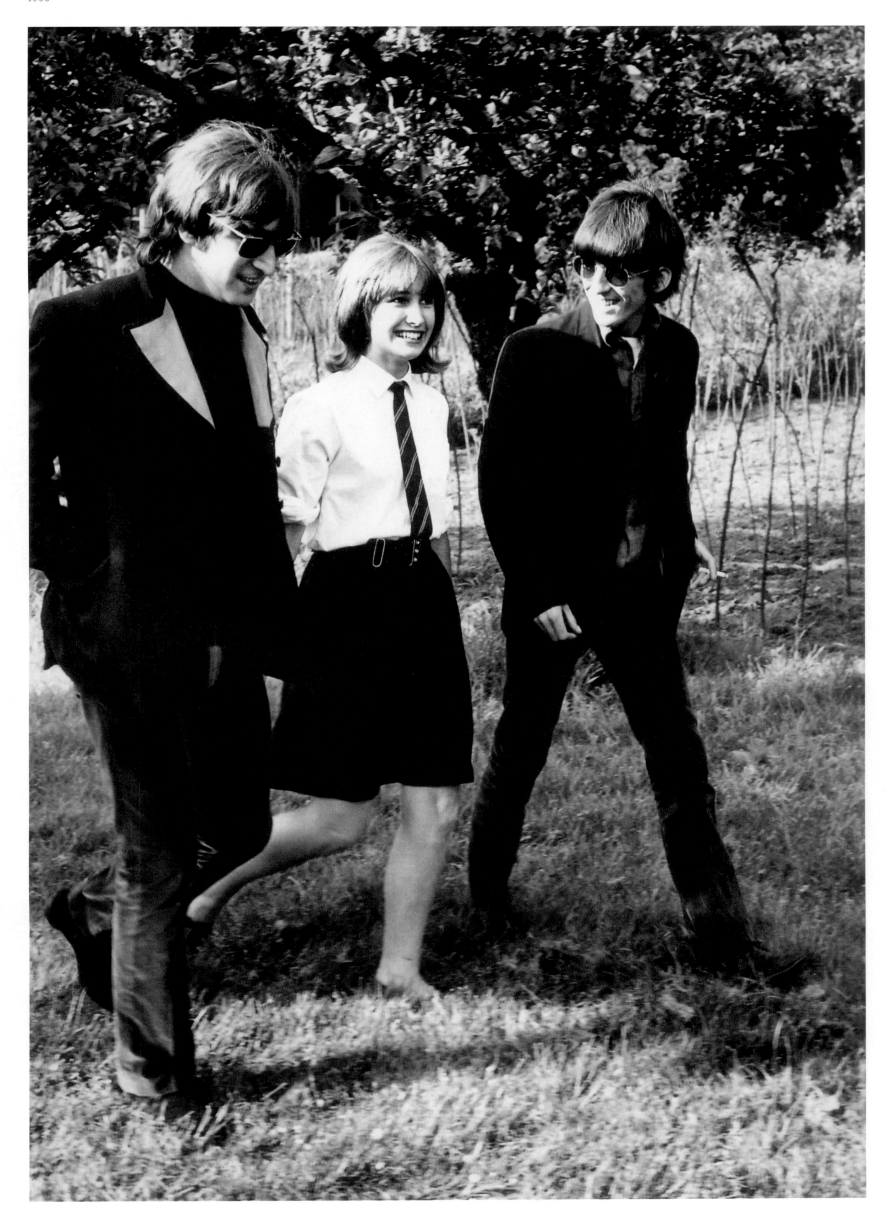

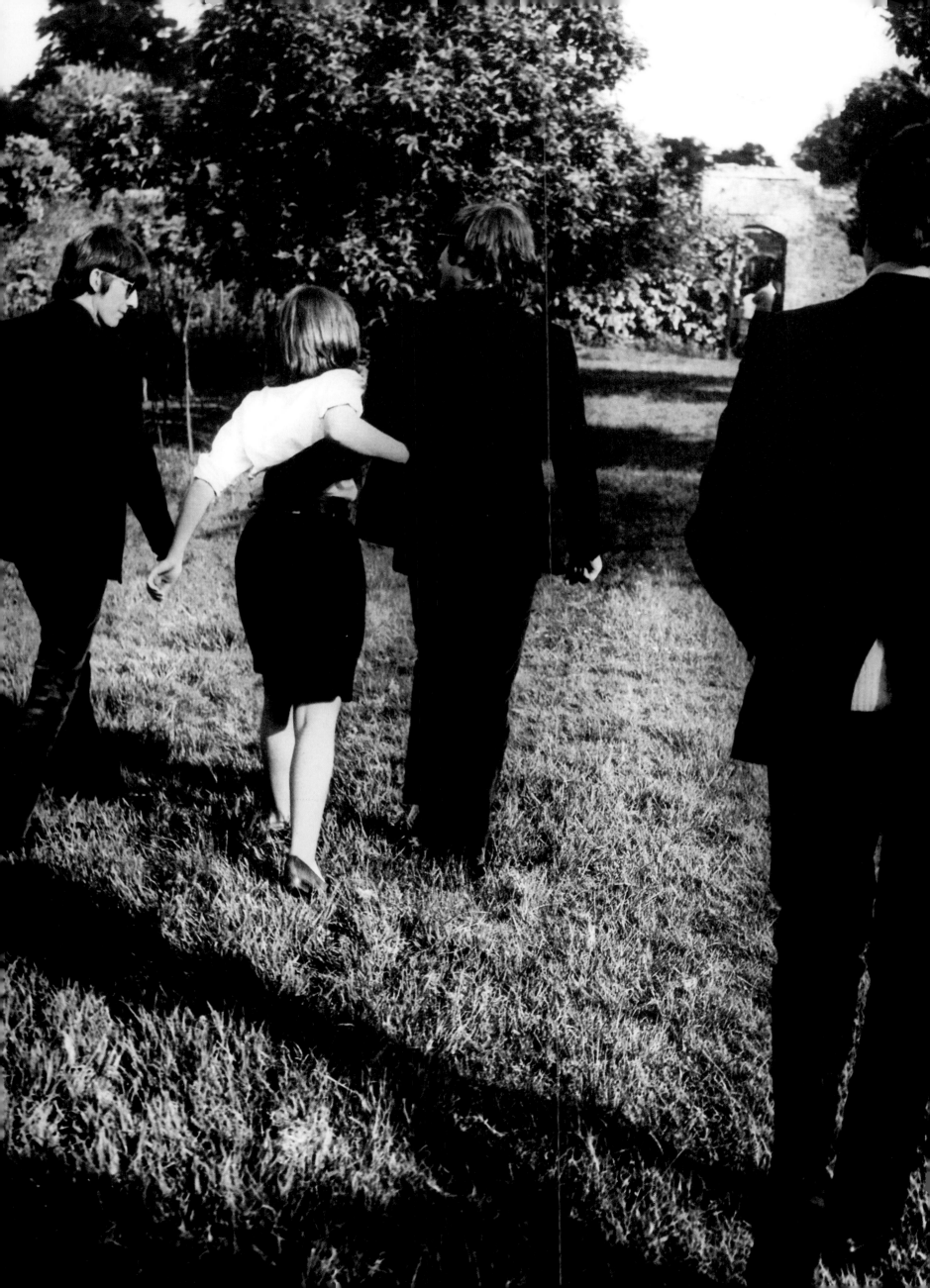

WHITAKER AND FILMMAKERS like Michael Lindsay-Hogg or Richard Lester weren't the only ones making images of the Beatles during the heyday. In fact, Whitaker recalled that the band members were uncommonly interested in making pictures of one another, and he would often loan them cameras or give them tips. With their own Polaroids, they, too, recorded an extraordinary time that, they seemed to realize, they and their future families would want to remember minutely.

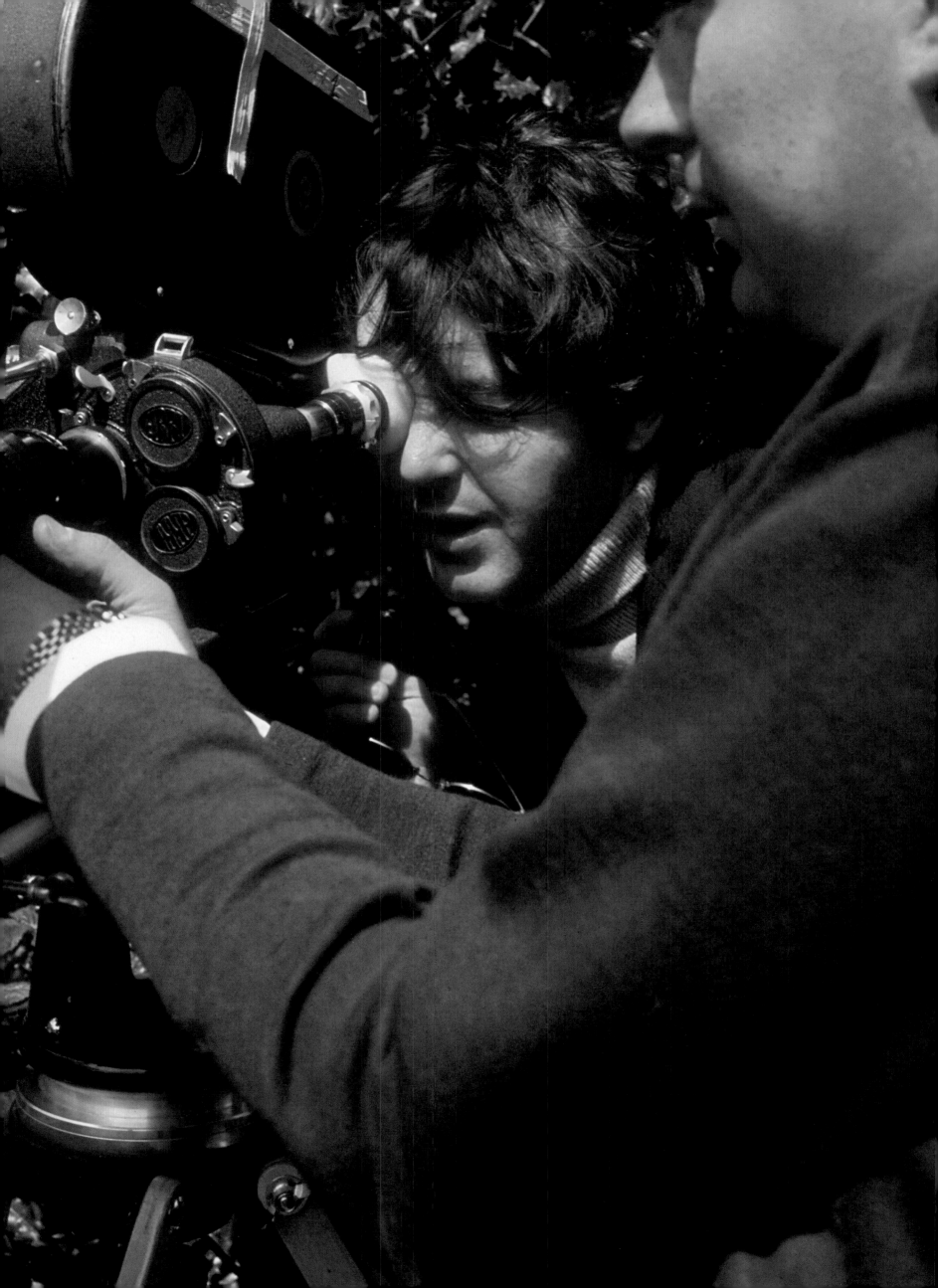

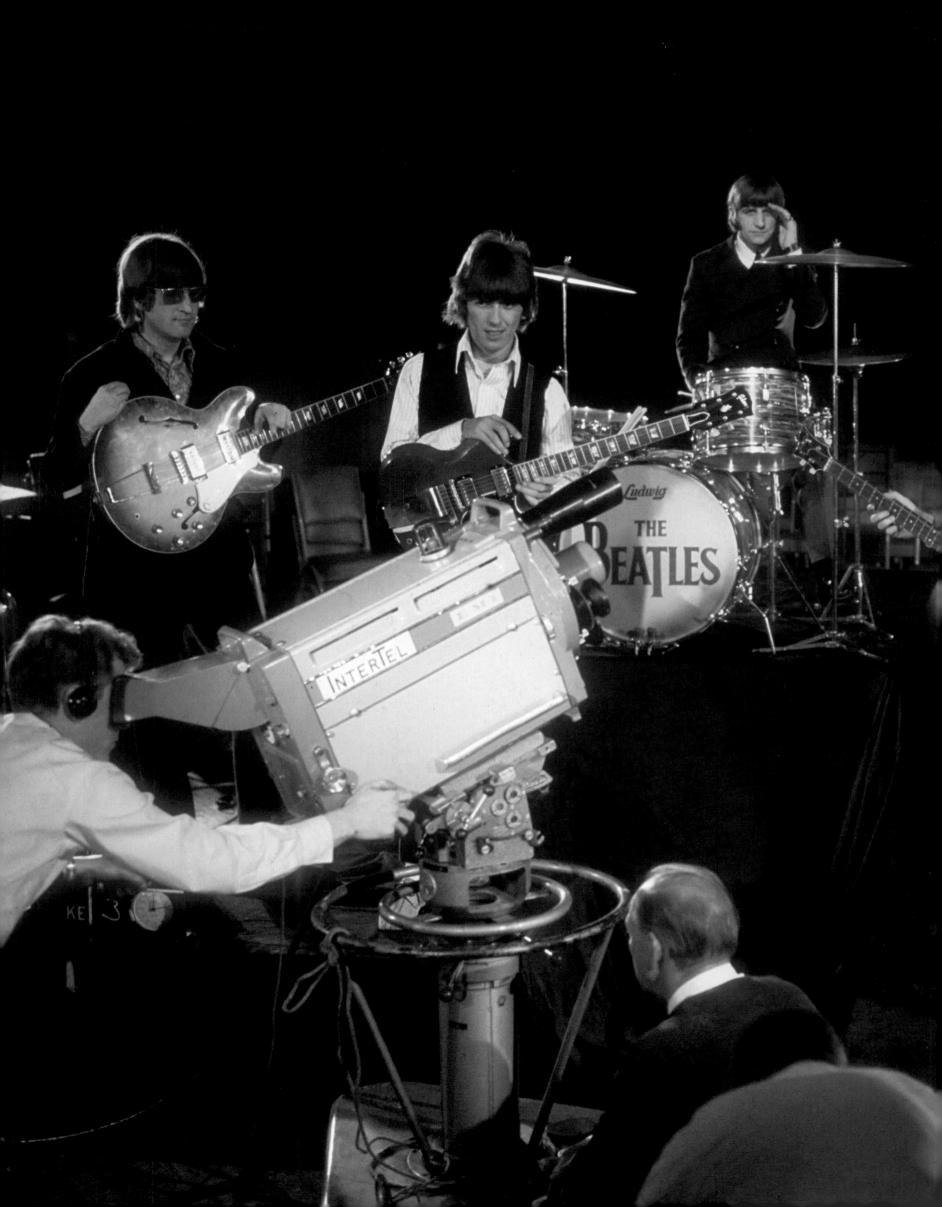

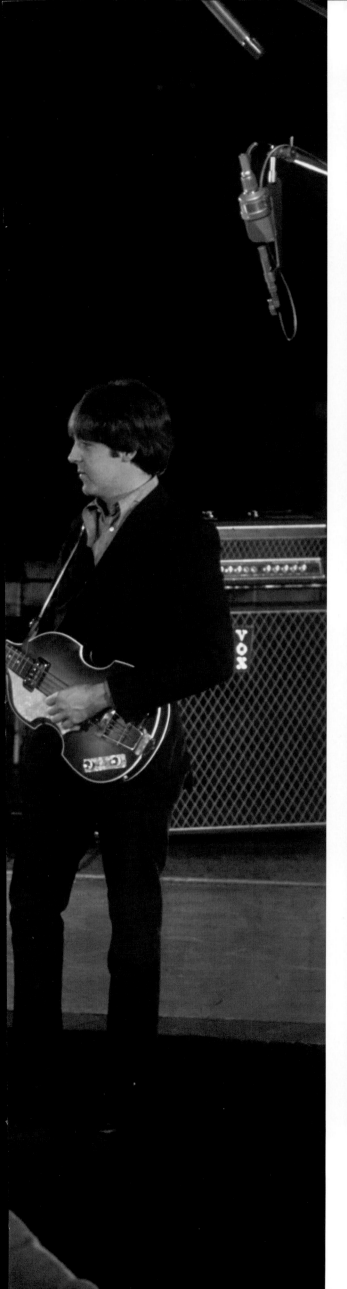

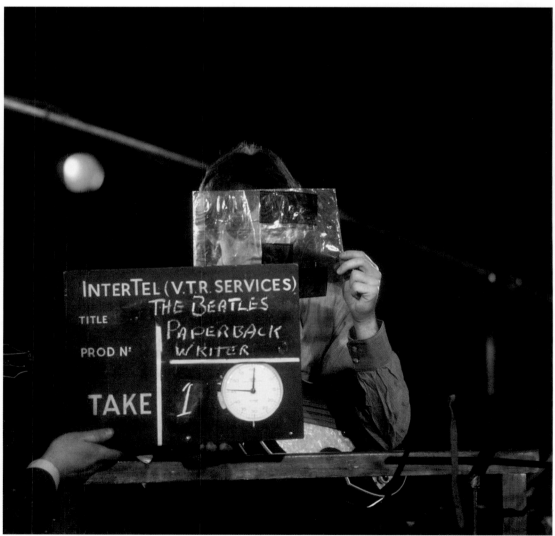

LARKING ABOUT in Chiswick Park or here on a soundstage for another "Paperback Writer" promo, the Beatles let others—directors and such—do the real work. The mood in these photographs contrasts with the Beatles' evident intensity when at the EMI studio, where they and producer George Martin were directly and solely responsible for the product.

ON JANUARY 21, 1966, George married the model Pattie Boyd, whom he had first met when she was an extra on *A Hard Day's Night*. She later remembered: "When we started filming, I could feel George looking at me, and I was a bit embarrassed." Not so nervous that she demurred however. They had first lived in London before they were married, but, George later wrote, "After a time we moved to Esher because I had to get out of town. That was when the novelty of being popular wore off." The house they moved into, at 16 Claremont Drive in Esher, Surrey, was called Kinfauns; George had bought it for £20,000 in 1964. After they were together there, Mr. and Mrs. Harrison started decorating Kinfauns in a most alarming fashion (yet a fashion that fit the times). It might not have been good to draw attention to the house. Besides Paul's place, it was where the Beatles most often convened (many of the demos for the White Album were made at Kinfauns), and now it is known that the Lennons (John and Cynthia) and soon-to-be-Harrisons (George and Pattie) came down from their first acid trip there. The Harrisons were subsequently busted for hashish possession at Kinfauns in 1969.

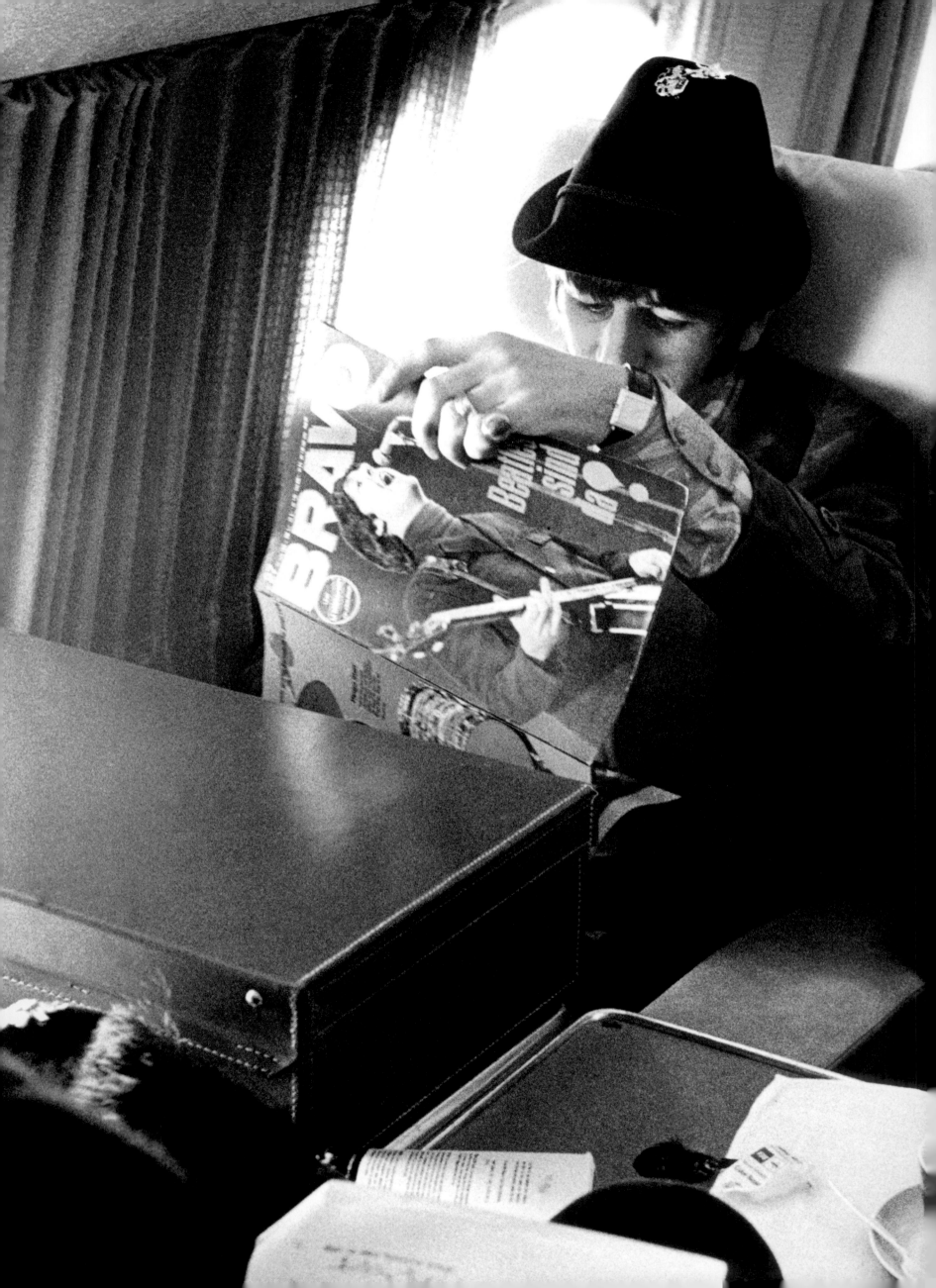

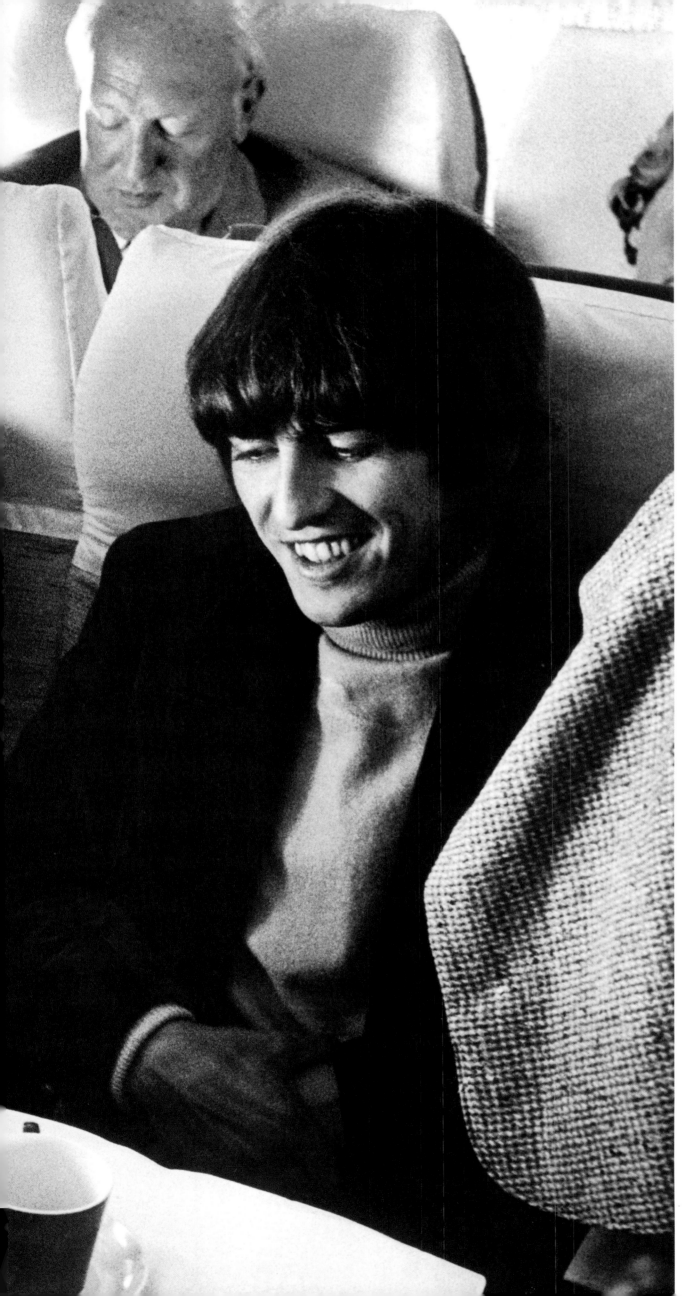

IT MIGHT BE supposed that the Beatles grew used to the lavishments that were bestowed upon them—foisted upon them—by the suddenly fawning world, but this wasn't the case—not in the early years. The four men would each become more sophisticated, certainly, and accustomed to their status as they grew older, but as we have mentioned, everything happened so quickly at first that it was all still new and fantastically exciting. It was also innocent, in a way—if a term such as *innocent* can be applied to veterans of the Reeperbahn. That reference brings us back to Germany, where, almost as much as Liverpool, it all began for the Beatles. Whitaker, looking at this photo and the one on the following pages, remembered that on the train from Munich to Essen, George was blown away by the marble bathtub in his personal suite. A personal suite: How sweet was that! When George learned on a later train ride through the Rhineland that they were on the same conveyance that the queen of England and her entourage had recently employed, he said, "This is how the royal family travel, and it's rather good." Well, yes, but once the train pulled into the station, there were those German boyos to deal with. On pages 224 and 225, at the stadium in Essen, the sign says BRAVO, but the band does not concur, and plays for less than half an hour, just 11 songs. Bob Spitz, in *The Beatles: The Biography*, describes how the concerts at Essen went down: "Boys—*thugs*—not the usual gaggle of teenaged girls—behaved like disembodied spirits, screaming, singing along, jerking their bodies back and forth, and fighting among themselves. Hordes of brutal-looking, jack-booted police, with loaded Lugers strapped to their hips, moved in." Not 1936, remember: 1966.

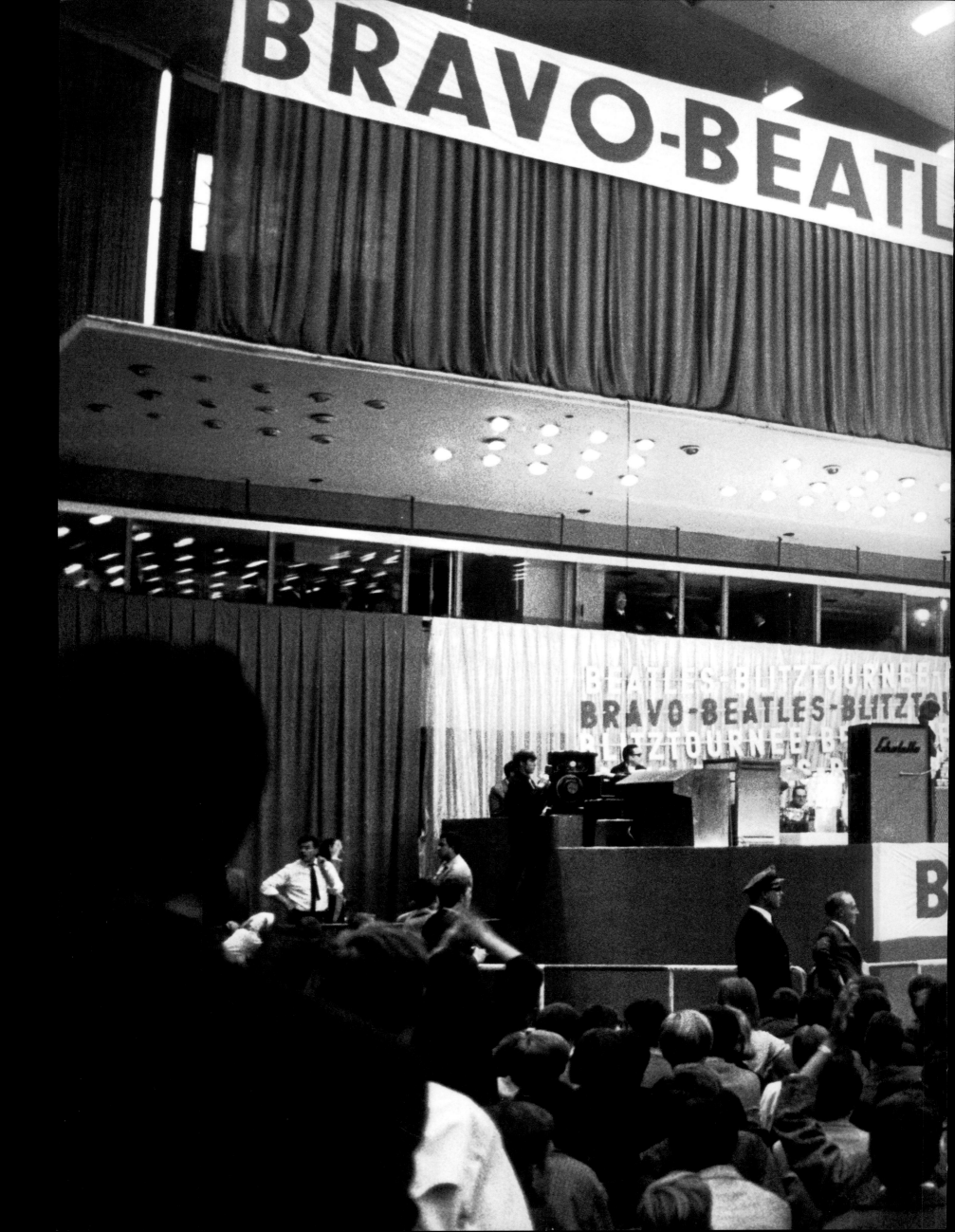

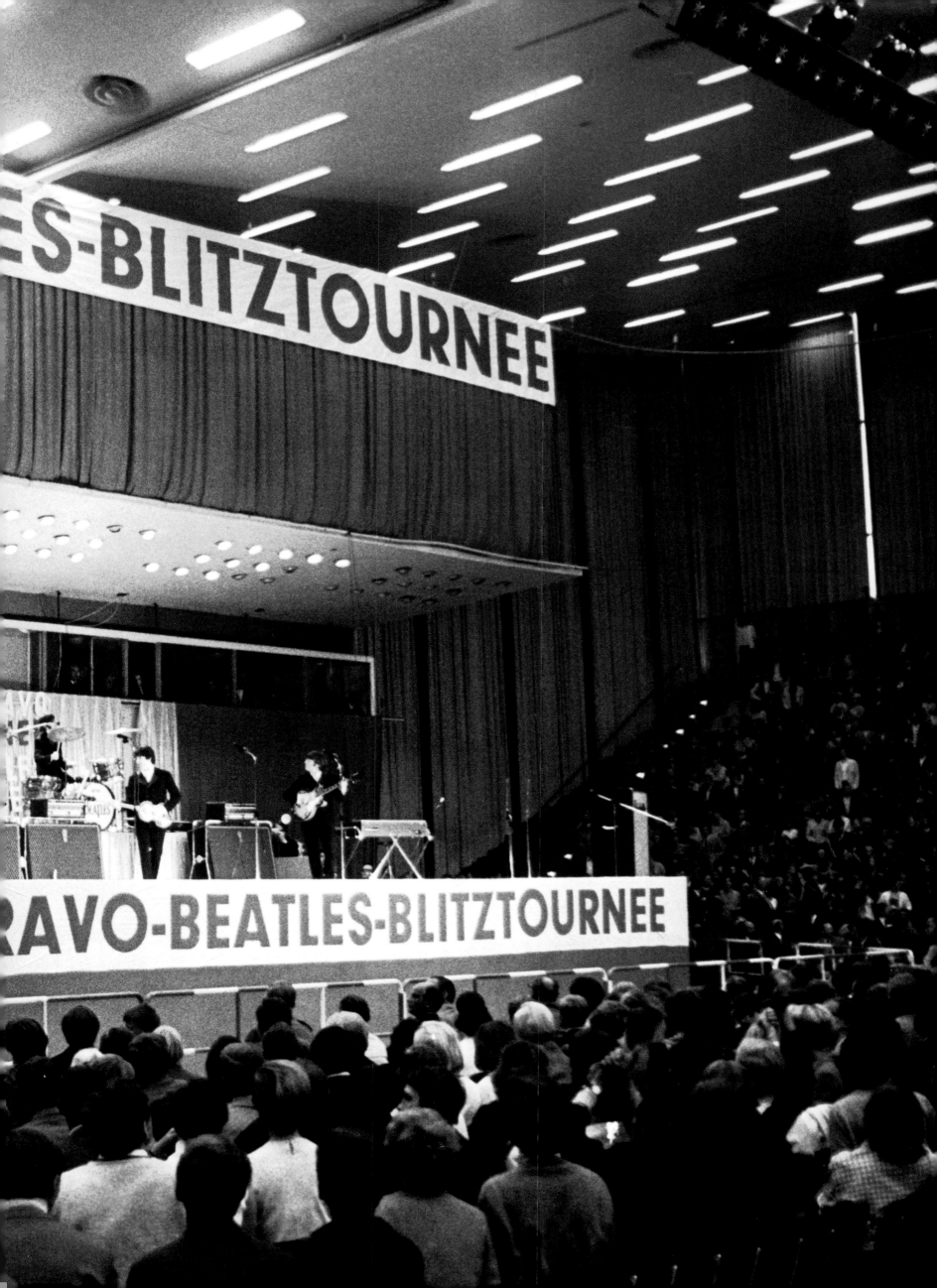

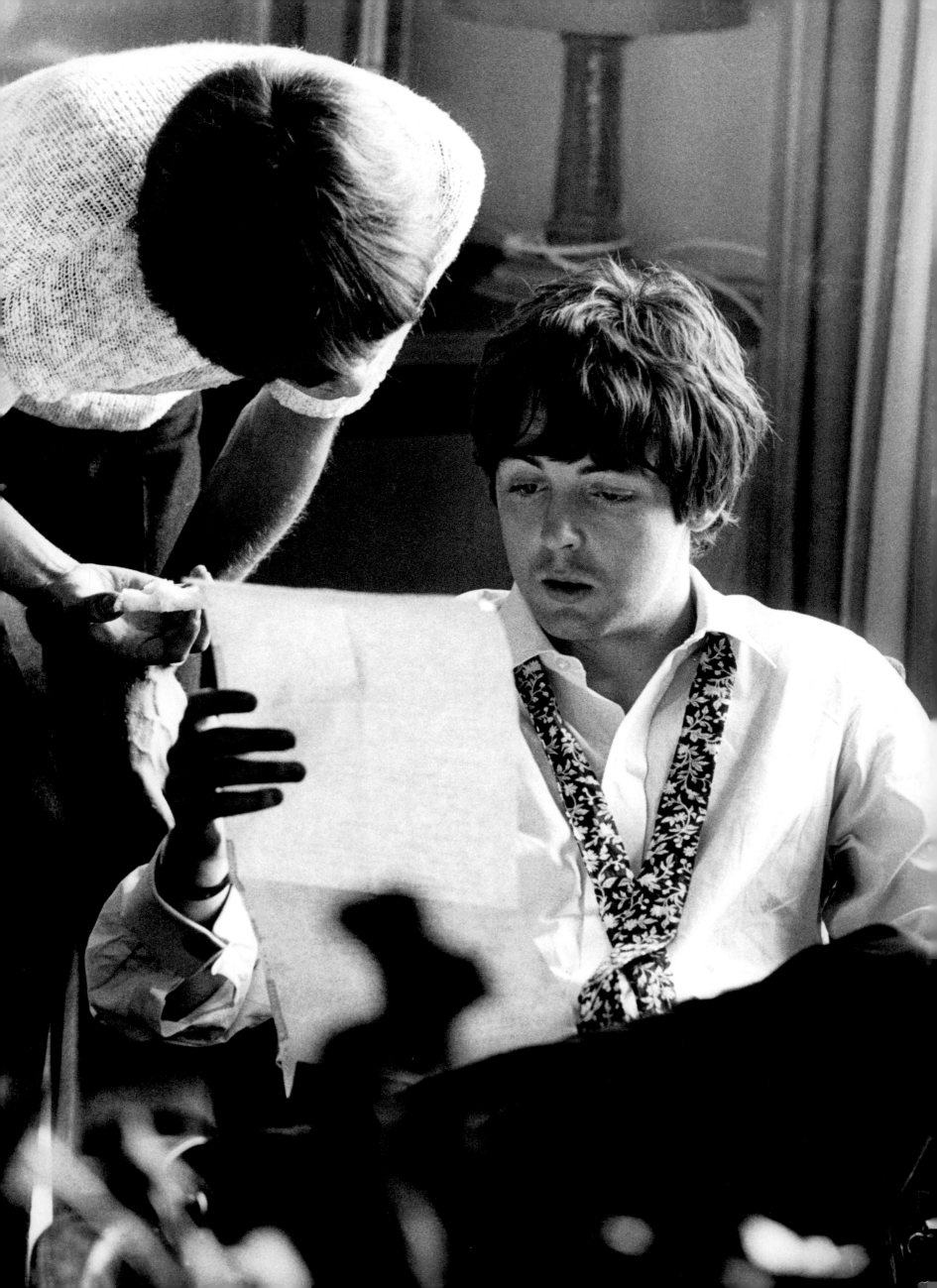

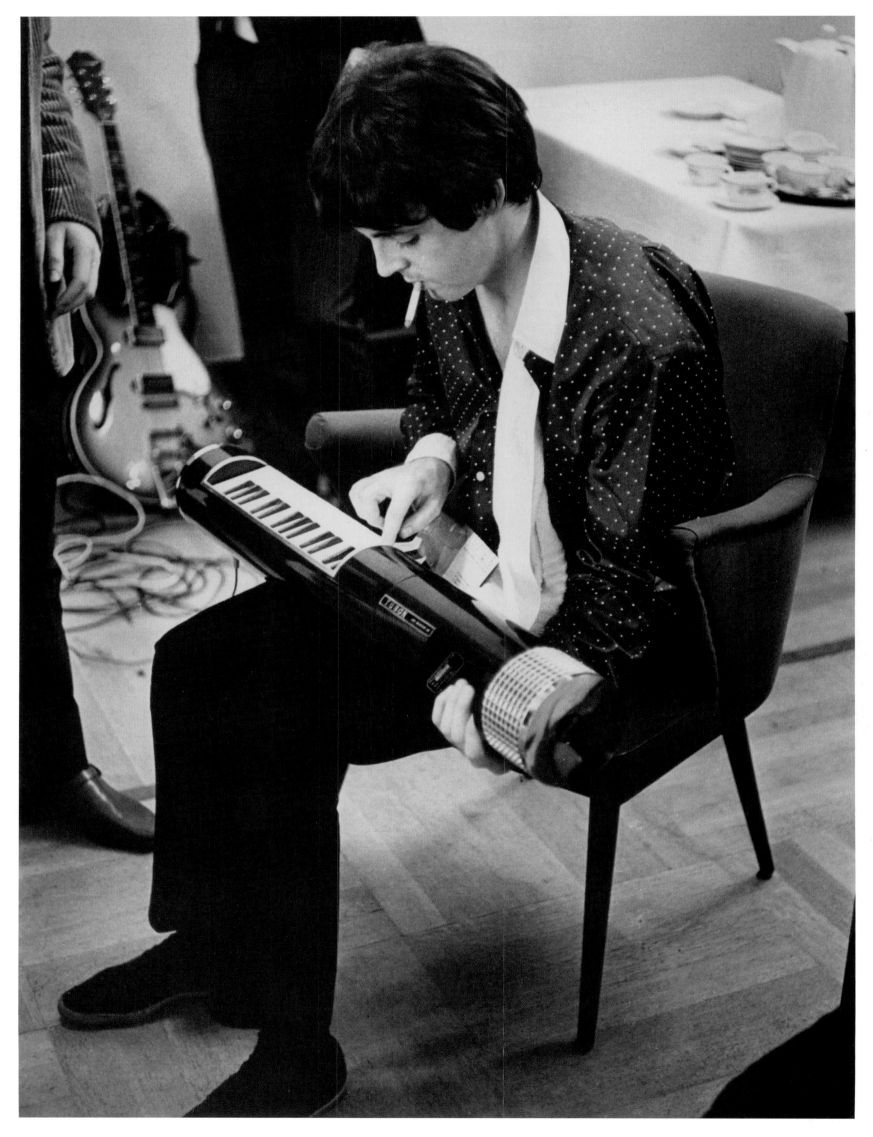

ON THESE PAGES and the following two, the band relaxes and rehearses in preparation for the Munich gig. Whitaker was privileged as an entourage member, and later remembered to LIFE, "I was fascinated to hear them play backstage—either Hamburg or Essen or Munich—to hear them singing in tune. Onstage, you couldn't hear a thing."

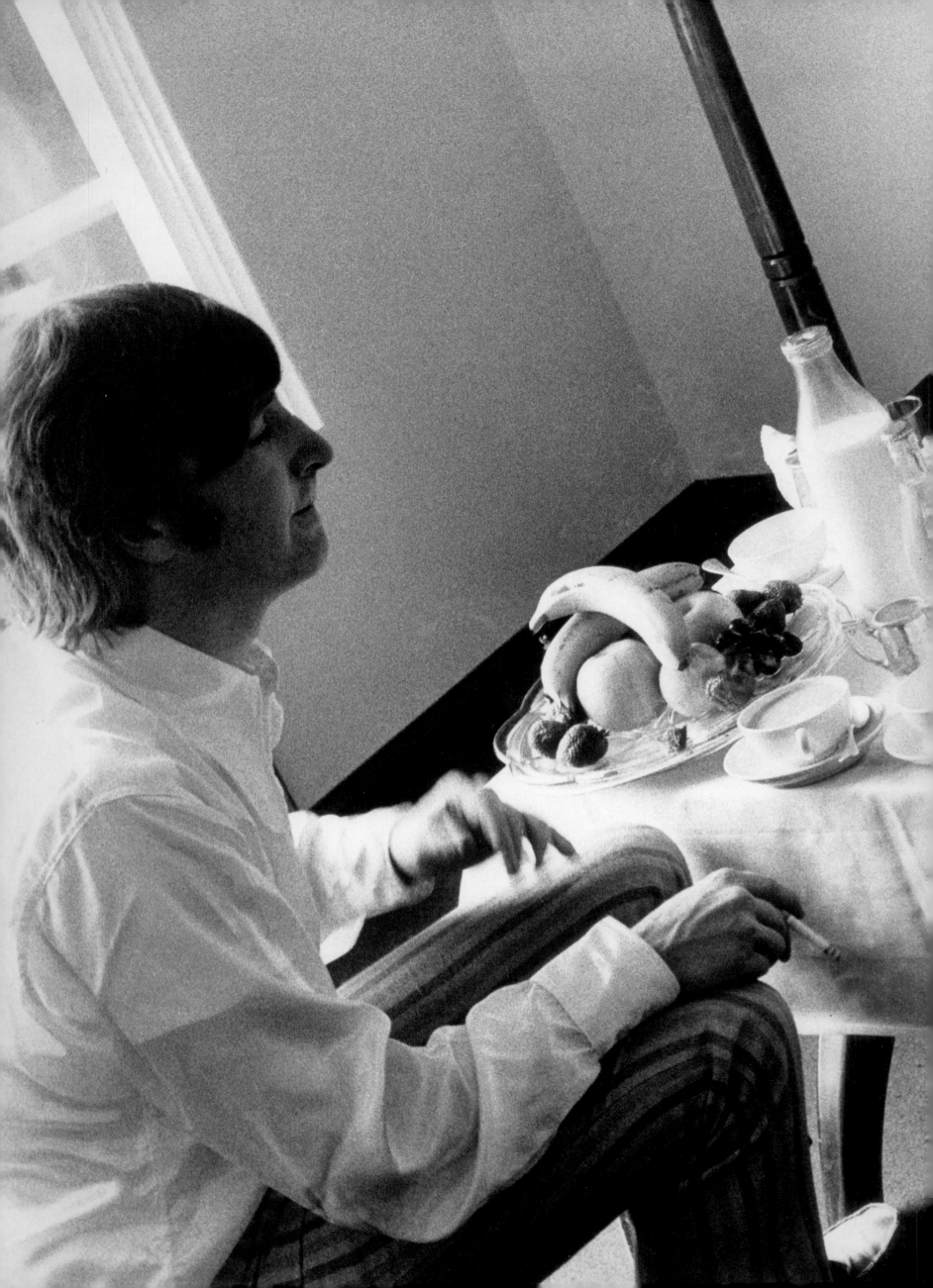

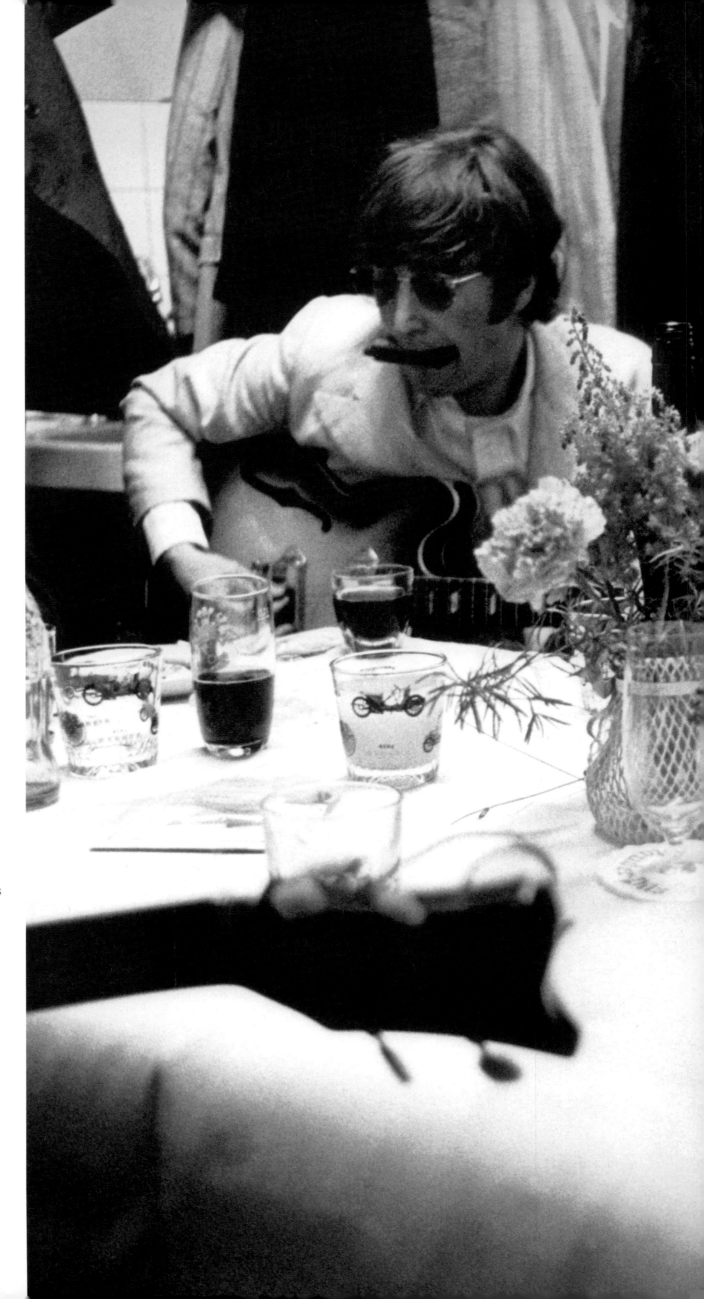

WHAT A MARVELOUS
progression, from the prior pages
to these! The Beatles try to kick
back and have a bit of lunch, but
the music is all, and eventually
it takes over. Also, notice, here,
a bottle that was omnipresent,
Coca-Cola—which often shared
the table with another: whisky.
"Scotch and sickly sweet Coke
was the Beatles' favorite tipple,"
recalled Whitaker. But they
were not big boozers at the time
(some of them would later
have problems), and John was
as wont to be reading, as he
is seen to do on the following
pages, sharing a deft passage
from a James Thurber book
with Brian Epstein.

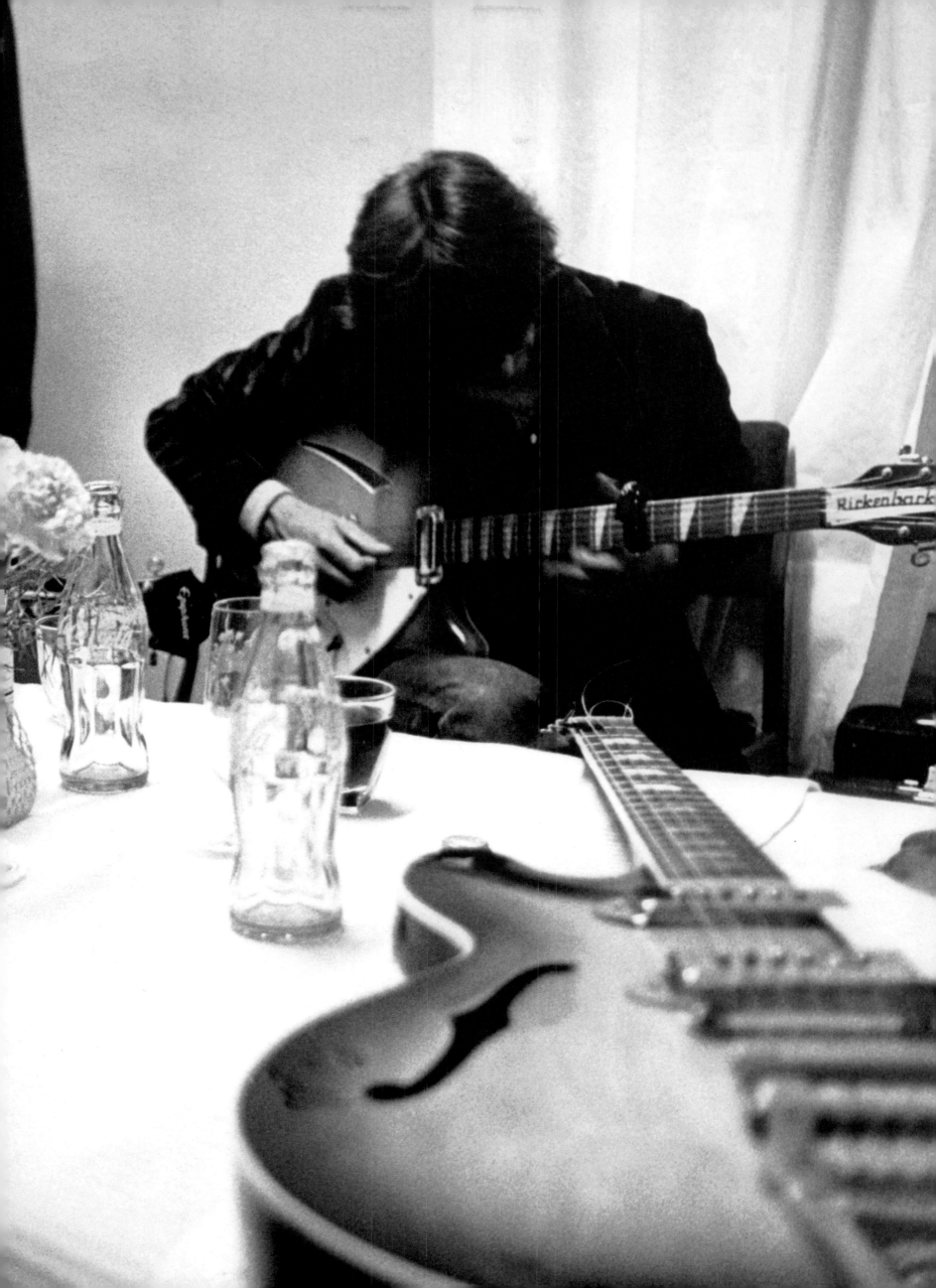

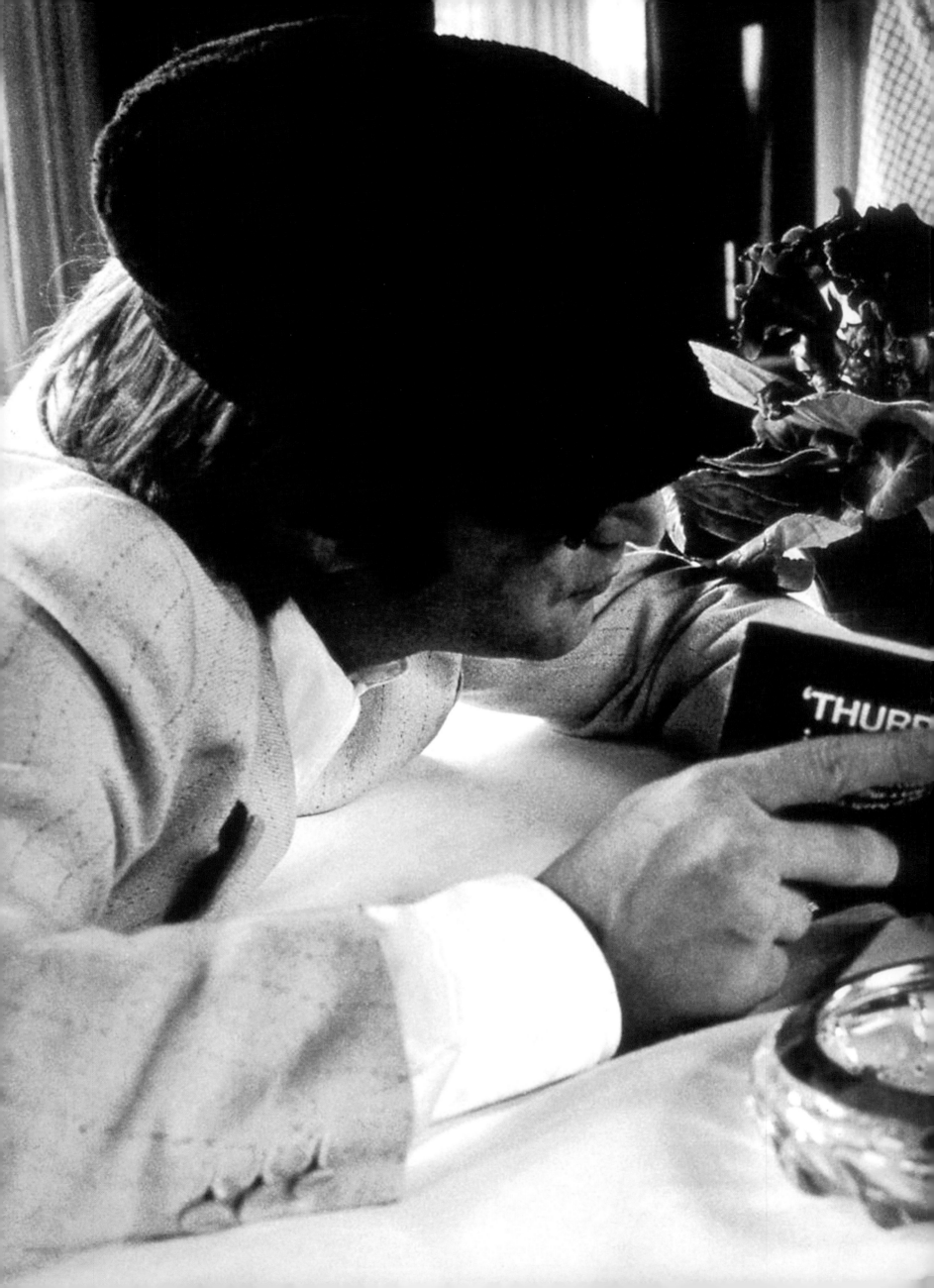

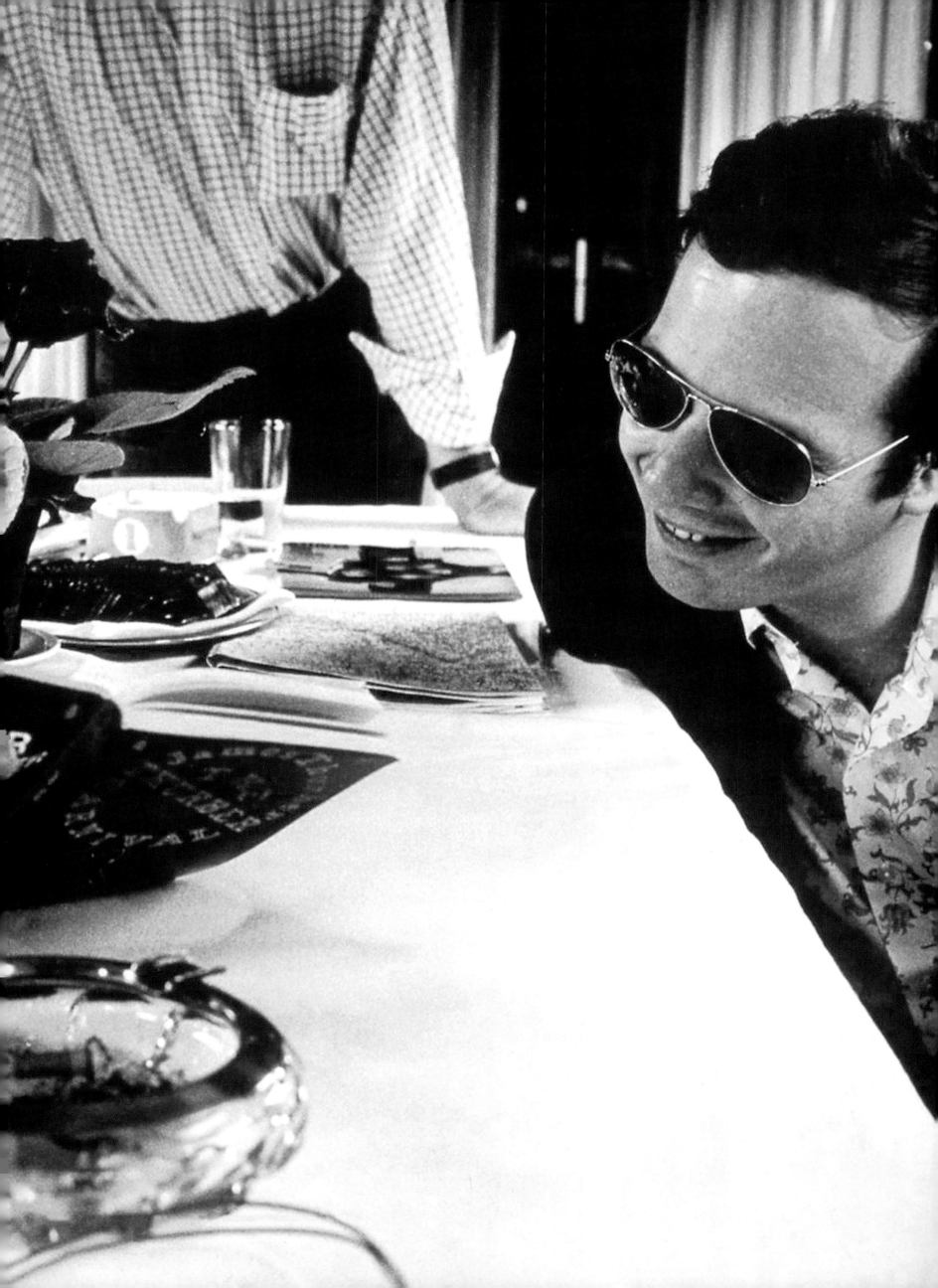

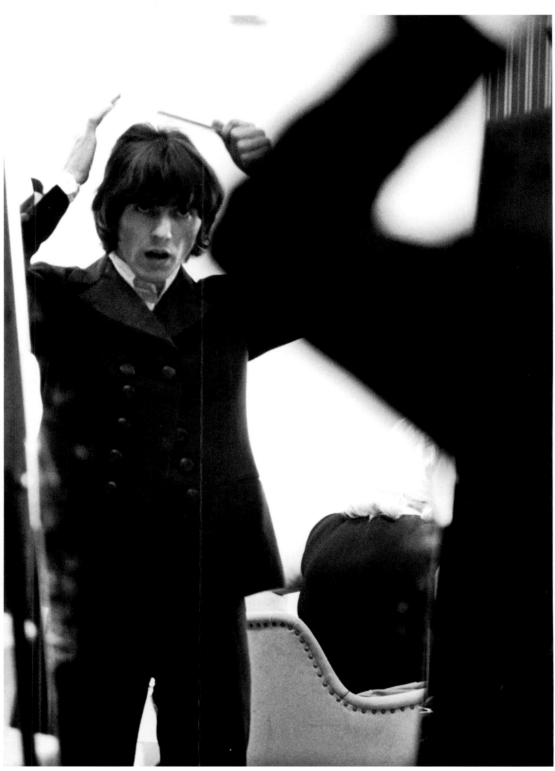

DURING THE GERMAN TOUR, Whitaker saw early signs of George feeling Beatle fatigue, and George's reluctance as much as anyone's would lead to an end of touring. "I didn't get particularly close to George during my time with the group," said Whitaker, "but I never ceased to find him fascinating. He was thoroughly enjoying his position as a Beatle, but it had struck me that by now he was also looking for something more in his life." The malaise—or the desire for something more—would spread throughout the band. On the following pages: Just before this photo was shot, someone had come up to John and asked, "If you've got a spare minute, could you write me a song?" John replied . . . Well, you can imagine what he replied.

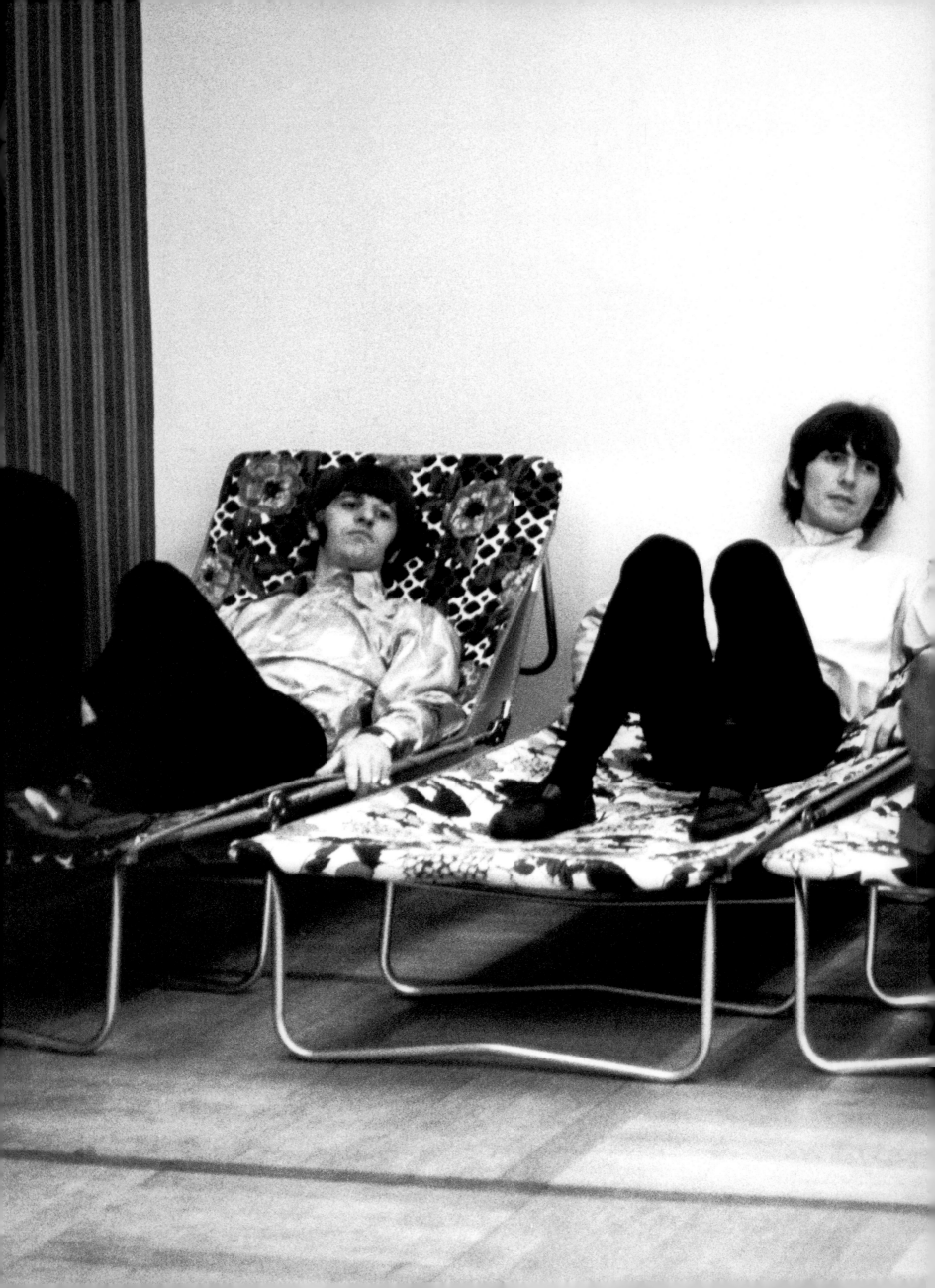

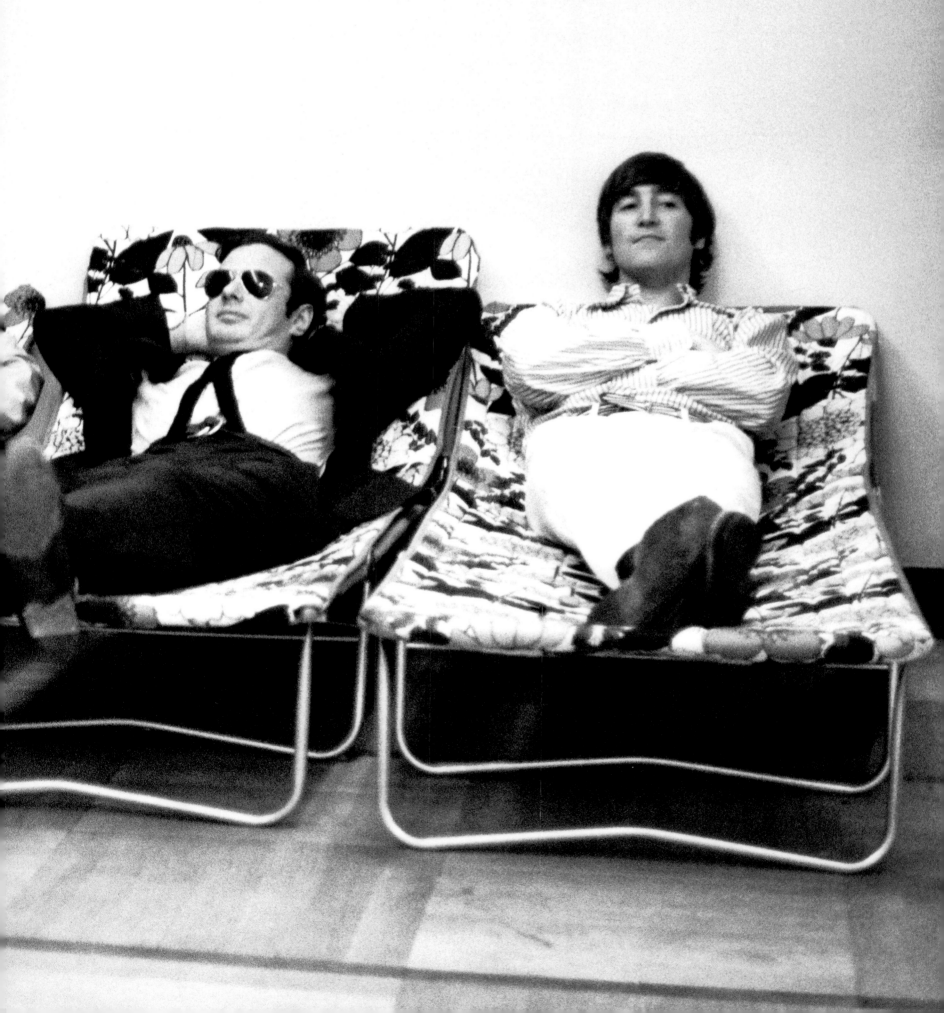

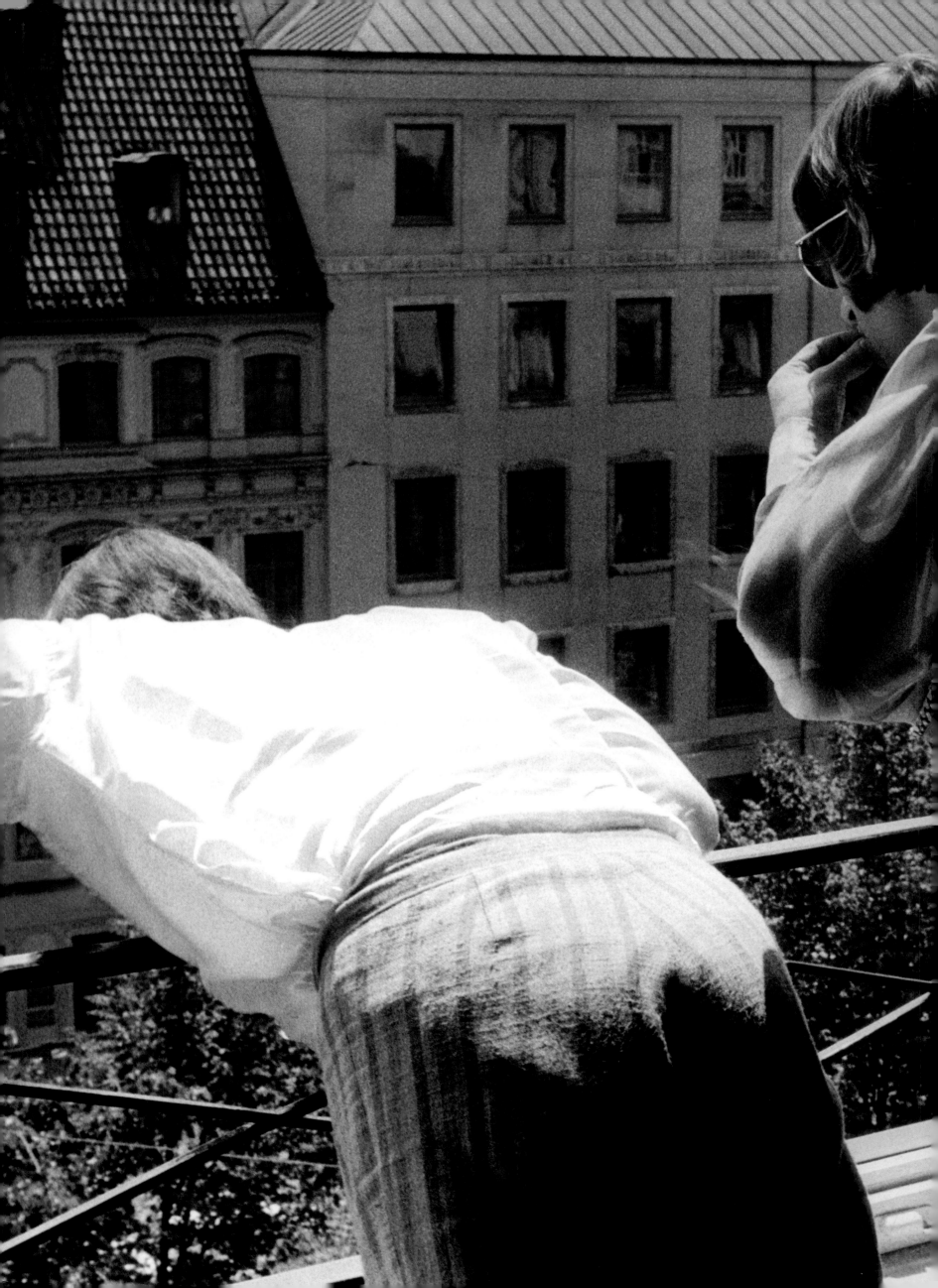

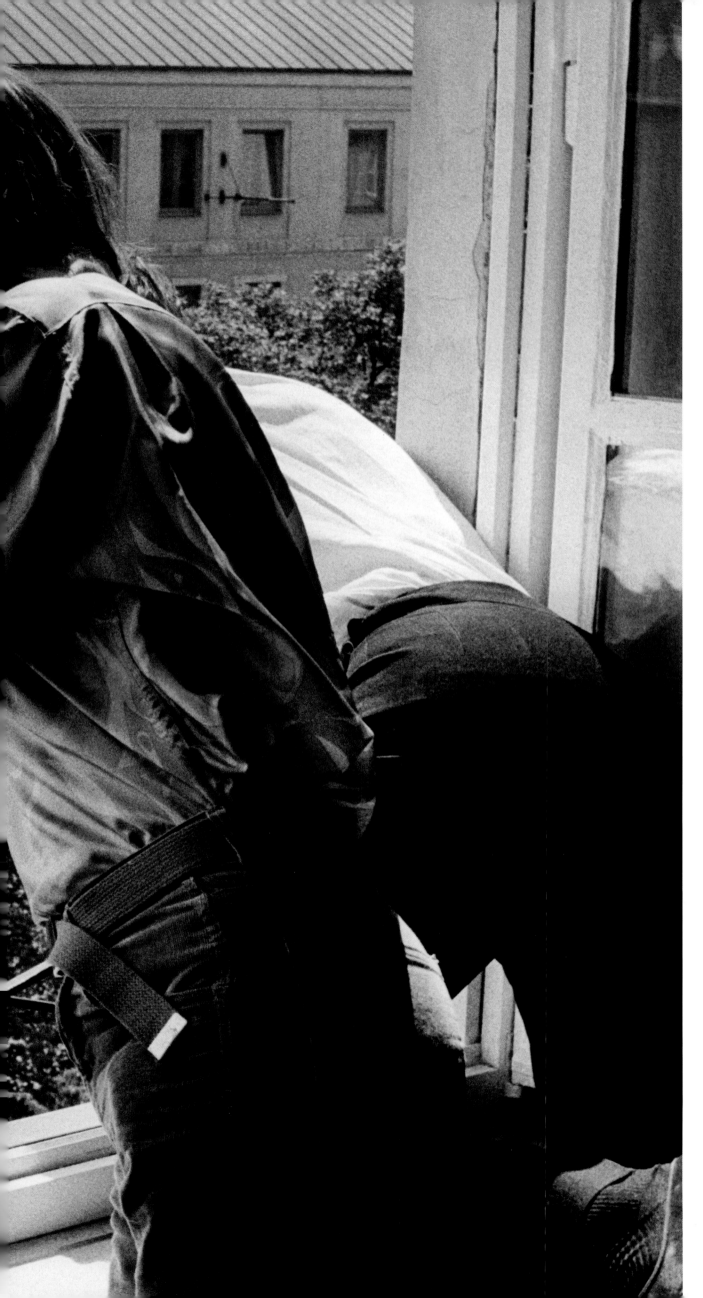

"HALLO!"

The boys greet the crowds below their hotel in Munich, as they have recently greeted so many thousands from so many scores of hotels around the world. Bob Spitz, in his Beatles bio, records how they then kick back in the suite after the Munich shows and toss around possible titles for their yet unnamed album. *Pendulums* is considered. (Holy Moses—sounds like Fairport Convention!) And also, believe it or not, *Fat Man and Bobby*. Ringo suggests *After Geography*, riffing off the Stones' newly released *Aftermath*. Finally, bang, the perfect solution for what would be a perfect and earthshaking LP: *Revolver*. How was it that the Beatles always got everything absolutely right in the end?

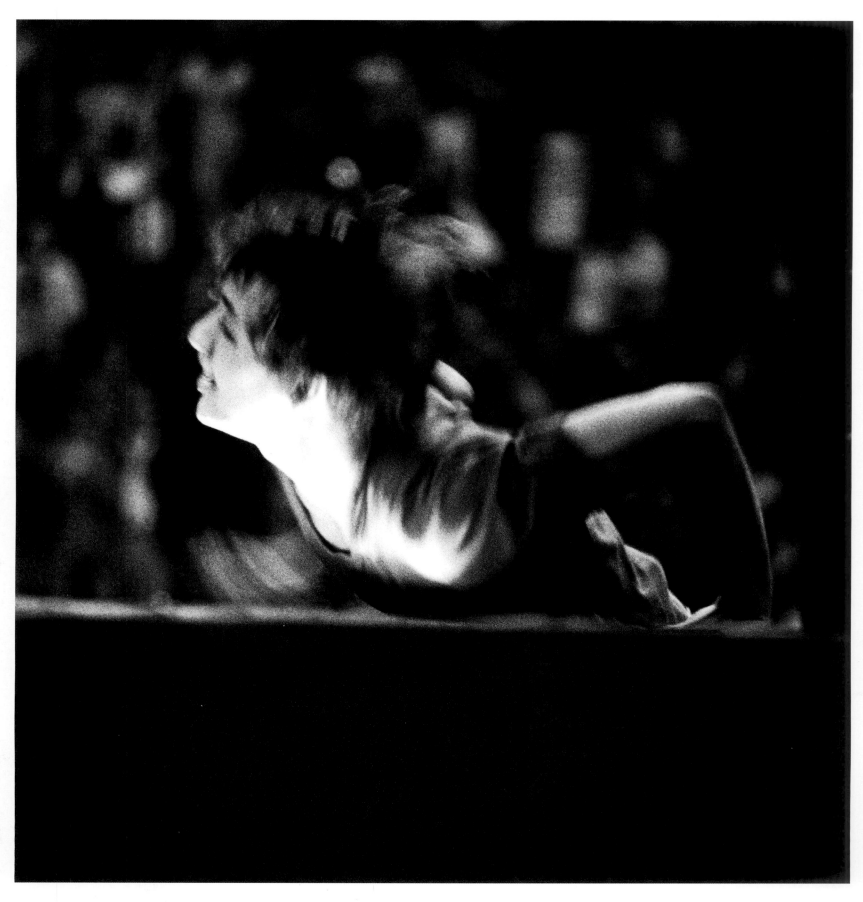

"I WAS CONSTANTLY amazed by the hysteria of the Beatles' fans, and I'm still surprised that humanity could be swayed to such extremes," remembered Whitaker. "It was typically girls who would chase after the group, but occasionally boys would clamber onstage in an effort to make their mark. Every now and then I would look out of the car window and see a charming young lady trying to get the eye of one of the Beatles. More often than not it was only the eye of my camera that caught them." Both situations, these occurring during the German tour, are rendered here.

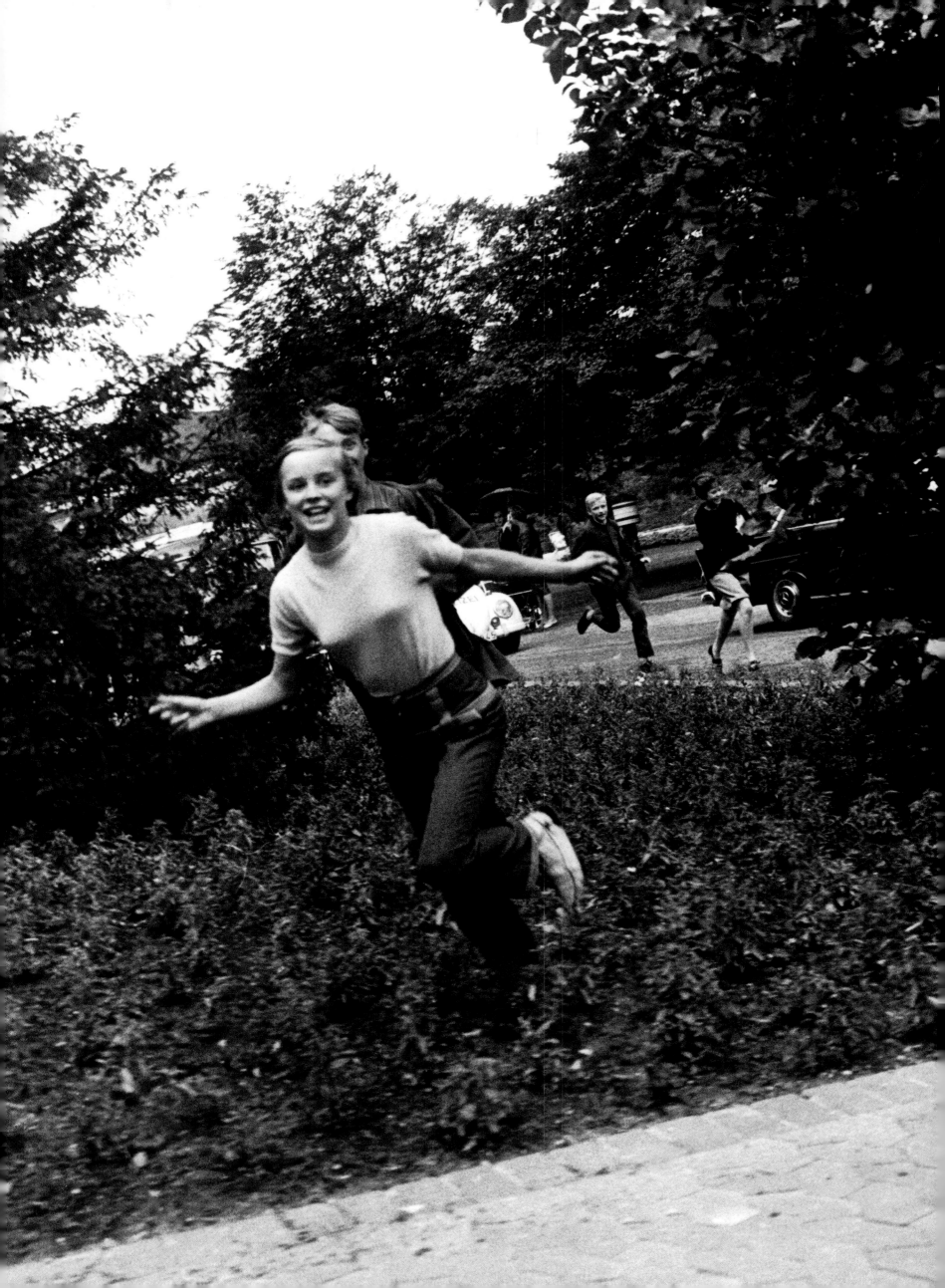

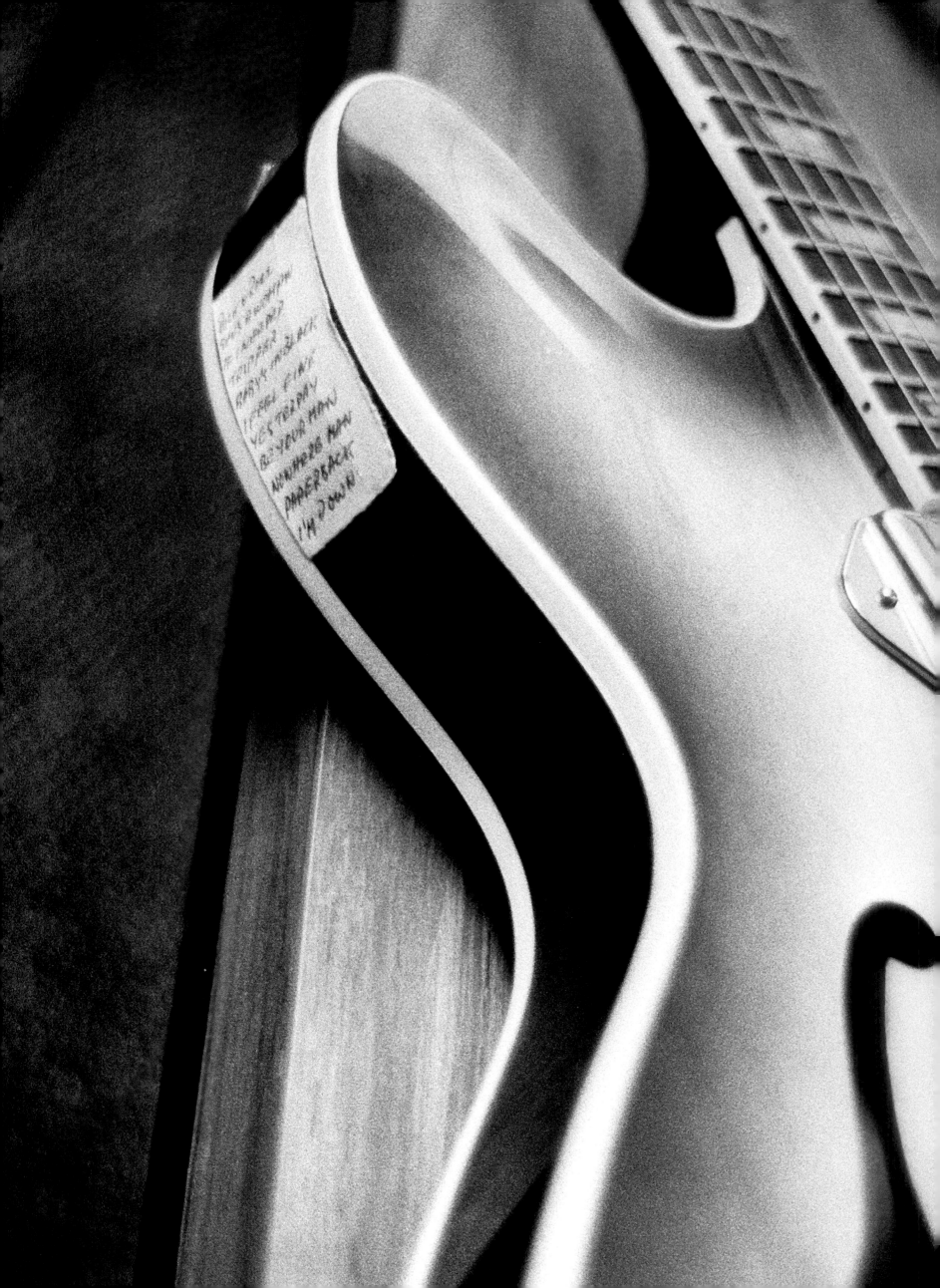

IN HAMBURG during the final leg of the Beatles' 1966 German tour, Whitaker made a photograph of George's Epiphone Casino guitar—a photograph that stands today as a fabulous artifact of that time and that band. The Beatles' stage routine was regimented down to what they would say between each song; the quips were scripted. And they launched from one song into the next in sets that were over just as soon as they had begun. On this night, and on most nights in this year, the set list (seen taped to George's guitar) included "Rock and Roll Music," "She's a Woman," "If I Needed Someone," "Day Tripper," "Baby's in Black," "I Feel Fine," "Yesterday," "I Wanna Be Your Man," "Nowhere Man," "Paperback Writer" and "I'm Down"—not a dud in the lot, and a barn burner for a finale, Paul going nuts. The picture on the two pages immediately following was made in Hamburg, too, and this was surely a nostalgic gig for the group. Back in 1962, playing at the Star-Club and other dives along the Reeperbahn, they were ingesting all sorts of uppers to survive the endless hours that were asked of them. They were wearing leather and trying to find their fashion. Now, here they were, only four years later: the very largest thing.

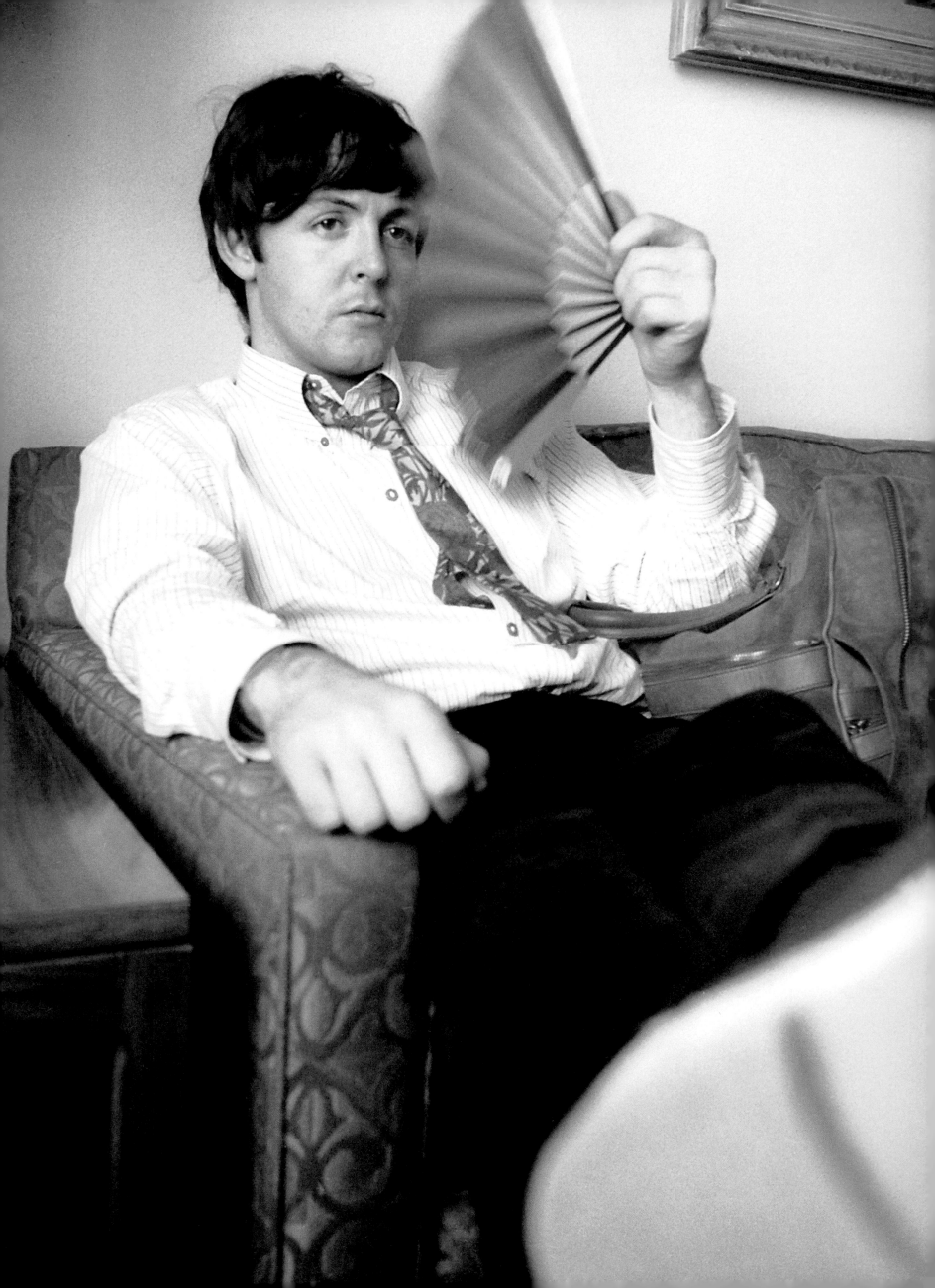

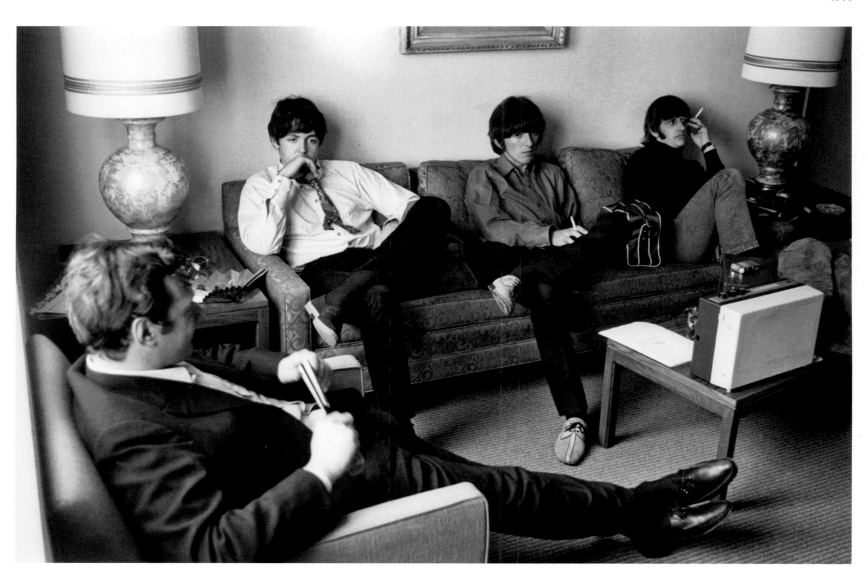

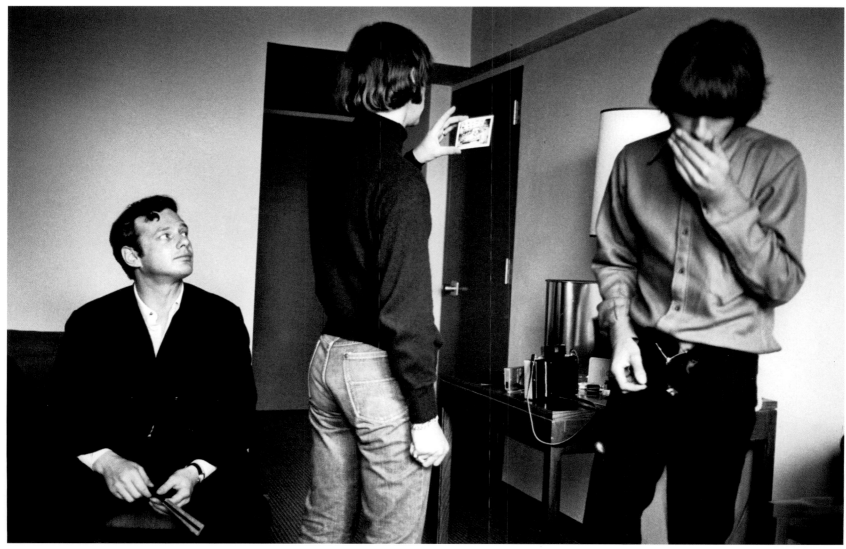

WHY SO GLUM, on these pages and the next few? Well, on June 27, 1966, the Beatles aren't supposed to be in a hotel room in Anchorage, Alaska. They're supposed to already be in Tokyo preparing for their shows there. How they got into this situation is a story worth telling, and we'll do so four pages further on.

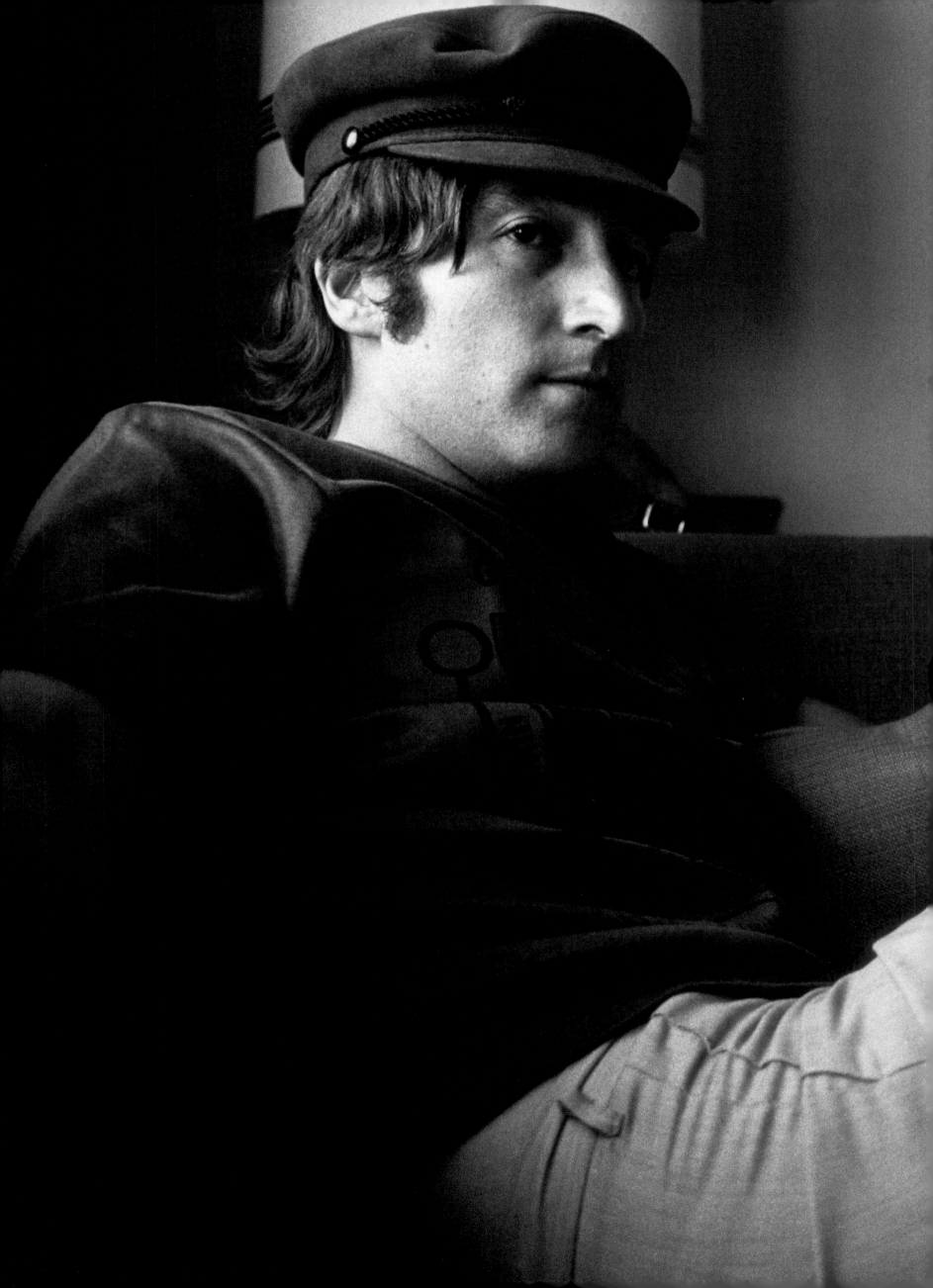

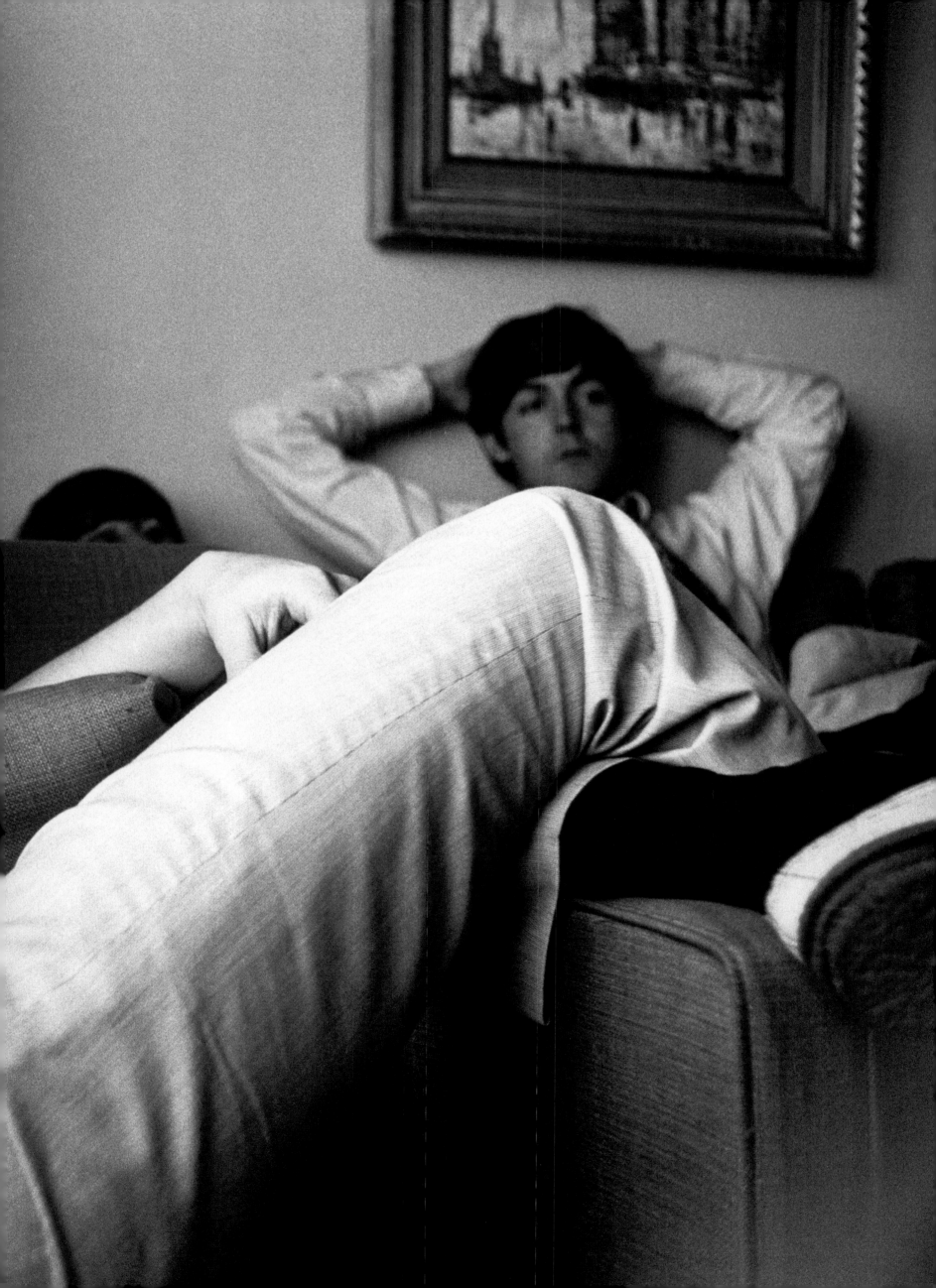

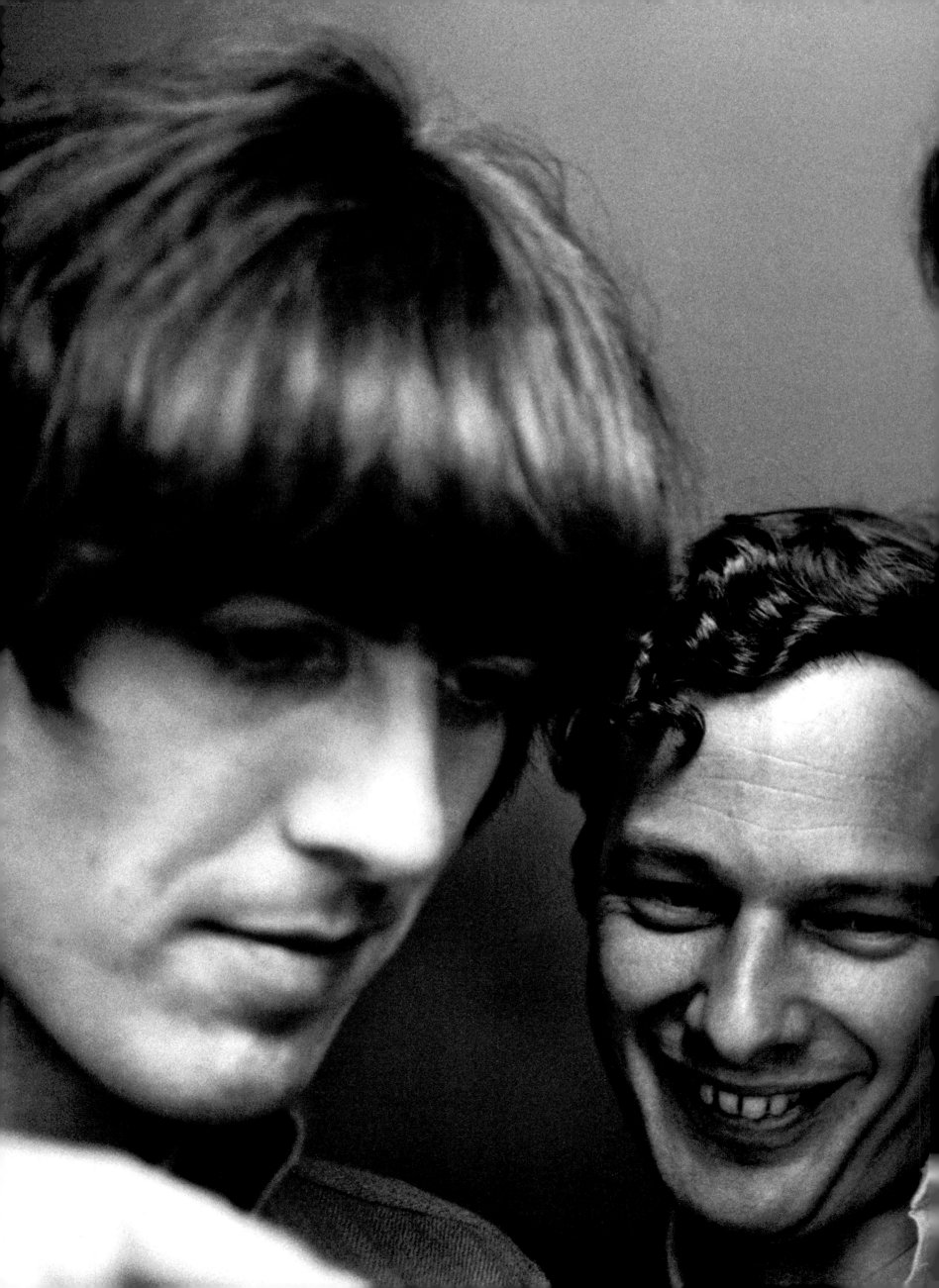

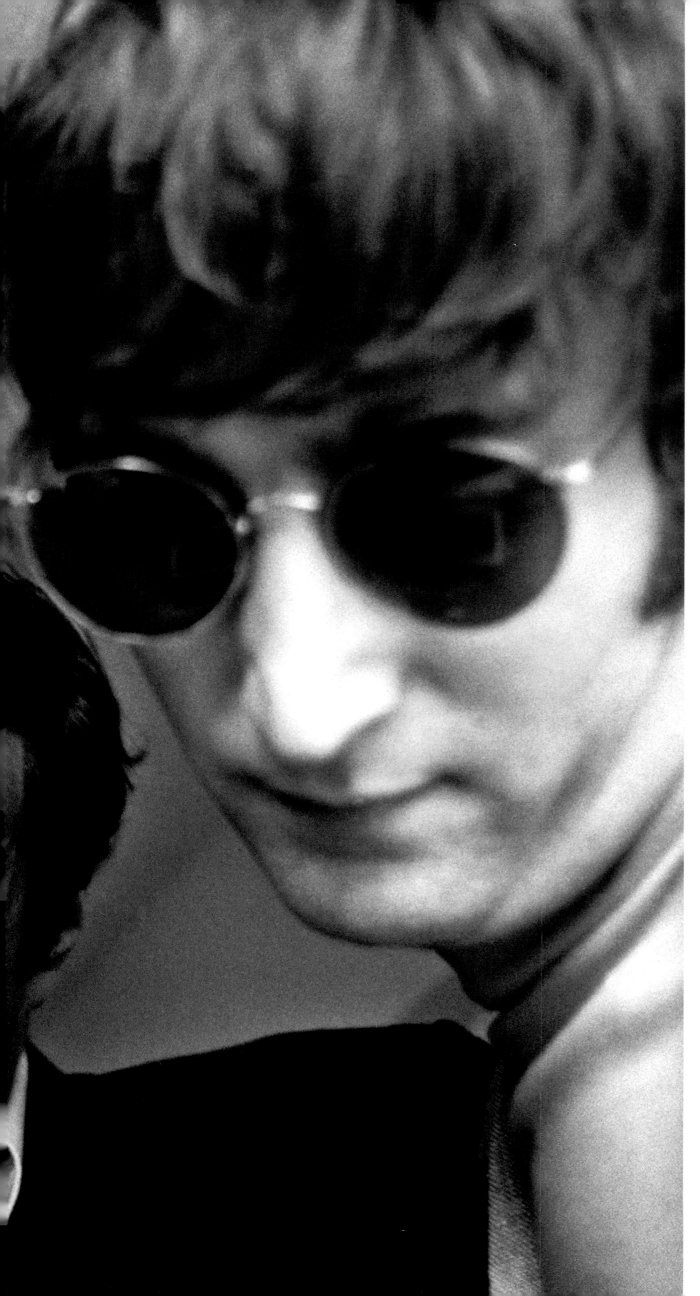

LOTS OF GLOBE-trotting tourists or even pampered expense-account celebrities plan a visit to Alaska. Why not? It is gorgeous beyond belief, and exotic in so many ways. The glaciers, the mountains, the eagles and bears, the lovely people! We can go out and sample it all! Well, all those nice Alaskan folks and critters and scenic opportunities didn't assuage the Beatles—didn't register with them, certainly, beyond the inconvenience of it all—when the pilot chauffeuring them over the North Pole from Hamburg to their next gigs in Japan received a warning that Typhoon Kit was heading in, and so he had to anchor down in Anchorage. Some local fans learned the news and made a pilgrimage, camping outside the Beatles' hotel, making even a stroll through town problematical. So there's nothing to cheer the Beatles as Whitaker records The Anchorage Stopover. He distinctly remembered making this image: George wanted at least a memory of this screwy episode and had taken a Polaroid at the hotel window. Whitaker noticed Brian Epstein and John join George to look at the results. "I slipped in under the three of them and took advantage of the natural light." At least Brian Epstein manages a smile. Next morning, it's off to Tokyo—at last.

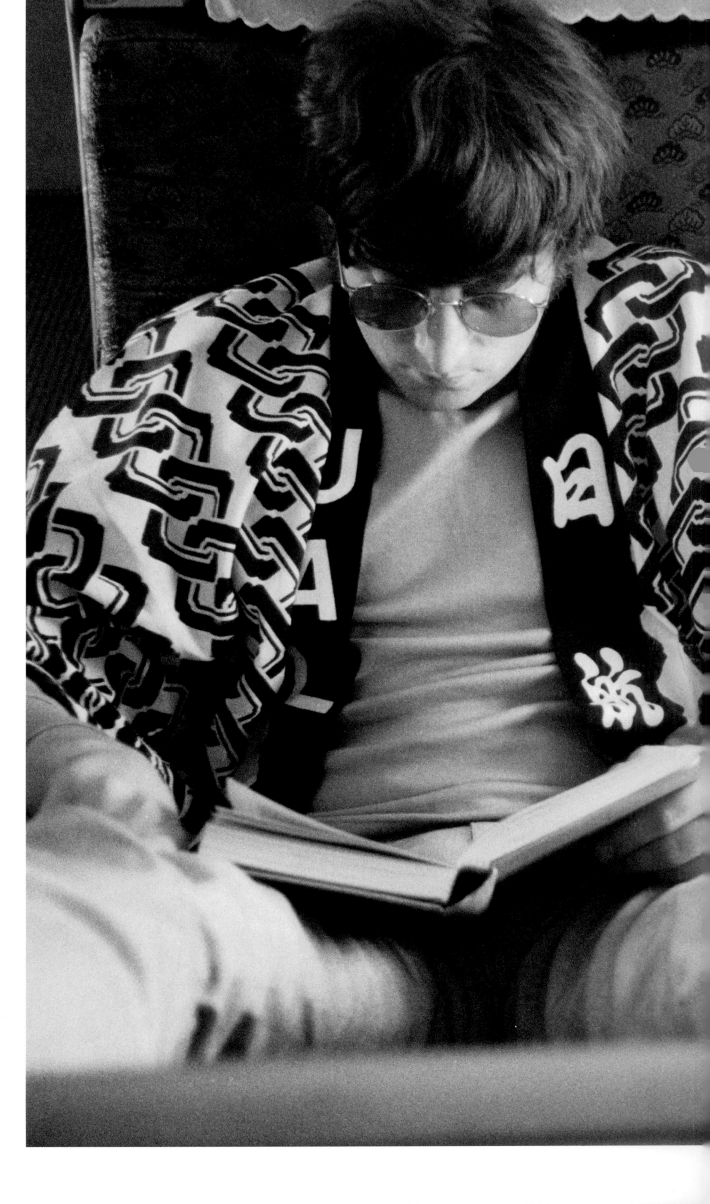

THE BEATLES, as might
be assumed, had never before
visited Japan, and it obviously
seemed a mysterious and
exotic land to them. But also:
It was just another place to
be put into a nice hotel, then
shuttled to a gig. On the long
flight from Alaska, they wear
airline-provided *happi* coats—
certainly as much for Whitaker's
camera as for any other
reason. Beyond that: playing
cards, taping conversations on
Ringo's recorder or reading
their books—or that of their
seatmate. They were not (not
yet) inclining toward Eastern
ways. George would lead them
there soon enough.

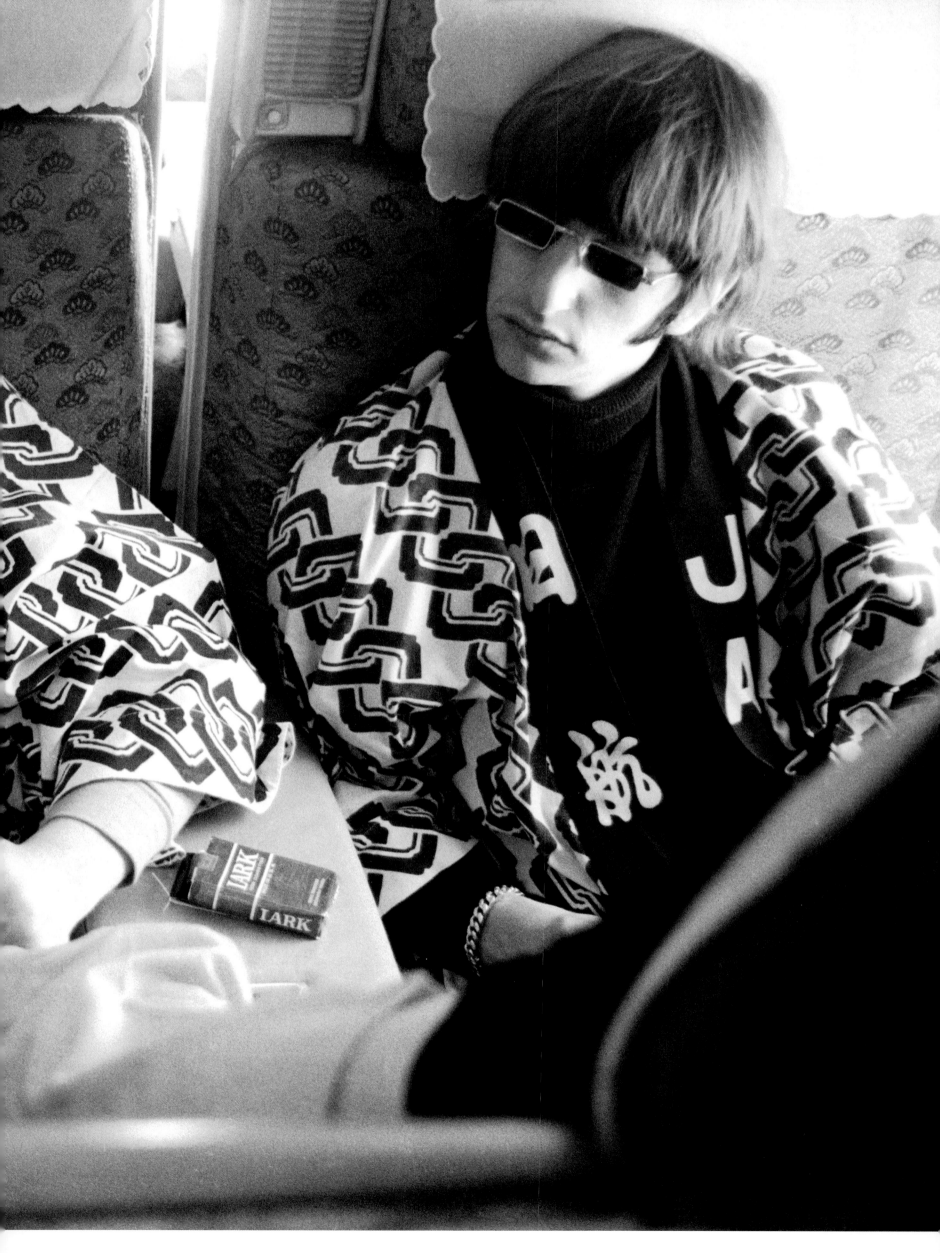

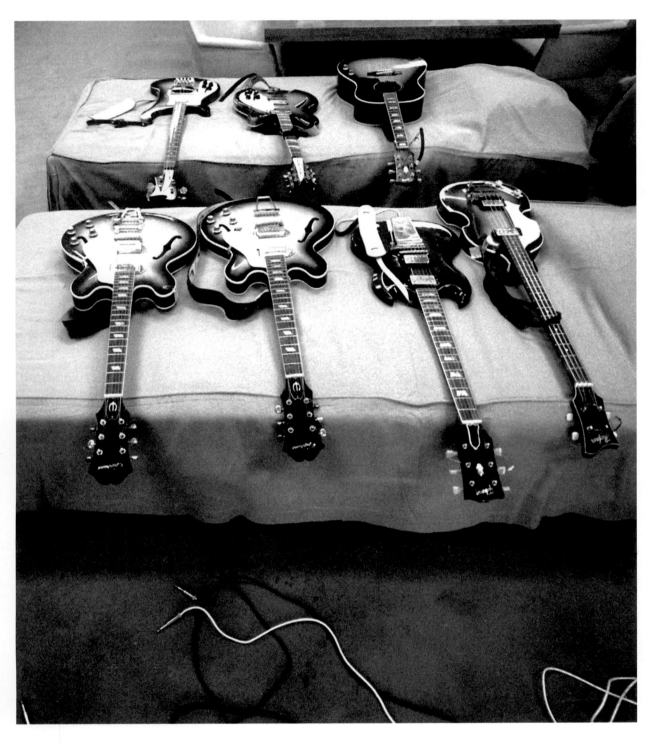

BACK IN THE DAY, Neil and Mal (Aspinall and Evans) took care of everything, and as the Beatles became a veritable industry, Neil and Mal still did. The guitars were always (or most always) where they were supposed to be, carefully laid out before any performance, and upon arrival in places like Tokyo, the luggage was neatly arrayed. "You hardly knew which city you were in," said Whitaker. "The schedules were punishing." Yes, they were. But who among us would not have wanted to be a Beatle, or the Beatles' personal photographer, or their handlers, back when? On the following pages, John and George practice in their hotel room.

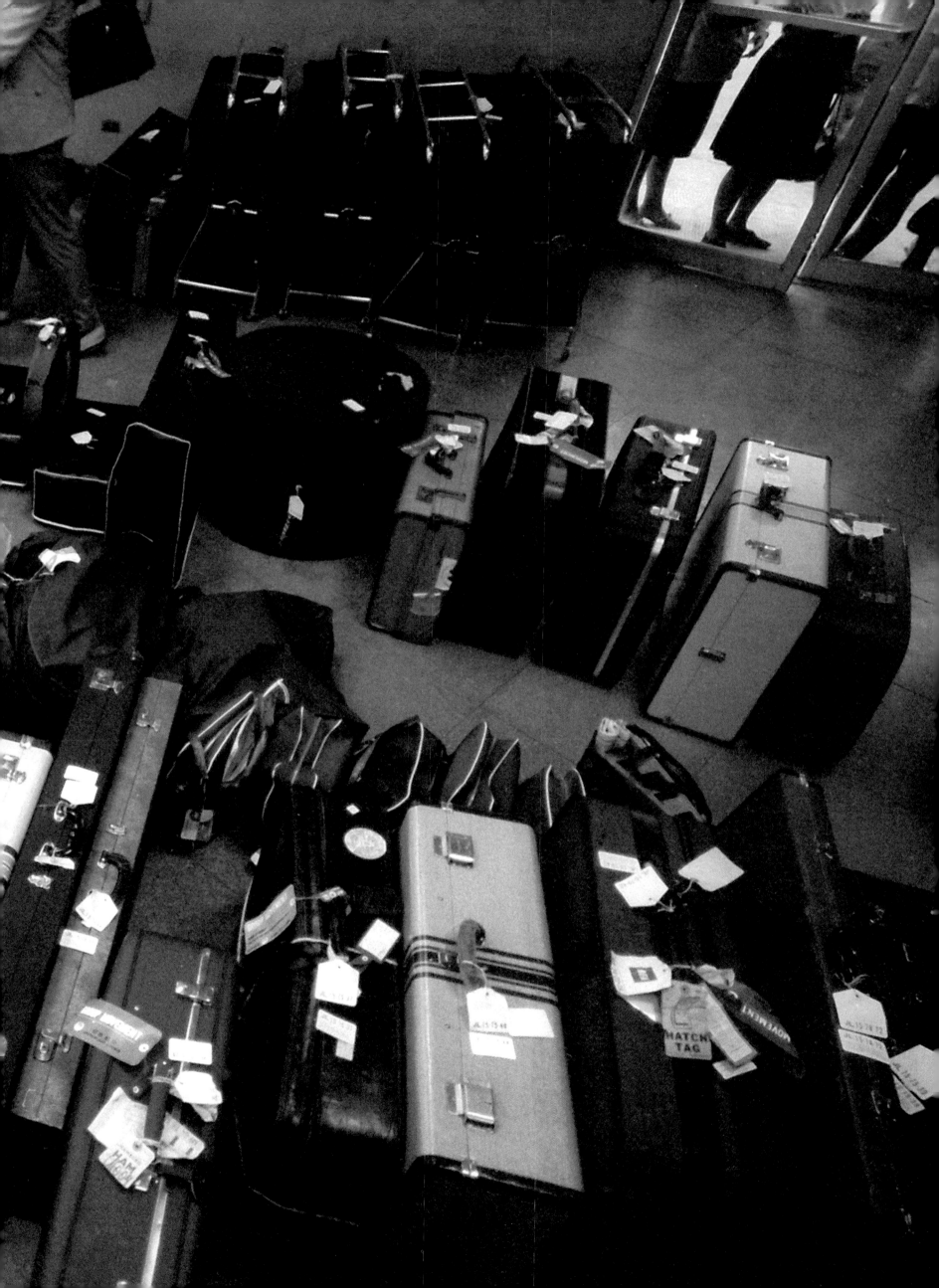

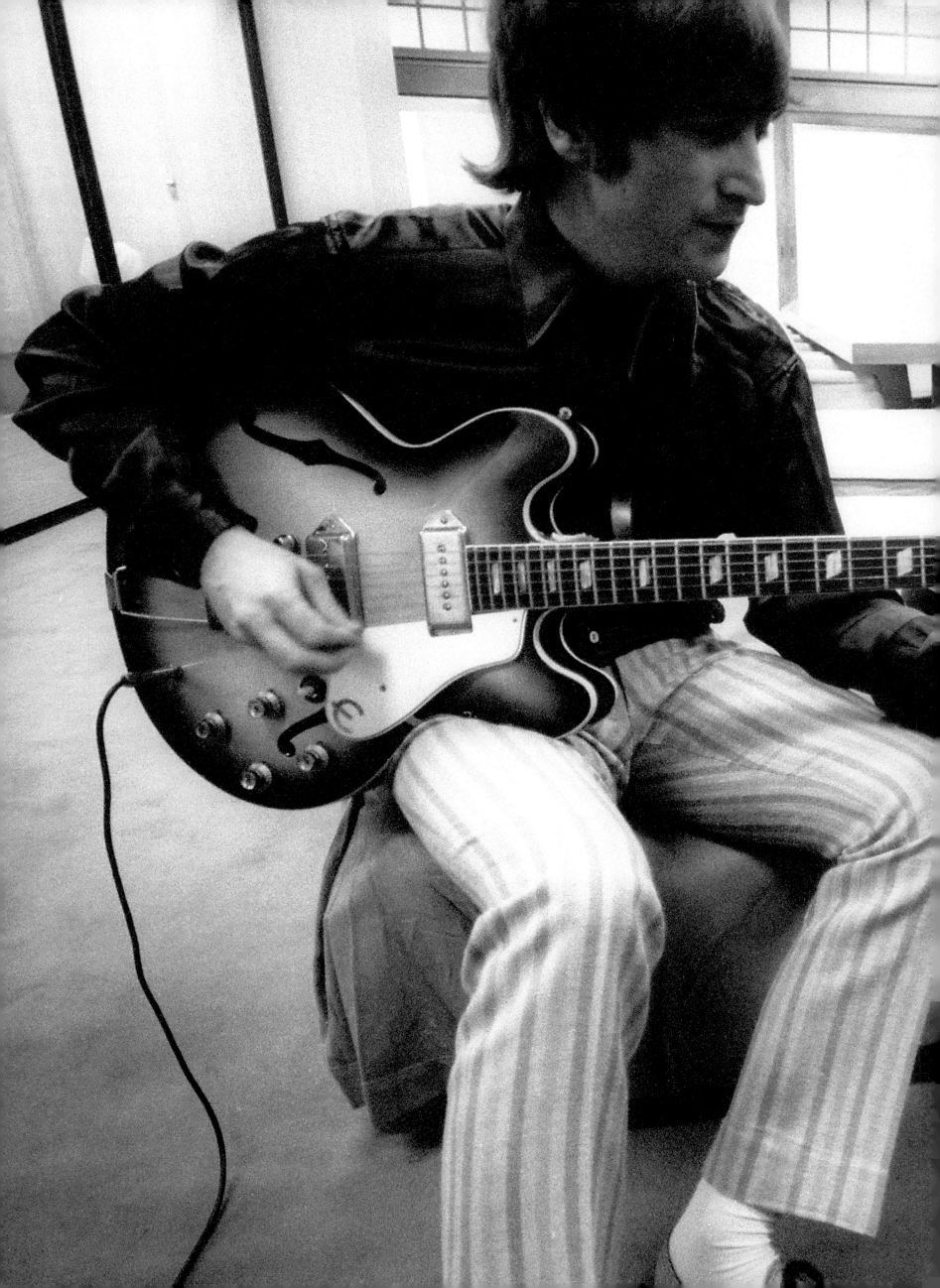

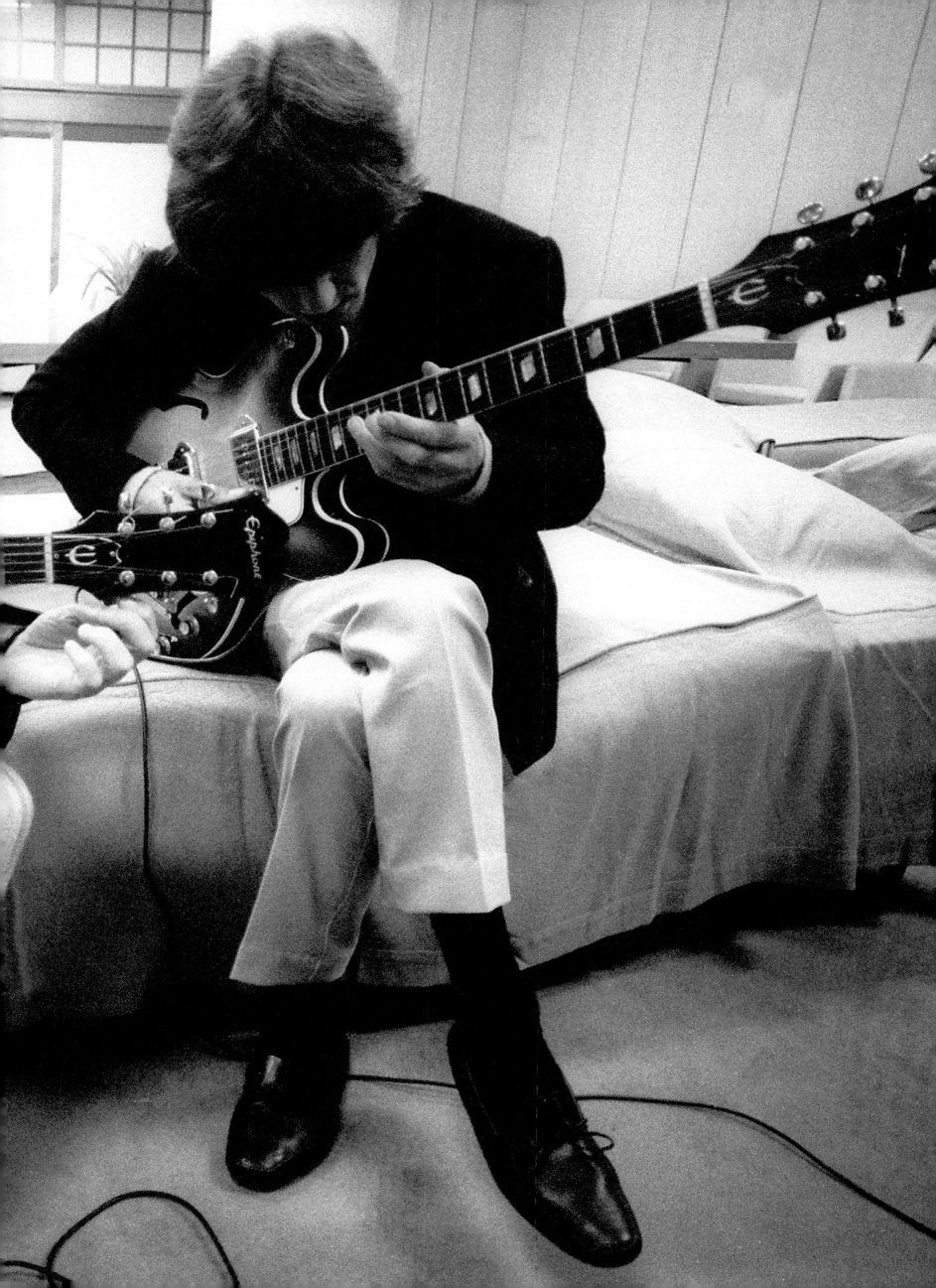

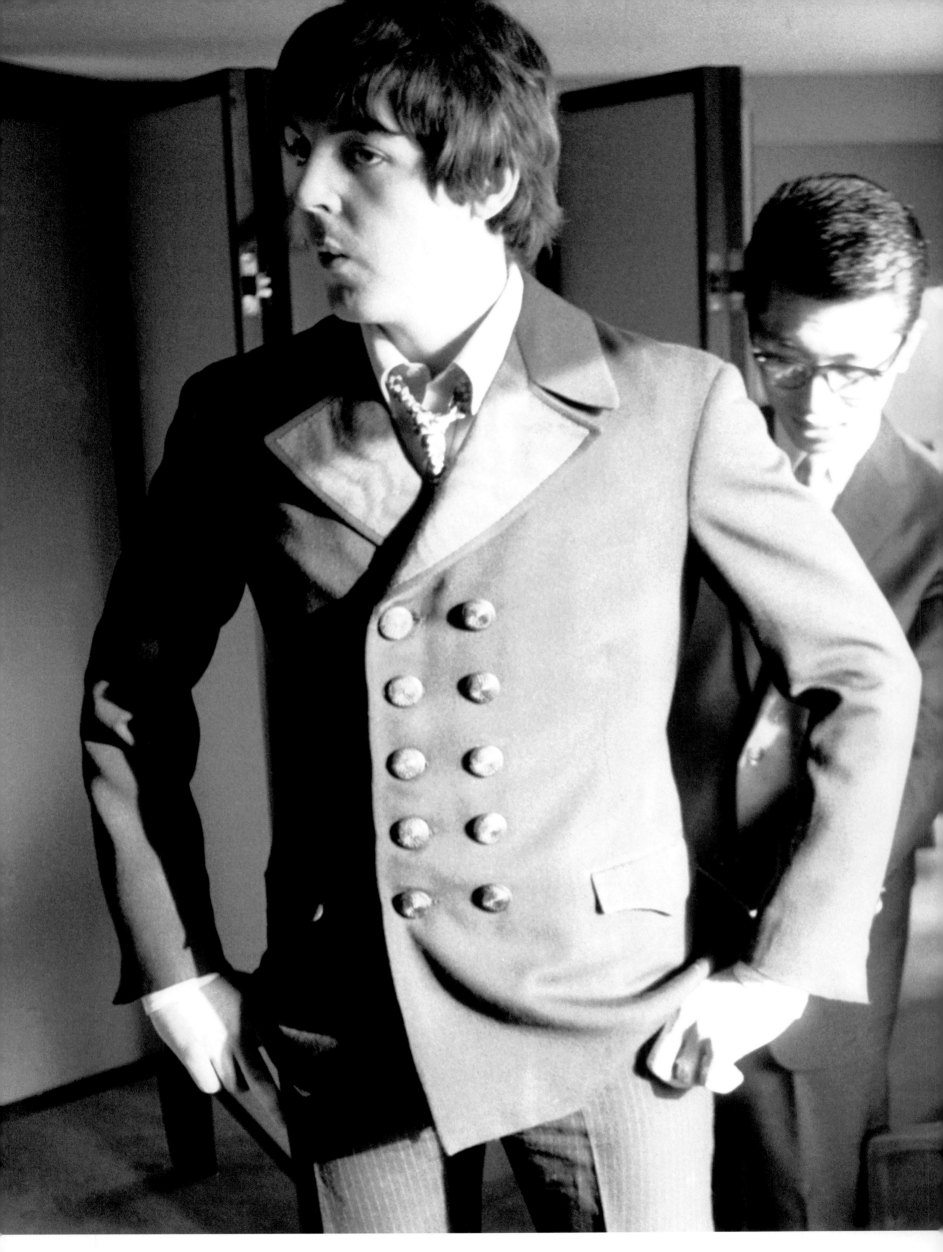

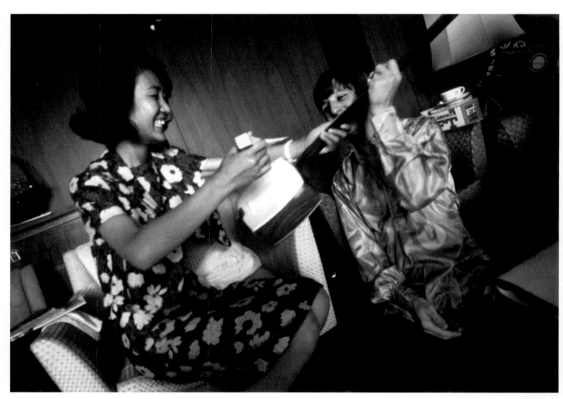

HERE PAUL GETS a visit from one of the best tailors in Tokyo—Savile Row being a world away. Whitaker recalled, "All the Beatles were very stage conscious and this picture shows Paul having one of his stage suits measured." Paul was perhaps more distant with Bob than the other three were, and whether that was because Bob had grown close to John is for history to parse. "I probably spent less time talking to Paul than any of the other Beatles, but I certainly admired his talent for writing brilliant music and words. Out of all of them Paul seemed to have the strongest passion for performing." But his passion, too, would be dented by the tumult of this last Asian tour—especially later events in Manila—and the Beatles had barely another month as a live band. On the following pages, Ringo primps as Mal Evans looks on, and then he takes a twirl, Tokyo style.

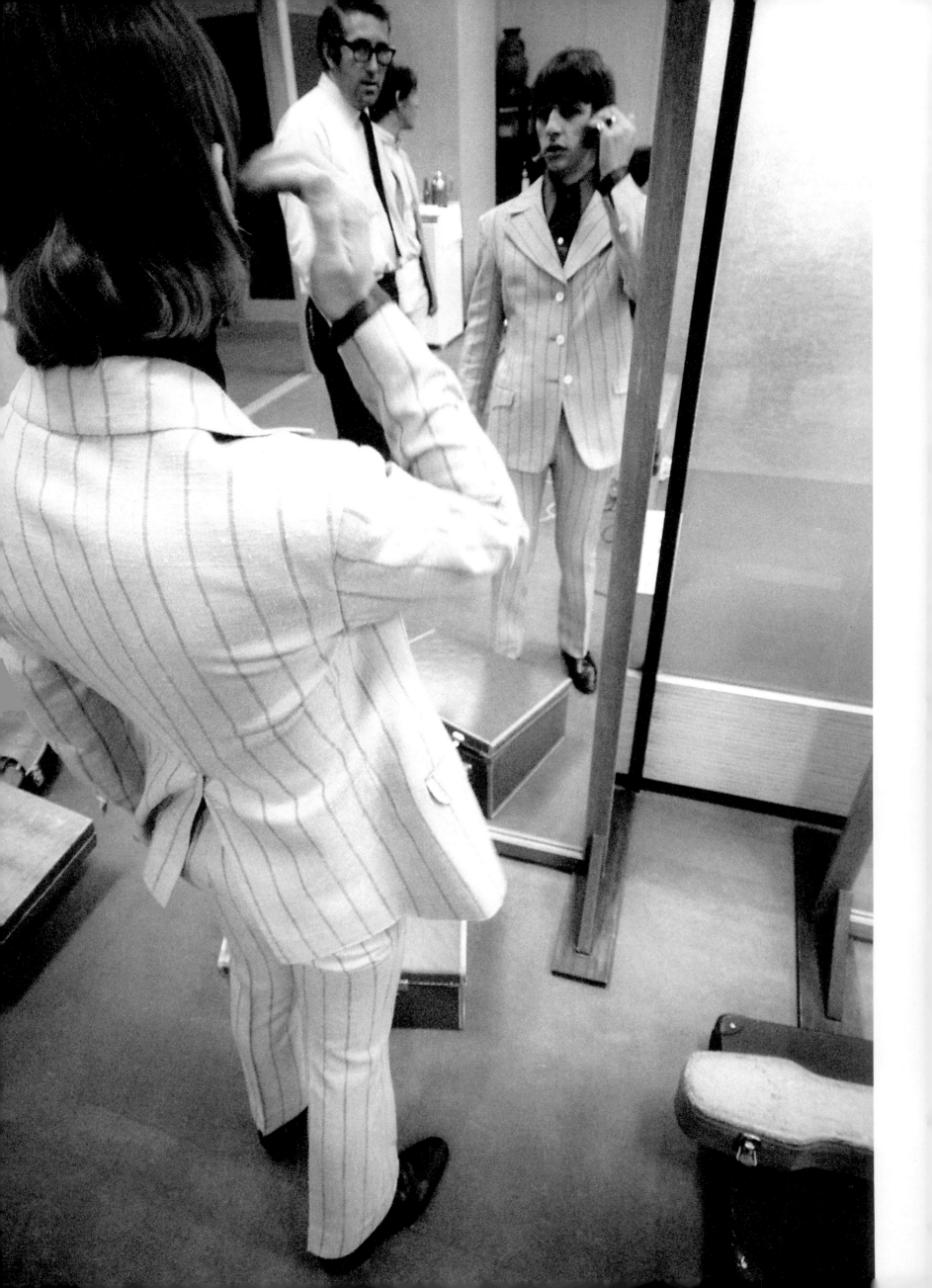

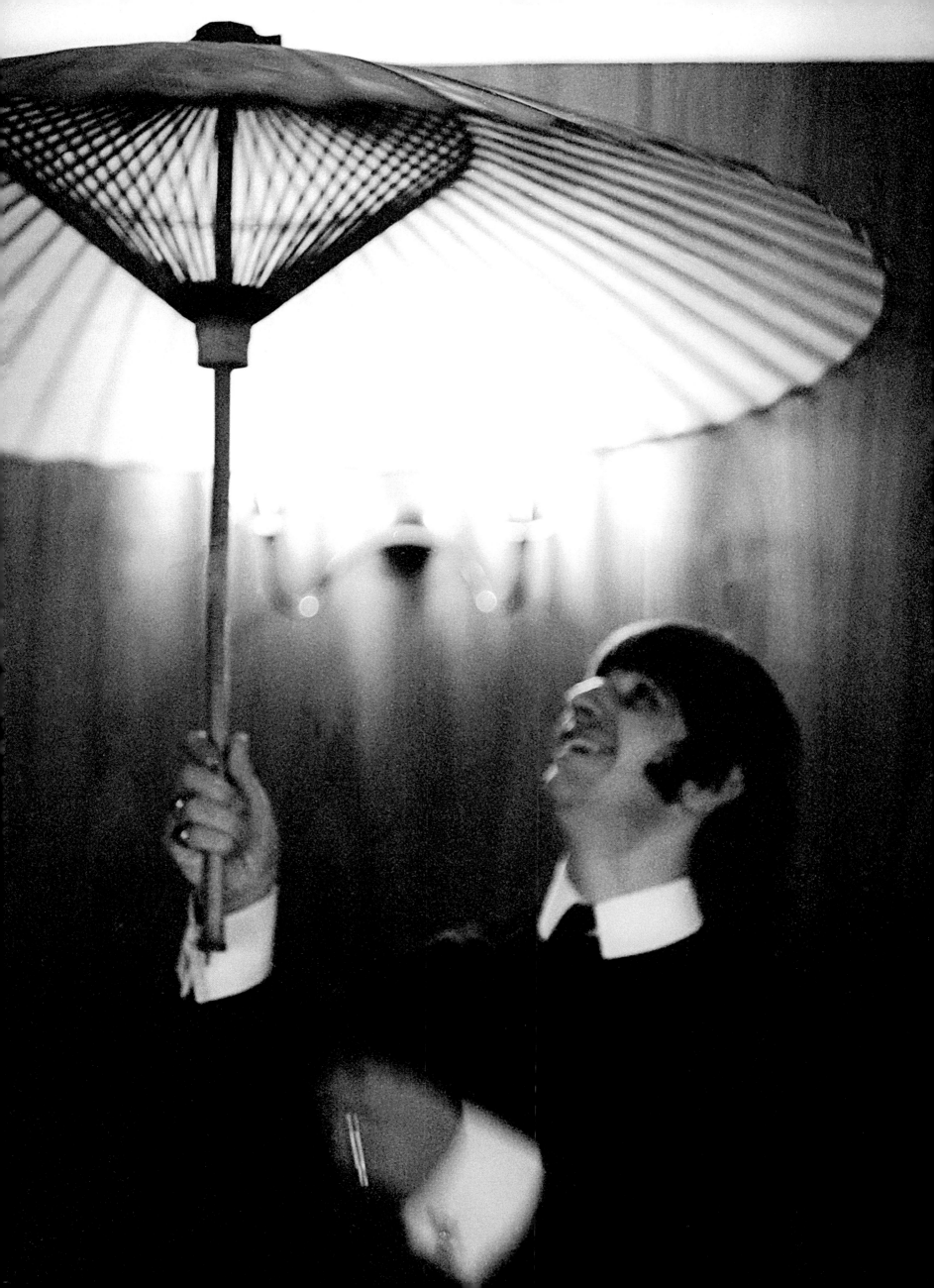

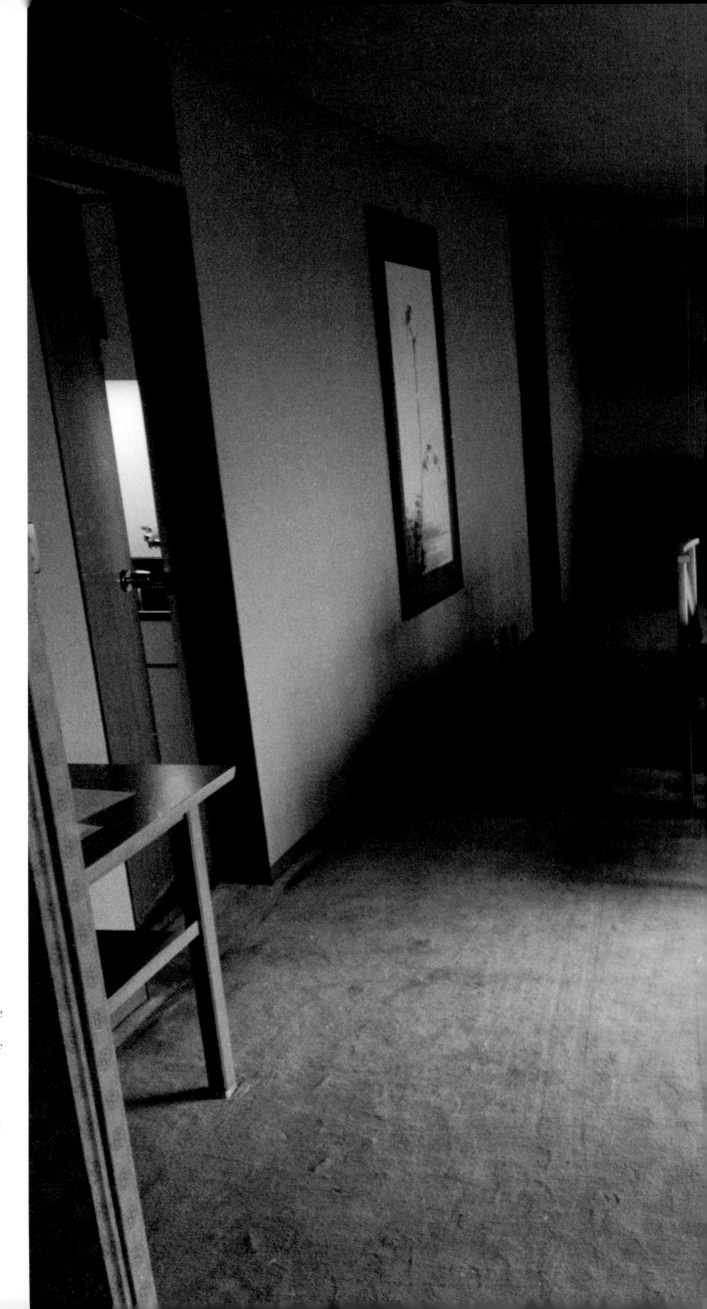

WHILE IN JAPAN,

the Beatles, frustratingly, are
confined like prisoners to their
hotel. But there is a reason,
and it's a good one—a reason
beyond groupies and others
who might tear their clothes off.
Unbeknownst to the band, there
have been protests, even death
threats, made by a small cult of
anti-Western Japanese students
who object that the concert
is being held in the Budokan.
That hall is considered by these
dissidents to be a sacred venue
dedicated to exclusive use by
the martial arts. Here, Ringo,
peering at the Beatle idolatry
outside, is symbolic of the
weird situation.

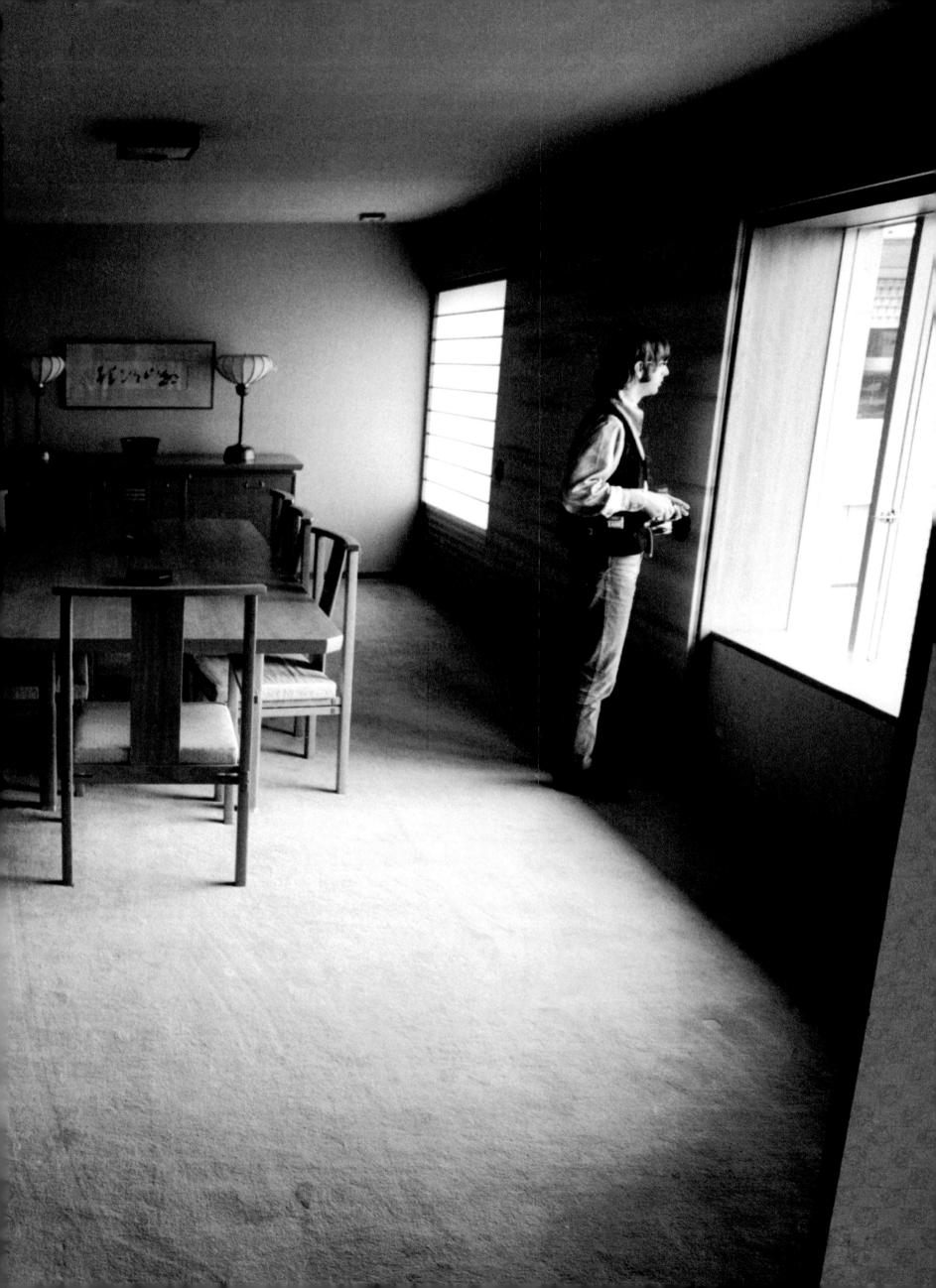

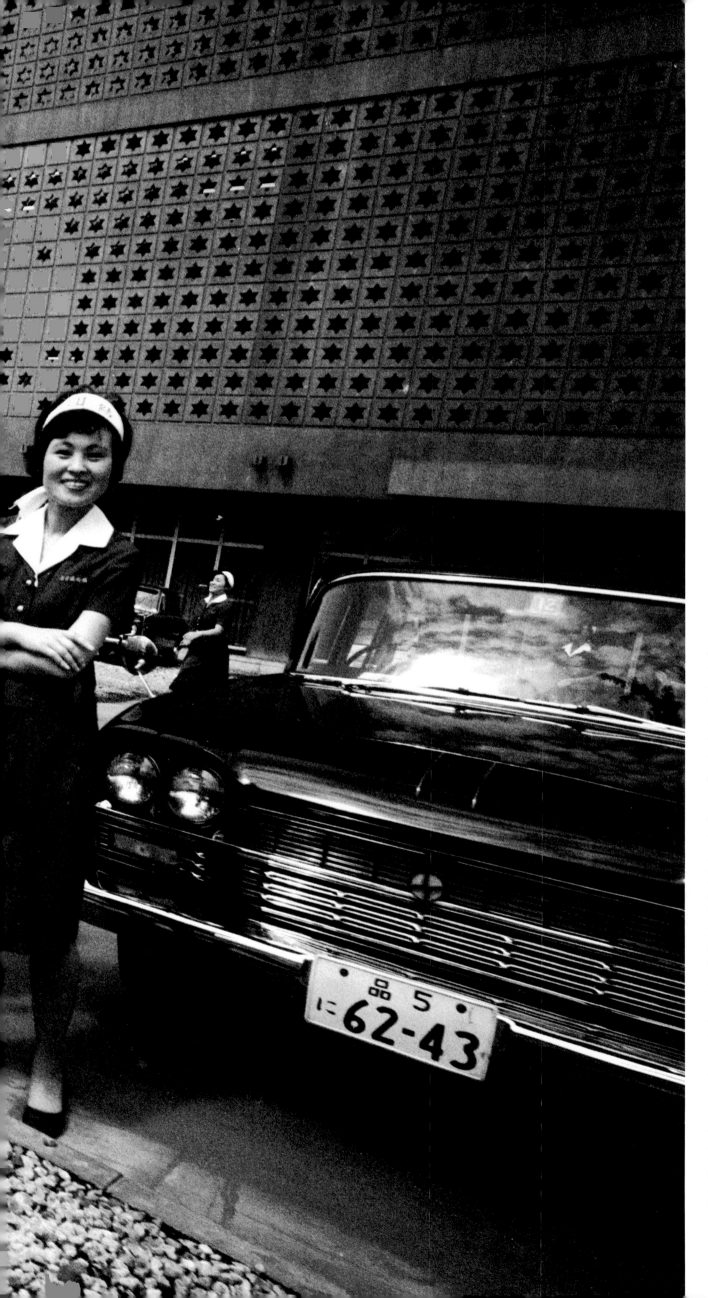

EVEN THOUGH the Beatles had a few enemies in Japan, they had many more friends, including the hotel staff, who—since the boys couldn't leave the premises—got to know them well. Here, they give the band a genial send-off just before the first Tokyo concert. The shows at the Budokan (seen on the following 10 pages) come off without a hitch. That is to say: They come off without any of the threatened violence, perhaps because there are 3,000 police in the hall, some of them behind the band, and the Beatles are playing on a stage eight feet above the audience. The band is out of tune in the first of its five shows— something the musicians take very seriously, and they dig deep between concerts, spending much time rehearsing. They're back on the beam for the remaining concerts. Before the Beatles called it quits as a live band, they still loved being a live band. Our Budokan mini-chapter begins on the very next pages, as the Beatles take a breather backstage with Brian Epstein, then storm the stage.

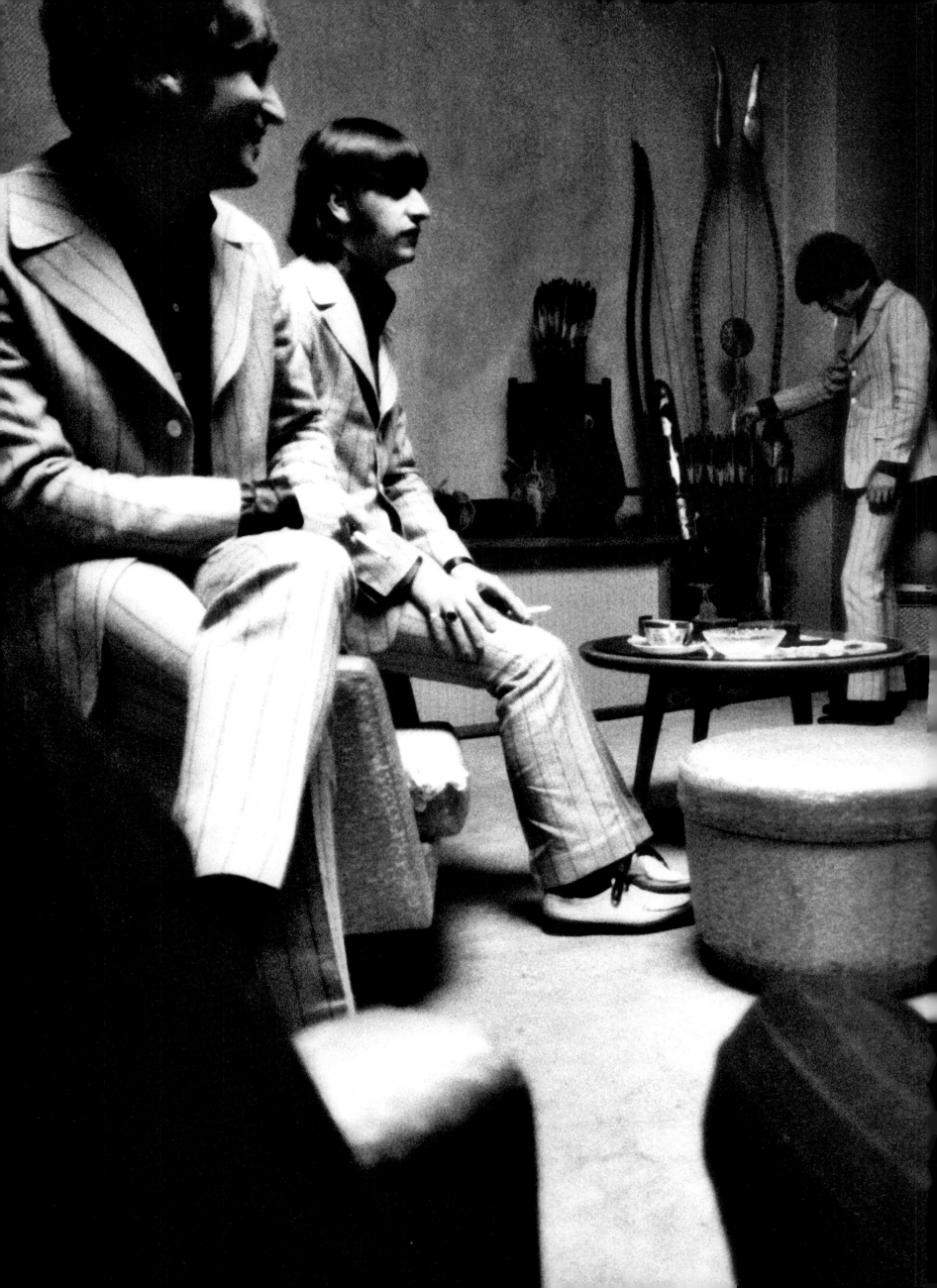

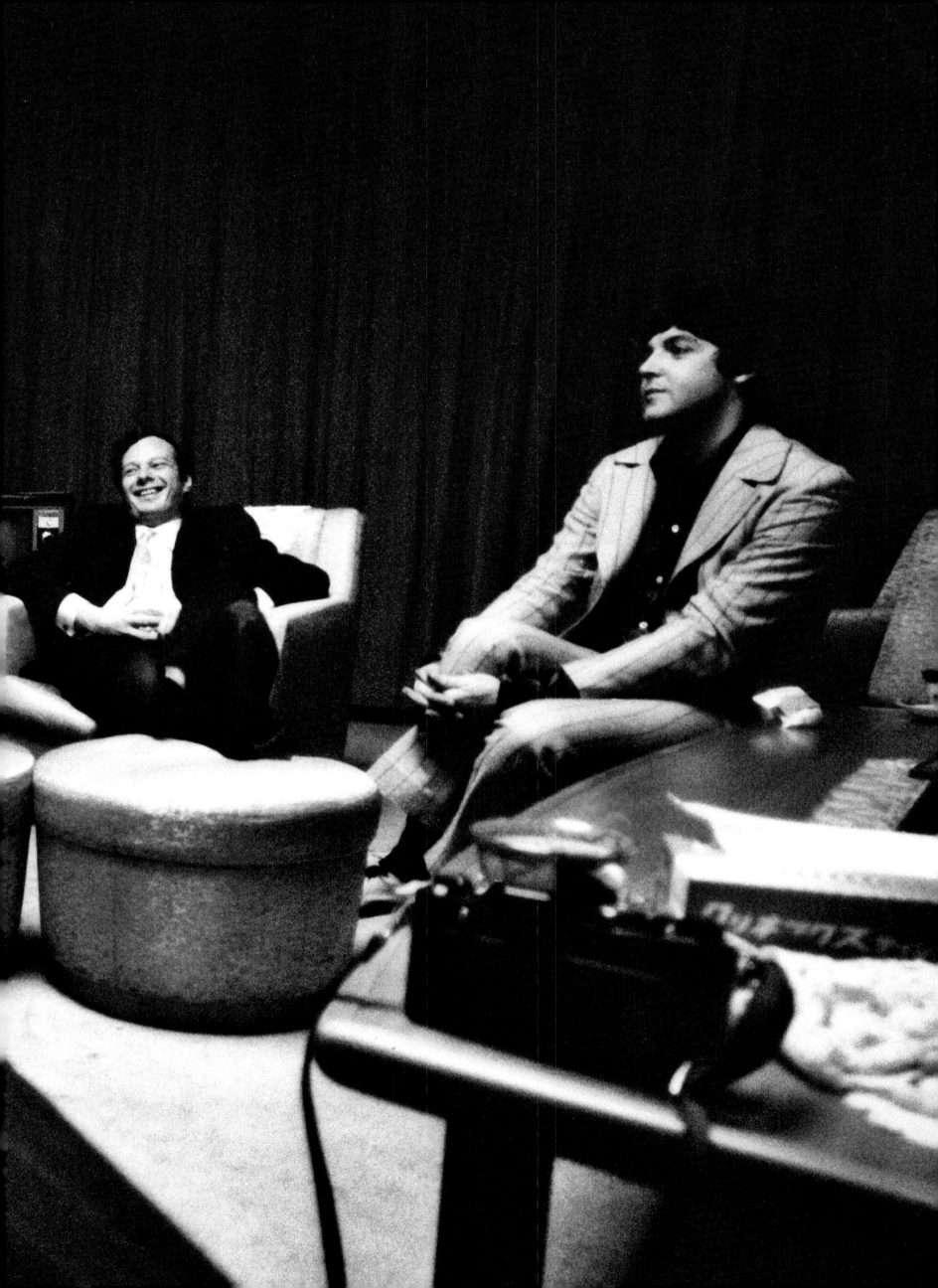

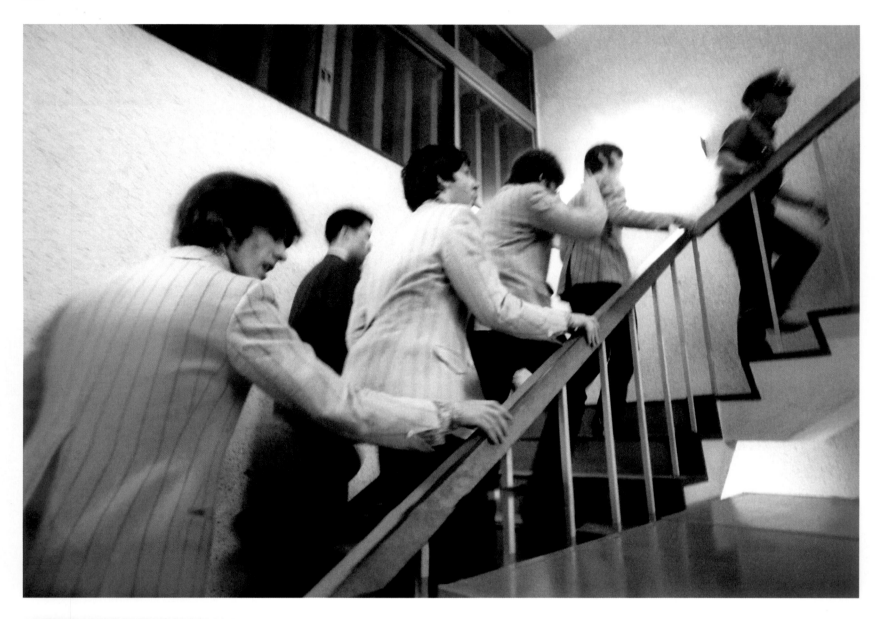

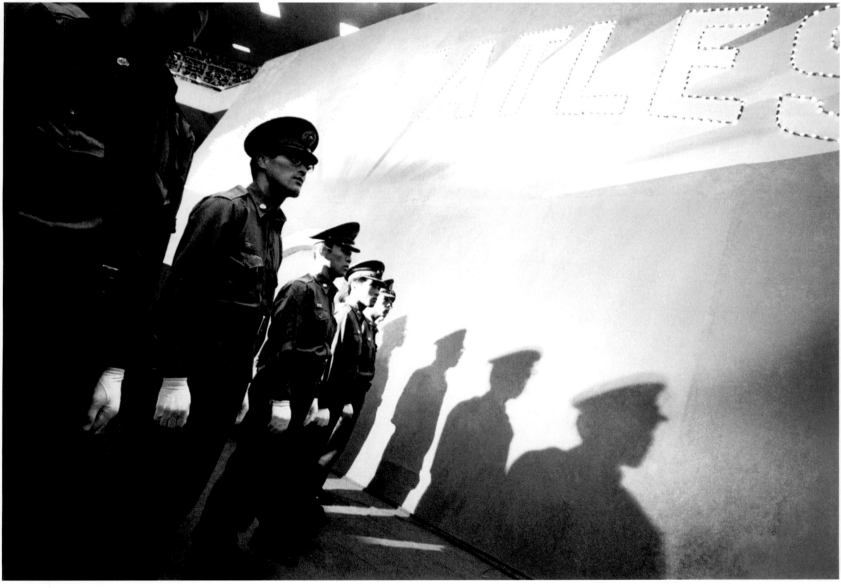

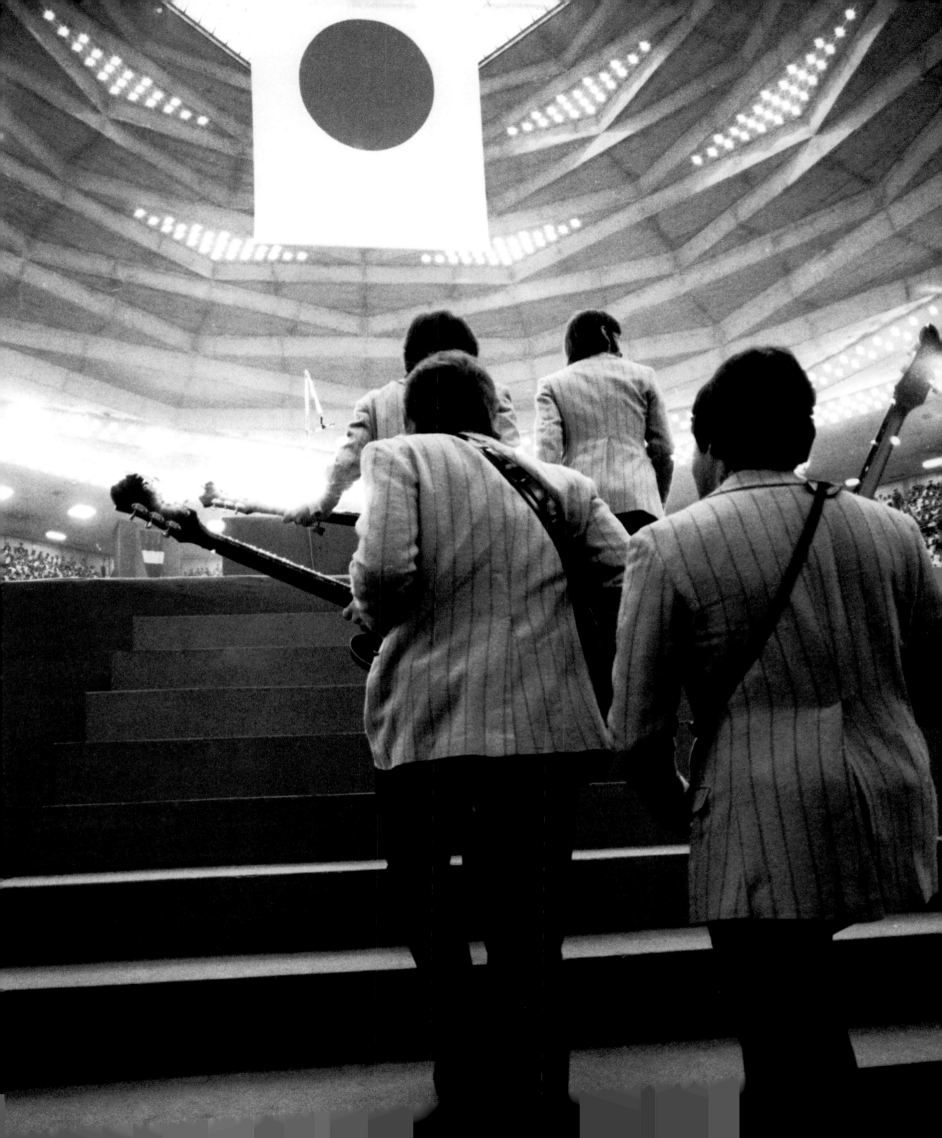

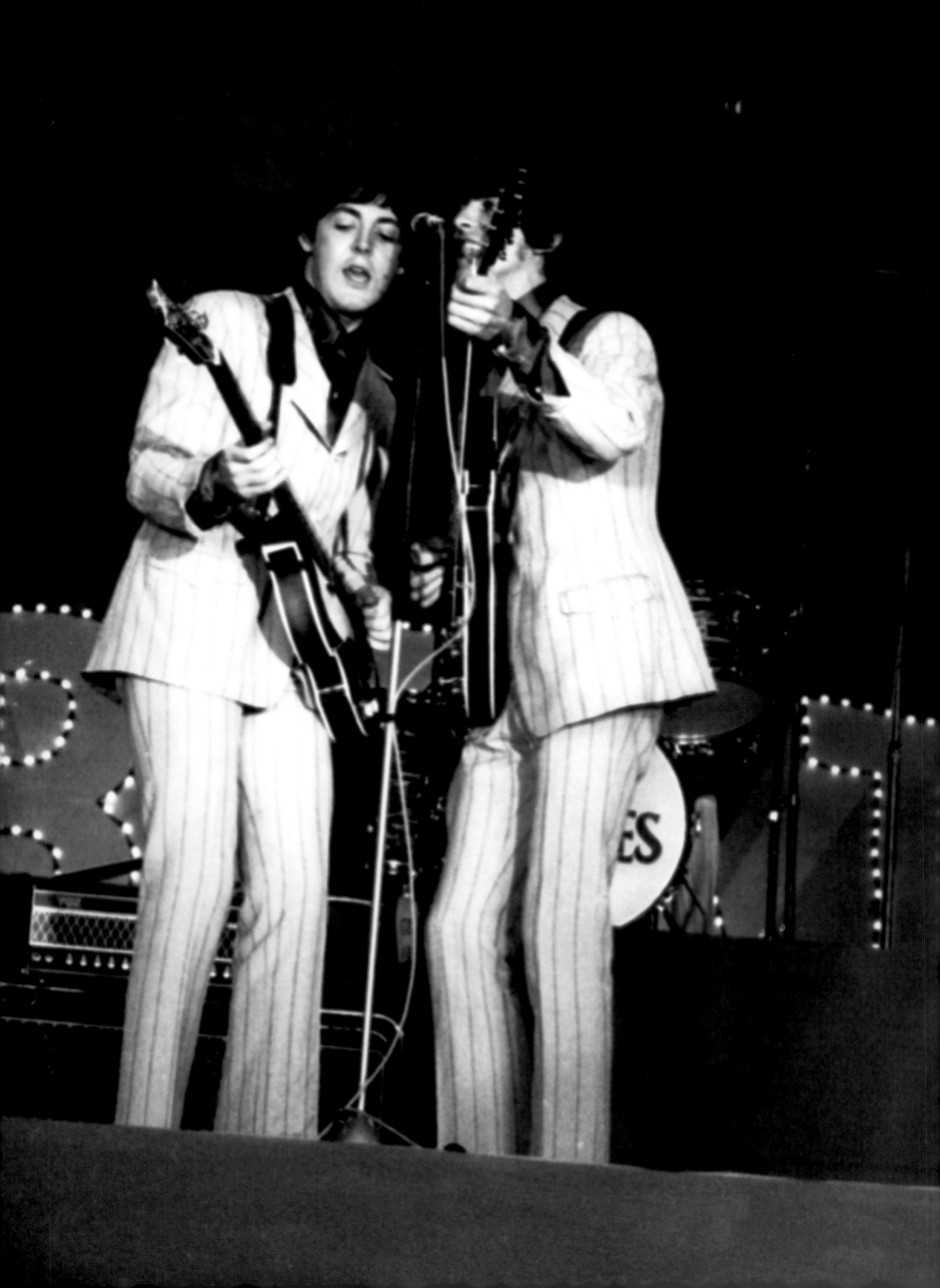

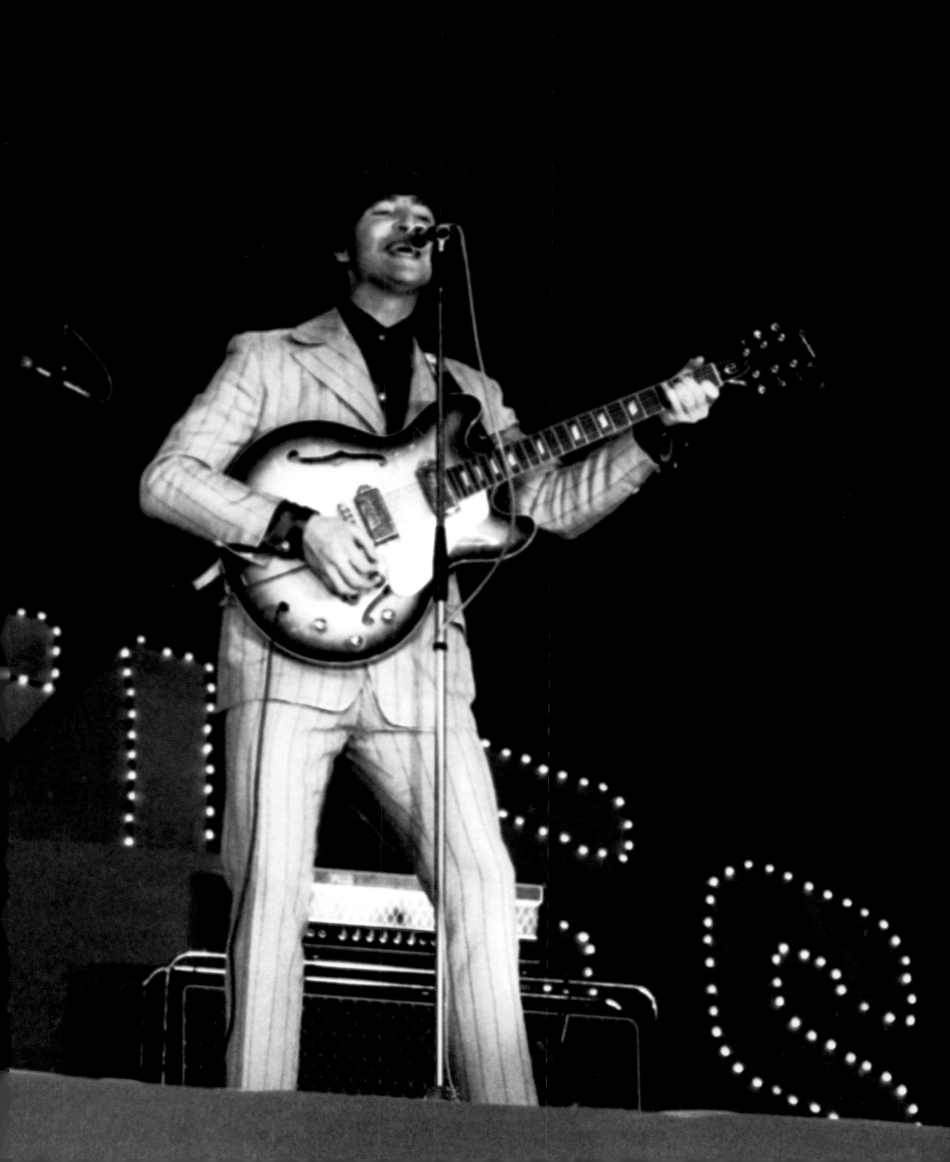

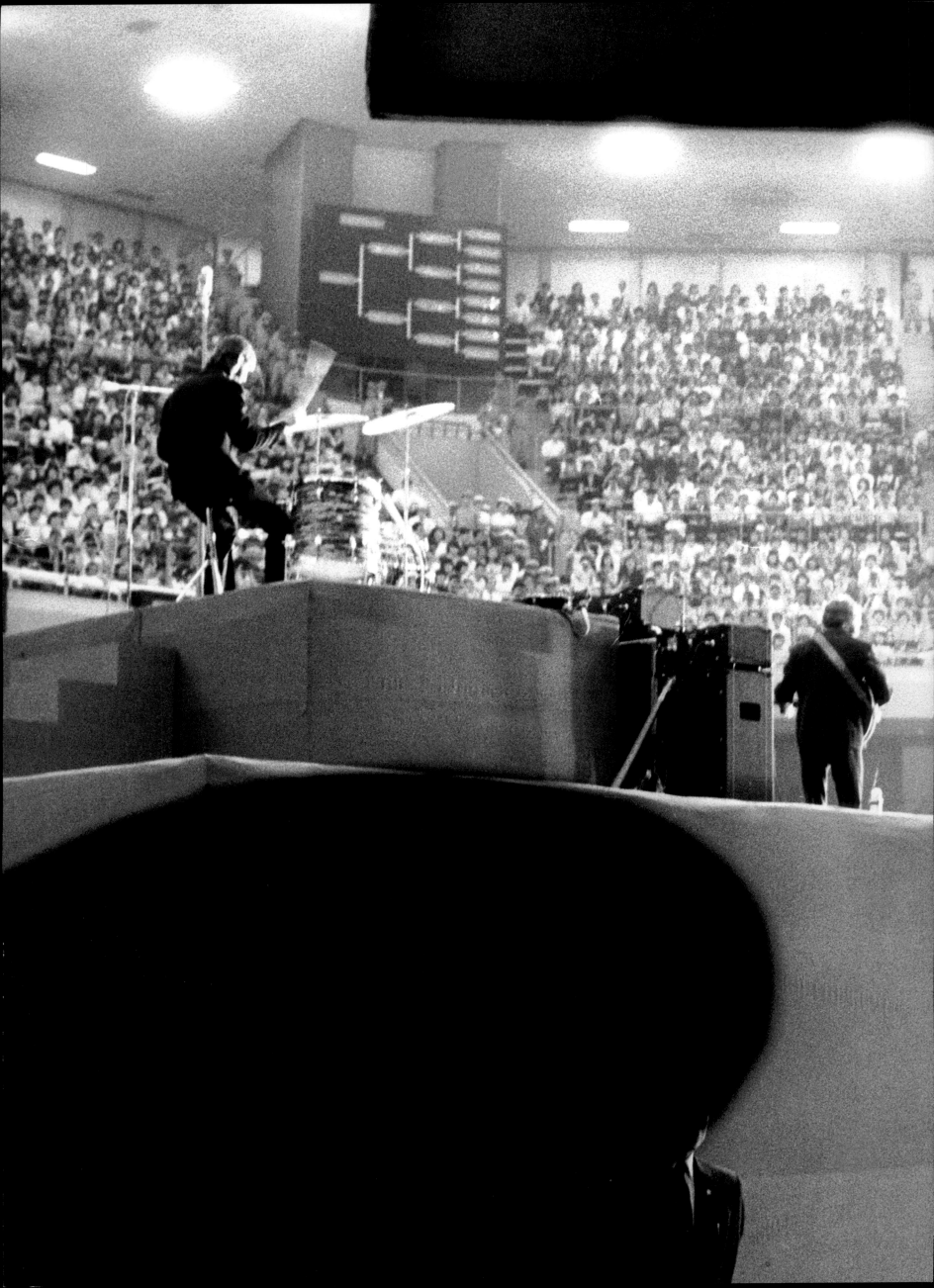

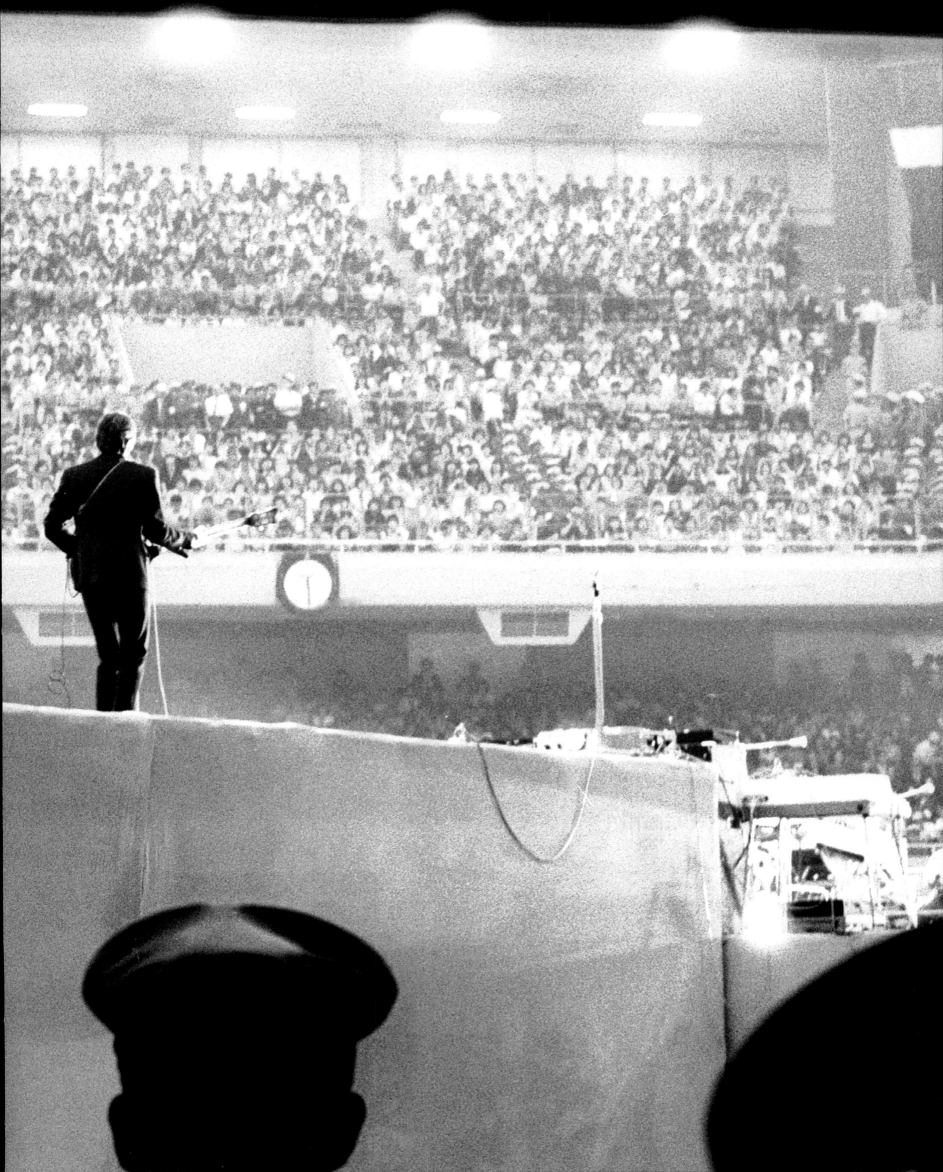

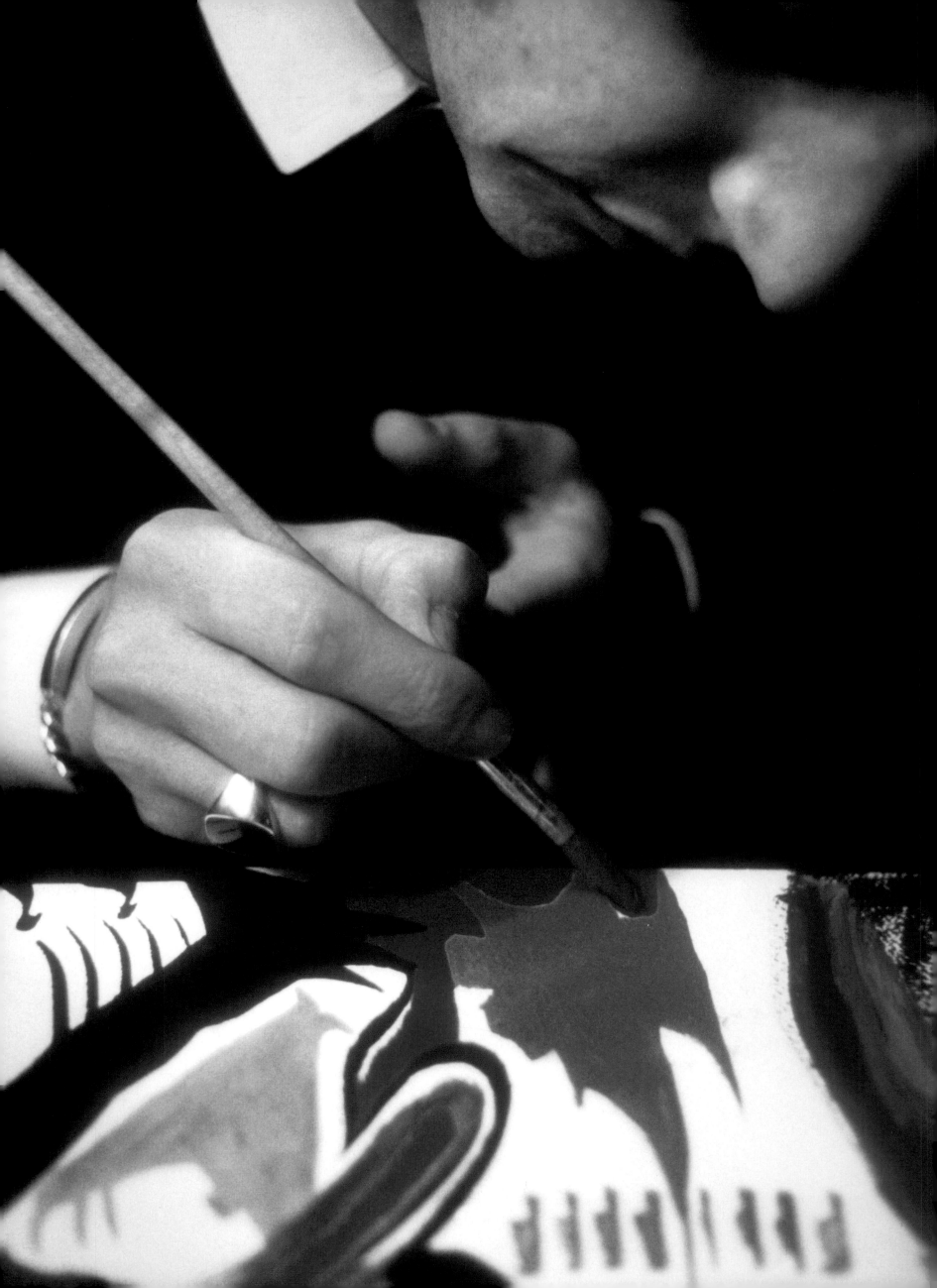

CONFINED AS THEY WERE to their hotel in Japan by the even-more-intense-than-usual circumstances, the boys began painting. Whitaker recalled, "They collaborated on their only joint venture that didn't involve music. I had never seen them so happy. They placed the paper on a small table and started painting toward the light. They never discussed what they were painting." The end result, seen in detail on the following pages, was informally known as "Images of a Woman." Which woman? Unnamed. The painting was sold for charity.

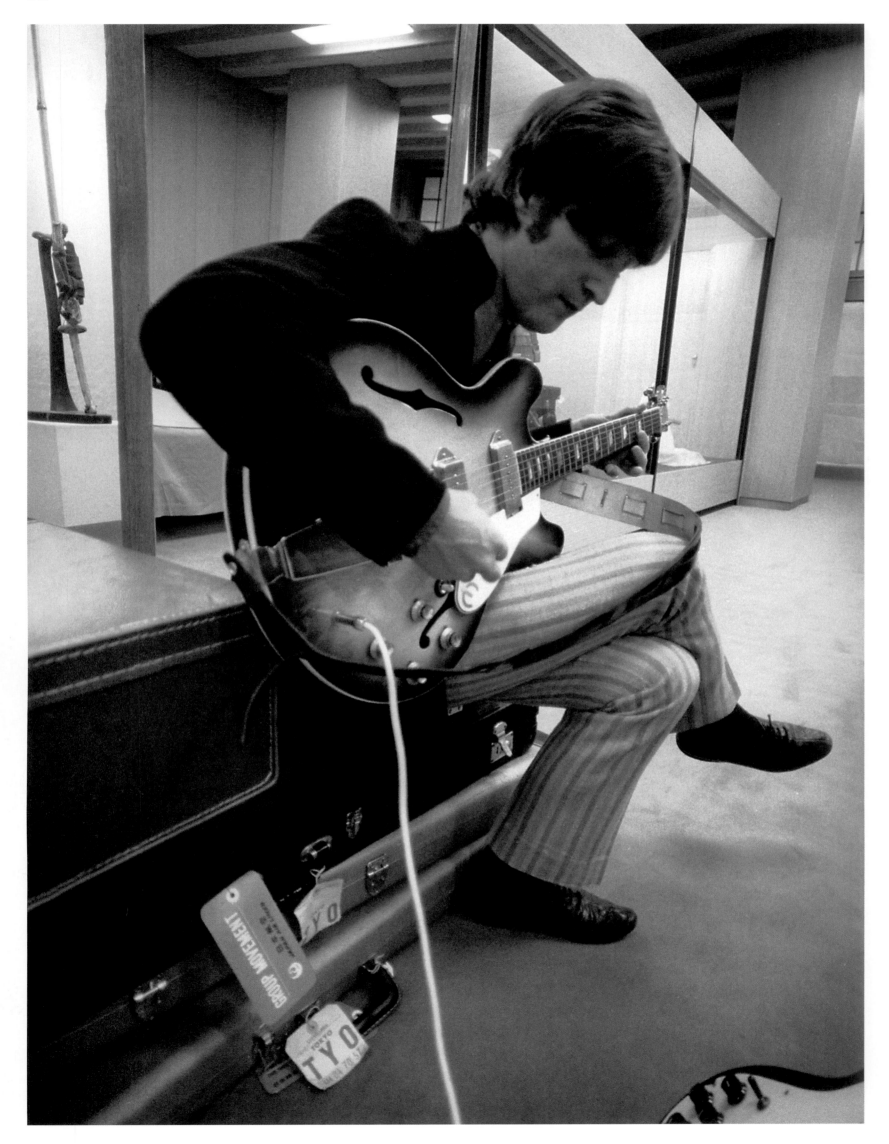

JOHN SOLO: Rehearsing (above) and during a *happi* moment in Japan (opposite). Whitaker recalled how John had been particularly fascinated by the Japanese masks, and when John shoved one under his jacket, Whitaker shot this image—which would become quite well known, and which captured the rapport he enjoyed with John.

ON THESE AND the following four pages are scenes from a layover at Kai Tak Airport in Hong Kong, where the Beatles spent 70 minutes before heading on to Manila. "In Hong Kong, and indeed most places we had been, there was always a hubbub to greet us," Whitaker recalled. "This photo shows what looks like a peculiar standoff as press photographers gather round the group." Yes, perhaps, but that was nothing compared to the several standoffs the Beatles would confront when they finally arrived at the Philippine capital, where they were slated to perform their last two shows in Asia before heading home to London. "I hated the Philippines," Ringo remembered in the book that accompanied *The Beatles Anthology* film. "We arrived there with thousands upon thousands of kids, with hundreds upon hundreds of policemen—and it was a little dodgy. Everyone had guns and it was really like that hot/Catholic, gun/Spanish Inquisition attitude."

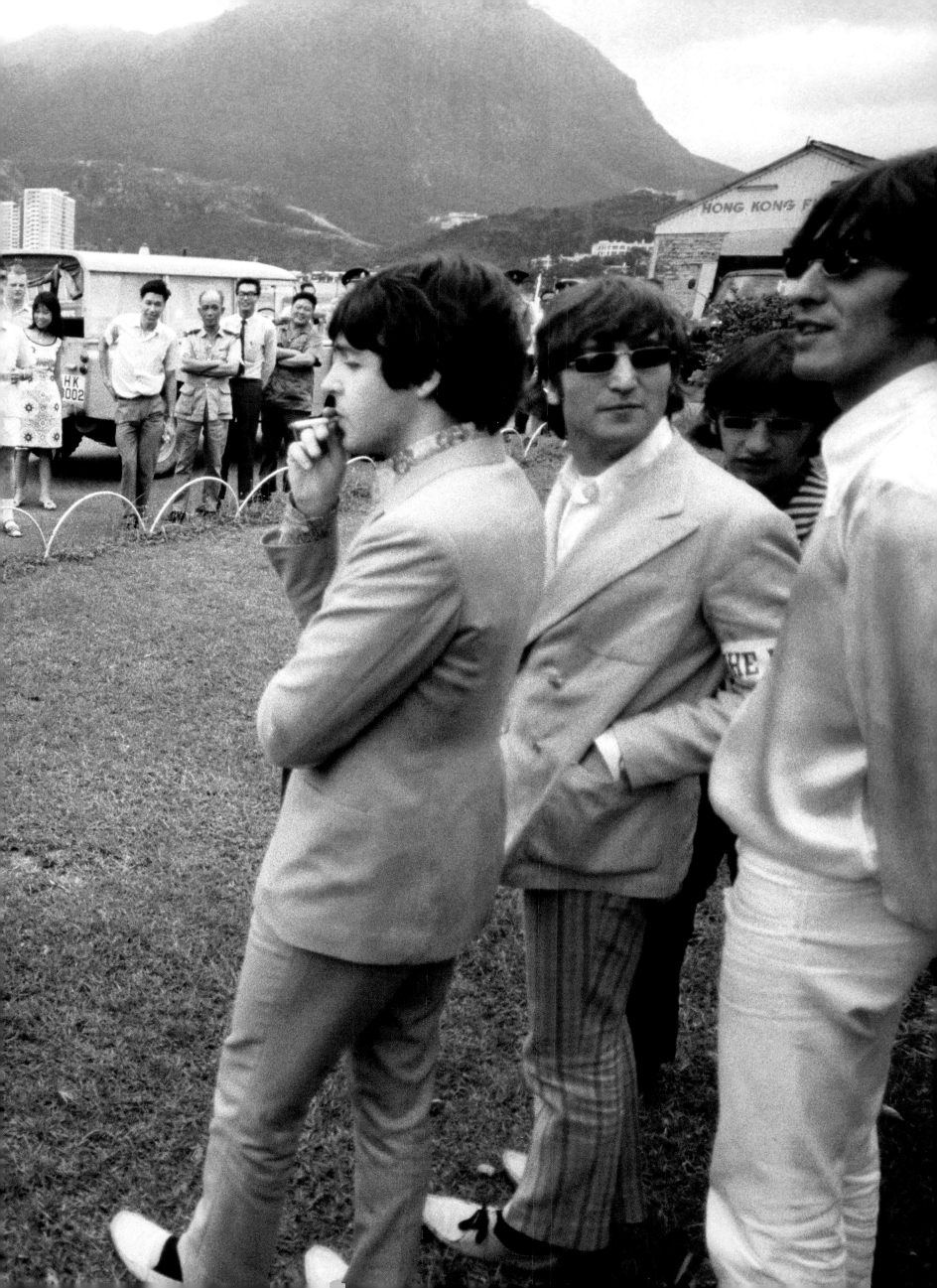

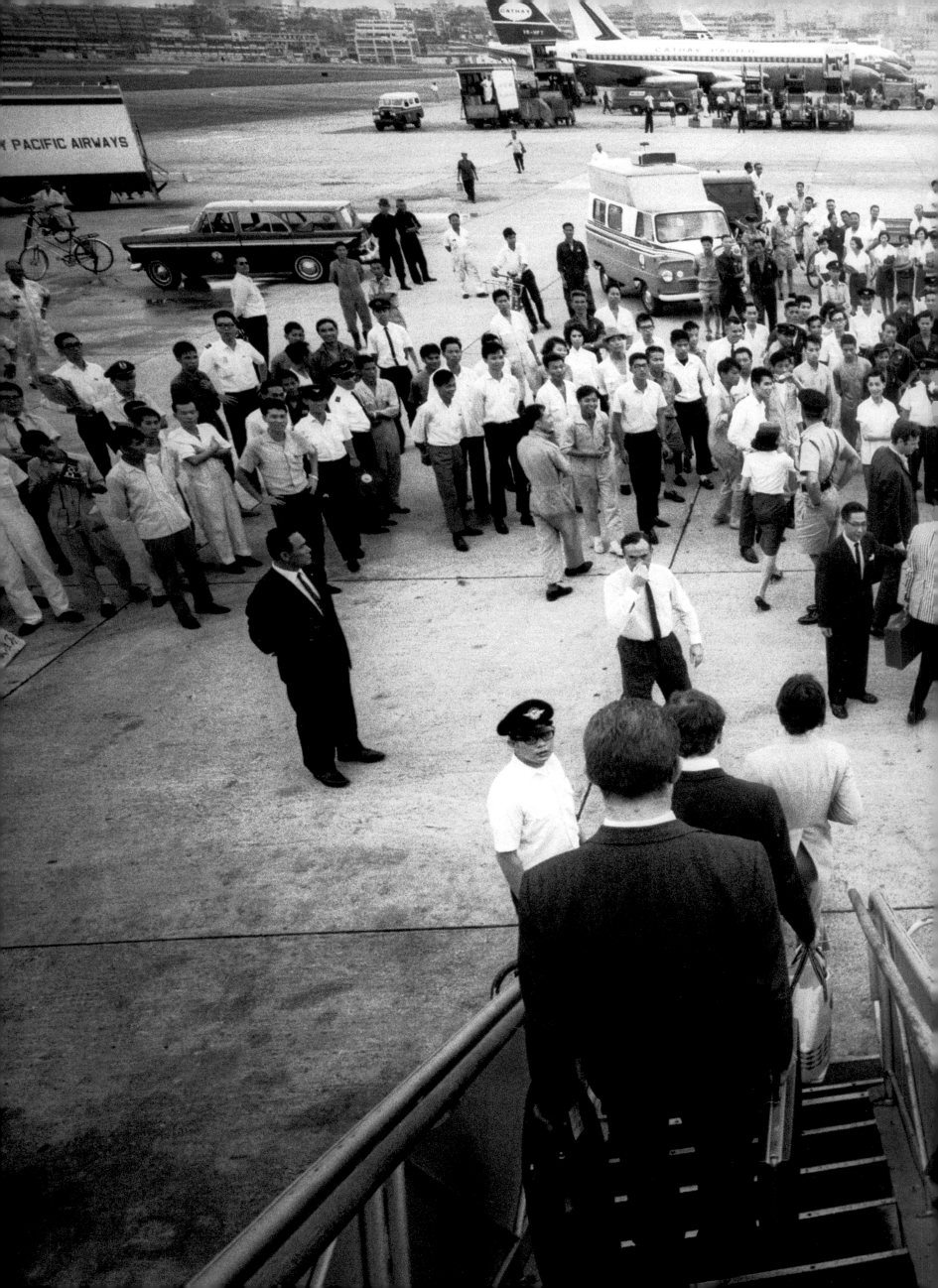

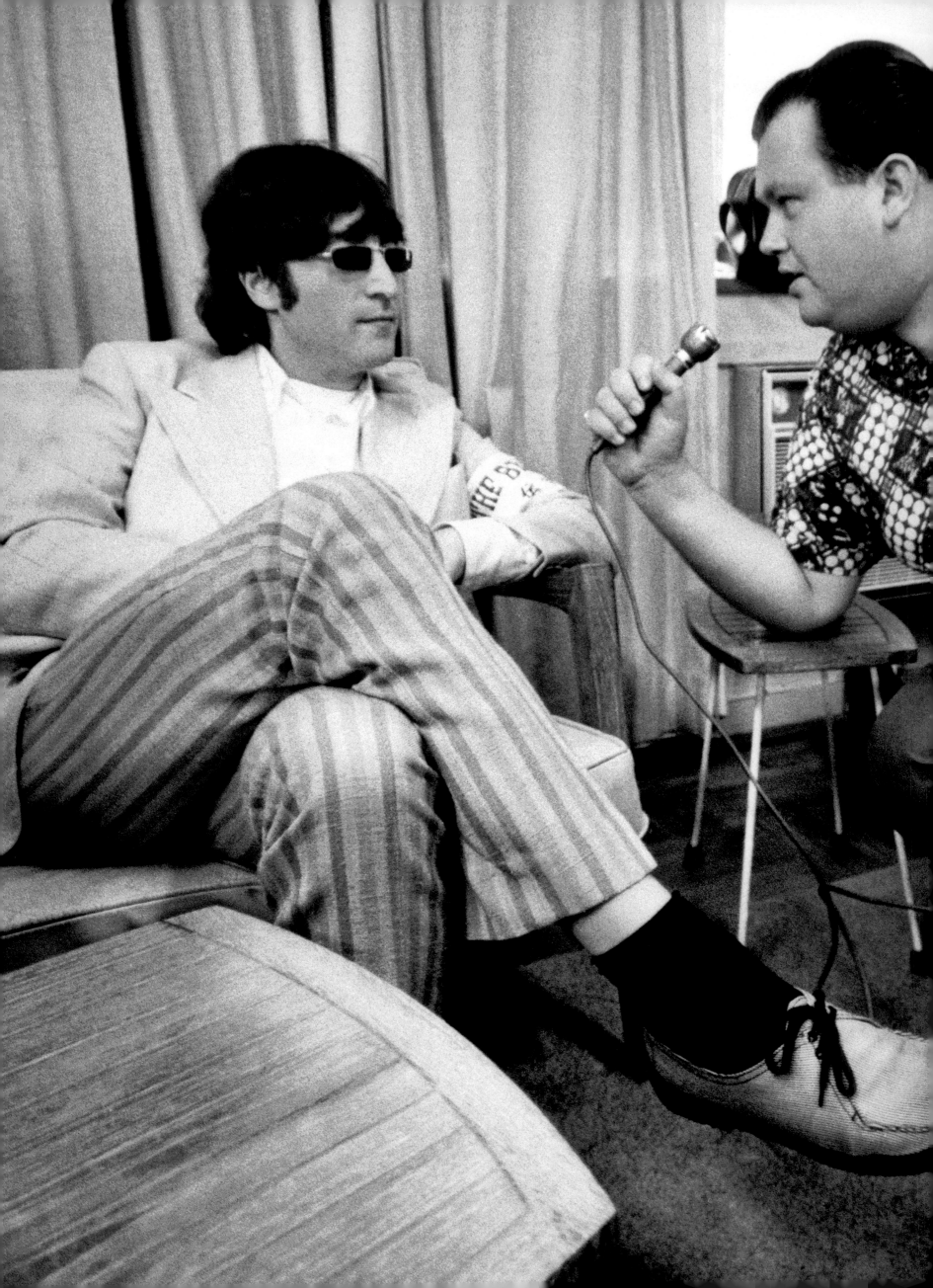

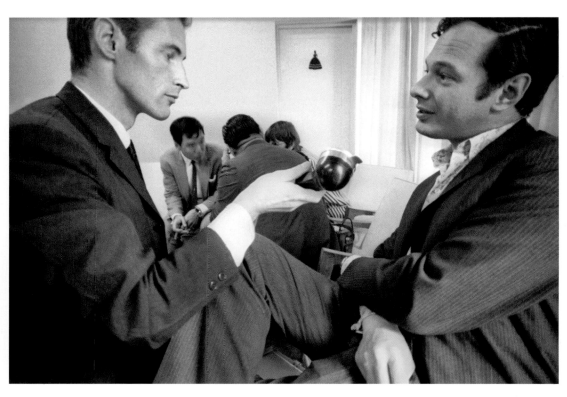

DURING THE BRIEF STOPOVER before heading to Manila, a last bit of relative calm before the storm: In the VIP lounge at Hong Kong's Kai Tak Airport, journalists interview the group (left, John talks rock 'n' roll; above, Brian talks business). "The Beatles had a great knack of responding to reporters' questions with hilarious quips," recalled Whitaker. "I think it helped them get through these sessions."

ON THE WAY to Manila for what would be the Beatles' last-ever concerts in Asia, John chills on the plane with what has been a favorite pastime since his boyhood: drawing. But look—he's defacing the Beatles! Perhaps he's sensing that some kind of end is near for this phase in the life of the band. If so, he will soon have more evidence. "I remember feeling uncomfortable as soon as we arrived in Manila," remembered Whitaker later. "The Beatles were immediately separated from us and whisked away with their bags still on the runway." They had never been without the security of Mal and Neil, and now they were taken out to a yacht without any explanation. "We've no idea why they took us to the boat," said George later. "We still don't know today." They weren't just uneasy, they were fearful. "The Philippines visit was really frightening," said Ringo in *The Beatles Anthology*. "It's probably the most frightening thing that's happened to me." The Beatles made it through the night, and it was probably a good thing Neil Aspinall had been left behind when the band was spirited away. The Beatles' luggage, as Whitaker said, had been left on the airport tarmac. Unfortunately, those bags contained marijuana. Very fortunately, however, Aspinall grabbed them before they were seized by authorities. One disaster averted. Another would not be, and surprisingly the man caught in the middle of it was mild-mannered Brian Epstein, seen on the next pages before the back-to-back concerts that would draw a total of 80,000 fans—and an army of security—to Rizal stadium on July 4. As events unfolded over the next several hours, Whitaker felt compassion for his friend and boss: "Brian Epstein was one of the most honorable people I have ever met. Brian changed my life when he asked me to come and work for him. I owe him a great deal and I've got a lot of fond memories about him." Whitaker, along with the Beatles, would be devastated when Brian was found dead in his London apartment, an apparent suicide, only the very next year. It has been speculated that, with the band deciding to leave the road, Brian felt at sea—he had nothing important to do but collect money—and drifted into depression. "After Brian died, we collapsed," said John. "We broke up then."

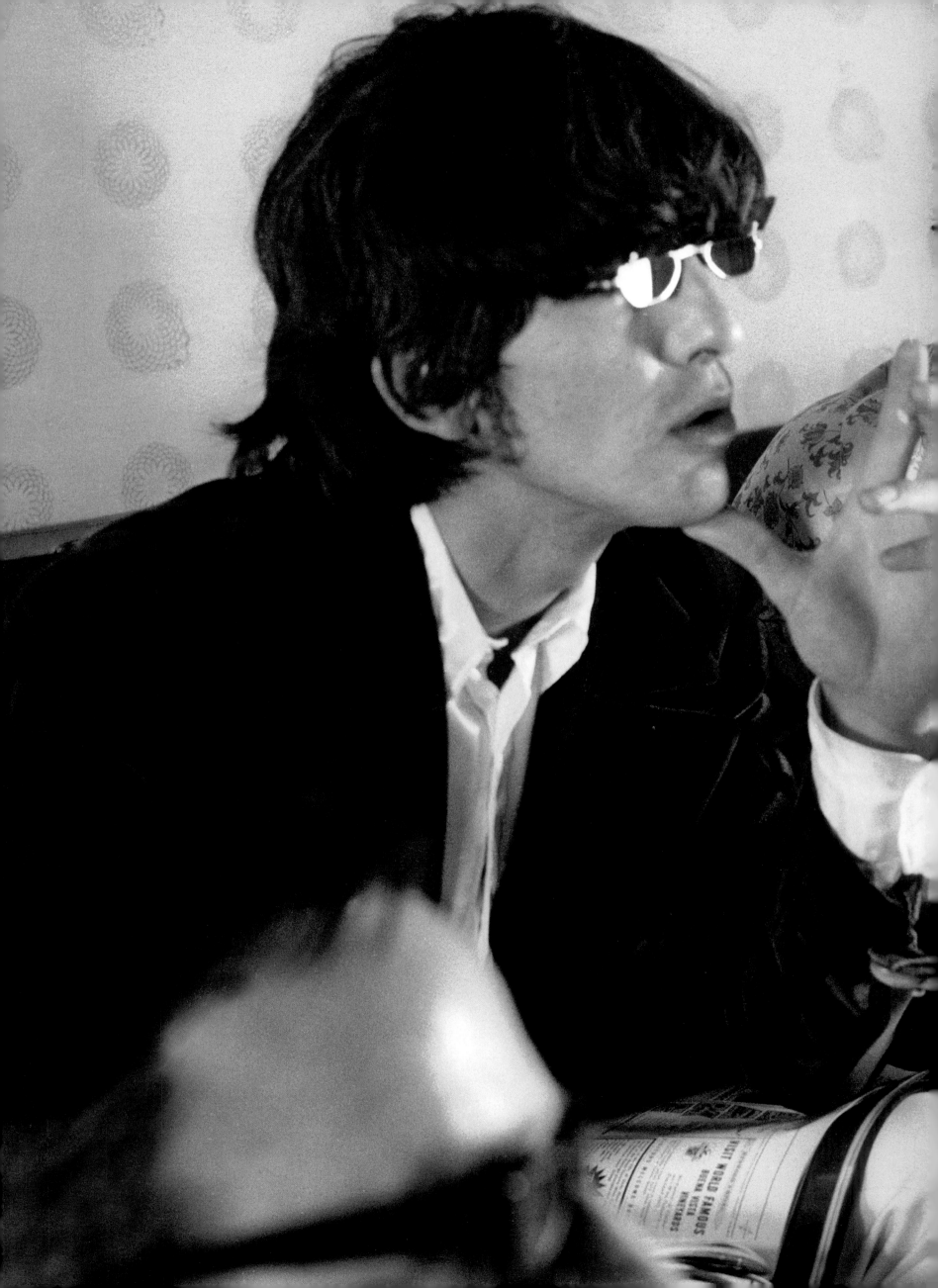

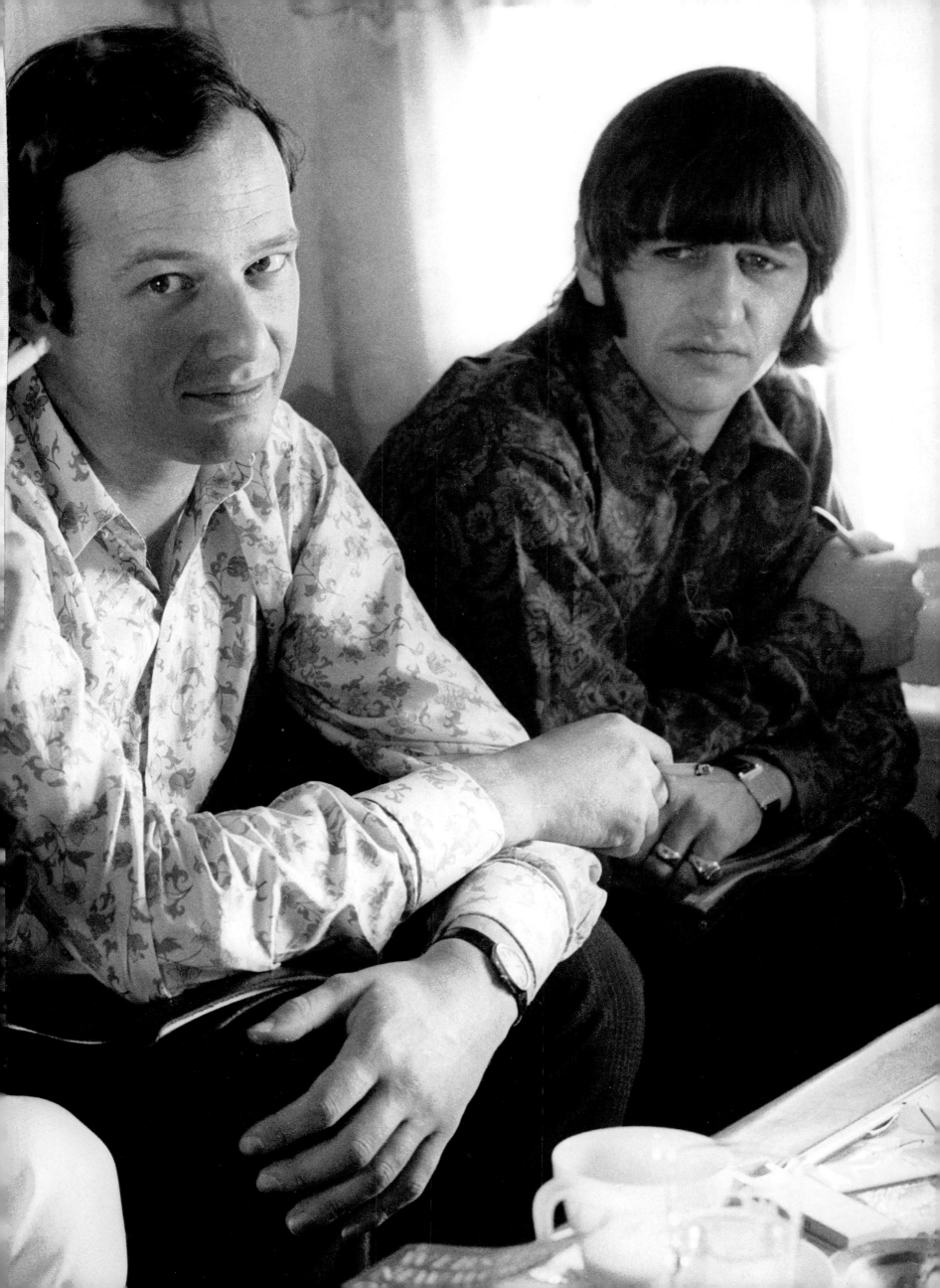

EVERYONE WAS

tired, everyone wanted to finish business in Manila and go home. You had to be young to pull off the kinds of tours that were booked for the world-beating Beatles in 1966. Consider the logistics of transporting them and their associates, not to mention these duds. June 24 they play Munich; June 25, Essen; June 26, Hamburg; they leave the next day for the other side of the world and get stuck in Anchorage. For three days straight beginning June 30 they play shows in Tokyo; July 3 they travel to Manila; July 4 they play two shows there. Only a day away, and the finish line still wasn't in sight. Something had happened behind the scenes—something not yet public—and later there would be conflicting accounts. Had someone in the Beatles' entourage received a dispatch inviting the band to an 11 a.m. July 4 reception with Philippine First Lady Imelda Marcos? Did Epstein receive a telexed invitation to which he sent regrets? Another story: Brian Epstein and the band didn't know about the party at all, and when an emissary came to summon them, Epstein said all four Beatles were sleeping, they had shows in the afternoon and evening at the stadium, and he wouldn't wake them. Neil Aspinall said later that even if the Beatles had known about the party, they wouldn't have gone, having, at the time, a disinclination to get involved in politics (and this was certainly political). In any event, the Beatles were absent at the reception, and the stage was set.

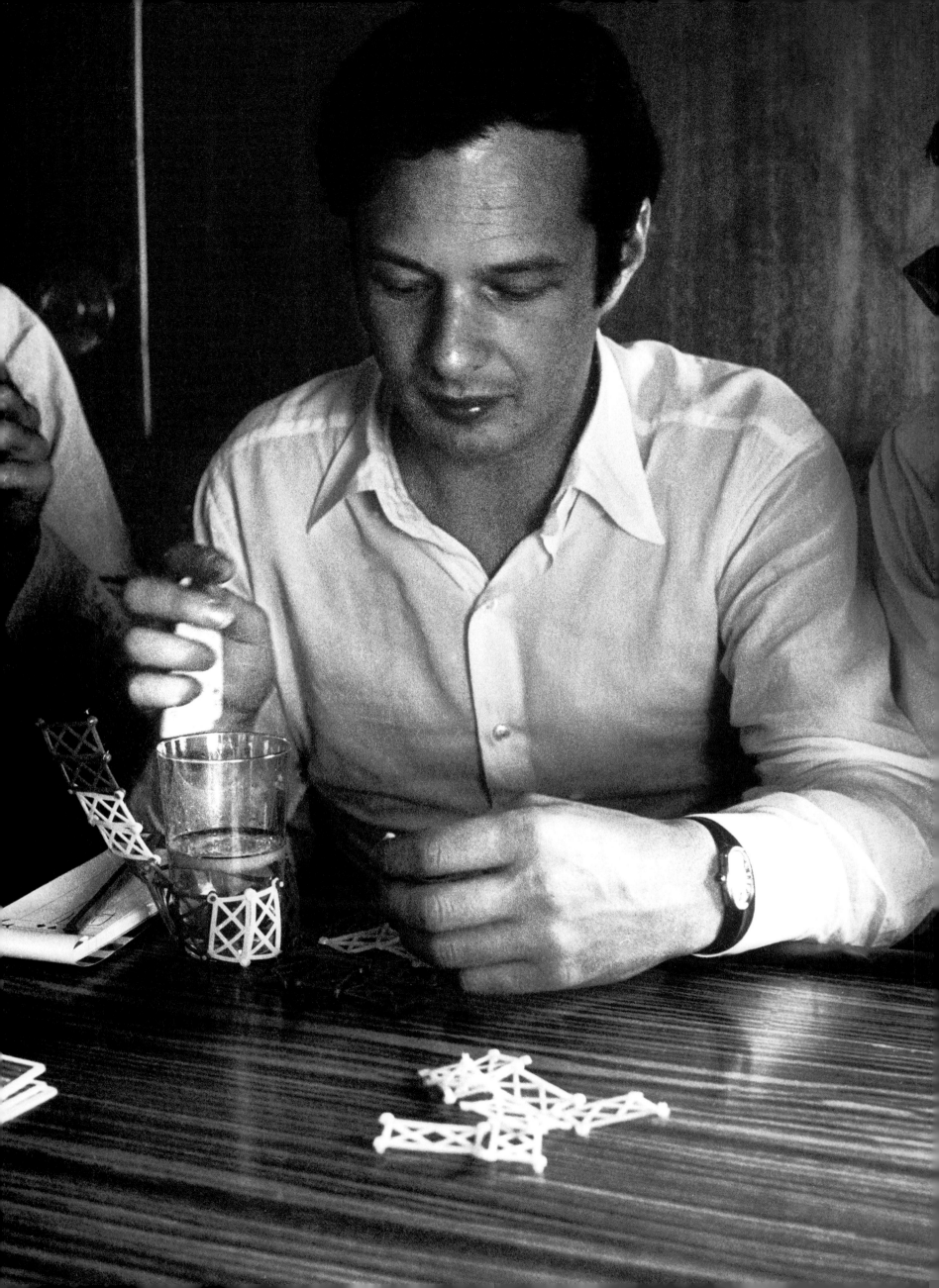

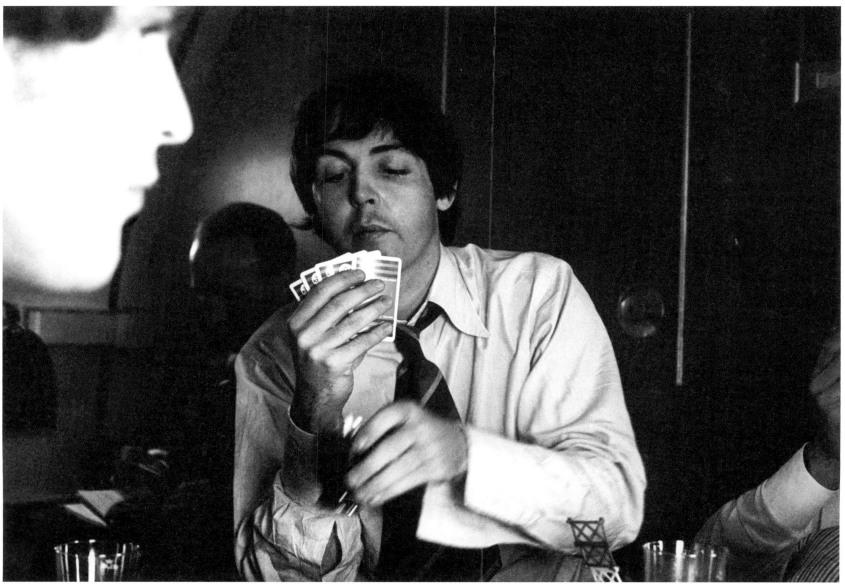

ALREADY, remembered Whitaker, "the Beatles were disturbed by numerous threats to their safety." He continued that, before traveling to Rizal stadium, "a game of cards helped to calm our nerves." Top: Mal Evans, too, is feeling the heat.

THE GOOD NEWS IS, word about the Beatles as a no-show for the Marcoses had not yet been widely disseminated to the Philippine public, and gun-toting security were able to control the two packed crowds. If the man in the street didn't yet know about what would become locally famous as "the snub," the elite of Manila did. In the packed coliseum, something caught Whitaker's eye: "I was intrigued by an area that was presumably reserved for dignitaries who didn't seem to have turned up." What would become a virulent Philippine protest against the Beatles had already begun in some sectors. It would spread overnight, but the Beatles, who were to leave for London the next day, were oblivious to it. They slept like babies.

RINGO REMEMBERS

in *The Beatles Anthology* that the boys were just laying around, wondering why breakfast hadn't been delivered. They called down; got no response. *Hmmm.* "So we put the TV on and there was a horrific TV show of Madame Marcos screaming, 'They've let me down!' There were all these shots with the cameraman focusing on empty plates and up into the little kids' faces, all crying because the Beatles hadn't turned up." When the Beatles got downstairs they realized that all the headlines were calling for their hides, and that their security had vanished. At the airport, things were truly hairy. In this photograph, Paul is jostled at passport control; the strain of what is happening shows on his face. On the tarmac, Mal Evans fell and was kicked. Eventually, everybody got on the plane. When they returned to London, Brian Epstein held a press conference and promised that planned gigs in the Philippines by Cilla Black and Sounds Incorporated, other artists under his management, were forthwith canceled. George suggested harsher reprisals: "If I had an atomic bomb, I'd go over there and drop it on them." He also said, "We're going to have a couple of weeks to recuperate before we go and get beaten up by the Americans." They made it through another night-after-night tour in the U.S. to the last show, August 29 at Candlestick Park in San Francisco. "I think the incident in Manila strengthened their resolve to stop playing live," said Whitaker. There can be no doubt. John now sided with George: no more touring. And that was that.

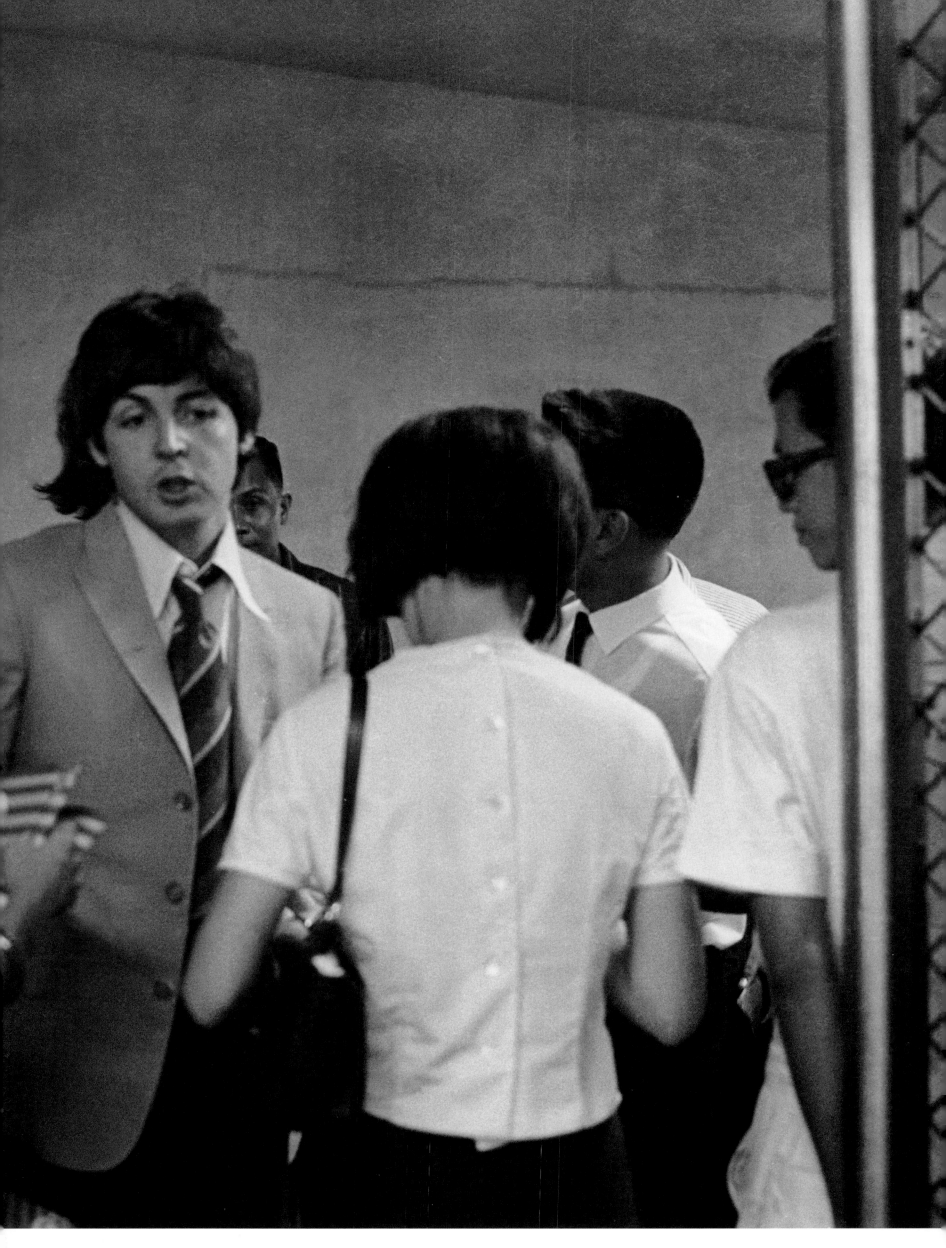

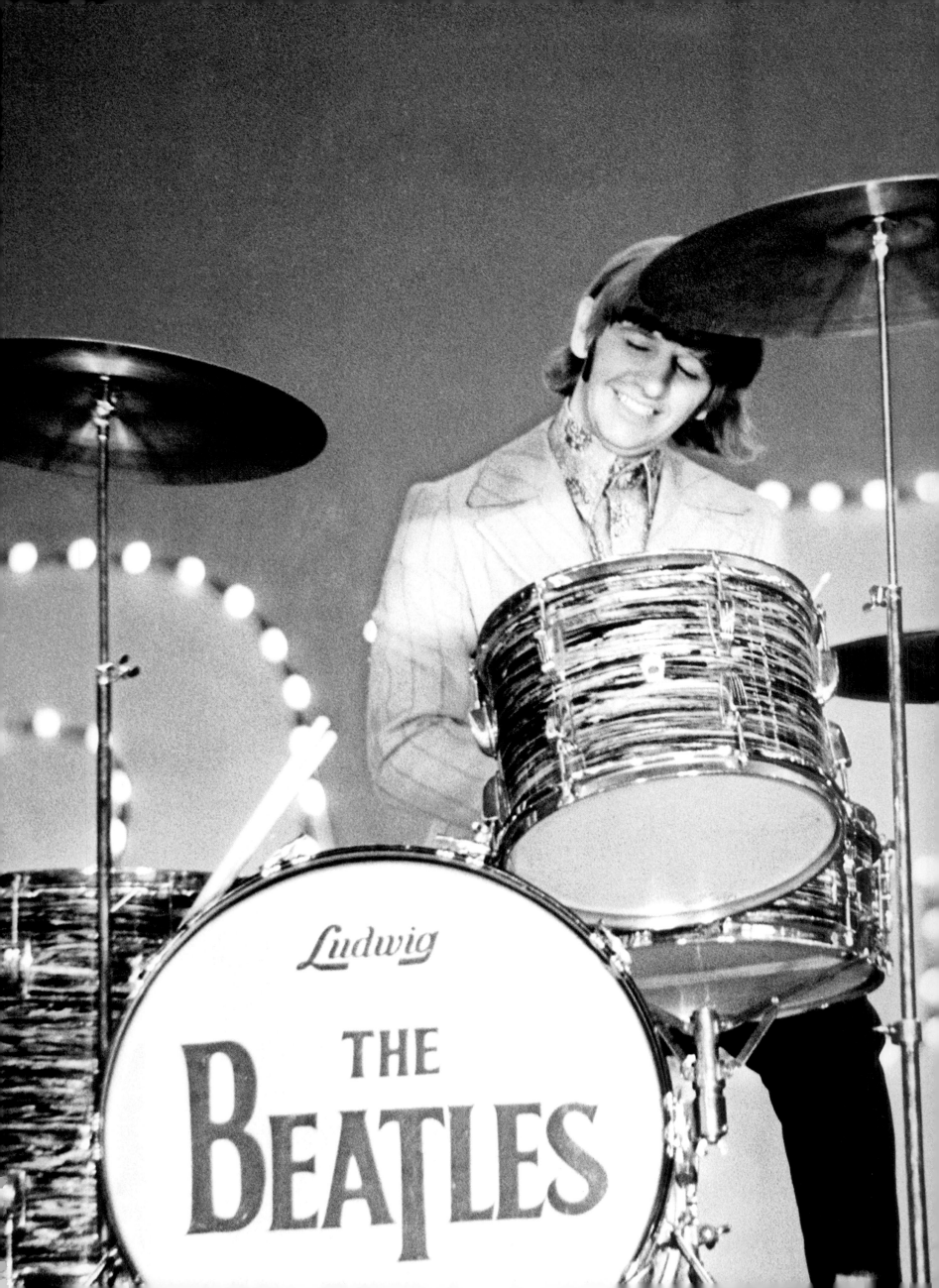

SO IF THERE would be much more fine Beatles music made, and if fans would still cluster outside the studio on Abbey Road whenever they learned the band was in residence, Beatlemania lasted only a relatively short time. Four young men from Liverpool survived the lot of it, often enjoyed it, and finally came to be fearful of it. Here we bid them—and Beatlemania, and therefore Bob Whitaker—farewell. We'll start with Ringo. The last into the band not too long before the mania spread, he was the oldest Beatle, having been born in Liverpool on July 7, 1940. His given name is Richard Starkey. His father, a baker also named Richard Starkey, left his wife, Elsie, and their delicate, big-eyed only child before little Richie was four. He was a sickly child, and school wasn't for him, but music was. Eventually he was drumming for the Liverpool band Rory Storm and the Hurricanes, who played the same haunts as the Beatles—both in Hamburg and at home. In the summer of 1962, Brian Epstein was shopping the Beatles to various record companies, and George Martin agreed to hear them. He said that, yes, he would record the group, but told Epstein the drummer, Pete Best, was "not good." On August 16 of '62, it was Epstein's unhappy job to tell Best that he was out of the band (if there was brief consolation for Pete, it was that Liverpool's rock 'n' roll fans screamed in outrage). Ringo, who had already filled in with the Beatles in Hamburg, was hired. In September, "Love Me Do" was recorded—and the rest truly is history. Today, the characteristically good-natured drummer is happy and healthy and has long since returned to the stage. He tours when he chooses with various iterations of his All Starr Band, featuring fellow veteran rockers. On the day Ringo turned 70 in 2010, the band was playing to a sold-out audience at Radio City Music Hall in New York City, and apparently had finished the show. At that point, Sir Paul McCartney bounded onstage and tore through the Beatles song "Birthday," Ringo blasting away on drums, as the crowd went crazy—just like back in the day.

PAUL WAS BORN in Liverpool on June 18, 1942, and George on February 25 the following year. Paul's father, James, was once leader of Jim Mac's Jazz Band and sometimes composed his own songs. A cleaning inspector and cotton salesman by day, he would play music hall tunes in the evenings on the family piano, doubtless inspiring such classics as "When I'm Sixty-Four" and "Lovely Rita." George's father was a music-loving bus driver named Harold, and he and George's mum, Louise, were regarded at the Liverpool Corporation Centre for Conductors and Drivers as top-notch ballroom dancers. George loved music as soon as he discovered it: "I remember as a baby standing on a leather stool singing 'One Meat Ball.'" Paul's childhood was a middle-class idyll, particularly when compared with those of John and Ringo. George enjoyed a wholesome home life, but was a phenomenally bad student, finding school at best "a pain in the neck" and at bottom "the worst time in my life." He was a lucky flunk-out, though, "fortunate enough to feel there's an alternative." That alternative commenced when Louise spent approximately eight dollars to buy him his first guitar at the age of 13. Paul was into guitars too, and when the boys met one day on a bus, they talked excitely of their shared obsession with rock 'n' roll. They started hanging out together, trading chords—just like in this photograph, taken by Whitaker only seven years later. (Seven years, from that to this—and now this was coming to a close!) The second crucial meeting was the now-famous one: Paul saw John's Quarrymen skiffle group play at a church social, met him after the set, and two weeks later was in the band. Not long thereafter Paul introduced John to his friend George, who auditioned by playing "Raunchy." John was wary of George's youth, but tolerated him as a kid brother. Eventually George became a Quarryman too. The band would morph further, but that's how the front line came together. After the Beatles broke up, George enjoyed a solo career the equal of Paul's or John's—all of them very successful. He would die in a friend's home in the Hollywood Hills after battling cancer; he was 58. Paul, of course, remains one of the world's very biggest musical celebrities and concert draws. After decades of keeping the Beatles years and songs at arm's length, he today embraces both warmly.

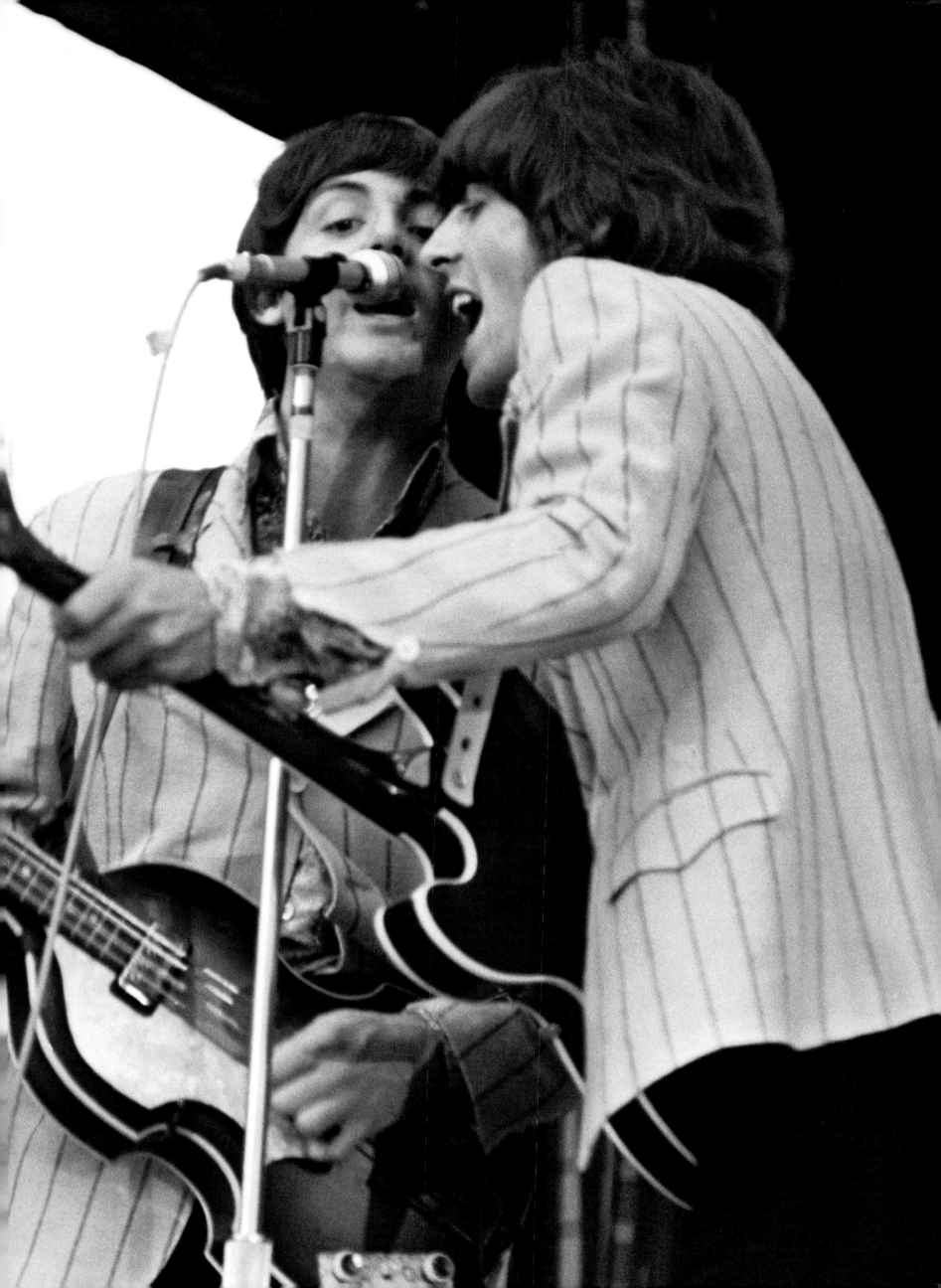

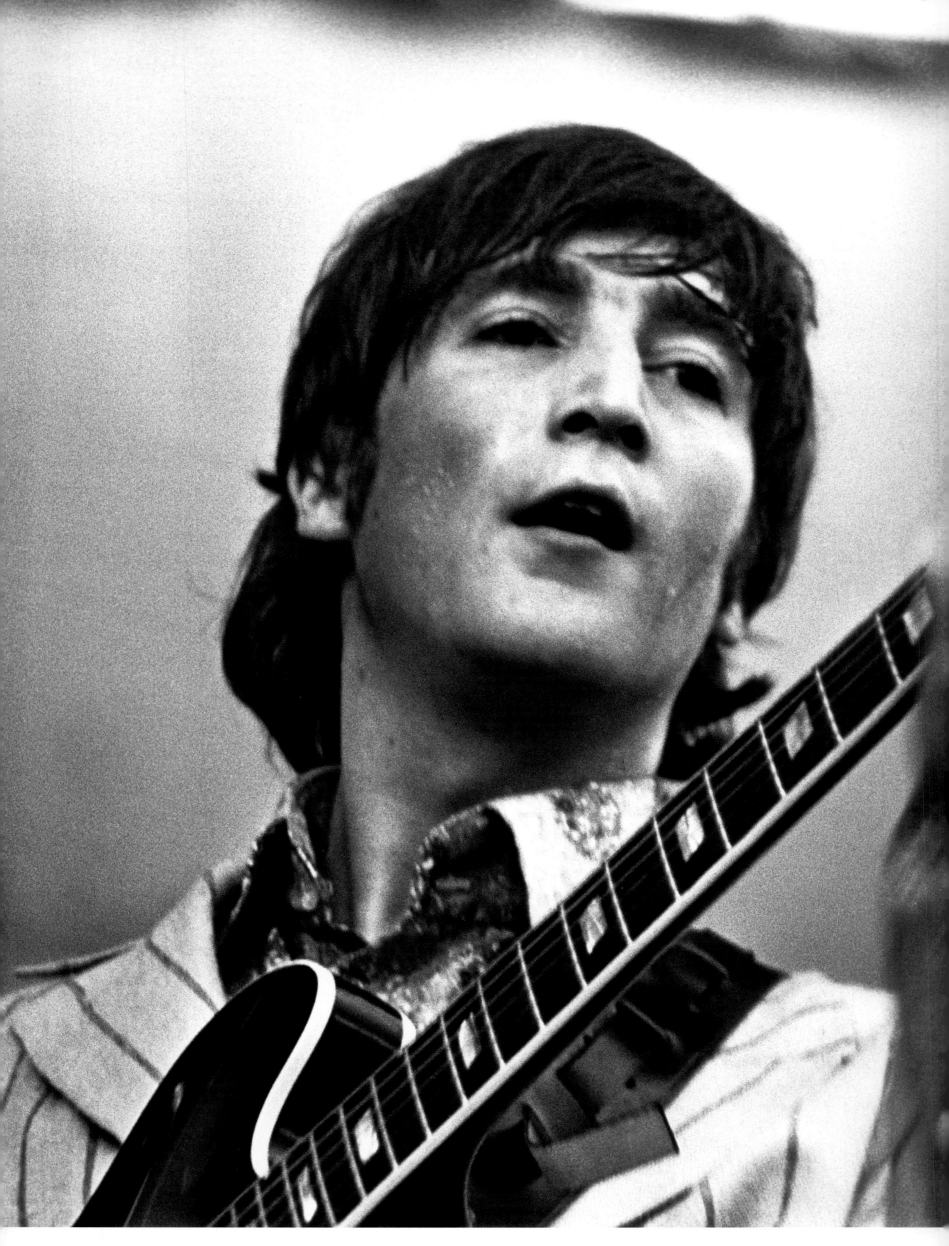

LASTLY, FITTINGLY: the fellow who started it all. Perhaps because John was Bob Whitaker's mate, he has probably been seen slightly more often in these pages than his fellow Beatles—and maybe that, too, is fitting. John Winston Lennon entered the world with a bang—a lot of bangs—on October 9, 1940, a night when Liverpool suffered a horrific Nazi air raid. John's father, Alfred "Freddie" Lennon, a sailor, saw little of his son until 1946. That year he took the lad on holiday to Blackpool and decided to emigrate to New Zealand with him. Luckily—for John, and for the future of rock 'n' roll—the boy was rescued by his mum, Julia (for whom the poignant, gorgeous ballad on the White Album would later be written). Julia would prove to be more a friend than a parent, and John was raised almost entirely by his crusty but lovable aunt Mary "Mimi" Smith and her soft-touch husband, George. Ambition wasn't young John's strong suit (he hoped to run off to sea one day and become a ship steward) until May 1956 when he heard Elvis Presley's "Heartbreak Hotel." (Interestingly, it was this same recording that, elsewhere in England at almost precisely the same time, instantly turned George Harrison and Keith Richards—and maybe a thousand other teenaged Brits—into r 'n' r obsessives.) "From then on I never got a minute's peace," Aunt Mimi later said. "It was Elvis Presley, Elvis Presley, Elvis Presley. In the end I said, 'Elvis Presley's all very well, John, but I don't want him for breakfast, dinner and tea.'" Good luck, dear Aunt Mimi. John formed the Quarrymen and the early reception of the group, even just among the locals, was lukewarm. Then he met and heard Paul, and suppressed his desire to be the one-and-only front man in order to build a better band. He was, as said, reluctant to induct George as a Quarryman, but every time George was allowed to play a gig, the group sounded better, and so George was in. By the time the Quarrymen yielded to the Beatles, John was ambitious indeed, and although he liked Pete Best, if a recording contract depended on a new drummer, then there was room for Ringo. Once formed, the Beatles felt they had something special. They were right, and, as we have seen in these pages, they went on to conquer the world. John was murdered by a deranged fan in New York City in 1980; he was 40 years old. The Beatles were long since past. The music, the excitement, the images, the memories—they lived on. They still do.

JUST ONE MORE

WHEN ALL THE MANIA started, the Fab Four were as excited as little boys to be driven around London in a nice car. They had no idea what a wild ride they were about to take.

SST 626